HEART *of a* NATION

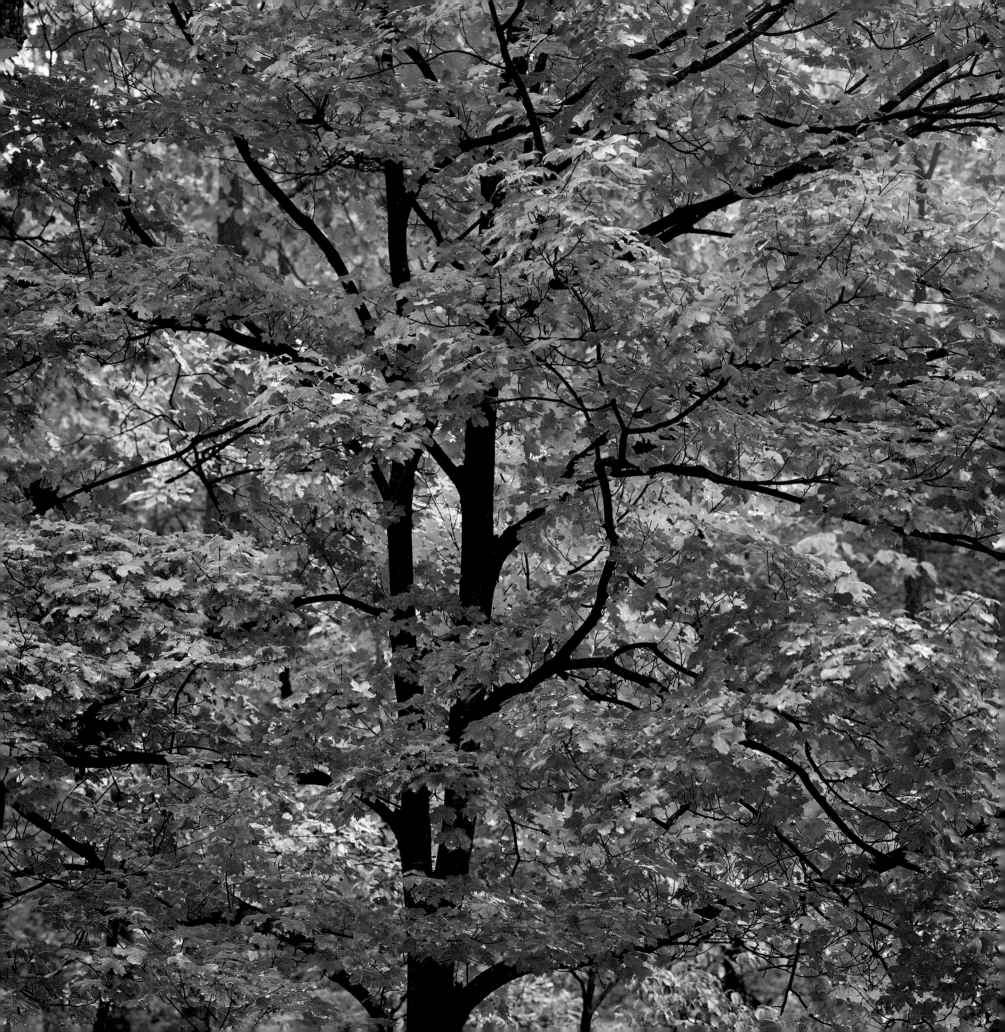

HEART *of a* NATION

Writers and Photographers Inspired by the American Landscape

NATIONAL
GEOGRAPHIC
WASHINGTON, D.C.

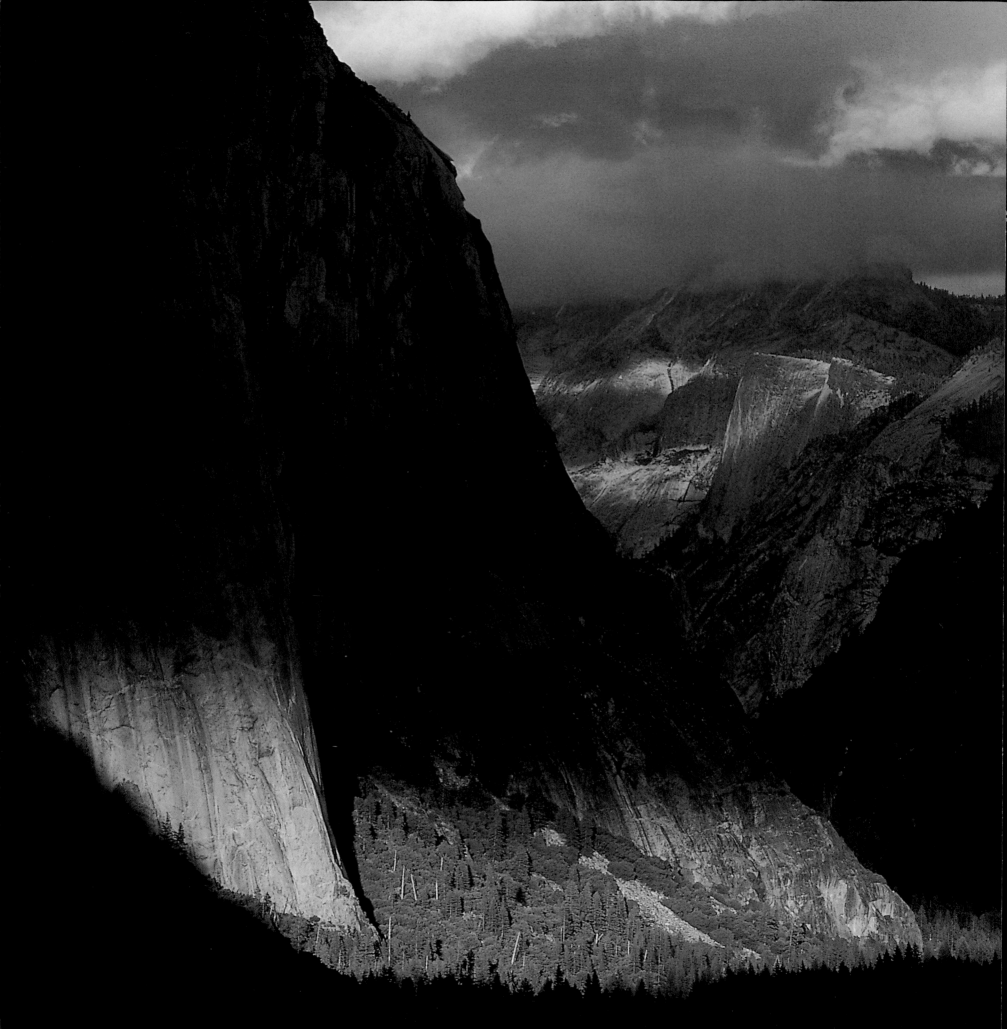

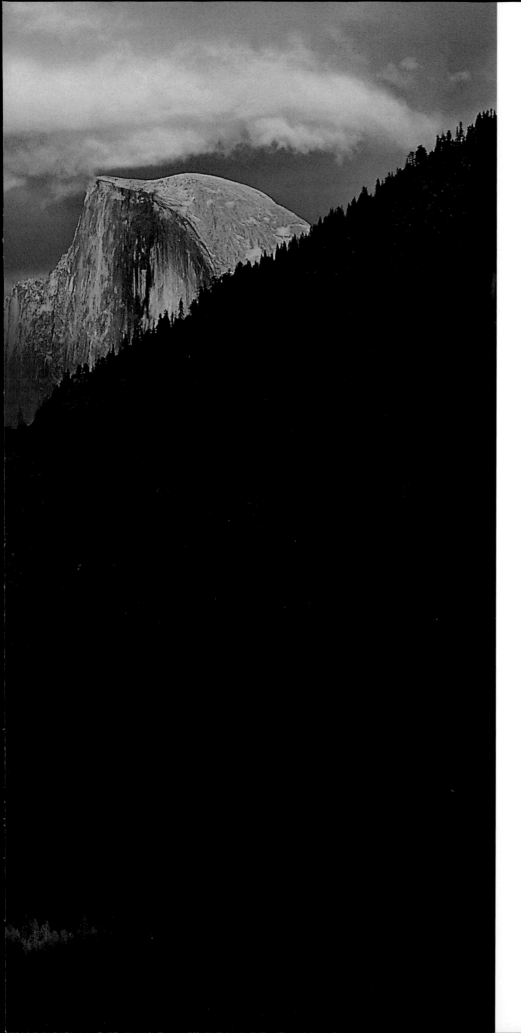

Contents

Phil Schermeister (Yosemite National Park, California) left; Christopher Burkett (Bernheim Forest, Kentucky) preceding page

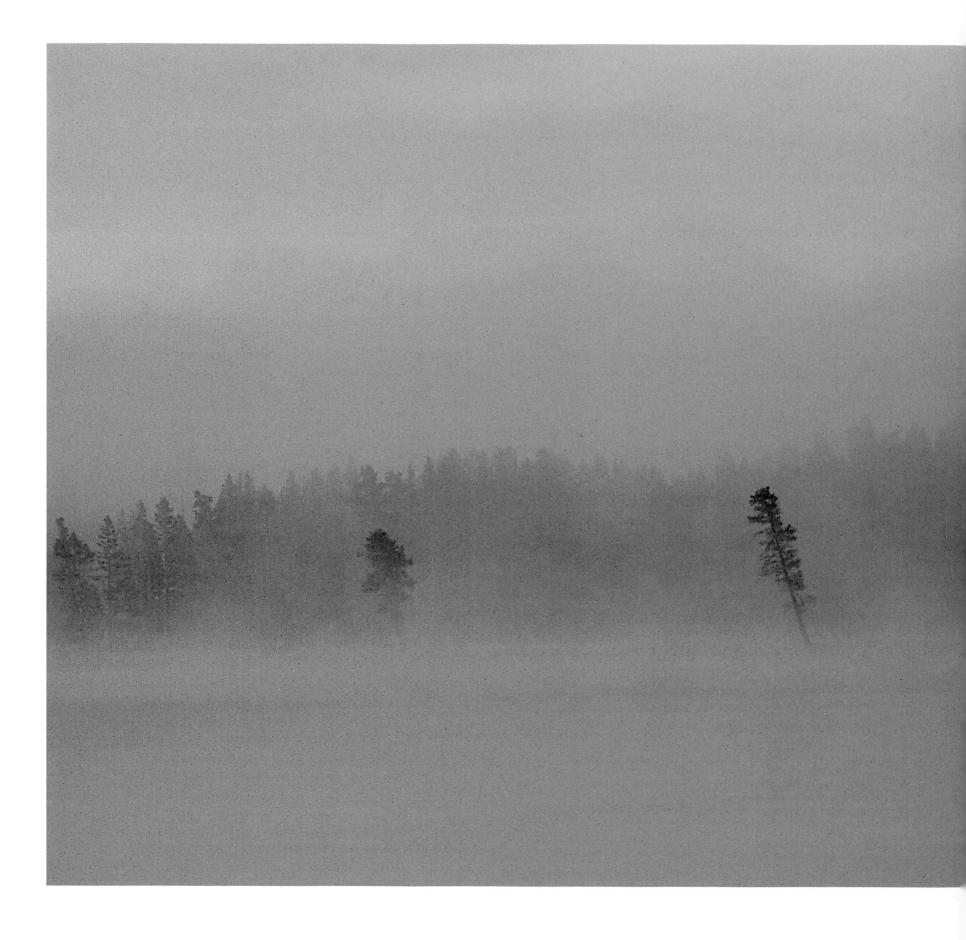

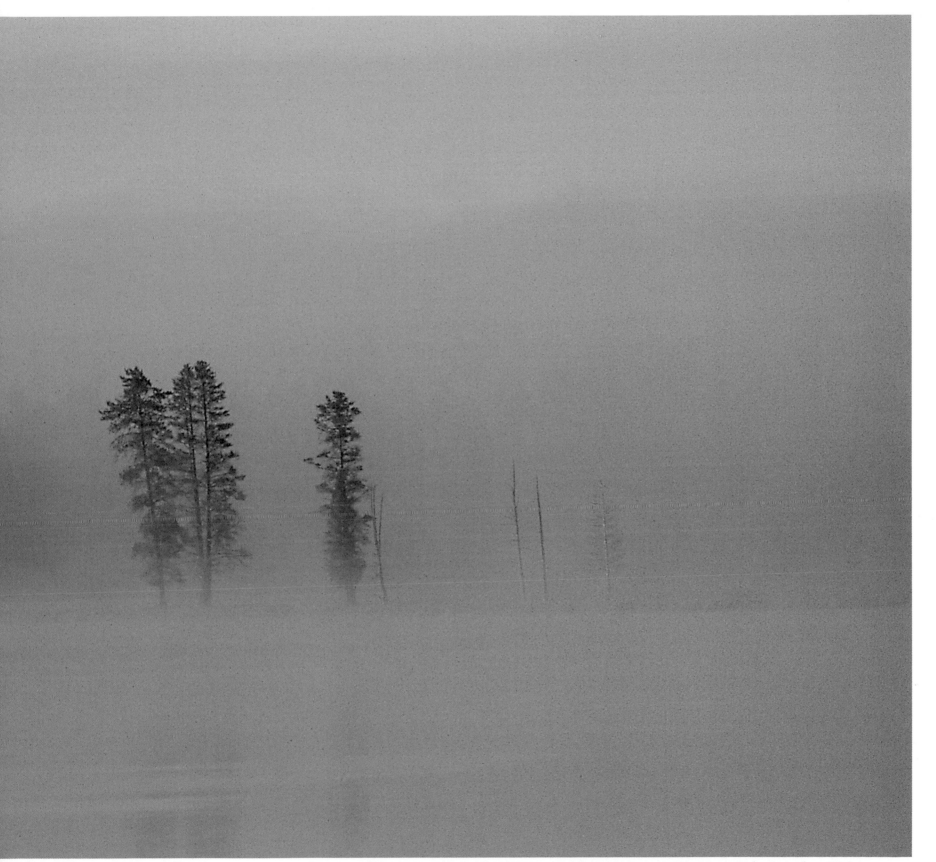

Raymond Gehman, Yellowstone National Park, Wyoming

"The heart of a nation. Where is it? What is it? The heart of this nation is beating, beating, beating; the heart of this nation is wild,... wild hearts in every one of us, wild with the courage to explore new terrain."

—Terry Tempest Williams, The Birthing Rock, Utah

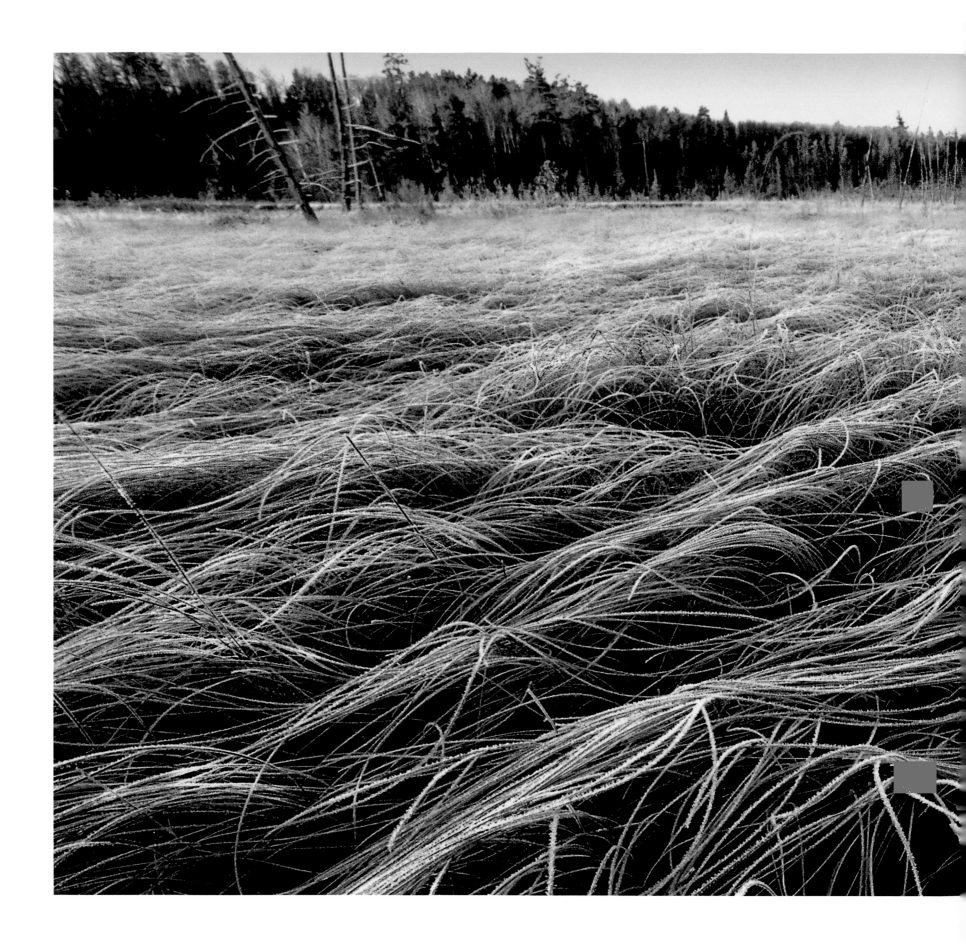

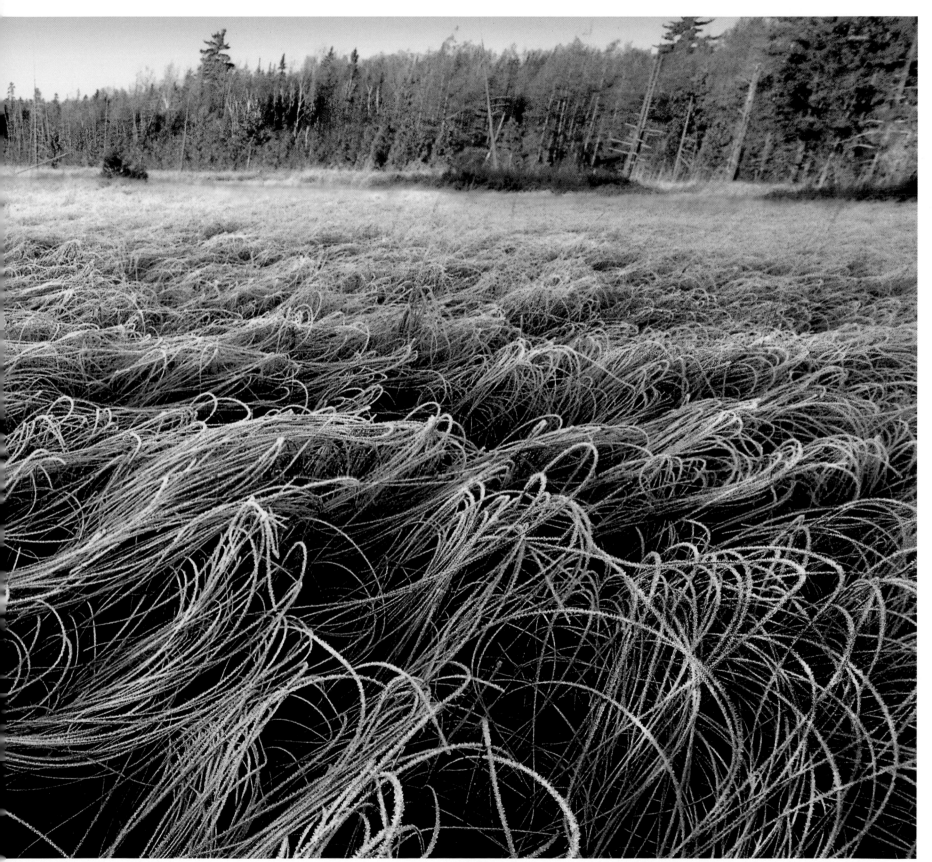

Jim Brandenburg, Northern Woodlands, Minnesota

"There is a way of being with the land

that remembers a place is more than geography,

landmarks, and features.

It's a bridge.

Things pass over it. Through it."

—Linda Hogan, Indian Territory

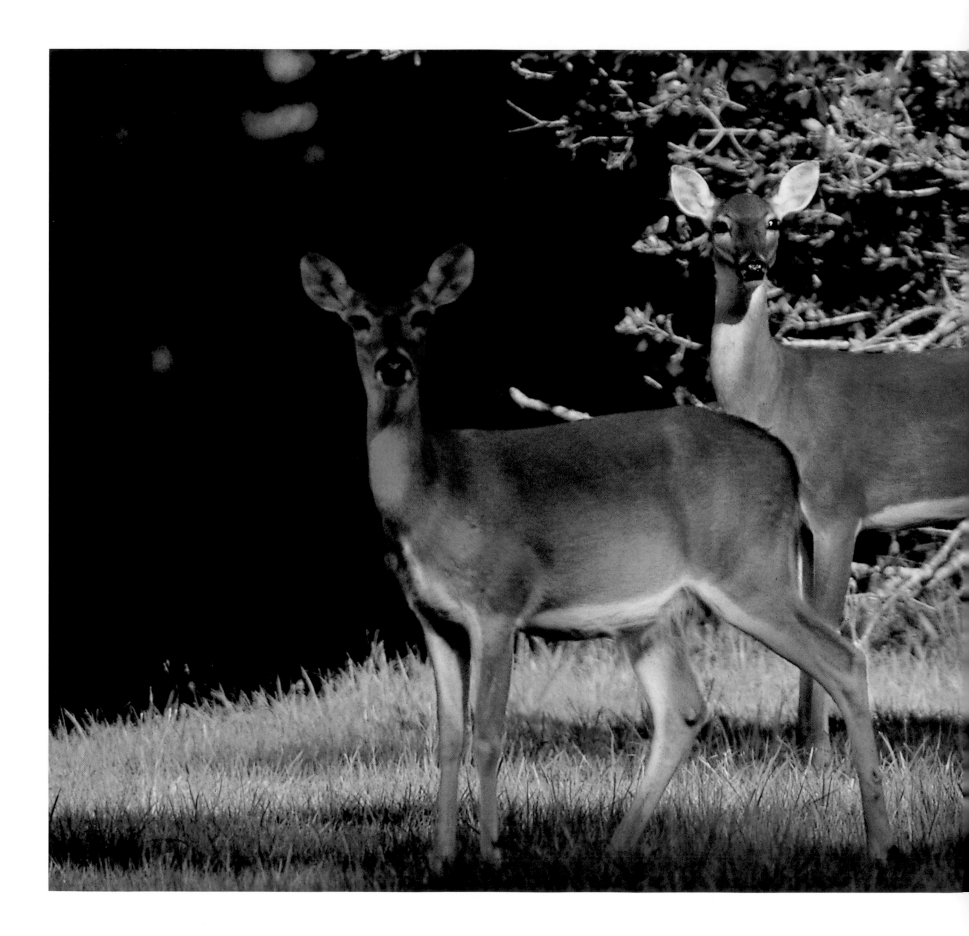

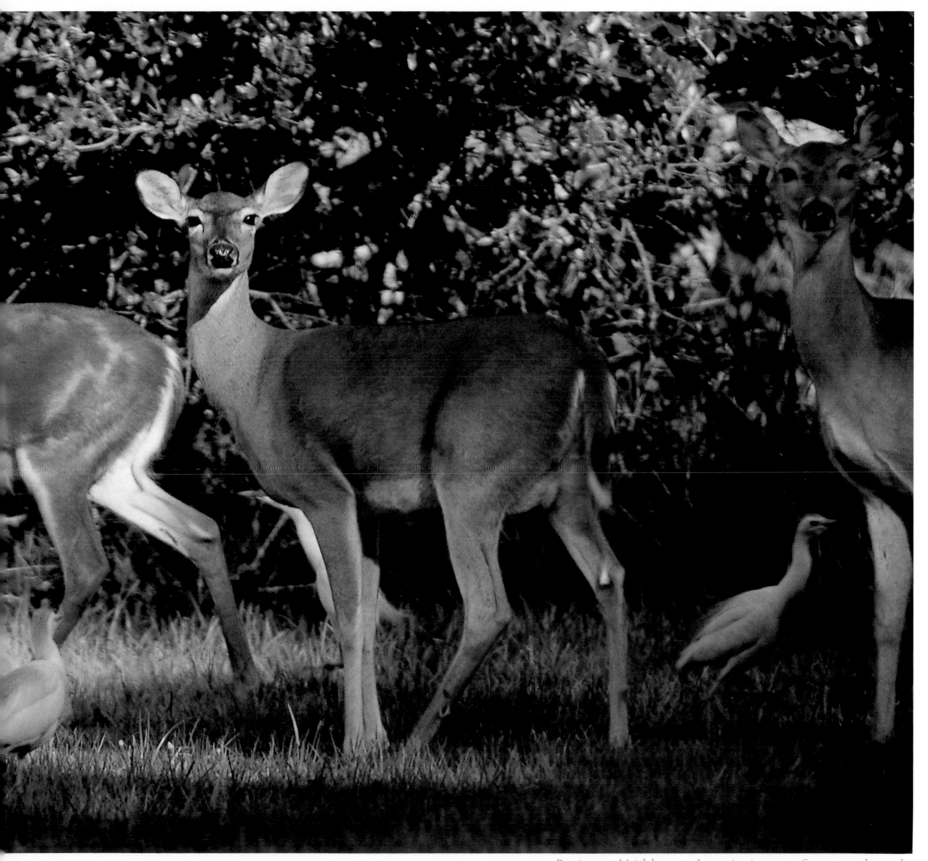

Brian Miller, Louisiana Swamplands

"The forest and sea flow inside my veins.
I cherish them for the sustenance they provide,
as much as I cherish them
for their beauty."

—Richard Nelson, Southeast Alaska

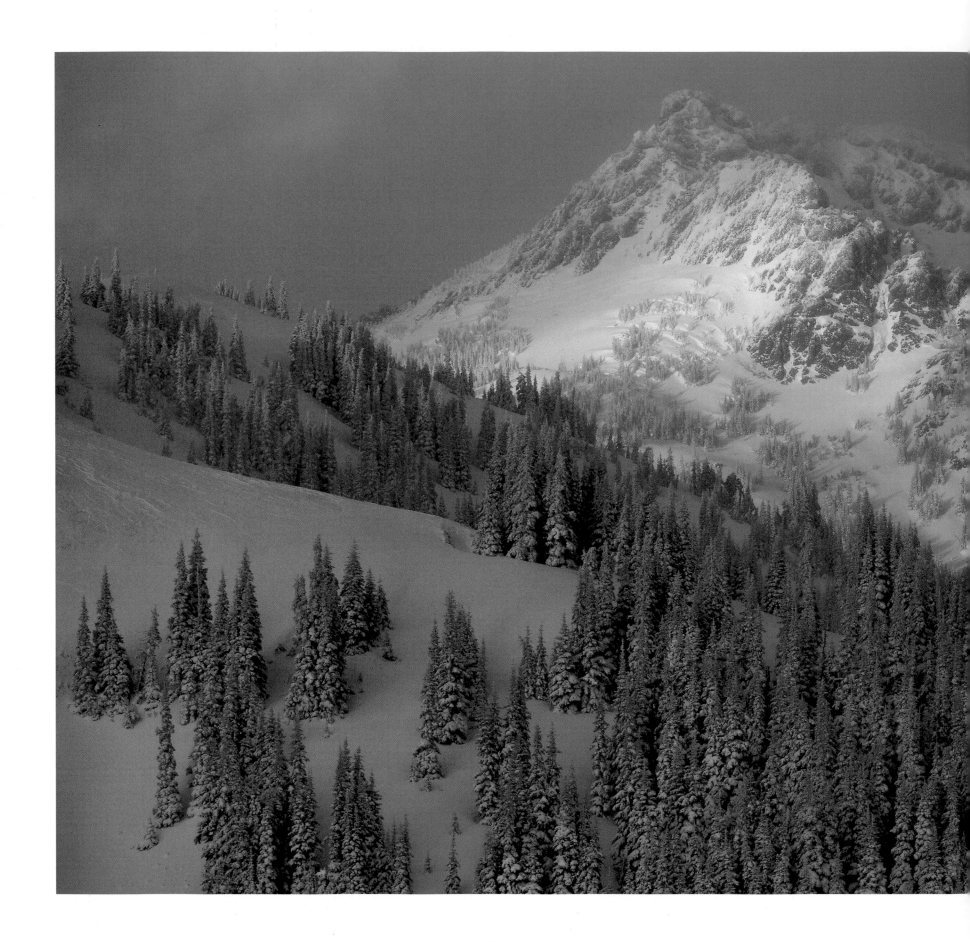

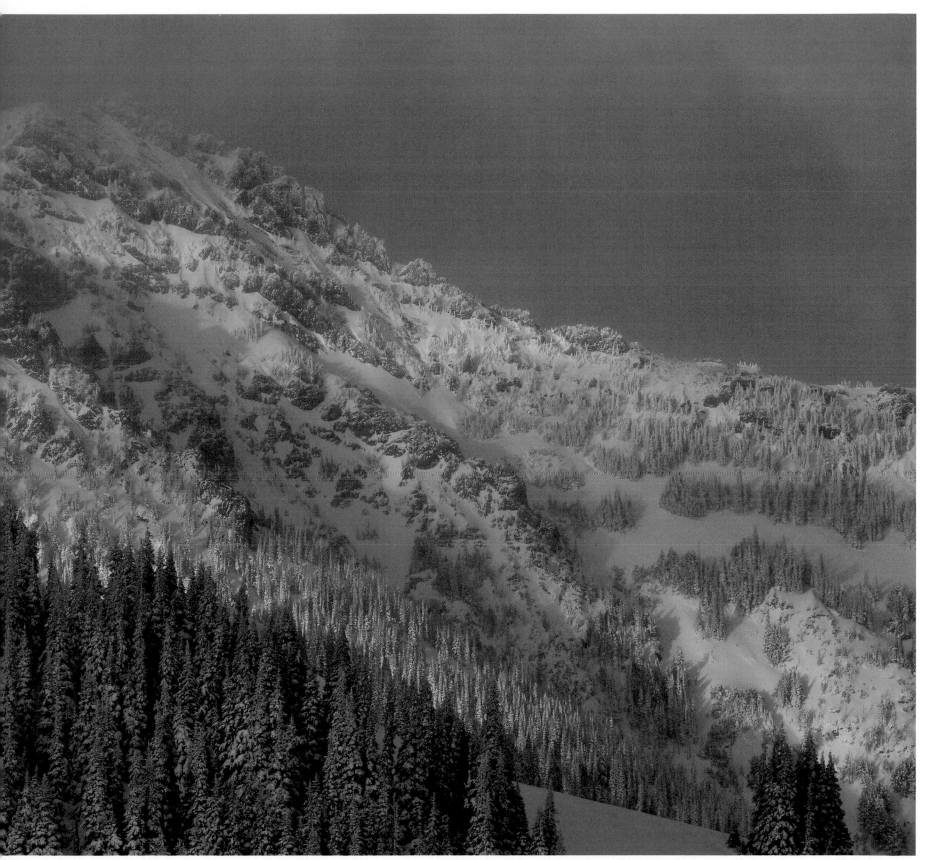

Pat O'Hara, Olympic National Park, Washington

Barry Lopez

Looking Homeward

I am away from home. I slept the night on a beach of coarse sand beneath a fingernail moon, buffeted by a strong northeast wind. I awoke once and lay quiet, watching the crowns of coconut palms sweep the Southern Cross. When my hand, idling in the sand, tipped a shell, a hermit crab pinched my thumb. I awoke hours later to see early flocks of red-footed boobies aloft in the pale light of dawn, coursing the length of the beach and circling their platform nests in a copse of ziricote trees to the south.

The landscape where I flourish is 2,800 miles to the northwest, a wooded slope on a white-water river in a temperate rain forest. We are not ambushed by hermit crabs. We do not gaze at pelagic birds, and the polestar stands 44 degrees above the horizon there, not 18. Even in summer you cannot sleep the night in those woods in a bathing suit and T-shirt, except to prove you can.

Half Moon Cay in the western Caribbean could not be the haunt of elk, black bear, and salmon, as are the western Cascade mountain valleys of Oregon, where I have lived for 30 years. It is different, more so than I can precisely say, even with the help of my sharp-eyed Belizian companions.

This lack of similarity, of course, is stimulating; and I relish the feeling. An exotic surround is one reason for my coming. But I am also here as an outlander, deepening my appreciation of the rarities of my home ground. Knowing you are from a different,

real, and particular place, that conscious awareness, it seems to me, establishes a tension that can help reveal the subtleties of a new place.

I AM STILL REFLECTING ON THE NUANCES of a night of rest at home in the woods versus one spent on a warm Caribbean beach, on the difference between bald eagles and frigate birds, when I sink past one hundred feet in a stadium full of saltwater, a hole in the middle of a large coral plateau 50 miles off the coast of Belize. At 110 feet, the limestone wall I have been using as a guide in the murk flares away from me, and I am looking at what I have deliberately come all these hundreds of miles to see: a colonnade of stalactites, hanging from a sloping roof toward a jutting shelf 20 feet farther down. Some form columns three feet thick. This cliff-face cloister, through which I now glide with six other divers, stands in the north wall of a fabled structure called the Blue Hole. With its flat bottom and sheer walls rising in a near-perfect circle, the Blue Hole is reminiscent of a volcanic caldera, about 412 feet deep and about 1,000 feet across. Its muddy floor is littered with limestone slabs and rubble, a derelict Acropolis—but you have to imagine that scene. I can't see farther down than the three black-tip sharks a hundred feet away, shadowing our explorations.

The Blue Hole has long been known, first possibly to Lowland Maya and then later to indigenous fishermen along what the British once called the Cockscomb Coast, on the Yucatán Peninsula. It was not carefully explored until 1972, however, when Jacques Cousteau brought his research vessel *Calypso* several miles across the treacherous shallows of the coral flat, and saw the transparent, turquoise-tinted water of Lighthouse Reef give way suddenly to a bottomless, deep Prussian blue. He sent divers and film crews into the Blue Hole's grottoes and caves, and two manned minisubs down to its floor. By these

excursions, he shook up the Caribbean folklore that had long storied this abyss as the lair of boat-devouring beasts.

At the height of the Pleistocene ice ages, the Blue Hole was an underground room in a limestone mountain, swirled out by currents of fresh water. As the continental ice sheets melted, the sea rose and began to inundate it. At some point, perhaps during a tectonic event, but before the chamber was entirely filled, its roof collapsed. A diver scrutinizing its stalactites today can see that the upper sections of many of them tilt toward the south at about a 12-degree angle. One widely held view is that the entire region was once tipped by just that much. Shortly afterward, geologically speaking, these stalactite galleries were buried beneath the sea and ceased growing.

The pressure on my body at this depth is five times what it is at the surface. The water around me, unmixed by currents and minimally disturbed by tides, is largely without life, a nutrient desert save for the wandering black tips, a lone lemon shark, and a small school of horse-eye jacks. The rock walls are strangely barren for Caribbean waters, only a little algae, a few sponges, some sea fans, and encrusting worms.

For me, the dimly lit water, the ghostly sharks, the limestone cloister through which I weave, and my awareness of the fallen roof below, intensify a sensation of detachment I often feel when I dive. In this particular place, my sense of separation from quotidian events in the world above, especially the intrusion of frenetic consumption and the hawking of wares, provokes rarified boyhood memories of another, formative trip. I recall walks at dawn around the Roman amphitheaters of southern France, in that hour before many of the residents of Nîmes or Arles were awake. The rediscovery of that sensation, this empirical experience of light, stone, and history in a drowned Pleistocene room, makes me glad I have come all this way.

I rise slowly toward the surface, back through a thermocline where the water is

suddenly warmer by ten degrees. At the lip of the formation, at a depth of 30 feet, sunlight floods a sandy bottom, which slopes up to the gorgeous brilliance of coral heads. At 15 feet I rest, suspended amid vivid schools of tropical fish, to let my body exhale the last of its load of excess nitrogen. When I break the surface I hear human voices and inhale the streaming balm of the trade wind. The pressure is one atmosphere. The horizon is back.

MY INQUISITIVE FEW DAYS IN THE CARIBBEAN, for whatever I may learn or clarify here, are a benign and innocent excursion by comparison with the chilling cultural diasporas of our era. While many move and adopt new places for good reason, ours is also a time of forced displacements, of journeys with, often, no return leg possible. People are driven from the singular place in which they have felt most embedded—their homes, their *oikos*—regularly by drought, by religious and ethnic persecution, by the exhaustion of local resources, by economic collapse, by industrial accidents. As the world tumbles toward globalization, the idea that an individual, a family, or a human community would voluntarily choose to remain in a specific physical landscape, choose it over the chance to gain strategic economic advantage somewhere else, seems increasingly nostalgic. Or, depending on your point of view, revolutionary.

Though we barely consider its application to ourselves, the idea that an organism evolves in concert with its environment is part of the bedrock of evolutionary biology, and not an idea to let go of lightly. The differing answers of different organisms to differing parts of the same environment is what we now call the phenomenon of diversity. In the last decade, many have come to believe that without such diversity in our multifaceted ecosystems, we are putting ourselves in significant biological danger. And yet most of us in developed countries today imagine our homes being situated in a cultural, not a biological,

environment. We stick with jobs and lifestyles, not with places. What this has created, I think, is a geography of risk. As more and more people break off intimate, long-term relations with a place, the chance that the biological integrity of that place will suffer the imposition of ill-considered development increases. The one-time *oikos* of a particular people becomes, in short, an object. A commodity.

What was once an intimacy with a home place that could be considered foundational for human beings, when we were, say, Magdalenian-phase, Cro-Magnon people painting the walls of limestone caverns in the Dordogne in France, when we were utterly dependent on a knowledge of such places for our survival, has become instead intimacy with information about a place. We now determine where we are by consulting a handheld receiver that translates satellite signals into latitudes and longitudes. We no longer mark the aggregate of species of flowers, the movement of birds, the set of the wind to survive. For many of us, the economic profile of a new neighborhood is more crucial to our decisions than its biological profile.

As small, place-based economies the world over have become urban, regional, then national and finally near-global economies, and as the oil-based economies of most developed nations give way today to information-based economies, the cultural importance of physical places in human life—an identity with them, concern about their treatment, joy in their presence—is in danger of diminishing nearly to insignificance.

As a nation, we seem more concerned about the fate of our culture, particularly its economic vitality, than with the fate of our land. Knowing, as we do now, that the fate of land and the fate of human beings can't be separated, however, the discomfiting and thorny question for us is: What degree of biological compromise will we permit to the places to which we are physically and emotionally linked in order to further increase the material wealth of a relative few in the world? As I read the reports,

the answer is: We are willing to go to the brink.

Human allegiance to a real geography these days, to real places, often translates in the popular media into a willingness to lead a backwater life, a life of less consequence, a life out on the margins of heat generated by a market-driven, pop culture. This can now be characterized as fallacious thinking. A culture without real geography—as distinct from a list of objects and locations—is the stuff of a nightmare. It is a tree shorn of its branches.

A folk saying has it that you can't really speak of a baby, you must speak of a "mother/baby." Without a mother, a baby is difficult to comprehend. Similarly, it is problematic economically and politically to consider any people apart from their place, apart from the landscapes that shape and nurture them. We've become more sensitive to this idea recently; and at the opening of the 21st century we appear to be turning back to this kind of thinking, to a more sophisticated recognition of our biological dependence on physical places.

As I understand it, many people now want "home" to mean an *oikos.* They would like to feel that the essence of their living places is rooted in their intrinsic nature, not in their utility or in a financial appraisal. They want to recapture a spiritual, even moral, connection with home. They'd like to imagine that when they are far away and miss their places, that their places miss them.

A new way of thinking, barely discernible, has begun to emerge around this longing. It recognizes the virtue of a moral relationship with a place, a sense that all living things share some fundamental rights. It equates general well-being with psychological and spiritual health, not solely with material well-being. It is fostering an economics based on an awareness of limited resources. And it is, I think, creating what could be called a politics of parents, of human-human relations, as contrasted with an aging 19th-century politics of the captains of industry.

Across a wide spectrum of writing in English-speaking countries today, a central, recurrent theme is the nature of human community. What holds a community together? What causes it to disintegrate? How do you rebuild a community, when a husband and wife are estranged, when a company town loses its factory, or when animals in a landscape are driven to extinction? Ecology is the study of coherence in communities; it speaks directly to these concerns. The principles and definitions of ecology clarify our cultural anxieties and provide us with direction. The hallmark of a healthy ecosystem—good relations in good order—is what we want in our cities, in our watersheds, in our families, in our wildernesses.

We are capable of developing a new awareness that points us this way, toward the stability, comfort, and sustenance we idealize in our phrase "to be at home." We can relocate the *oikos* that was for millennia our primary psychological anchor in the universe.

SUSPENDED BENEATH THE DIVE BOAT *OFFSHORE EXPRESS,* at the edge of the Blue Hole, I have a chance to wonder for the umpteenth time why I leave my home in the United States. I am immersed here in the miracle of sustained, earthly life, which goes by the name of particular corals and fishes. I want, by comparisons and contrasts with this foreign place, to know my own *oikos* better. I want to bring back a story that will, in the reading, intensify a reader's sense of his or her *oikos.* I am like a salmon in one respect, a creature born to a particular river but nourished by a distant ocean, a creature who returns to spawn but also to reintegrate itself. Imagine seedlings growing in a riparian zone where raccoons have abandoned a salmon carcass, or the breath of an island bear smelling faintly of the ocean.

I go away to refresh my sense of where it is I live.

We are at the start of something promising in this country, it seems to me, a rethinking of our notions of what it means to swear allegiance. We are on the verge of a deeper awareness of the meaning of our physical environment, aided by recent, huge gains in scientific knowledge that have intensified, simultaneously, a vision of the staggering biological richness we inhabit, and the preciousness of our residency in it. The miracle is larger than we thought, and our control of it less than we imagined. However we work our way through it, if we are not to have a diminished existence, we are going to have to change our basic cultural relationship with land from an economic one to an ethical one.

It is not so simple as that, of course; but many have posited that the colonial era of aggressive land exploitation is drawing to a close. We are talking now of refugia, of large-scale reorganization, of restoration. The 20th-century assumption that we could simply empty the Earth out like a warehouse and then reconfigure it to our own ends is read by many people today, even if in private, as adolescent naïveté.

The question then is: Where from here?

I begin one morning with the tumbledown limestone of a Caribbean reef and thoughts of Rome and earlier human empires. It is the particular cant of my mind. Another, in the pages to follow, looks back at the sacred rudiments and the trustworthy patterns of life in a now vanished, wooded Mississippi plain. Another starts with an overnight hike to a Rocky Mountain lake with his son. Yet another begins with his camera, alone on an island off the coast of California, another in the North Woods of Minnesota.

Out of such personal and family histories as are featured in this collection of essays, out of our ancestors', even our Cro-Magnon ancestors', wisdom, out of our new-found biological awareness, we will draft the constitution of a new relationship with our home places. We will do it, along some as yet unnamed path, because we do not want our ideals to die. ■

Edward Hoagland

Two Faces of Vermont

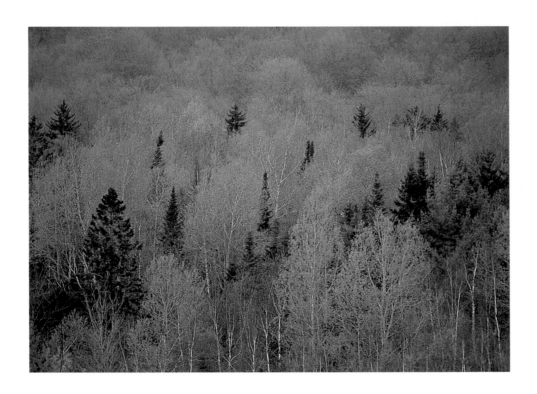

The landscapes were like a violin bow
that played upon my soul.

—Henri Beyle Stendhal

I've had my heart in northern Vermont for 30-some years—specifically in a hundred-year-old, eight-room house on a hundred up-and-down acres, surrounded by an 8,000-acre state forest that lends the place further diversity. Moose and bears cross my yard. Redtail hawks, broadwings, and goshawks nest nearby; also pileated woodpeckers, barred owls, and ravens. Loons giggle overhead occasionally when flying between ponds; or a peregrine falcon, visiting my mountain notch, will stoop to grab a blue jay. Coyotes howl at strategic moments from the vicinity of their den, up a ledgy ridge slope facing my gray-blue house, and, more rarely, a bobcat may yowl from a steeper, bouldery-tumbled redoubt above a talus slide, or simply from the birch woods behind my barn.

I'm between Wheeler and Moose Mountains. Both are under 2,500 feet, but well forested and stippled with springs. Wheeler curves around in a stiff, sprucey cliff in front of my door ("like Idaho," I thought when I first saw the property), with alpine krummholz and glacial chatter marks on the near-naked granite outcroppings on top. It can be a breathless climb, if you hurry, but worth the view stretching from Mount Washington, New Hampshire's highest, to the southeast, and Mount Mansfield, Vermont's highest, in the southwest, to Jay Peak, northeastward, close to the Canadian border, and the Sutton Mountains, straight north in Quebec. Over and down the back side of Wheeler is a tangled wood descending to a swamp that fringes May Pond, a little headwaters for Crystal Lake that eventually feeds the St. Lawrence River. Or, behind my house, if you climb Moose Mountain, you'd then go down into Big Valley and the wetlands of Big Valley Brook, Blake Pond, Vail Pond, Bean Pond, Duck Pond, and Marl Pond, between Mount Hor and Norris Mountain. Some of this rainwater flows south to the Connecticut River and Long Island Sound, instead of toward Quebec, but Mount Hor's other face looks down vertiginously on Willoughby Lake, which is St. Lawrence-bound, and otherwise partly bordered by Stillwater Swamp. So, wildlife of sufficient size and enterprise can migrate between all of these feeding grounds.

It's sumptuous country, in other words, and remote: a five-hour drive from Boston and seven from New York. The mix of trees is about half-and-half evergreens like red spruce and balsam fir, and hardwoods such as sugar maple, red maple, yellow birch, white birch, and beech. There are plenty of trembly poplars thrown in, and cedars, tamaracks, hemlocks, white pines, white spruce, white ash, black cherry, red oak, basswood, or butternut, if you look. The autumn colors are less

Wheeler Mountain, Vermont; Michael Yamashita (opposite)

rouged with scarlet, more subtly various than in southern Vermont (where I go to teach in the winter). Snow falls earlier here and is more obdurate, staggering many people by the time it finally lets up in the spring. Their faces become tightly white by February, symptomizing shock; and two elderly Vermonters I know who bag groceries in our three-register food mart escape all the icy hassle by promptly taking off with their wives in their pickups for Florida by Columbus Day, to live in a trailer park and bag groceries in a 21-register supermarket until May rolls around again.

In October, I just drive three-and-a-half hours south to Bennington, in the Taconic Mountains, still in Vermont but ten degrees or so warmer than my hometown of Barton. Bennington is close to Massachusetts' Berkshires and quite a different habitat. The woodchucks and garter snakes are lighter colored. Opossums are able to thrive despite their furless tails, but I see fewer porcupines. The song sparrows and snapping turtles lay their eggs two weeks earlier, and cottontail rabbits, not snowshoe hares, find the climate to their liking. So do wild turkeys, ground-feeding in the shallower snow. And deer seem to prosper better than moose, instead of vice versa; moose are big, tall wilderness creatures. But the coyotes and foxes sometimes have mange, which I've not happened to see in the north and which may be an indicator of stress, my dog's veterinarian says. Indeed, I spot them more often in southern Vermont because the countryside is such a hodgepodge of housing and commercial development that to hunt they need to hopscotch across any number of roadways and back lots, dodging cars and .22s and dogs, apart from the ordinary factors of their own territoriality.

The bobcat den I know about near my Bennington home is not located in a talus slide on a wild slope like Wheeler Mountain's, but in a thin rock slit overlooking a power substation, three power lines, two 24-hour supermarkets, a movie multiplex, a hardware outlet, and a drug discount chain. The local pair of coyotes dens under an antique maple tree rather close by, perhaps for lack of another secluded site (although a construction crew for a new highway bypass in Bennington is scheduled to flatten it within a year). Both dens are near the top of my hill in fourth-growth forest thickly briared and as far from the local roads as was manageable. But the result of their presence may be that the doe that gives birth to a couple of fawns every June does so in a patch of long grass almost beside our road, where the frequent traffic might intimidate a prowling bobcat or coyote. The closest foxes, too, have their pups in a stand of red pines very near the blacktop and a full field's

span away from where the mother bobcat or the coyote parents would be likelier to hang out. In future dry spells, I don't know where any of these animals will be able to drink because the one never-fail water source has been the Walloomsac River, in the valley down the hill, and the new bypass will sever the route, interpose a belt of high-speed pavement between us and it. This makes me understand why you see so many roadkills during that first summer after a highway is opened.

Not a problem at Wheeler: to follow old trails or try to reach water. A cow moose gives birth to her calf in a swampy swale tucked into a curve of the mountain about a quarter mile in front of my house, and not far underneath the coyotes' den—whose pups are about two months old by then. The site is lush enough with succulent plants in June that she needn't go far to feed, and not even a bear would challenge her for the meat of her newborn. Some years, a mother bear also gives birth (two months earlier than the coyotes and four months earlier than the moose) to a couple of cubs during hibernation in a den among steep ledgy strata, a half mile from my house in a different direction. Hers is across the narrow notch from the coyotes' cozy hole, which is under leaf-strewn rock rubble on a gentle pitch under a short cliff—and across from the moose's spring-fed, V-walled calving copse—because she wants a north-facing slope that will postpone the winter's thaw until the vegetation she requires for nutrition has budded. Coyotes give birth in April, not February, and thus seek a situation facing south for maximum warmth for themselves and their young; the dynamics of hibernation have no part in it.

CARS AREN'T A PROBLEM, where I am in Barton, under Wheeler Mountain, but my doe deer (the one I particularly watch)—like the Bennington doe—appears to worry about the coyotes' presence when she has a fawn. And therefore she does so in the willows alongside the stream 150 yards in front of my house, where at least during the long hours of daylight she'll have some protection from them and the bears. And my foxes, also in danger of having a coyote or bear eat their babies, have appropriated a woodchuck's burrow under chokecherry bushes in the back field, 100 yards from the house. Coyotes weren't residents here till after I'd bought my property. They migrated from the prairie states via Ontario, by increments, to fill a niche when the wolves were killed off, as New England's farms waxed and waned and were abandoned, gradually growing back to brush. So

the foxes, like the deer, have just lately had to adjust to them. One solution has been for the foxes to set up shop in interstitial areas between the established territories of separate coyote families, where the coyotes don't prowl much, in order to avoid conflict with each other. Another seems to be that they will form concentric circles—the foxes and the deer closer to human habitations, the coyotes, bears, and moose a bit farther out. Moose had been Vermonters before white people arrived, but went the way of the wolves a century ago. They are now returning as the forest does.

Deer, of course, are less flummoxed by human activity than by a heavy snow, and almost everywhere have found people's presence a boon. I see little herds of up to a dozen of them at both my Bennington and Barton homes in the early spring and late fall. They are used to being "betrayed"—Bambi shot for Thanksgiving—and vanish in deer season, then become everybody's darlings, out in the open a good deal again. Logic is not what they expect, just regularity in the cycle. But bears aren't vouchsafed a comparable ambiguity. They are pursued; and although in the north I see frequent bear sign, in the 13 years I've lived in Bennington I've come upon just one in this banana-belt of the state. It was a disoriented cub that had apparently wandered down off Mount Anthony, the short pyramidal feature overlooking our town of 16,500 people (Barton has about a thousand), in the fall, perhaps after its mother had been killed. It never did enter a normal hibernation, but foraged alone for beech, pine, and hickory nuts, and dried cherries, or amid the corn stubble in a field alongside the Walloomsac, when hunger woke it from a fitful sleep.

Another floundering beast showed up that October in Bennington: a six-month-old red fox, not orphaned, in all probability, but looking for a niche of its own somewhere, as they are wont to do at that age. The difference is, with such a splintered and fast-changing habitat and the enormous ethological impact of the coyotes' invasion, the dispersal of more traditional tyro predators is complex. The pair of foxes that den near the blacktop road, mousing in my hayfield, for instance, and a second pair that owns Reynard rights along the bank of the Walloomsac—catching river rats and muskrats—and in the wetland next to the power substation near the shopping center would not have permitted him to linger in their ranges. Ditto, the gray foxes that maintain a den under an ash tree in my field quite close to the hilltop forest where the coyote family sometimes hangs out (because unlike red foxes, gray foxes can climb trees and are safer from being caught and eaten).

Thus, this gawky, black-legged, six-month-old fox had a web of scary threats to contend with, after roaming however far he'd come from his birthplace. So he apparently settled upon a rock pile and thicket under four landscaped Norway spruce trees near my house as a sanctuary in which to sleep—and the acreage in the vicinity to find his livelihood of meadow mice and fat grasshoppers, now catatonic from the frosts, to munch. The dog scent was perhaps less intimidating than the fe-fi-fo-fum coyotes were, closer to the woods, or the very hostile mated foxes whose den was by the road and who would gladly bite, if not make a meal out of him. The low birdbath provided an easy source of water, and the compost heap beside the vegetable garden was a magnet for incautious rodents and sometimes had organic garbage in it containing edibles. The septic-tank leach field was also lush with mouse nests in the grasses, since I have no cat, as were the flower beds next to the house. I was content to let *him* be my cat, and he got so confident that after stalking a bathing brown thrasher, he would drink with his back turned toward the house, facing where he thought the real danger lay. The barking dog was confined inside most of the night and day and had been trained not to kill animals of fox size, anyhow. A clump of apple trees were dropping their juicy fruits, and he visited them daily to beat the deer: plus a plum tree, his favorite, which leaned so far over that he could scramble up into the first fork of the trunk (almost like a gray fox) and eat whatever he could reach from there. Then he'd trot around the house to lie in the sun on an anthill in the mown grass under a maple that was slowly losing its orange leaves, and let the insects treat his itchy mange, removing the mites and flaking skin.

The paths and drive were his runways, and it was a sumptuous setup—sort of a '90s Vermont scene, where vegetarians may live cheek-by-jowl with gun nuts who shoot at any wild thing. Strike the right dooryard, if you're an adolescent fox, and live high on the hog. Nothing is impregnable, however; and one day the next-door dogs, an elkhound and a foxhound that wear electronic collars that deliver shocks to their necks if they go near their owner's property line, grew so frustrated they suddenly braved the pain, crossed the boundary, and chased him. He ran toward my house, against a retaining wall, where they grabbed him, head and leg. Fortunately I was home, heard the racket, rushed out, and, though his head was in the elkhound's mouth, his hip in the foxhound's, and he was limp from being shaken, saved him. He then ran onto the front porch for safety, and only left with baffled reluctance, when I forced him.

UP NORTH, WHERE THERE'S MORE SPACE, you don't yet find a fractured ecology of close-hemmed, few-acre patches of shattered woods, and wildlife dislodged from eclipsed baili-wicks piled on top of one another, scouting for habitation. For example, when Bennington College, where I teach, lets out and I occupy my house in Barton again, the moose that have been using my front yard as a thoroughfare have plenty of alternative trails. The seasonal road they're crossing (stop-ping to look both ways) is four miles long, east to west, and not paralleled by other human obstacles for eight miles to the south and three miles to the north. Farms, woodlots, sugarbushes, swamps, state forestland—the yearly crop of novice animals moves along, sniffing for empty territorial slots, not squeezed into my lap. Birds, too: I have 30 years of memories of the rhythm of how it works, despite the reticence of most wild things. The real-estate feeding frenzy so familiar elsewhere was delayed for two decades here. Lovely stretches of landscape are available for $500 an acre, and there are so many of them that the agents are less brusque and ubiquitous than elsewhere. The old land ethic still exists, at least as a pentimento, in the minds of older people with tender links to family farms.

Land was not regarded then as a financial asset, but where you lived your life and then passed it along as a homesite, nourishing and stable, to your children to maintain and come back to, if they ever left. Continuity was a virtue, and character your central attribute. A farm wasn't simply its milk production versus its mortgage payments—but where the barn swallows nested on the beams (and cliff swallows, sometimes, in mud gourds under the house's eaves). Or where Denise's pet gray goose paddled, when she was a girl and liked to rest with a magazine under a silver maple by the stream. A maple so broad-boughed that a smart woodchuck climbed up and sprawled on it on sunny days, till her brother shot him to see whether he'd be good to eat.

The memories framing such a place dissipate like chimney smoke when it passes over to strangers. Those all-nighters when a calf was born ass-backward, or a hay pile overheated nearly to spontaneous combustion, or the electricity blew out and the generator wouldn't work and all the milking had to be hand-done. Cutting corn one time, the tractor lost a wheel on the hill and jack-knifed into the corn-chopper and the chopper into the wagon it feeds that's hauled behind. That was a royal mess. Or the bear who got into the garden despite the electric fence. But the charge then penned him *in;* he was afraid to leave. And how the kids when they were little walked around in floppy barn boots way too big for them. They laid feed bags over the pigs as saddles so they could

"ride" them—and would laugh, putting a doe and buck rabbit into a cage together. Darryl, so proud, showed his white turkeys at the county fair, and seldom took an indoor bath after school let out because he could swim in the pond. Walking in to see the banker wasn't much fun, however, when the milk cooler failed, or when the unloader up in the silo, with a 500-pound motor, conked out and had to be lowered and fixed. But the cows were so happy on that first day of spring when they could be let out in the greened-up pasture, with the mists curling on it, that you'd have to ride the horse after them at milking time to bring them in.

MY OWN MEMORIES OF MY PLACE, less comprehensive and tactile, extend only for half a lifetime through half the months of the year. But I remember reams of Barton history: of the children of people I knew as children. And the marriages and divorces of my neighbor's three daughters, his flights of imagination as a born-again Christian, and his wife's ice-skid in her car that almost changed their lives. He is a retired milk-tester, a solid citizen, whereas the man I bought my house from was more in the "outlaw" mode. He brewed corn whiskey and bathtub beer, which he sold for $1.50 and 35 cents a pint, respectively, if you supplied the bottle; and his wife, Kay, kept a 1950 clipping from the *Caledonian-Record* in their family Bible showing Donald with a 40-pound bobcat he had trapped, whose skin brought them a windfall of $65. When she made applesauce in October, she would save her parings for him to bait deer with in midwinter. And once he shot four on a single full-moon night.

Now, that old outlaw way of life is over. (Uplink computer scams originating in Vermont might be more likely.) And the empty cliffs that bewitched me as Idaho-like in 1969 draw hundreds of hikers some weeks during the summer. The wildlife must acquire an elasticity to thrive, lending habitat to loads of people for nine or ten hours on a balmy day, then reclaiming it to forage in after sunset. Similarly, Vermont's towns are lent to its summer people and reclaimed after Labor Day. Barton remains intact by means of frequent church suppers, volunteer fire and ambulance crews, bingo nights, school-board squabbles (plus a spirited parochial school). The Legionnaires meet over the village office; the Masons over the Franklyn Store; the Knights of Columbus over the bank. Yet the new national economy of fast wealth and mall or cyber shopping is having an impact.

The feed store and food mart struggle along, but the drugstore and Franklyn Store have had to close. So did a series of hardware, curio, and sandwich shops—although real estate offices are opening up in competition with each other and ads for subdivided land metastasize in the papers, the strangers who buy being often accustomed to asset turnover. They'll split the acreage to get their money back, then build another house on what's left because they don't want to live where anybody else has ever lived, but wish to feel creative. Manhandling the landscape as if it were some form of gym machinery, they lop off this, cut down that, rip out copses of hazelnut, elderberry, or service-berry without ever knowing it was there, maul a sugarbush, scrape bare a vista until perhaps they have Xeroxed a rough replica of what they had left somewhere behind.

Mobility and self-reinvention are the mantras now, but there's a lot of blundering just the same. And self-reinvention is not a natural process for most people. It simply means that nothing's sacred. Trial and error: then move on. One man with a camp on a woods pond in Barton may ask the game warden to transplant some beavers to this sanctuary to maintain the dam and water level, but another guy with property on the bank will shoot them for chewing at "his" trees. On a dirt road, a grade-school teacher may build a cabin catty-corner to a career Army sergeant's shack and shoot-ing range, and an Internet millionaire's vacation house—all provisional homes placed out of sight, with just a cable chained across a bulldozed drive, where they each go not to mix with other peo-ple but to recoup from the central scrimmages of their lives—while the caretaker for all three lives in a trailer down in a gravel pit by the highway. We have working farms around, but also a retired CIA spook, a retired IBM hardware assembler, a retired General Electric engineer, a pensioned-off Green Beret, a retired newsman, a cashiered sheriff, a cow hauler, a furniture factory supervisor, a roofer. And recently a Seventh Day Adventist psychiatrist and llama farmer down the road died while trying to take off in a do-it-yourself airplane that he had built.

The hobbies or passions of individual landholders sometimes seem to cancel each other out. In the woods in Bennington last year I stumbled across a hunter lying in the leaves in such high-tech camouflage I needed my dog's nose in order to spot him at all. On the other hand, the next day I met a man who not only posts his land against hunting, but also said he had planted 16,000 corn seeds in the spring so that wildlife could venture off the nearest mountainside, and eat in safety, and had a thousand apple trees at their disposal also. I've heard of a man who shoots

nothing but cowbirds, because of their practice of laying their eggs in warblers' nests, and know another, who, in bib overalls and white beard, hauls stones and logs with oxen. Animals now have a role like Chauncey Gardiner, in Jerzy Kosinski's novel *Being There,* who is endlessly available for everybody to read into him what they wish. From dogs to deer, they dramatize our own confusion, panic, and mortality. As predator or victim (and we like both bunnies and mountain lions), they impersonate for us our roles and hallucinations. With equal, almost parallel zeal, we'll try to kill or protect them: a sort of parallax view of creation—the atavism of the hunt versus a sympathetic blending of one's own identity with the creatures. One person flattens a froggy swamp to enlarge his lawn. Another preserves it for the turtles, bitterns, and herons. One shoots a Canada goose; another entrusts a mote of his spirit to the bird for the flight south.

But now with land a commodity that's totted up as part of an individual's net worth and resumé of lifestyle changes, people may sell "the ski place" in New England to buy a ranchette in the degraded Arizona desert, a beachfront condo on the crowded Carolina coast, or rent a palazzo in Tuscany. Such flux is regarded as interesting in a way that fidelity isn't. And particularly in this centrifugal time, fidelity to place is out of fashion: almost like never having left home. To know the moosey glades and coverts where ostrich ferns grow belt-high, an oak limb where hummingbirds always nest, a vernal pool where wood frogs cluck and peepers sing, and the green mossy rock under which a white ermine caches peppery-brown meadow mice when the snow starts to fly is surely a sign that you lack enterprise. Labrador tea and pitcher plants, goldthread or Christmas fern, pennyroyal, pipsissewa, Virginia creeper, fringed gentian, milkweed, witch-hazel, plantain, trillium, and columbine are all the same to a bulldozer's blade. Land can be a punching bag. Blitz it and move on.

In northern Vermont this has not happened yet on nearly a scale like Massachusetts' and southern Vermont's development, and may never quite, if priorities change soon. In the meantime, I love what I know. Mount Hor, Moose Mountain, Big Valley Brook, and Wheeler Mountain are my glue. The trickly waterfalls that freeze golden, of a January noon, above the fir-spruce deer yard and the grousey turkey nesting-thickets along my stream. The black cherry and butternut, rock maple and red oak, hickory, slippery elm, smooth beech, and yellow birches standing akimbo on an old fence line. The otters and wood ducks, rumors of wolves, of bee trees and bat caves. Whether they're really there or not, they could be. And the falcon scouting on the cliff can stay and nest. ■

Christopher Burkett

The Resplendent Forest

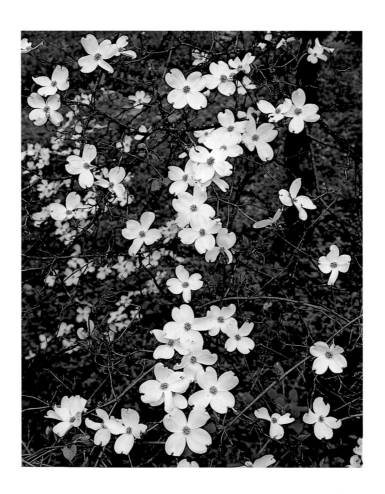

Love all God's creation...love every leaf, every ray of God's light.

—Fyodor Dostoevsky

It felt strangely like coming home, although I knew I'd never been to Bernheim Forest before, when first I saw it on an autumn day in 1990. Maybe it was the rolling landscape, what they call "the knobs" in this part of Kentucky, that struck a chord similar to the foothill country around my home in the Pacific Northwest. But this is a very different forest from the eternally lush, somber green, and so often dripping firs and spruce of my Oregon coast. Here in the uplands of this inland plateau, the eastern hardwoods' buds, blossoms, and leaves come and go in a shifting of colors, sometimes subtle, sometimes bold, ordered by the changing angle at which the sun shines on the planet. I was captivated by the ballet of the seasons, and I've been coming back to record it ever since.

If you're lucky enough to wander the forest day after day, you'll see the palette change before your eyes. I was privileged to do just that, on a grant from the Bernheim Arboretum and Research Forest. More fundamentally, I was the beneficiary of the largess and vision of Isaac Bernheim, a German Jewish immigrant who arrived in New York in 1867 with four dollars in his pocket. The land of opportunity drew him across the Appalachians to Kentucky, where a fortune awaited in a whiskey distillery he founded. The clear limestone spring waters of the knobs gave root to a bourbon still popular today. They also nourish a verdant woodland in which Bernheim saw an alternative to humanity's self-inflicted ills. In 1928 he bought wooded lots, eroded ridgelines, and cut-over, farmed-out fields, and oversaw their nurture back to health to become Bernheim Forest.

The adopted Kentuckian spent the rest of his life shaping the preserve into a living testament to his vision of how humanity and nature can cooperate rather than conflict…and to how people of all different races can do the same. In the arboretum's 240 acres, sculpted paths lead past North America's largest collection of hollies, as well as world-class plantings of ginkgoes, beeches, and nut trees. The other 12,000 acres are wild, home to six distinct forest types. One of Bernheim's creeds was that wild and tended nature should blend and complement one another. He also stipulated that the whole of Bernheim should be open to all people of all races. It was a bold position for his time, but not surprising from a man who saw so clearly our human need for nature, and made his life's gift this place where we can see God's spirit in His handiwork and understand our part in it. ■

Dogwood tree blossoms, Kentucky (opposite)

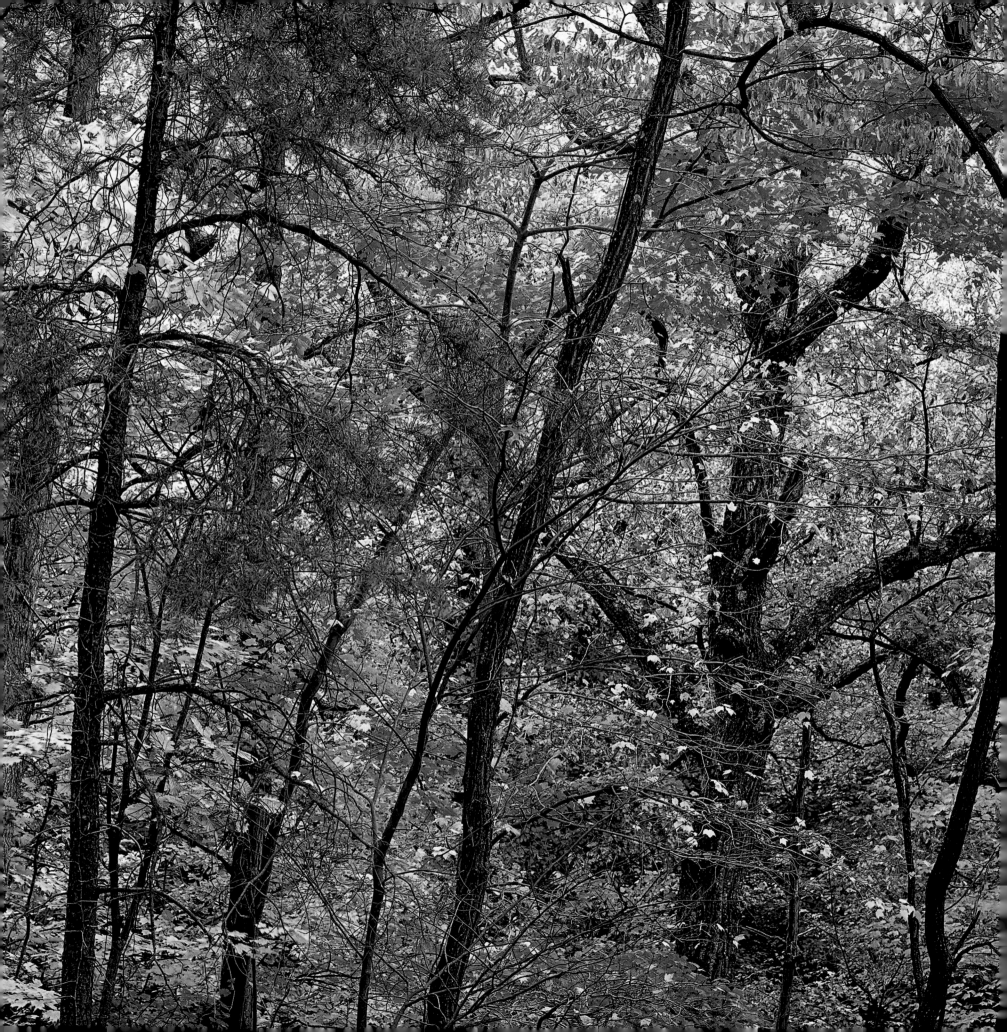

The exuberance of life reaches through the press of multicanopied foliage in Wildcat Hollow (left), one of Bernheim's wilder corners. Autumn's anarchy of hues is tempered by carefully crafted artistry in the arboretum. I purposely included my own shadow beside that cast by a flaming maple (right) on a mown lawn in a nod of respect to the hands of unseen shapers.

PRECEDING PAGES: A chance discovery at dawn revealed a field of wild raspberries moments before the sun's first rays melted their filigree of frost. I found them near a fire road not open to the public, though 35 miles of hiking trails run through the reserve. Part of Bernheim's wisdom was in knowing when to intervene in the natural world and when to leave it to itself.

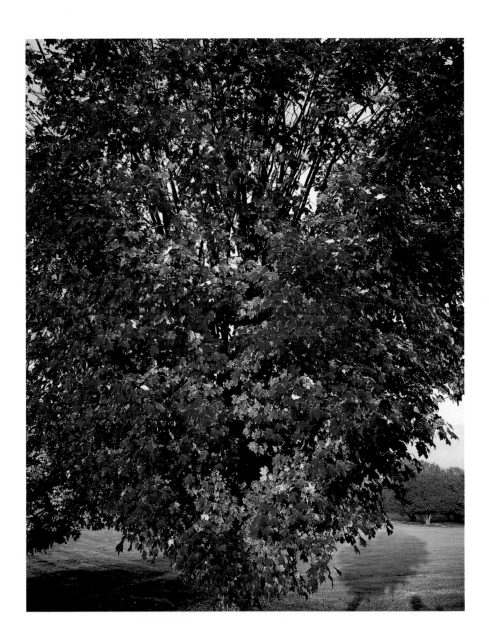

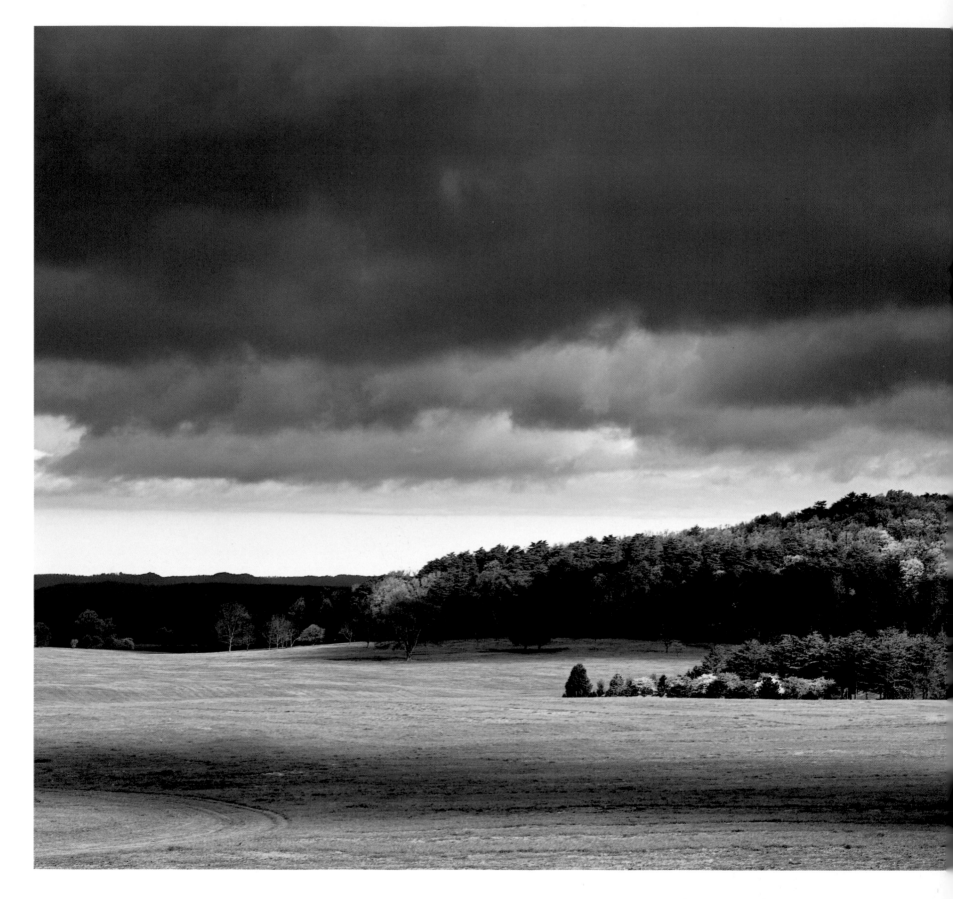

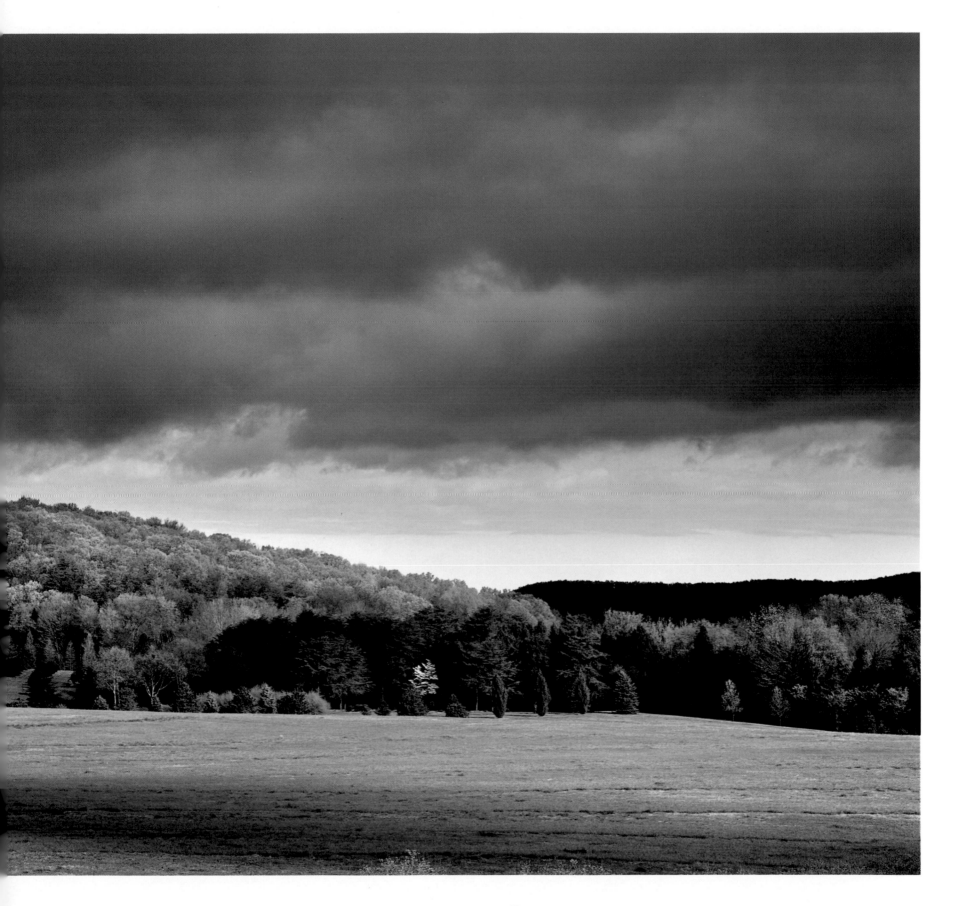

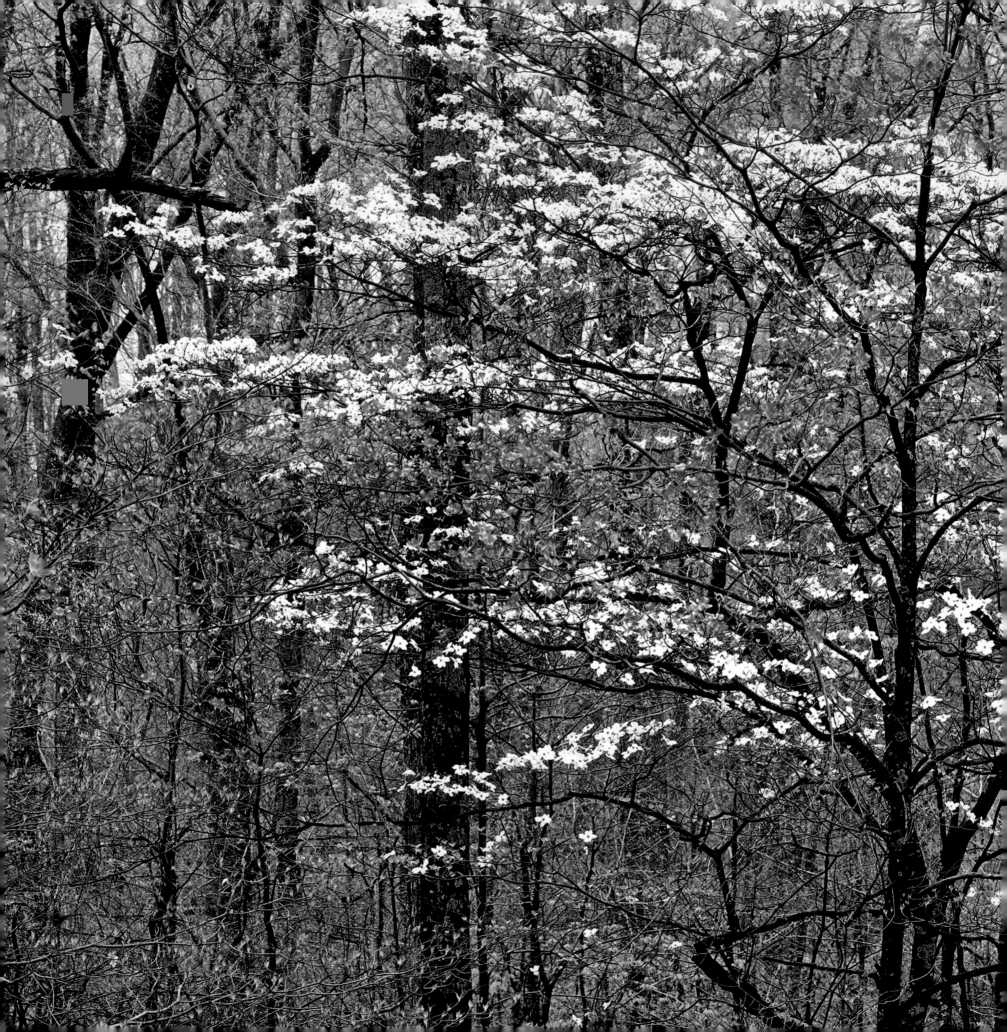

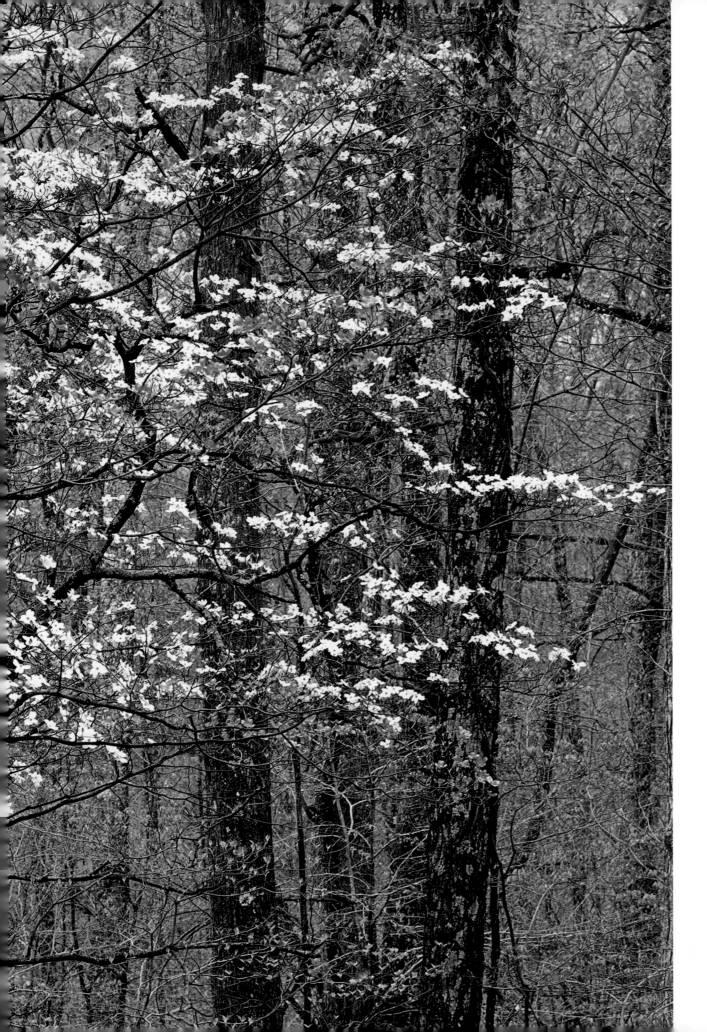

Spring draws a veil of dogwood blossoms across the wild wood, seen here from the arboretum grounds. White flowers adorn a dogwood native to these forests. The pink blooms grow on a hybrid cultivated by human breeding. Bernheim envisioned his creation's landscapes as uniting the natural and human spheres.

PRECEDING PAGES: Brooding Appalachian skies lower over Big Meadow, a patch of prairie surrounded by woods. Isaac Bernheim and wife, Amanda, watch over the meadow for eternity from the final resting place they chose, at the spot where I made this photograph. Seconds later I had to run from a sudden, drenching spring rainstorm.

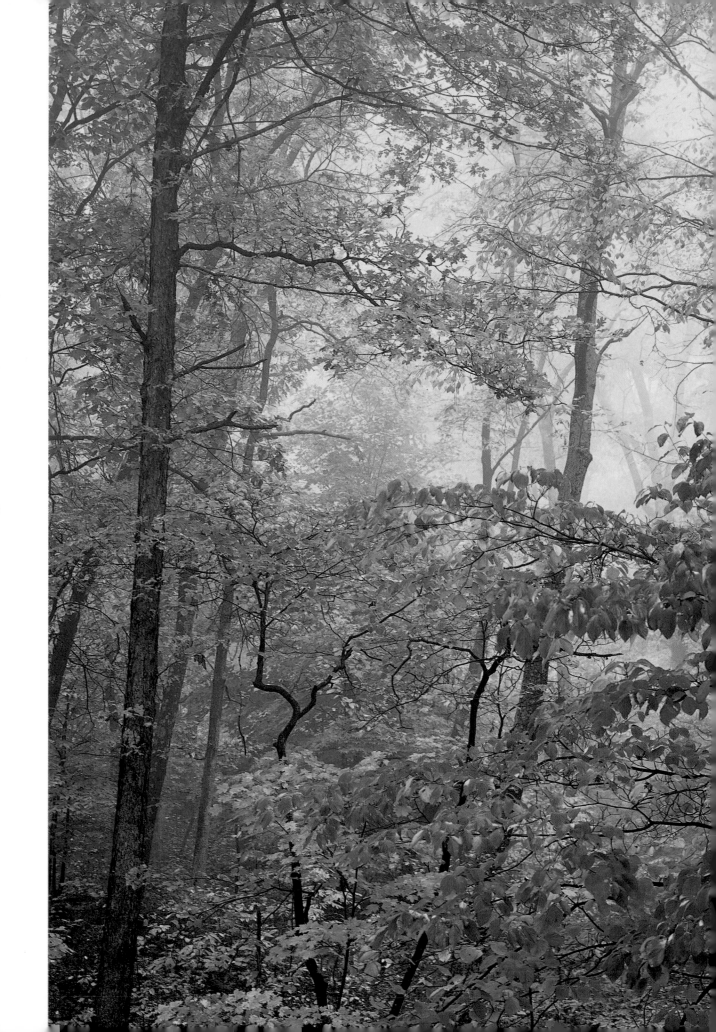

A meditative hush breathes through
the sanctuary of the forest in an early
morning mist. The woods never cease
to remind me of God's presence, which
constantly renews and restores all of
creation. Through my photography,
I strive to convey a small taste of this
subtle, radiant, and transforming
reality. Bernheim's goals were akin.
He enlisted the best landscape architect
of the era, Frederick Law Olmstead,
designer of Manhattan's Central Park,
to create the plans. His artifice sits
as light as a falling leaf on a canvas
of nature, painted by a hand far
finer than ours.

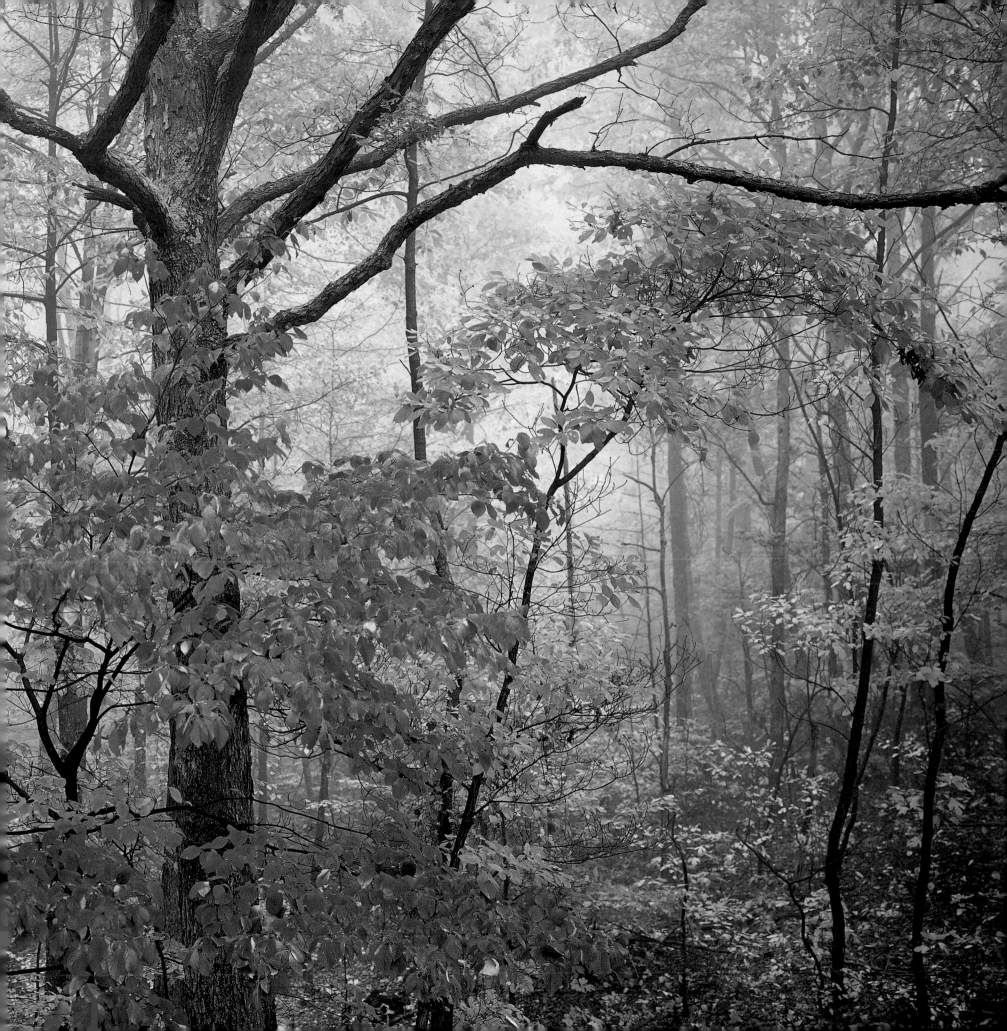

Lisa Couturier

Rediscovering the Potomac

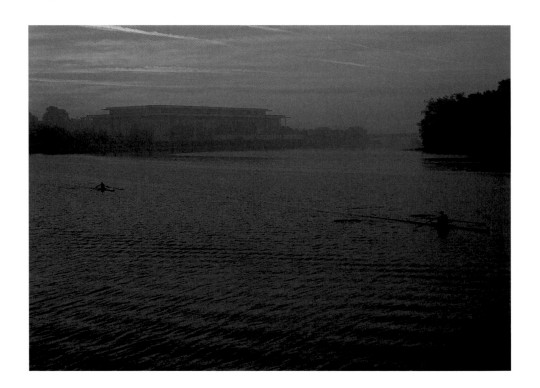

*And the end of all our exploring will be to arrive where
we started and know the place for the first time.*

—*T. S. Eliot*

I am rocking in a 60-foot-long boat on the Potomac River, under a massive concrete arch of the Francis Scott Key Bridge that connects Virginia to Washington, D.C. It is a late summer morning, and although I know another workday in Washington is heating up—the coffee shop doors are squeaking open and road-raged commuters are honking their horns—the most I hear from my spot on the river is the resonant humming of the 7 a.m. traffic racing across the six lanes above me.

It's river time on the water, a time of day that has played itself out for eons. It's when the barred owls have departed the matte gray sky and the herons have arrived to fish; when the sycamores patiently reach for the new day's burgeoning light, morning after morning after morning.

While I wait with seven people—my crew—for our rowing coach to begin a race between our boat and another, I dip my hand into the river that surrounds, almost swallows, our skinny boat. The green satin current splits around my fingers as I stretch them straight. Quickly, though, I pull my hand out. The water stings the blisters the other rowers and I show off almost as badges of honor, resulting from the friction of river, oar, and skin. But deep down I feel, too, that the river has been searing its way into me since before the rowing season began this past spring. Blisters reveal only one, physical, point of entry. There have been others.

Three-and-a-half miles northwest of where we wait below Key Bridge is a rocky span of the river called Little Falls, where I live, in Maryland. When I watch the Potomac outside the window of my study, I watch a river that has meandered east and south from its headwaters in West Virginia. By the time it reaches my house, already it has traveled some 270 of its 383 miles.

Little Falls is a place of some significance, since it is here the Potomac turns into a tidal estuary just as it enters the city of Washington. Some 84 species of fish, such as herring, striped bass, and sturgeon, use the 40-mile span of the river from Little Falls through the city and beyond as a spawning and nursery area. And some four million people live within the river's Washington area watershed. In George Washington's day, the largest ships of the ocean navigated up the Potomac to what is now Georgetown—the oldest section of the city with its steep, cobblestoned streets—delivering cargo to this frontier land. In Washington's mind, the riverfront would expand into a place of fabulous markets and exchanges; it would be a place where he envisioned a great city. His city. My city. The country's city: Washington, D.C.

Rowers on the Potomac River; Alexander Cohn (opposite)

East of Key Bridge and into the heart of the city is the boathouse from where we launched. Across the river from the boathouse is an 88-acre leafy green island memorial for our 26th President, Theodore Roosevelt, a conservationist who during one of his speeches roared: "I hate a man who would skin the land." Blanketed with forests, Roosevelt Island is a haven for beaver, red-tailed hawk, great horned owl, opossum, and the occasional fox. I imagine it's the sort of refuge President Nixon must have dreamed of escaping to when, just across the river, behind the glass-and-concrete convolutions of the infamous Watergate building, his misdeeds were unearthed.

Beyond Watergate, for the next eight or so miles south, the river runs through a picture-perfect postcard of the nation's capital—snaking alongside the Kennedy Center, the Lincoln Memorial, the FDR Memorial, the Jefferson Memorial, the Pentagon, and Washington National Airport toward the southern tip of the city near the Woodrow Wilson Bridge. Some one hundred miles beyond the Wilson Bridge the Potomac melts into the Chesapeake Bay.

The city's sites quickly pass our river-splashed eyes. It is only when we paddle slowly or stop that there's time to acknowledge where I am along the Potomac. Idle chitchat is not allowed on the boat. The bunch of us who row at 5:45 a.m. appear from the dim corridors of the metro area, greet one another, row until 7:45 a.m., and leave. That I have recently returned to the Washington area after living in Manhattan for nearly 15 years; that my young daughter waits for me at home; that if the person sitting in front of me would look up to the sky she would see the six-foot wingspan of a great blue heron flying over the boat, and how glorious is that!?—all of this I cannot say. As much as rowing is a team sport, it is also a necessarily solitary one; the strongest relationship I nurture is the one with the river and its landscape.

IT WAS ABOUT THIS TIME LAST SUMMER when my husband, my then nearly three-year-old daughter Madeleine, and I came to live in an old neighborhood on a ridge along the Potomac. Our small stone cottage is so close to the city limits of Washington that if I climbed the 50-foot oak across the street I would likely see the top of the Washington Monument.

That first day we arrived, the weather was typical for a summer day in Washington—sweltering, oppressive, with a thunderstorm threatening to roll in. My body instantly registered the heat as

something familiar from my childhood spent in the Washington suburbs of the Potomac River watershed. Thunderstorms, a neighbor informed me—in that helpful way new neighbors have of telling you everything they know about your new home, perceiving your lack of experience with the place—run up the Potomac like tornadoes, ripping through the floodplain forest of sycamore, beech, oak, red maple, and elm. You'll need to buckle down, the neighbor said, stay inside.

So we headed out. My daughter dashed ahead of me, like a fledgling, into her new land. We walked toward the floodplain forest that is protected within the C&O Canal National Historic Park. The thunderclouds passed as we made our way over a lock on the canal and through the underbrush, drawn by the sound of the river crashing around rocks. Though, as I walked, I thought my neighbor's perception of me may be right. I had lived in Washington long ago; after such an absence, perhaps I *was* like a greenhorn in a new country.

Twelve hours earlier, just that morning, I had parted with a landscape to which I was deeply attached, a small forested parcel of parkland near my apartment along New York City's East River. The East River, with her roily currents, slow sighs, colors, and creatures restored some peace into the hectic lifestyle that is Manhattan. My daughter took her very first steps outdoors in those trees by the East River. And although there was no green shoreline to the water, penned in as it was by sea walls and a city highway, my girl and I walked along the iron-and-concrete promenade every day. It was the most urbanized body of water I'd ever known, yet it managed to nourish the lives of the peregrine falcons, cormorants, fish, snapping turtles, and herons that made their homes along it.

It was difficult to leave the East River behind. But as my daughter grew I began to understand her birth as an invitation for my husband and me to leave New York. Living as hard-core urbanites for so long, we fantasized about relocating to some cabin in the backcountry of Minnesota. We considered the northern California coast. But our thoughts turned again and again to the river that had raised us and the landscape that had nurtured us: the Potomac River watershed.

Back in Washington and traversing the promenade of the Potomac all these years later, I felt the land of my childhood reinhabiting me: The smell of wet soil and rotting logs, the scraping sound of long wild grass against my legs and the asthmatic squealing *keeer-r-r* of a red-tailed hawk, a flash of a pileated woodpecker's flaming red crest high in the green trees. I was overcome with feeling

strangely lost yet found at the same time. I imagined it must be what a migrating bird experiences: a sudden departure from one terrain and arrival in another. In the new-old land, the bird begins a quest of belonging again, an adventure in re-placing itself.

I scooped my daughter up and watched her survey the river. Her eyes followed a belted kingfisher rattling down the shoreline, heading for the city.

"This is *Wash-ing-ton,*" I said.

"Big sky," Madeleine answered, clearly dazzled.

She was beginning to speak for the world. And she was right. Compared to the enormous verticality of the Manhattan skyline she was used to, with its eclectic mix of skyscrapers, Washington's skyline was barely one at all, almost horizontal in its low-lying expansiveness.

As we headed home, she dabbled in the dusk, charmed with the magnificence of simple things along the path: ladybugs, wild pink roses, potato bugs, and buttercups. Like the saplings surrounding her willowy body, she stood in front of me, a gift to the land. I envisioned her ripening over the years with the young trees, harboring the stories of the Potomac, growing into the landscape she would call her own.

PADDLING THE BOAT UPRIVER ONE DAY IN SPRING, the coach yelled, "Beaver!" Everyone on the boat was anxious to see a beaver since, several weeks before, three beavers had captured the city's attention by chopping down several trees from the renowned cherry tree grove near the Tidal Basin, a peaceful, pond-like body of water that opens into the Potomac River.

It was a sensitive area the beavers attempted to infiltrate, an area that attracts tourists eager to stroll around the white marble splendor of the Jefferson and Lincoln Memorials and the fastidiously groomed green parkland. I'll admit I was disappointed when a trapper caught and relocated the city's comical fugitives. The animals had shown Washingtonians that as much as the city is an urban landscape, it also harbors, through the lure of the Potomac, a wild landscape.

Back on the boat, in the second it took me to turn to see the coach's beaver, it had disappeared. The rest of the crew missed it as well, and there was a collective sigh of disappointment.

I've come upon a beaver once, with my husband and daughter as we rode our bikes into the city along the C&O Canal's towpath. I swerved to miss the suddenly evident scaly paddle of a tail. Immediately, we stopped. The beaver slid down the bank of the canal and into the water. Hoping it might resurface in the cool morning we were sharing, we waited.

A fervor ran through me, an excitement in knowing that the woods and the stream were the beaver's world. I think often there is the tendency to believe that the landscape of the city and the suburbs is a rather empty one, to believe that nature exists more fully in the countryside. Indeed, the preservation of open, undeveloped space is essential, critical to wildlife. But I feel the need to appreciate, also, the beaver living on the city line, the urban beaver that is both a gift from the wilder world as well as a reminder that in some ways we have failed that wilder place. My near collision with the beaver was one of those capricious moments that makes irreclaimable the mundane routine of life before that instant. It was like a dream that splits open your mind, revealing to you your hidden happinesses or loves. And from now on, whenever you recall the dream, you feel the tiniest bit different in the world.

Soon after the encounter with the towpath beaver, I took Madeleine to a stream that feeds into Cabin John Creek, a tributary of the Potomac near our home, to search for beavers I'd read were living there. We drove along a bustling suburban road busy with the latest SUVs and an assortment of service vans and trucks. Just off the roadside we found the spot: a mangled little valley of some 40 downed trees situated in a neighborhood of expensive homes hidden in the woods.

I carried Madeleine through the green underbrush and toward the water. We walked near some maples the beavers had left like pencil points precariously balanced against one another in the stark sunlit morning and slid our fingers over the waves of teeth marks the animals had sculpted into the wood. Madeleine stuffed her pockets with the beavers' scattered wood chips, for later examination, for when, she said, "I will play beaver."

At the bank of the stream we followed a slide of grass down to the muddy, pebbly shoreline. Madeleine, expecting a rush of beavers in the sunshine, spotted a bulky and well-camouflaged American toad hiding behind a broad old leaf. Its black eyes seemed to sink into the orbits of its skull as we bent down closer. Which is when I saw that the toad was injured; two large patches of abraded skin revealed the pink muscle of its stout and solid body.

Because it did not move, Madeleine believed it was waiting for her to hold it. I showed her the animal's wounds and explained that lifting the toad might hurt it. What had happened, she wanted to know? I could only guess at what to say. A deer's hoof scraped it? A car's wheel sideswiped it? A fox pinned it to the ground, though somehow it escaped?

"Let's leave it here," I whispered.

In the typical battle of wills that her age brings, she insisted that the toad was waiting for her. She was certain the animal was in need of her and, by extension, that the Earth was in need of her help. Caught between wishing to encourage my daughter's compassion and wanting to let the toad die peacefully, I tried, "Let's let the toad rest while we get more chips to take home to play beaver."

But in her mind this time was much like several others. And she recalled them: Stopping on the way to the grocery store for an injured robin in the street; snatching the brown snake out from under the rake; escorting the box turtle across a suburban boulevard on a rainy day; relocating the praying mantis off the driveway. She was correct on all counts, and I was humbled by the detailed memories children carry within them.

"Is it going to die?" she asked without looking at me.

"Probably," I said, sensing that because she knew death already—through the loss of her cat—I could tell her what I believed to be true about the dire-looking toad.

"But . . . ," she trailed off.

"But what?"

"The leaf will cover the toad. It will be safe. And the beaver will be here."

"Well," I paused, "maybe the toad will grow new skin."

"Well," she paused, copying and interrupting me at the same time, "maybe the leaf will cover the toad and the beaver will take care of it."

There was no point in telling her otherwise.

It is said that children are our teachers, like little Buddhas placed in our path. In their own way, they have a vivid understanding that a community other than the human one lives around them. I suppose my daughter imbued this community with compassion because she listened to the thoughts of her heart. And although rationality, biology, everything proven, told me a leaf and a beaver wouldn't rescue the toad, I left the stream singed by her idea of a sentient landscape.

SOMETIMES WHILE ON THE BOAT I long to point out to my crewmates that a fish just shot out of the water, or that the black serpentine neck floating nearby is not a miniature Loch Ness monster but that of the double-crested cormorant.

But I mostly wish that a bald eagle, our national symbol, would soar over the boat and thrill us. A pair of eagles has recently taken up residence within the city limits, an event that, having last occurred 53 years ago, speaks to the improving quality of the Potomac and its fishery. Because these eagles are what biologists call first-year nesters—something like being a nervous newlywed and a new parent at the same time—the location of the nest remains undisclosed until the birds fully establish themselves.

The nests of Washington's other two pairs of bald eagles are situated like bookends to the metropolitan area. In only the last three years, a pair has settled in a cove on the Maryland shore of the Potomac, just over the city limits at the southeastern boundary of Washington, a scant half mile from the heavily trafficked Woodrow Wilson Bridge. From their cove, the eagles soar on seven-foot wingspans to forage over the Potomac, silhouetting themselves against the distant back-drop of the city.

In a more serene setting ten miles northwest of the city, at a place on the river called Great Falls, lives another pair of eagles. At Great Falls the Potomac explodes through a rock-and-boulder-strewn, almost prehistoric, landscape as it descends 76 feet in a dramatic series of falls. The eagles' nest is above the falls, as a park ranger explained it, in a giant sycamore tree leaning into the river's green water. "You can't miss it," he said cheerily.

When I was a kid in the 1970s, Great Falls was my refuge—a place to hike flowered trails, swing on vines like Tarzan through the trees, climb gray cliffs, navigate shallow streams of the river. Though, thanks to the toxic effects of the pesticide DDT, it was a refuge without eagles. Back then, fewer than 500 nesting pairs of eagles remained in the lower 48 states. Now, 500 nest-ing pairs live in Maryland and Virginia alone, while several hundred immature, or non-breeding, nomadic eagles roost in the winter along secluded areas of the Potomac. Some of those nomads—12 have been counted—use six miles of the Potomac within Washington to feast on the exposed fish at low tide.

It was a nomadic, immature eagle that landed during a long, slow rain one day in the 50-foot

oak tree across from my house, where it, too, might have seen the Washington Monument had the river valley not been fogged over. An intensity flames through you when you see a wild eagle for the first time. It's as though, as the mystic Rumi said, "We are alive with other life." You feel more clearly the slope of the tree the eagle is in, the texture of the land you're standing on, the smell of the sky, the color of the wind.

All of this, while the eagle sat hunkered down like a general on the front line, inciting crows into black arrows of rage and desperation. The eagle may be the god of birds to us, but it was Lucifer to the crows: They demanded their tree back. For 20 minutes the eagle perched on the oak, which was forever to me, before weaving its brown wings into a cape to grab the fog and go.

Somehow, I never saw the eagles at Great Falls, though I did spot their grand nest in the sycamore. Perhaps seeing the eagles was less important than knowing they are thriving along the Potomac. Even when there is no encounter, there is still the kindling of anticipation, the private thoughts of huge brown wings hunting over you.

Rowing downstream one spring morning, we quietly passed herons fishing off the shore of Roosevelt Island. Without stopping, we rowed along the Washington shoreline of Rock Creek Park, passing the mouth of Rock Creek that opens into the Potomac. I tried to get a good look at these spots along the river because one of them held the answer to a certain mystery: the mystery of two red foxes, a male and female, that somehow came to live on a golf course in downtown Washington. Rowing along the river, I tried to imagine the foxes traveling to the golf course in the two ways naturalists theorize it could have happened during a night in 1996.

If the foxes arrived by land, they tumbled out of the 2,100 acres of wooded national parkland that make up Rock Creek Park within the city limits of Washington. Rock Creek itself meanders 30 miles through the Maryland countryside and the suburbs outside the city before cutting through Washington and emptying into the Potomac just over a mile from the White House. Great stands of tulip poplars, oak, ash, birch, and hickory blanket the steep hillsides of what are the remains of the city's ancient mountains.

In 1890 Congress described Rock Creek as a place of "pleasant valleys and deep ravines,

primeval forests and open fields" and set it aside as the first urban natural area. The deep ravines and dark forests of Rock Creek still exist, though a web of houses, embassies, and offices surrounds them. Some twelve million drivers a year use the park's thoroughfares, and two million people a year hike, bike, and horseback ride in the park. Yet, surprisingly, Rock Creek remains a refuge for deer, raccoon, beaver, flying squirrel, great horned owl, red-tailed hawk, Eastern screech owl, dozens of songbirds, a variety of amphibians and reptiles, as well as muskrat, opossum, groundhog, and gray and, finally, red fox.

Whispering themselves out of the leafy enclaves of Rock Creek Park would have been, for the foxes, the easy part. They would then have had to travel several dark miles through the city, along highways, around government buildings and presidential memorials, and over a small bridge to reach their final destination: a drainage ditch flanking a hillock on the golf course. The golf course is the wildest part of Washington's 700-acre Potomac Park, an urban green space that begins just off the busy city streets and leads down to the Potomac River.

The second itinerary takes us directly to a night on the Potomac, during the wrath of hurricane-force winds and flood-level waters. It is possible—picture it if you will—that the river surged into the floodplain forest and grabbed two foxes from the sycamores. The foxes, not adept swimmers, would have had to float through the black storm on a log, perhaps, the current landing them at the golf course.

Thanks to rowing, it is my habit to wake early, early enough to get to Potomac Park by dawn and glimpse the foxes as they return to their den after a night of foxy duties: stalking rats and mice by the Vietnam Veterans Memorial, scent-marking the woods by the FDR Memorial, caching into sand piles on the golf course any fish that may have washed up along the Potomac.

Over the weeks I've pieced together the foxes' story: When the golf course superintendent spotted the animals in the drainage ditch, he, being a man who enjoys foxes, allowed the hillock to grow over, unkempt and wild. By the following spring the foxes had kits that frolicked in the grass of the 18-hole course that is in such demand that golfers arrive at 6 a.m. to assure a chance to play. Other piles of soil grew over, more foxes were born, now there are nine. Some mornings the foxes can be seen playfully pouncing on golf balls as they roll by. Yet they've been working, too. Since their arrival, they've eased the park's overpopulated species of

squirrel, Canada goose, seagull, and rat.

Arriving at the golf course, I walked toward the summer river, through the tang of fresh-cut grass that smelled like the backyards of suburbia. Crouched down near a scruffy hill, I saw a dart of bright rust-colored fur dash across the smooth grass. Then another. Minutes later, two more. The breeze, though, was betraying me, revealing the scent of my skin and the sounds of my minute movements. The first three foxes bolted into the den. But the fourth sat on its haunches, head cocked in doglike curiosity, watching. I felt the great privilege of being not only recognized and tolerated by a wild animal, but also of being the subject of its interest.

I wondered if seeing the foxes in such a setting might alleviate what seems to be a growing fear of the animals in the area. Recently, more than 430 nuisance calls from my Maryland county were made to wildlife officials about foxes. And a woman I read about in the paper had a fox den near her suburban home exterminated, fearing the vixen and her mate "could eat you up in a gulp."

The poet Kahlil Gibran said in *The Prophet:* "Your soul is oftentimes a battlefield upon which your reason and your judgment wage war against your passion and your appetite." Could the incongruity of foxes coexisting with people on a golf course be a blessing, something that might calm the battle we wage with predators? If, as predicted by the United Nations, an astonishing 80 percent of the population of the United States will live in cities in the year 2010, our urban and suburban landscapes will need to be re-envisioned as the primary places to sustain our passion for the wildlife living among us.

Meanwhile, in front of me a splendid red fox was perched, its plumy, luxuriant tail spilling around its paws. There was a deliciousness in the air, like the great pleasure that floats between two who immediately attract. Eventually, the careful and slow movement of bringing my binoculars to my eyes frightened the fox, and it slid away into the shadows.

I peered toward the city in the background, toward the Washington Monument and the modern office buildings standing like glass mountains reflecting the new day's sunlight. As surreal as it was, the golf course flickered in my mind like a seething Serengeti, where the foxes were the lions and the gulls were the gazelles. I felt reassured by this territory, by the fact that evolution continues to sculpt the minds and bodies of urban predator and prey. Looking around, I saw the park as a

microcosm of the larger world of the metropolitan fox, which flames along the Potomac and through the suburbs, quickening the landscape, sustaining it with winners and losers, life and death.

MY SCATTERED REMEMBRANCES OF THE RIVERSCAPE FADE as my thoughts return to the morning's race from Key Bridge back to the boathouse. Vigorously slicing my oars through the water, I arrive at the dock, soaked from the waist down. I wipe the sweat from my brow and help the crew lift the boat out of the Potomac. Fifteen minutes later I am on my way home.

Driving along the city streets, I plan my day with my daughter. We could walk along the canal and listen for the whistle of a Northern oriole or the flutelike melody of a wood thrush. Maybe we could manage to sneak by a great blue heron patiently fishing in the canal without startling it out of its steadfastness. Or we could head to the place we befuddled the beaver.

I think of greeting Madeleine. In her sleepy state she will tell me, in all seriousness, how she too has just returned from rowing, how she was rowing in my boat, but I did not see her. I delight in how she imagines herself into the Potomac.

In the time we've lived here, she has reimagined the landscape of the Washington area for me as well, sharing the world of a child through her impromptu discernments: "Bees paint the tulips," she exclaimed in the garden one spring day; and "Can you see the melting clouds?" she asked one windy afternoon; and "The sky has glass on it," she described during an ice storm last winter.

In an urban environment—a place in which nature is at times held in disrepute or ignored— my daughter teaches me that beauty is as much a state of the mind as a state of the land.

I turn into my neighborhood, pass neighbors walking their dogs, pull into my driveway, and hurry to let go of the steering wheel that has aggravated my blisters. In the sky, an airplane uses the river as a road and follows it toward National Airport, while a traffic helicopter zips upriver to the rush-hour chaos on the beltway. It is 8:30, and morning is in full swing. I hear blue jays squabbling and watch squirrels race through the trees. Overhead, a community of crows mobs a red-tailed hawk. The birds pepper the sky with their zest, asserting their convictions and intentions. And I stand fused to this busy land by the river, enjoying the aerial dramas of a new day, feeling acutely that just "to be here," as the poet Rilke wrote, "is so much." ∎

Brian Miller

Southern Wetlands

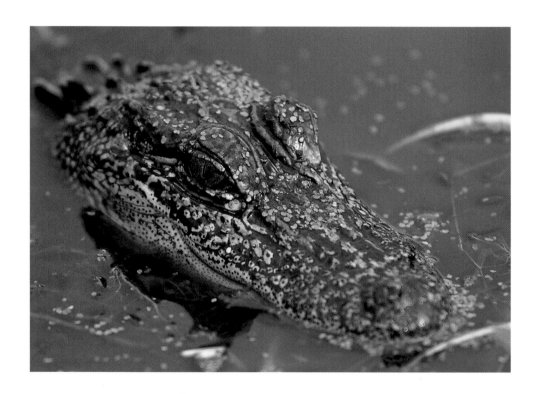

But ask now the beasts, and they shall teach thee;
the fowls...shall tell thee...and the fishes...shall declare unto thee....
In [God's] hand is the soul of every living thing....

—Job 12:7-10

I've always been drawn to wild places, to those blank spots on the map. When I moved to Louisiana ten years ago from the rolling hills of Massachusetts, the swamps and marshes of bayou country were unknown to me. Before long I began to fill in the empty spots as I acquainted myself with the southern third of the state that's mostly waterways and soupy real estate. These waterlands are my backyard, but I still find them something of the enchanting stranger.

Taken as a whole, Louisiana's are the greatest wetlands in the lower 48 states, stretching inland as much as 60 miles from the Gulf of Mexico across the entire 300-mile breadth of the state. They're an empire of mud that crawls with life. When God said to Noah, "...come out of the Ark...bring out every living kind that is with you," it seems as if many of the animals ended up here.

The wetlands are a complex jigsaw of astoundingly rich ecosystems, from freshwater swamps like the Atchafalaya Basin—a flooded forest irrigated by an offshoot of the Mississippi—and intermediate brackish zones where salt and fresh water mix—nurseries for the spawn of much of the Gulf's marine life—to salt marshes full of shrimp and fish. Fur-bearing muskrats, otters, and nutria abound. Passerine birds festoon the coastal trees and bushes when migrants fly through in spring and fall. Shorebirds and wading birds line the beaches and shallows. Winter pulls geese and ducks down the Mississippi and Central Flyways in sky-filling flocks.

The ruler of these marshes is unquestionably the alligator, at least any alligator grown past a size that a heron or garfish would contemplate getting its mouth around. One morning, on a trail in Sabine National Wildlife Refuge, I spied an otter that spied me too. It kept ahead of me, swimming along a canal where I could track it by the wave it made. Each time it popped up, I took its picture. Each time I did, it became more annoyed and began to growl and shake and chitter at me.

An 11-foot-long alligator spoke the otter's language well enough to recognize a commotion that might hold an opportunity for it. As the gator cruised around a bend to investigate, I backed off, afraid I had inadvertently condemned the otter. The alligator slowly inched forward, and the scolding otter paid it no attention. My heart sank, then jumped when the gator lunged.

The otter simply sidestepped the reptile. It had been on top of the situation all along.

Watching this scene unfold, I learned something: These animals survive in the marsh, knowing their home in a way I never will. But I know that I will keep coming back and that the life here will continue to teach me. ■

Alligator in Sabine National Wildlife Refuge, Louisiana (opposite)

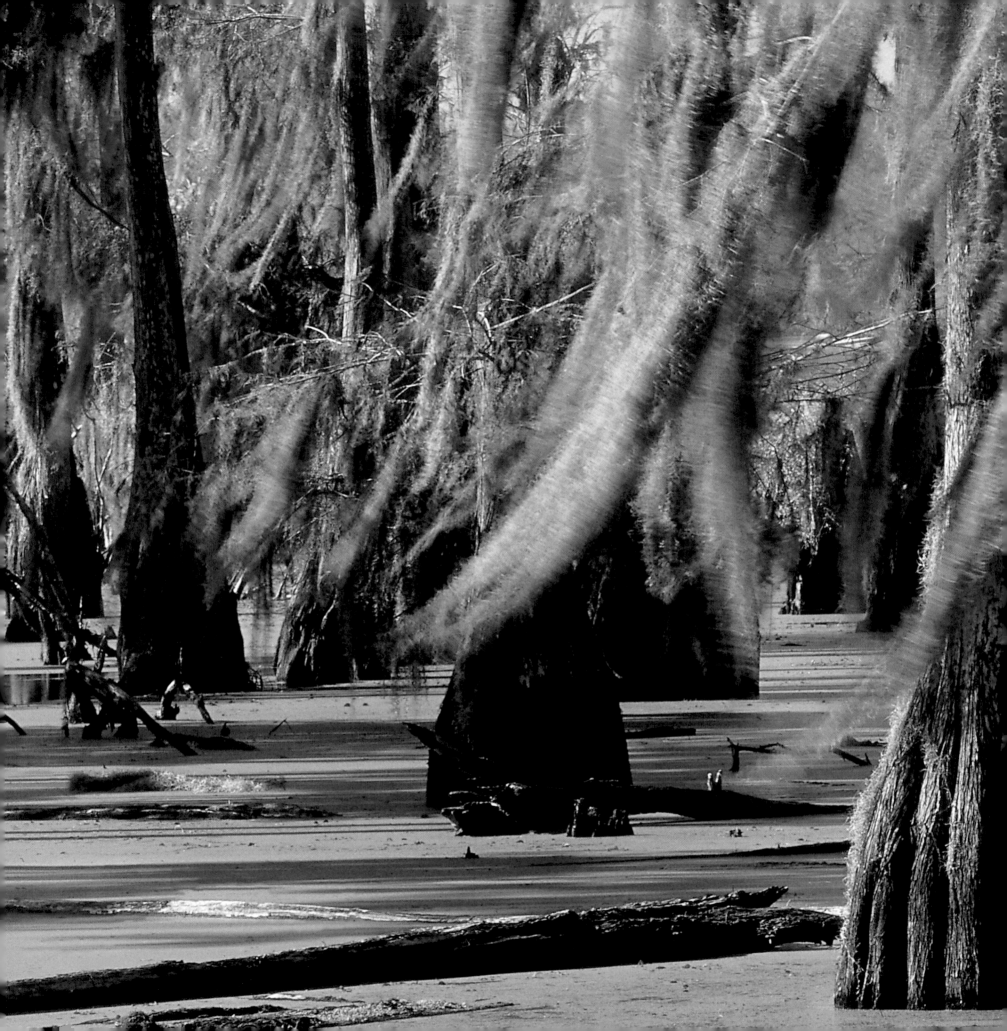

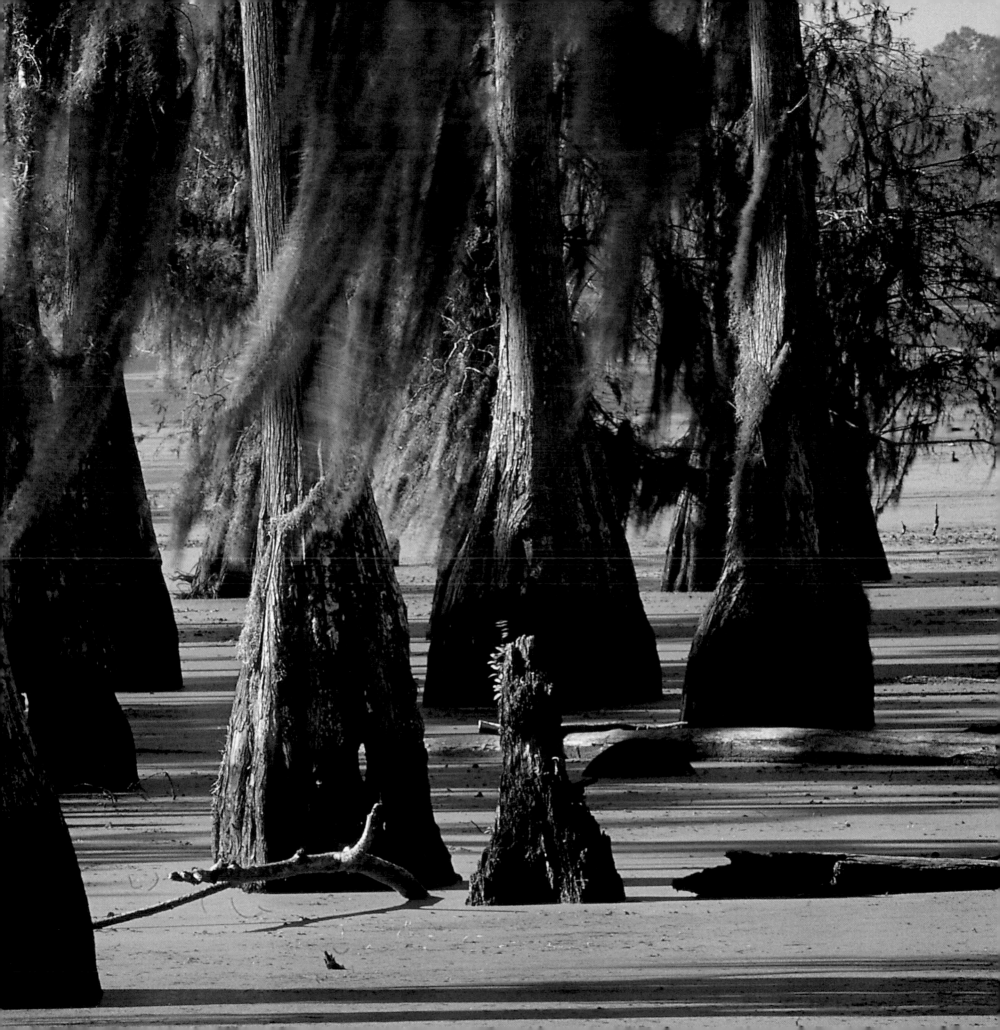

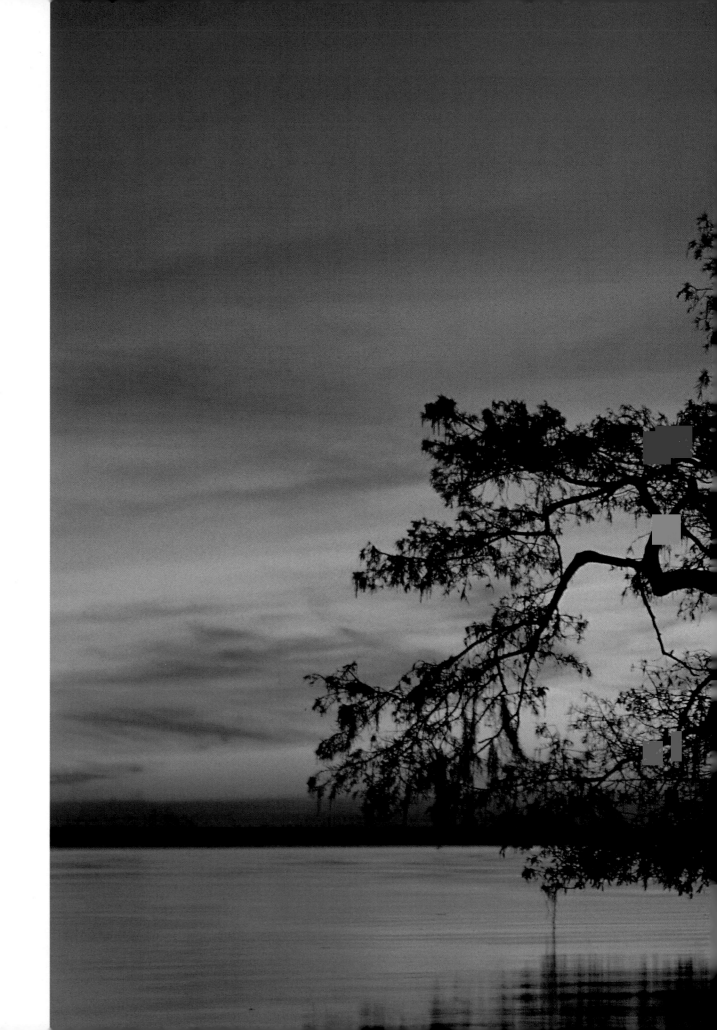

As I gaze at this old cypress tree, sitting on its own away from the shoreline, I think of self-reliance and freedom. It seems to say, "Here I am, away from the crowd, doing fine." A tree like this is an ecosystem in itself, a roost for birds, and a spot for the swamp's plentiful amphibians and reptiles to sun, hunt, and hide.

PRECEDING PAGES: Skirts of Spanish moss brush the ankles of cypress trees in Atchafalaya lowlands, which may be inundated or uncovered by the river's rise and fall, but can never be called dry. Duckweed coats the water between rot-resistant trunks, which are capable of surviving endless cycles of flood and drought.

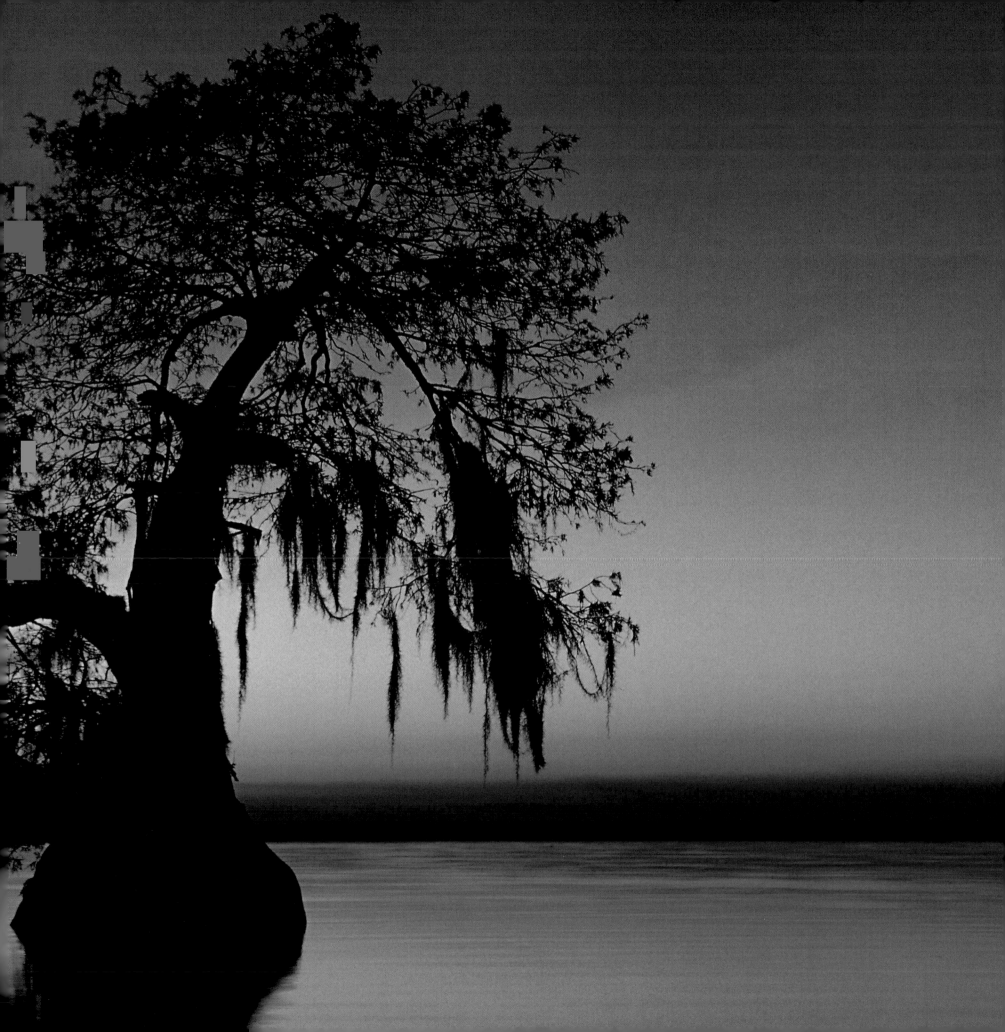

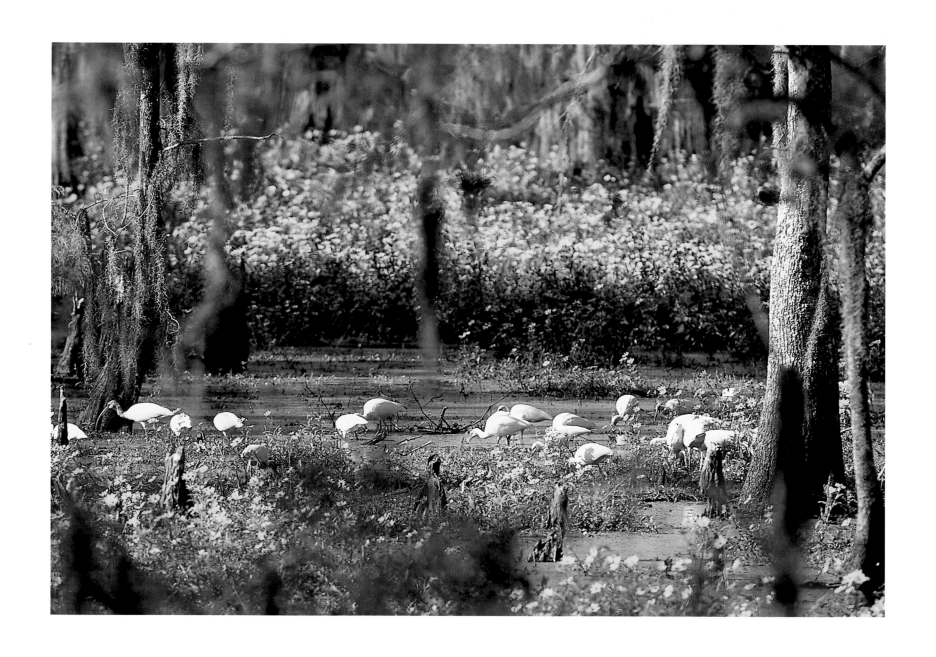

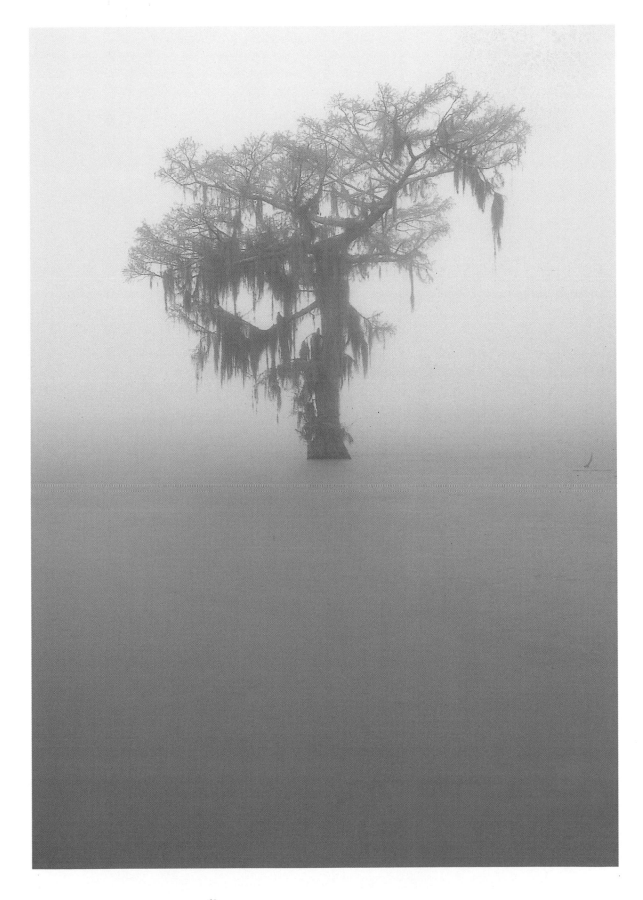

Mists of spring envelop a lone cypress hung with Spanish moss (right), a plant that thrives year-round on nothing else but air and water and the nutrients they deliver. Late in autumn's gentle advance toward a nearly frost-free winter, white ibis (opposite) scour shallows for snails, frogs, fish, and whatever else may teem in the opaque water, amid banks of gloriously flowering bur marigolds. All seasons except summer are subtle here in America's deepest South, warmed by subtropical latitudes and the Gulf of Mexico's damp breath. Ibis and other birds allergic to cold live here year-round.

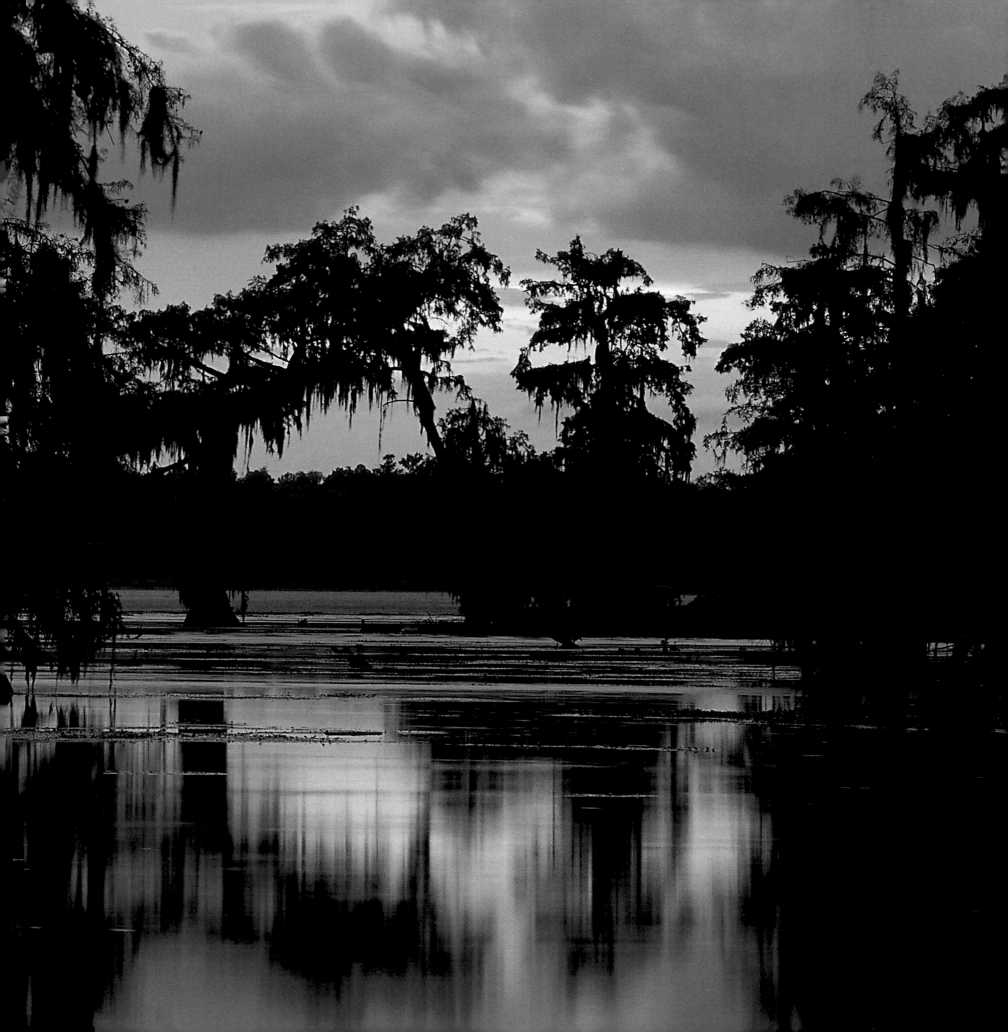

Moments of otherworldly peace descend in the hush of sunset, when my mind turns to the Creator's hand. The tangible beauty of these wetlands is what first drew me into them—cypress trees in twilight, wood ducks' wings whistling unseen through treetops, a chorus of frogs on a sultry night—but it is the intangibles I return for, the sense of awe and reverence I feel the moment I arrive. Not surprisingly, the hand of man has not been kind to this watery Eden. Even in its heart, virgin cypress of legendary size live only in memory.

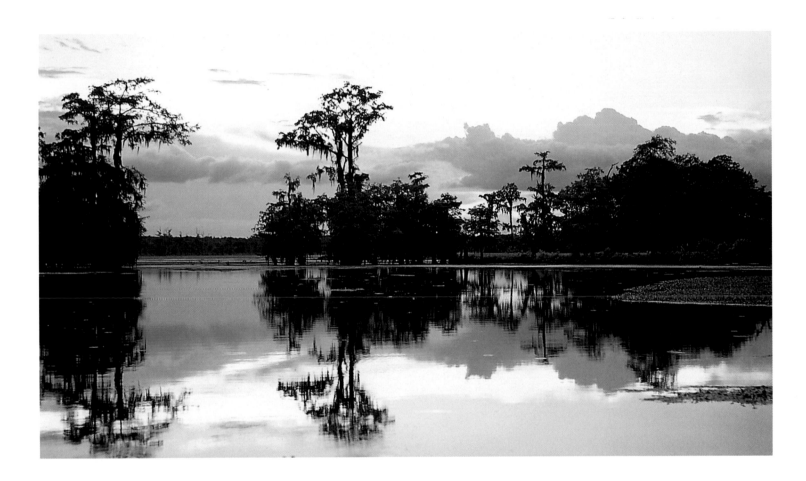

FOLLOWING PAGES: Saltwater meets fresh in the brackish marshes of Sabine National Wildlife Refuge in Louisiana's southwest corner. Beneath its placid surface bubbles a cauldron of marine life in every stage of growth. Elsewhere, marshes are vanishing due to causes both natural and man-made.

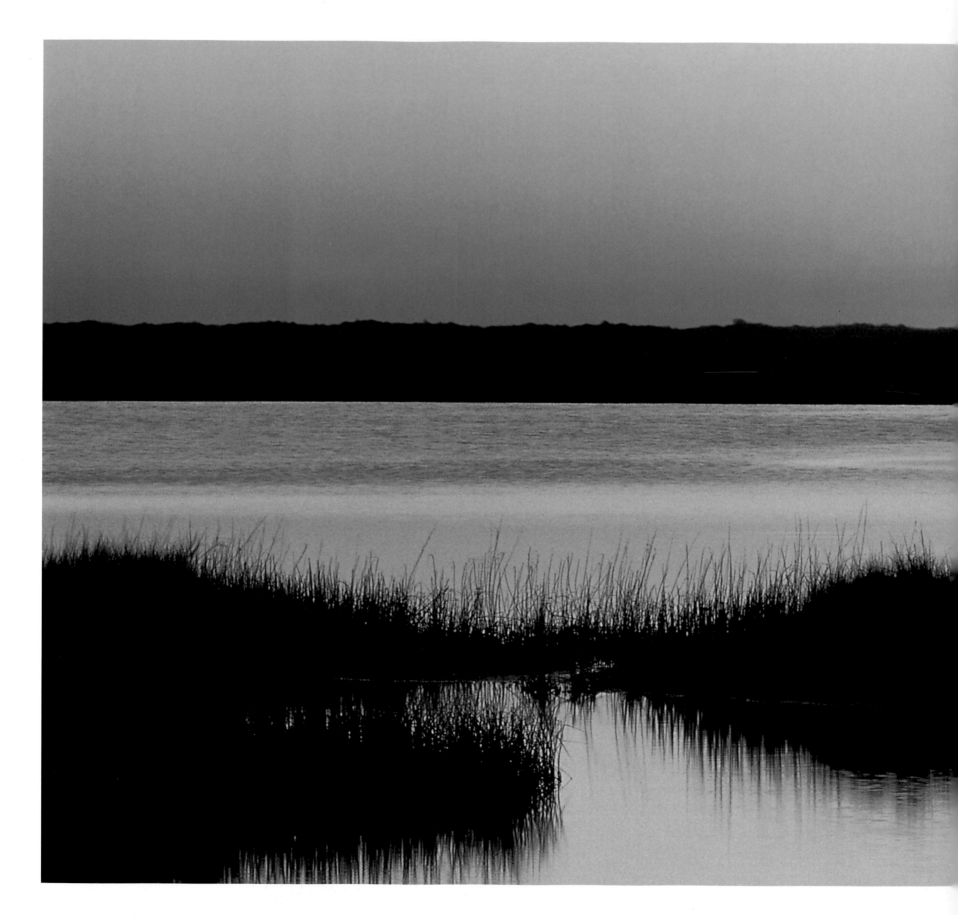

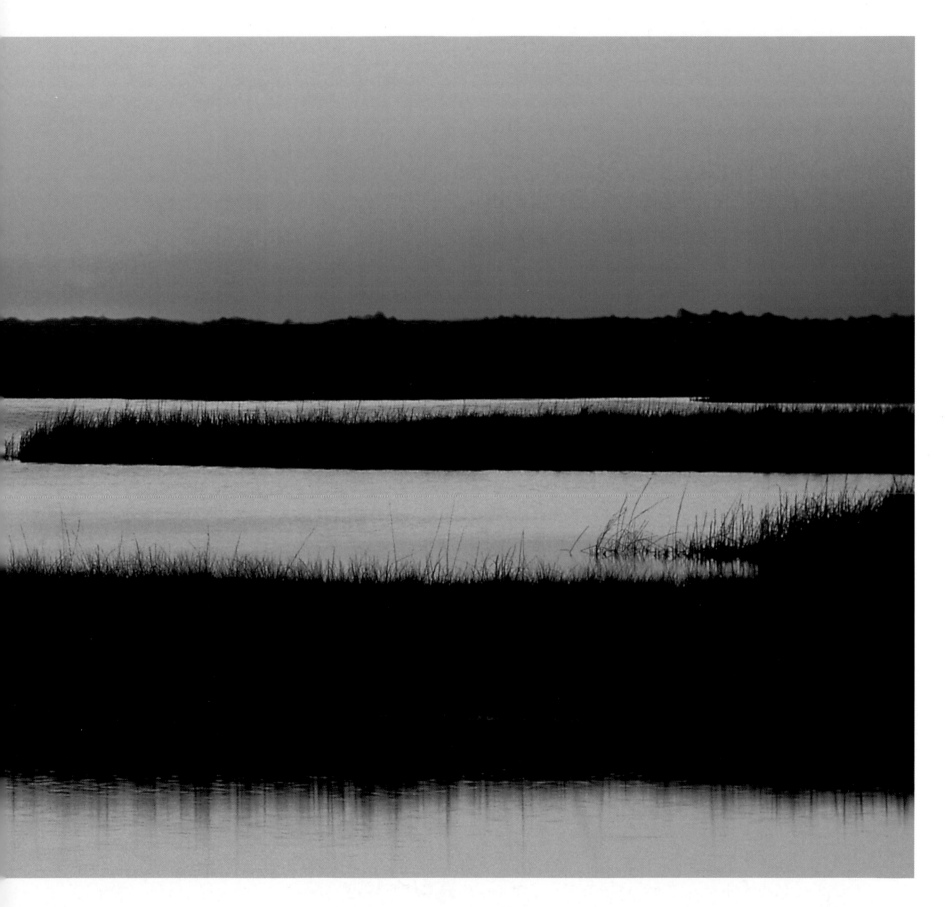

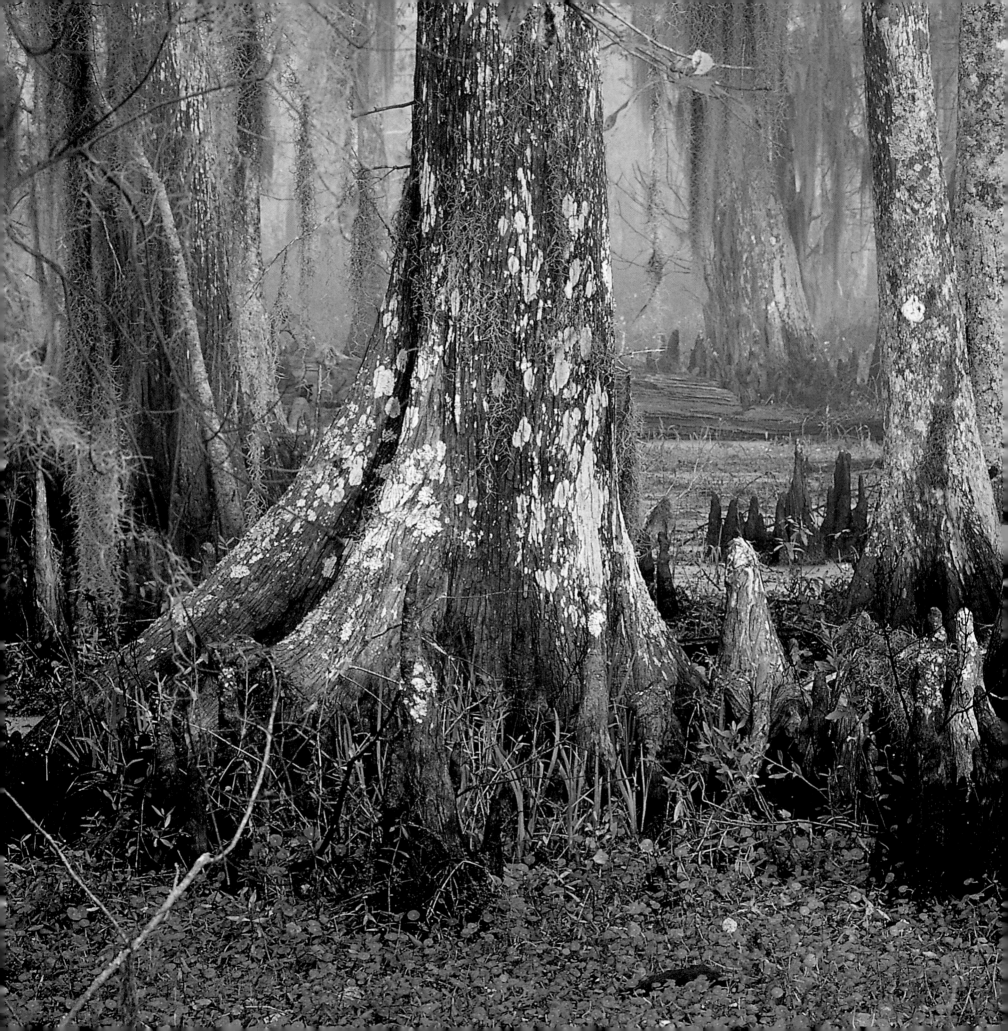

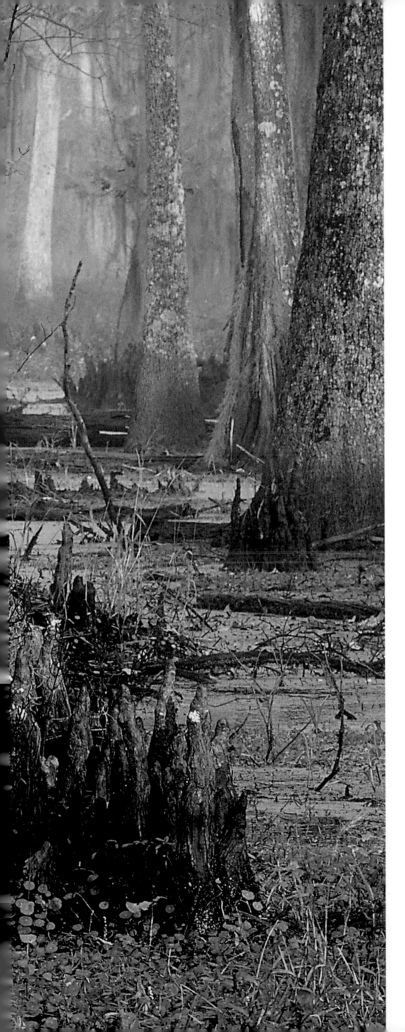

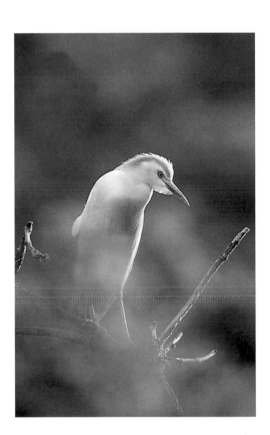

Cypress knees' hollow tubular growths (left) help waterlogged roots to breathe in the often flooded fastness of the Atchafalaya Basin. No other tree so totally captures the gnarled grandeur of the life-choked wetlands. A cattle egret (right) in breeding plumage on a rookery nearby cannot make the same claim to native status. The birds were introduced from Africa to South America and made their way here via Florida. Luckily they are creatures that don't unbalance their adopted home, feeding harmlessly on insects.

FOLLOWING PAGES: God's finest brush marks reveal themselves in winter at Sabine Refuge. This is the canal where I followed the otter that outfoxed the alligator. Often it looks like nothing much is happening here. Yet beneath its waters, within its grasses, and in the sky above unscrolls a testament to life abundant.

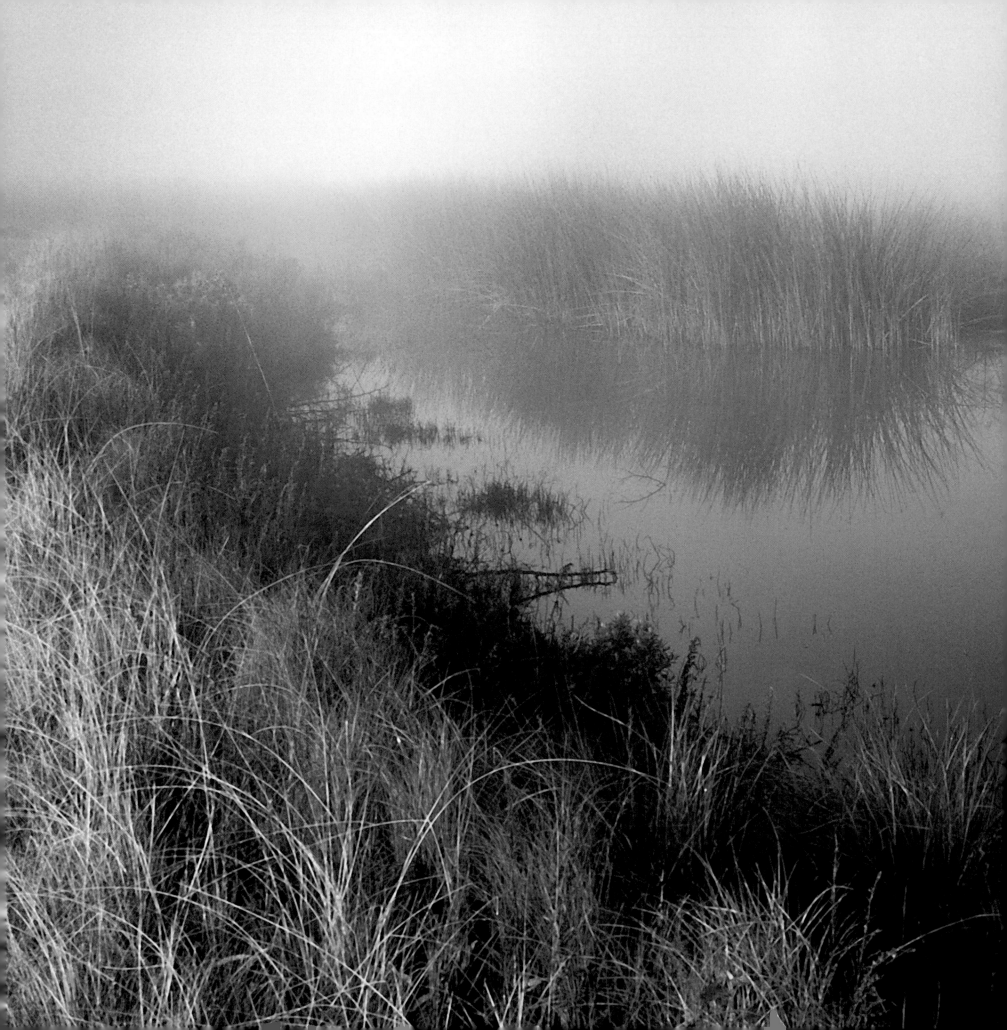

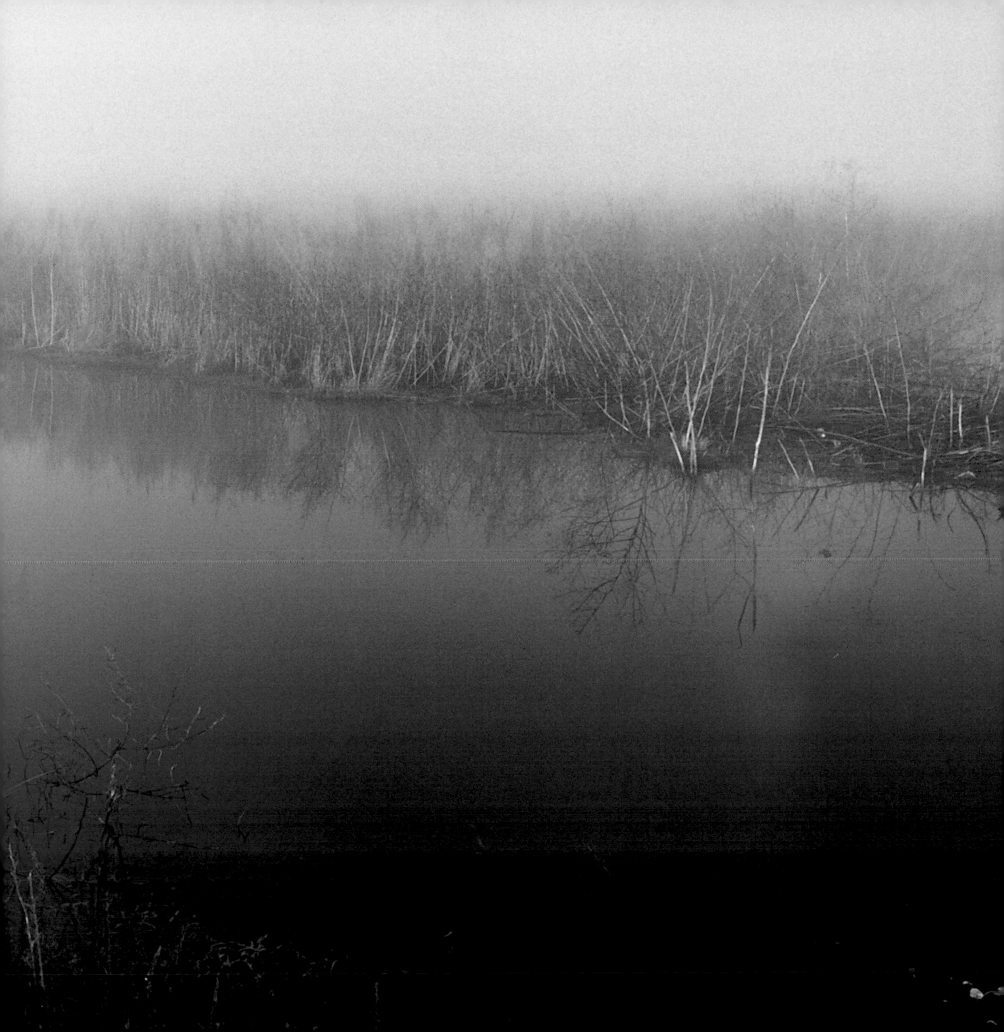

John Lane

Confluence:
The Pacolet River

Of course the greatest confluence of all is that which makes up
the human memory—the individual human memory.

—Eudora Welty

The Blue Ridge Mountains, visible from Spartanburg, South Carolina, on a clear day, have always had the nostalgic force of a song for my family. Stories told by my aunts and uncles in the early 1960s confirmed that we had come from there. They told me how my great-grandparents migrated from mountainous Rutherford County in North Carolina to work in Spartanburg's numerous Piedmont cotton mills at the end of the 19th century. With time off from shift work and a little gas in the ramshackle car, my mother would often take me back there to cool down on a summer day.

On those childhood outings we traveled up U.S. Highway 176, the original road from Spartanburg into the mountains. As it approaches the mountain front, the highway follows the course of the North Pacolet River. As a child I loved how the narrow two-lane climbed the slopes of Big and Little Warrior and Cedar Mountains in steep switchbacks. Local historians say it follows an ancient game trail along the dizzy gradient of the river and marks the descent of an Indian trading path walked for thousands of years to reach the Piedmont Plateau and the coast two hundred miles away. On the other side of the river is one of the steepest railroad grades in the eastern United States, and now, just east of the old highway, Interstate 26 carries commerce quickly across the flank of Tryon Mountain and over Howard Gap onto the Hendersonville Plateau.

My mother would load me in our beat-up, cantaloupe-colored DeSoto convertible with the white rag top and head out for those cooler mountains. It was water she was headed toward, cool water falling over stones. We would pick up her younger brothers, the twins Bobby and Billy, in Saxon, a mill village on the city's outskirts. As my mother remembers, back then, they were "into loafing," young boys often laying off from relentless work in the cotton mills.

One of the twins, with his white T-shirt, duck-tailed hair (it was the 1960s), and Pall Mall in his mouth, would drive the DeSoto. The other twin would sit in the passenger seat twisting the AM from station to station. Mama and I would sit in the back, her black hair pulled back secure from the hot Piedmont wind by a patterned rayon scarf. After crossing into North Carolina and negotiating most of the Saluda Grade, a switchback highway, my uncle would park by the side of the road in a narrow pullout crowded on one side by a sweating gneiss cliff and on the other by the highway. For each trip Mama packed fried chicken, deviled eggs, potato salad, and sweet tea for me. There would be some hidden Budweiser in the trunk. We would sit roadside at a small concrete table and picnic.

Pacolet River, South Carolina; Mark Olencki (opposite)

Then we'd work our way down to the roaring North Pacolet, and I would slide over the rocks left by ice wedging and flood in the channel. Back then, I never thought of that river as going somewhere, falling toward sea level. It was always as if it had been laid out like a carnival ride (or today's water parks) simply for my enjoyment—big slick rocks, falling water, overhanging rhododendron. When the sun dropped below the gorge walls we would retrace our steps up to the highway, pack up the DeSoto, and head back down into the mill village.

These are my earliest memories of water—of escape and relief. It's said the Cherokee, who claimed what would become Spartanburg County as their territory, went regularly to water to purify. For them each river was "the Long Man" with its head in the mountains and feet dangling in the ocean far away. I look back now at the irony of that cantaloupe-colored DeSoto named after the first Spanish explorer who in 1540 looped decisively through this territory. Traveling a Piedmont river like the Pacolet (probably the Catawba), DeSoto set the tone for the future, looking for gold and trailing a herd of pigs.

IT'S NOW NOVEMBER, and I am back on the Pacolet, though 30 miles downstream from my childhood picnic spot. I'm floating the river this time, not playing among boulders and waterfalls. At this point along its course the Pacolet has become wide and shallow with very little exposed rock as it makes its way over the wide Carolina Piedmont, an area of steep hills but few extremes in elevation or scenery. I've realized recently that I've somehow missed this river my entire life. I am an expert kayaker, and challenging rivers were always somewhere else, never close by. Twenty years ago, when I began white-water kayaking, I always had to head west from Spartanburg and climb into the mountains where there were steeper gradients. (Once it leaves the mountain front, the Pacolet drops only an average of five feet a mile. In contrast, the Chattooga, 70 miles west, can drop as much as 200 feet a mile.) In this way my kayaking adventures reflected my youthful picnics. I'm older, less driven by adrenaline, and paying attention to nearby places as never before. Now, Piedmont rivers like the Pacolet are appealing for the first time, and I've made a vow to paddle them all over the next few seasons.

There's not much time left this year to keep my vow. We've already had the first hard frost. The

tulip poplar leaves have already turned yellow and fallen. I am paddling with my partner, Betsy, and her ten-year-old-son, Russell. We've packed a lunch of sandwiches, apples, and soft drinks. It's my equivalent of the childhood picnics, minus the beer. We are on the northern edge of Spartanburg, in a rural area near Interstate 85. We plan to put in with our sea kayaks and float the river from Bud Arthur Bridge Road to the old abandoned Converse cotton mill where my uncle Tommy once worked, a distance of about five river miles. Though I've never paddled it before, I've been told the stretch just downstream from where the river crosses the Interstate (maybe 30 miles from the river's origin) is marked by only one road crossing, a house or two, and a mining operation for sand. I know the current will be steady, and there is abundant wildlife: Wood ducks, mallards, great blue herons, hawks, and kingfishers frequent the stretch.

The stretch will make for a pleasant fall paddle. The air temperature is in the 70s. The river is maybe a hundred feet wide, clear, and two feet deep. Looking at my topo map before we left I could see that the river sweeps through two large meanders. The bunched up lines tell me there are steep, north-facing bluffs along the way, probably covered with mountain laurel (a species common to the Blue Ridge, but no stranger to cool Piedmont river bluffs) and dark hardwood. Though we will only be three miles from the city limits of Spartanburg, I know it will feel like we are surrounded by wooded country thick with mature oaks and poplars.

A friend will pick us up downstream later in the day, and so we leave my truck parked near the bridge, slide the brightly colored plastic kayaks like otters (sometimes still seen on the Pacolet) down the steep, long approach our paddling friends have told us about. I wrestle each kayak down as far as possible and let go. The boats bounce to an angled stop short of the river. I laugh at how difficult it is to get into the flow. "It seems a resource so public should have some sort of access short of skydiving," I say.

When I pause and listen, it's possible to pick up the sound of a small wild shoal one hundred yards upstream. The water is noisy as it works its angled descent over the exposed country rock; and beyond that, hanging in the air like static, is the sound of hundreds of cars and trucks humming over the expansion joints on the interstate. Just above us is one of the busiest stretches of highway on the East Coast, and yet in a few moments we will push off from shore and Huck Finn our way downstream in a rhythm as old as any human impulse. Floating, my kayaking friends call it.

"Let's go float a river," they say.

On the topo map the Pacolet's two main branches are laid like a tuning fork against the South Carolina Piedmont and the mountains to the west. Along its 60-mile journey, before the confluence with the Broad River in Union County, the river falls over many (though widely spaced) sets of shoals. They are often designated on the map by double bars piercing the blue line of the river. Before railroads rendered the river redundant for transportation, these shoals made long-distance navigation on the Pacolet difficult, but created many "mill seats," topography with enough fall to generate power for early industry. This natural power, and the jobs it created in cotton mills, is what drew my family down from the mountains to Spartanburg County. It was a confluence of need and geography that formed our connection to this river and its many tributaries.

Along the Saluda Grade, where we had parked to picnic, the north fork of the river falls precipitously for 15 miles through rhododendron, laurel hells, and mixed hardwoods and conifers (hemlock, sweet birch, white oak) on slopes too steep to log. The North Pacolet's noisy descent now comforts porch sitters in vacation cabins and finally flattens out near Tryon (where F. Scott Fitzgerald spent summers in the mid-1930s) and flows swiftly through old farm country in what's known as "the thermal belt," an area traditionally associated with milder winter temperatures and fewer days of frost, though no one has confirmed this scientifically.

The South Pacolet, the other prong of the tuning fork, is much shorter and less extroverted, falling off the lower slopes of Hogback Mountain as a series of narrow creeks. Then it quickly ceases its mountain song as it meanders quietly among Piedmont hills, abandoned peach orchards, old field succession, and the first hints of suburban sprawl.

Confluence of uses, confluence of memory, I think as we begin our float on the main branch of the river. In high school I water-skied on Lake Bowen, the reservoir formed on the dammed South Pacolet River. Lake Bowen is the source of Spartanburg's drinking water and is tightly ringed with waterfront vacation homes. Powerboats and jet skis rage over the surface three seasons a year, the latter expelling a flume of ruddy lake water as they push into the tiniest coves and inlets.

No one in my family had made it beyond mill work at that time, so we could not afford this affluent form of fun on a regular basis. (Those fried chicken picnics and self-propelled slides down

a slick rock were mostly what I knew of water recreation.) It was through the generosity of high school friends from across town that I once strapped on a ski belt, snapped on water skis, and waited as the Evinrude torqued the prop into high enough rotation to pull me from the grip of the Pacolet's impounded flow.

I remember gliding over the lake's waters, my arms and legs stiff with exertion. It was an unnatural motion for me. There was too much trust of machinery. It didn't take long for me to tire, swerve, and plow into the lukewarm surface of the water. My buddies cheered as I fell, and they circled the boat back to pick me up. Another boy entered the water for his turn on the skis. Sitting in the stern, recovering my senses, I remember distinctly the sharp bite of petroleum fumes and a rainbow sheen spreading in the bilge pooling in the boat.

SOON AFTER WE ENTER THE CURRENT in our kayaks, I point upstream toward the sound of the traffic and say that we can paddle up toward the gravel roar of the small rapid and play there. Russell's not appeased. When I say "river" he always thinks of rapids. Russell wants his floating to be punctuated by drops and waves. He's young and still on the adrenaline program. He wants to know if there is white water downstream and acts disappointed when I admit it's doubtful. I try to explain that this is not the Blue Ridge, but instead a Piedmont stream with less of the gradient that produces white water than its mountain counterparts. I guarantee him it will be swift water though and he will not have to paddle much. "Just float," I smile. He likes that, and we float into the current and head downstream.

Betsy is glad to hear there won't be any significant white water. The summer before we were floating a calm mountain river punctuated with occasional rapids, and the curling edge of a wave caught the stern of her boat and dumped her in the cold current. We rescued her, but she still remembers the sting of the cold water. She likes to float but would rather not swim on this warm fall day.

Just downstream from our put-in, as we pass under the Bud Arthur Bridge, we see the first signs of one of the river's historic functions: trash heap for the locals. Someone has thrown two of the newspaper dispensers for the Spartanburg daily paper off the bridge in the river. "Somebody

must have frisked them for their quarters," Betsy speculates. I nose my boat up to one. It has been in the river for a long time, unmoved by recent floods. A sheen of algae makes it look more like rock than machine. I peek through the machine's gate into the paper compartment. It's too dark to see anything, but I tell the story of a radial tire a friend picked up on one of the Pacolet's tributaries during a river sweep once. Inside was living a three-pound catfish. With enough time, maybe the river can claim anything.

Remembering the catfish in the tire reminds me that this is a living stream, with bass, bream, riffle beetles, gilled snails, sowbugs, dobsonflies, crayfish, a whole world beneath the surface. It wasn't always so for a river once as impaired as the Pacolet. I know that as recent as the 1960s the textile mills along its length dumped their raw sewage directly into the river. My Uncle Tommy, who worked for decades inspecting cloth and marking it in the cloth room downstream in the Converse cotton mill, likes to tell the story of camping on the wide sandbar at Poole's Bend, a large, sweeping meander on the Pacolet a few miles below the mill. He and some buddies ran a trot line and pulled in a washtub full of catfish. "We skinned some to cook over the fire that night. When I opened them up they smelled like sewage. I couldn't eat catfish for 50 years."

Russell, floating ahead of us, is more interested in the white-and-turquoise wreck of a jet ski that has somehow landed in the river than the catfish probably living below its surface. He gets excited. "Maybe we can fix it up?" he asks. I only think how the infernal machine probably washed downstream from Lake Bowen in a flood and how its owner pushed the noisy thing all over the lake in the summer. I am strangely hopeful we'll see more and can pretend they are wreckage of some lost world. "It's like *Planet of the Apes*," Betsy says. "You know, the final scene where they discover the Statue of Liberty and realize they have stumbled into the future."

FLOATING A RIVER IS ALWAYS A LITTLE LIKE WADING into another time, especially a river once as heavily settled as the Pacolet. At one time there were farms along these banks, and now we float through a forest of 30-year-old poplars, oaks, and sycamores grown toward maturity in the grace period when the farms were abandoned and the mills closed down. The South

Carolina Piedmont is a region in the midst of transition: once wilderness, then farmland, but now in an uneasy peace before the war of real estate consumes it all. The contrast between our daily lives—streets, cars, mechanical noise—and the quiet of the post-industrial river is appealing and fragile. As we float for an hour south toward our ride back to town, I think about the scarred yet somehow peaceful landscape this river drains.

I am a native of this place, not merely a visitor, a recreator. It is no water park where I pay admission. Though I was born in the coastal plain of North Carolina, my mother moved us back to upstate South Carolina after my father's death in 1959; with the exceptions of a year out west, three in Virginia, and two in the mountains of North Carolina, I have lived the rest of my life in the drainage of the Pacolet River. Upon my father's death I was introduced to the rich flow of the Piedmont's declining mill culture where my mother's family had worked in cotton mills for two generations. My mother's family's personal history (which was mine as well) was hardscrabble and stained by long hours and low pay. After migrating from the mountains, they moved in tightening geographic circles from mill to mill, pursuing jobs, working shifts, and living in company-owned mill houses in villages sprawled over hillsides right next to the river and its tributaries, the Buck, Chinquapin, and Lawson's Fork Creek.

Now the mills have all closed down, and in many places the forest has returned. I can see from the maps that the river meanders, in its final 30 miles below where we paddle, past four abandoned cotton mills—Converse, two mills at Clifton, and Pacolet—and on through miles of pine plantations, impressive stands of oak and poplar, and a few remaining farms. I do not pretend to know much more than the maps tell me about those lower stretches. The river, before it meets up with the Broad, is hard to see from roads (the river keeps to itself), and I've never paddled it.

"Is Pacolet an Indian word?" Betsy wants to know.

Yes, I explain. One of the theories as to the origin of the name "Pacolet" is that it is a Cherokee word meaning "running horse." Others say the river was named for a French man who settled in the county early on. "No one seems to know which is true," I add.

"Why aren't there more rapids?" Russell asks.

I tell him there were once three impressive river-wide waterfalls in the mile-long trough of steep, erosion-resistant rock known as Trough Shoals about 15 miles below the stretch we are

paddling. The first town there was even named Trough, the river was dammed, and the steep drop of the river converted into power, enough to turn thousands of spindles. Later, when the town changed its name, the waterfalls were long forgotten beneath the waters of the impounded river. Russell, the lover of adrenaline, likes my story of the waterfalls. He asks if we can ever paddle them. I have to admit that there is something compelling about those waterfalls trapped beneath the waters backed up behind an inactive dam.

We stop and eat our lunch on a sharp bend where the physics of the river has created a sandbar on the inside curve. As the water sweeps downstream, the heavier sand held in suspension by the current drops out first as the river is pushed toward the outside of the curve. A few miles upstream from this spot was once a bend so wide and a sandbar so thick that locals called it "Cowpens Beach" until an enterprising sand-and-gravel company bought the site and mined it out for concrete production.

We eat our sandwiches in the sun on the small beach. All around the kayaks there are dark mollusk shells open like angel wings. I comment on their beauty, but Betsy reminds me they are a sign of how compromised the river really is. They are an intrusive Asian species that has driven out the native mussels.

After lunch we return to our kayaks, pack the trash into the empty dry bag, and head downstream. A few minutes later I realize we've floated along as quietly as a raft of ducks. Even Russell sees the beauty of such a gradient-free float so close to town. He seems reflective at moments, a rarity for a rambunctious ten-year-old. He has settled into the pace of our outing. Then suddenly he's singing at the top of his lungs. We pass the heavily wooded banks and they retreat behind us. As if in answer, a dusty blue kingfisher taunts the river from limb to limb with its shrill, cackling voice. The river offers a child's joy for unconstrained spaces where Russell can push the boundaries of what's acceptable in polite company, and he fills it with his whoops. It's only when Russell's vocalizations are answered by men on a high bluff above the river that some of the joy goes out of our journey. It looks (and sounds, with sporadic hammering filling the air) as if they are building a deer stand, though it is hard to tell, looking up through the woods. "You better duck," the men yell in accents as shrill and local as the kingfisher. "We might start shooting." Betsy quiets Russell, ushers him between us. We float on in silence with only

the sound of the mens' hammers following us downstream.

Soon after the hint of trouble, the Saturday river turns turbid and deepens. For a mile or more we paddle across the mill pond I know is backed up behind the dam at Converse. Around one bend there are two men fishing in a bass boat, and someone has cleared a pasture down to the water and built a small dock. A muscovy duck paddles along the muddy river edge. Russell's earlier screams of freedom now come out as moans of outrage at having to expend energy to move his boat. "Around the next bend," I keep telling him, not really knowing for sure when or where the dam will appear.

We pass a big bend in the river full of dredging equipment where a local concrete company has been mining sand for decades. In its weekend idleness, the dredge looks like some rusted industrial dinosaur. "Someone has gotten rich mining the river for sand," I explain to Betsy as we float past the spot. I find this ironic, how over the last half a century many of the concrete buildings downtown have been molded out of the river bottom itself. We drink its water, share its power, and we mine its sand. The river gives in all ways and ceaselessly.

I finally spot the mill. I have somehow paddled a few hundred yards ahead of Betsy and Russell. I turn my boat and look back upstream and can see them working toward me over the surface of the impounded river. I float a few moments without paddling, sit still on the surface of the pond. I can hear the falling water of the mill dam only a few hundred yards in the distance. The river forms a horizon line as it plunges in a perfect fall over the rock dam. Just downstream from every Pacolet River mill (Fingerville, the Clifton mills, Pacolet) there is a dam such as this one, which at one point may have produced electricity to power the manufacturing processes before the advent of the power grid.

THE PIEDMONT COTTON MILLS always had "a village," a company-constructed community, a clutch of wooden houses, now often sided with vinyl and altered by ownership. And, of course, there is the river itself, channel and flow, which for years swept away effluvium of countless origin: sewage, process dyes, dead dogs and cows, garbage of settlement. There is that tough species, the catfish, still living in the impaired waters of the post-industrial stream. Now that the

mills have almost all closed, one is more likely to see these fish pulled from the deep eddies below the dams. If a Piedmont river has a soul it is probably hidden in the swim bladders of these native bottom-feeders. Their genetic predisposition is toward making the best out of the current's changing conditions. They are well suited to life in the Piedmont.

There is beauty in such a cultural landscape for sure, but for a moment I find this a scene of unaccountable hardship, and suffer through the darkest nostalgia when I see the bricked-up windows of the old mill. I get a vague ache—the way amputees have described the nerve memory of lost limbs—when I consider these Piedmont mills and their neighboring rivers. My family tree is like one of the surviving river birches along an upcountry stream like this one, the roots undercut by the eroding flow of our particular regional economic history (king cotton, king textiles, king development), the skinny limbs leaning out over the current, working hard for a place in the sun.

One element of this river's history I return to as I sit waiting for Betsy and Russell to catch up is the flood that roared out of the mountains on June 6th, 1903. Historic accounts describe how a gentle rain fell for almost five days, and then a cloudburst pushed the Pacolet to alarming levels. It was the single greatest catastrophe to ever befall the county. That morning, the slow music of the shoals turned into the cacophony of disaster. The waters swept away bridges, roads, and houses, leaving the small mill communities isolated from each other. Fifty people died, as three cotton mills were carried downstream by the power of the waters.

My Uncle Tommy's family worked in this same Converse mill, "long as the mill had been open," as my Mama says. Uncle Tommy worked there from 1942 to 1979, when it closed. His father had been the paymaster for the Clifton mills; his grandfather, born on April 13th, 1903, a few months before the flood, was later the R.F.D. mail carrier for that corner of the county. Once, while visiting, I asked Uncle Tommy if he grew up hearing stories of the flood, and he said, "Didn't nobody talk about it very much." The memory was deep and painful. People moved away because of the damage, and almost every family in the village was affected by the death toll.

What had he been told happened to his father and grandfather? He said that the mill whistle blew that morning to warn everyone, but most thought it was simply a call to go to work. "When the flood came my Grandpa hollered for my Aunt Helen and picked up my father Thomas. They

came out of the house in knee-deep water." He waded with Helen under one arm and Thomas under the other, and headed for higher ground, watching as the house was washed downstream.

"YOU CAN COMPREHEND A PIECE OF RIVER," says John Graves, talking of the Brazos in *Goodbye to a River.* "A whole river that is really a river is much to comprehend." He says all a human being comprehends if he spends his life navigating a really big river—like the Mississippi—is its "channels, topography, and perhaps the honky-tonk in the river towns." There are no honky-tonks on the Pacolet. This is the Bible Belt, the river was never plied by riverboats, and barge traffic in the 19th century was local, stifled by those shoals, those rocky ribs of gneiss.

I love rivers because they are real and not only metaphorical. In upstate South Carolina many of the very real rivers (we have always been a place defined by swift-flowing water) were used first for power in the late 19th century by the growing textile industry; later, when power became more available, our rivers continued to be used as discharge channels for waste, human and industrial. I write about rivers because the ones I know best—those of the Carolinas—give me hope for the recovery of the land after great abuse. Even in the face of such abuse, a red clay river like the Pacolet endures, and our relationships with it endure.

Betsy and Russell paddle up behind me. Russell releases one final whoop of arrival as our friend appears with his pickup to carry us back to our car. We pull the boats ashore safely upstream of the dam and step out on dry land. I drag my boat through brush willows, yellowing sumac, and saplings of volunteer hardwoods, poplar and birch.

I am not tied to the Pacolet the way my uncle, mother, grandmother were, but I still drink its treated water. I know if it rains tonight the runoff from my city street will quickly find its way to a culvert and into the nearest "branch," and on down to the river in a day or two. Within two weeks that same water could be in the Atlantic Ocean. If the rain soaks in as groundwater it might take years before it flows into the nearest stream.

I do not watch the river stained by red clay to gauge its flow, to dream its flood, fish it for extra protein, but I float it to gain some time to reflect, to recreate. I do not really know the Pacolet, but my history is adrift on it as surely as today I have drifted on the surface of this living stream. ■

Jim Brandenburg

Northern Woodlands

Our relationship with the earth must be like our relationship
with one another...a ceaseless exercise in respect.

—*Aldo Leopold*

I stepped outside last night at midnight and a barred owl hooted, seeming to laugh at me. Even at night, this dark and misty boreal forest north of Lake Superior never really sleeps. The owl's chuckle came from a Hansel-and-Gretel-like grove of cedars, down the creek below the waterfall where two nights earlier a timber wolf had walked. My hand couldn't cover its track. In the many years I've spent photographing wolves, it's the largest print I've ever seen.

I was born and raised on the prairie, and learned my photographic calling there on its wide-open and windy spaces. Even though I deeply loved that land, I left if for another. A land lacking in wild animals with large teeth seems empty to me. I needed trees and wildness. So I came to the northern reaches of Minnesota, to a place where moose are eaten by hungry wolves and where ravens tell the whole wild neighborhood about it.

It's been 20 years since I met this wild country—tough but somehow feminine. Yet the more I get to know her curves, the more mysterious she becomes. She can be cold, thin-skinned, and moody. Since the last glacier scraped and groaned its way over this soil ten thousand years ago, only a foot of soil has grown on the bare, ancient bedrock. A couple of winters ago the thermometer read minus 68 degrees Fahrenheit. You have to be a romantic to stay in love with this hard land.

The North Woods has a special sort of beauty that's elusive to the camera. There's a kind of visual chaos to the endless miles of pines, spruce, and birch. Strangely, I find more images in a day of shooting on the prairie, whose simpler elements speak a familiar language that I grew up with.

But living in this northern wilderness is exhilarating. Within 30 miles of my cabin I can visit a thousand lakes. That's more water than I can canoe in a lifetime. Just over the hill from where I sit, the Boundary Waters Canoe Area Wilderness and Canada's adjoining Quetico Provincial Park enshrine three million roadless acres and four thousand lakes. This immense area offers some of the finest wilderness canoeing in the nation.

Most every one of these lakes holds a pair of yodeling common loons—which create one of nature's most evocative sounds, surpassed perhaps only by the haunting howl of the wolf. More than once I've heard the two in duet—a symphony unlike any other in the world, an event impossible to capture on film. It makes me smile to know that some things are above and beyond our ability to trap them for replay. I guess that's why I'm here, connected to and still getting to know this remote and enchanting land. ■

Ruffed grouse, Minnesota: Jim Brandenburg and David Huston (opposite)

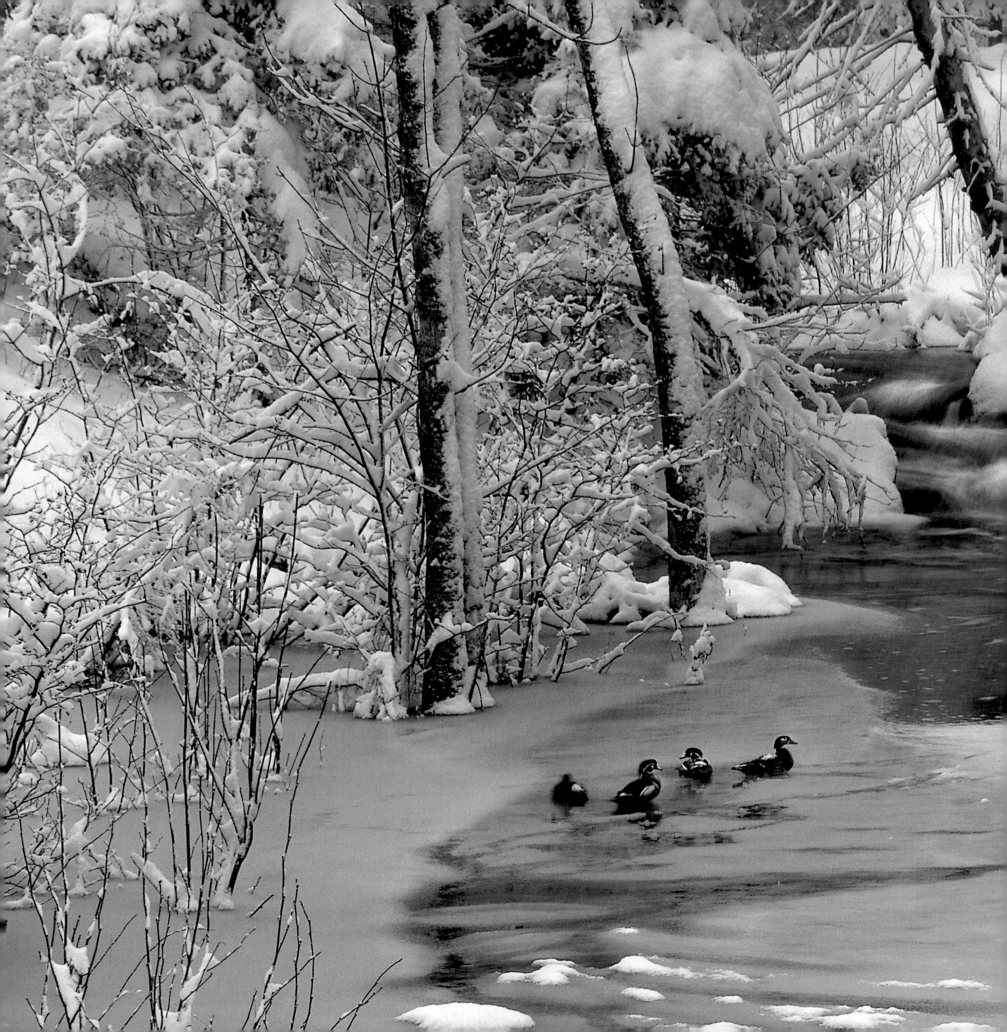

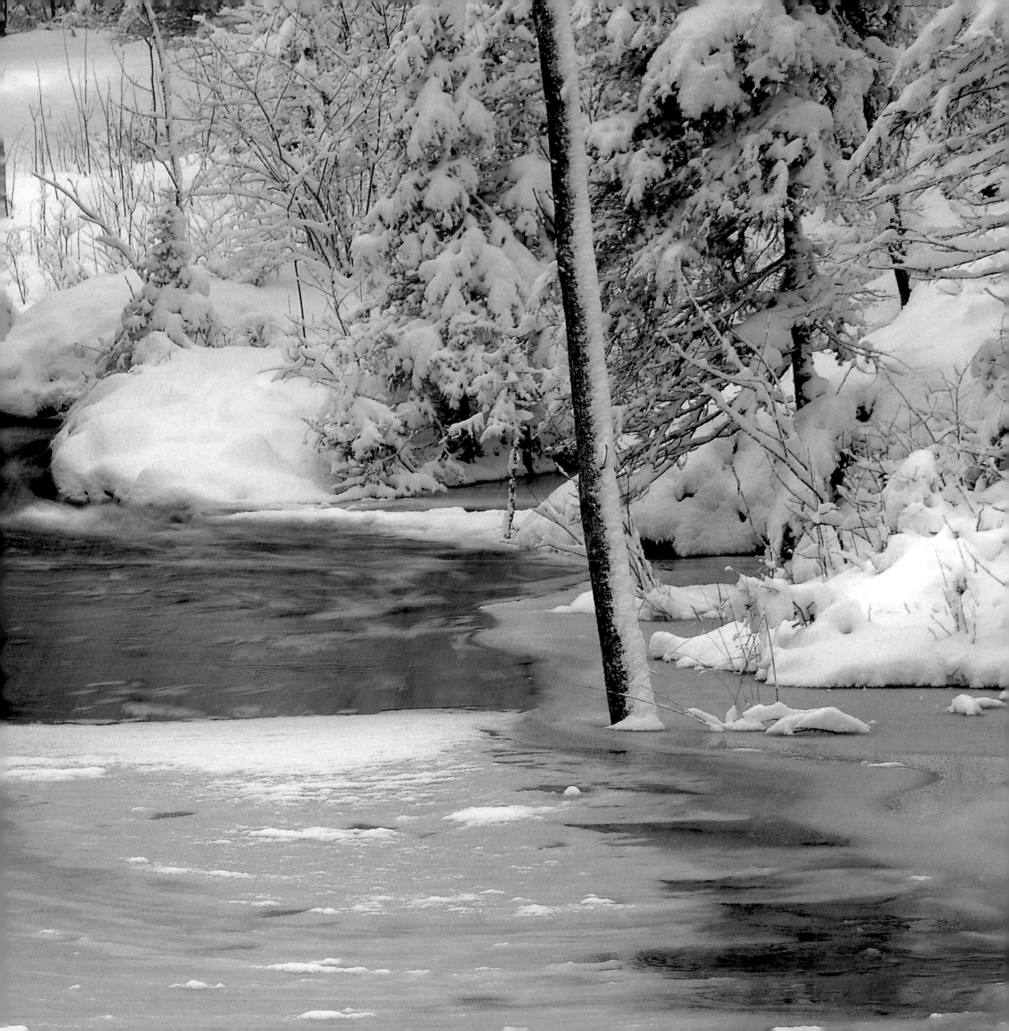

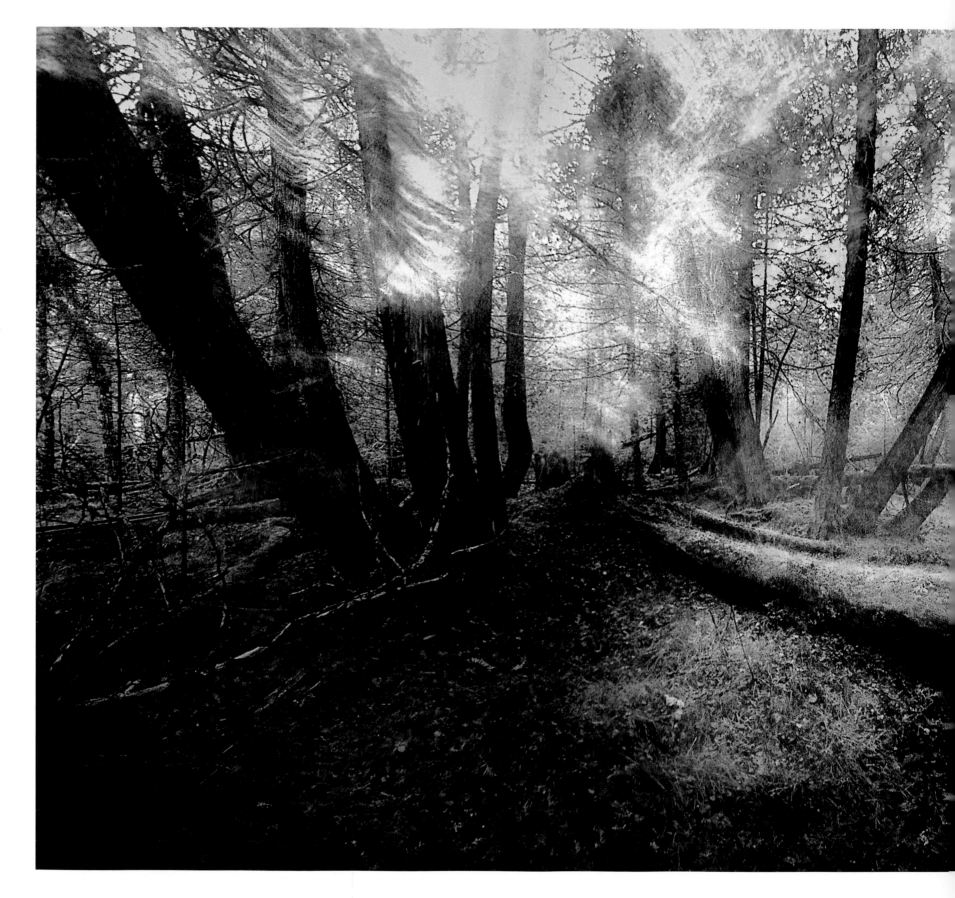

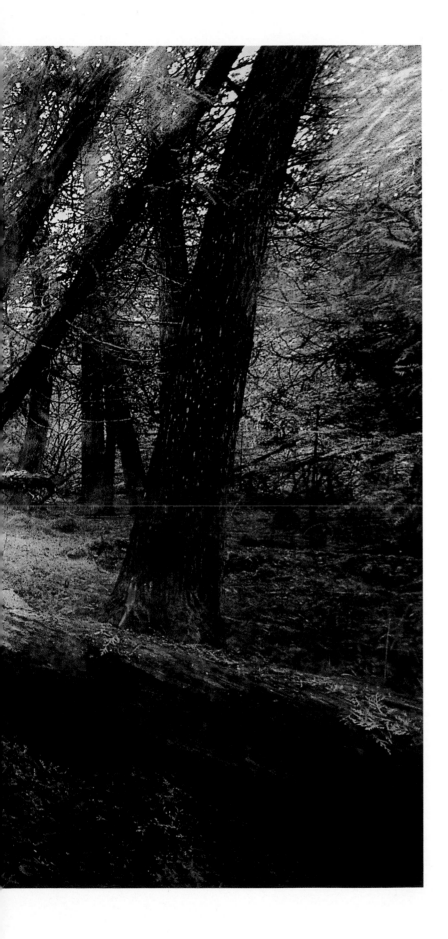

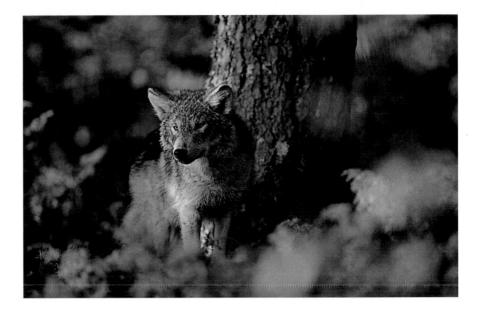

Spirits from an elder time dwell in the ancient copse of cedars (left) where owls call and wolves walk just below my cabin near Ely, Minnesota. I can almost toss a stone at the grove from my front door. But in another more profound way it's far removed from the here and now. Some of these trees sprouted more than 350 years ago, miraculously escaping the fire and axes that razed most of their contemporaries over the past century of logging. I spend a lot of time here, listening to the woods. Wolves seem to like it here too. A lone animal (above) took a good long gaze at me when our paths crossed not far from the cedar grove.

PRECEDING PAGES: Wood ducks return before the spring melt on the stream that runs through my front yard. The birds winter far south of here, where hunting is heavy; upon their return, they're jumpy until the enchanted forest works its calming magic.

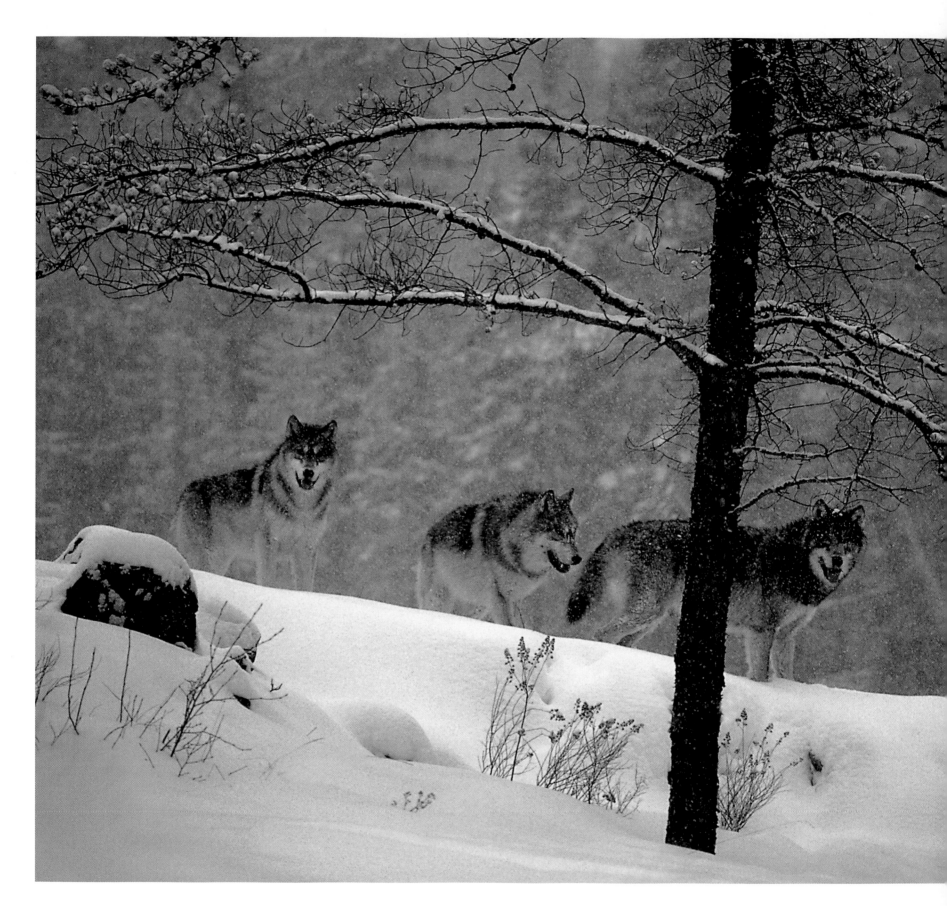

Atop many totem poles carved by Native Americans of the Pacific Northwest stands the raven, a powerful trickster spirit revered for its canny feats. This bird (above right) is also high in my regard, for it has an IQ comparable to that master survivalist, the wolf (left). In fact, the two have a partnership I've witnessed time and again. When wolves hunt down prey, ravens feast on the leavings. While wolves feed, ravens alert them to any approaching threat. Further, they have a special call that brings wolves to carrion. Snowshoe hares (below right) may lack wits and fangs, but they have the ability to change coats and blend with the seasons: winter white or summer brown.

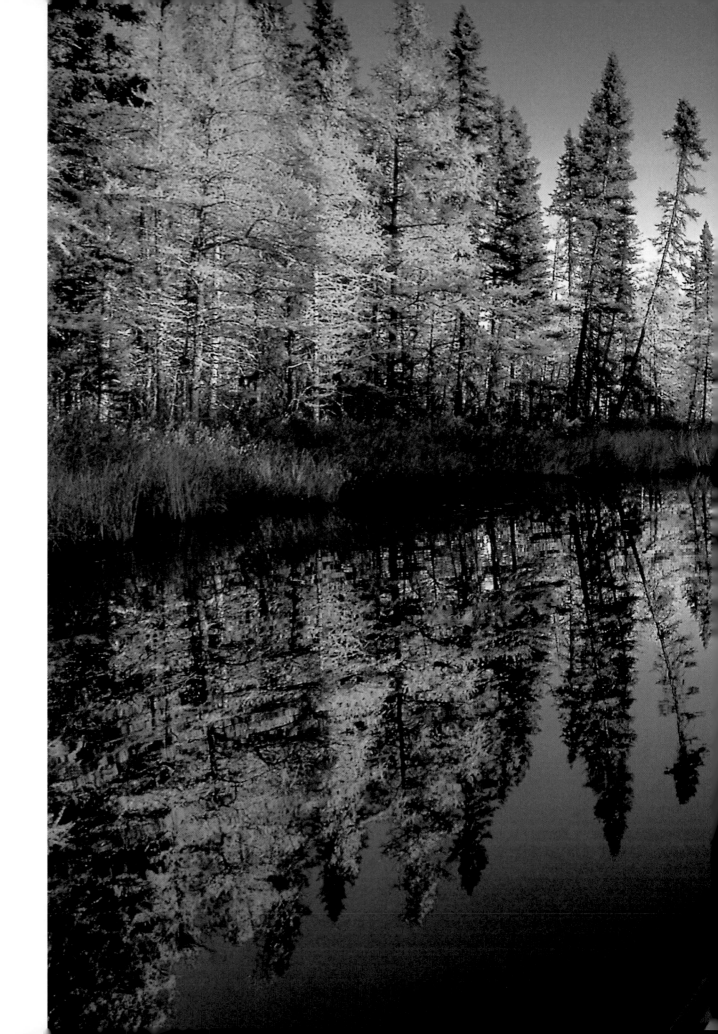

A yellow-leaf road leads into the heart of autumn on one of the watery highways that open into this dense, boggy forest. Golden tamaracks face a forest dominated by black spruce, the primary tree of the boreal forest that stretches from here to the continent's northern tree line, above the Arctic Circle. North country is all about canoes, and my wood-and-canvas craft is handmade by a master artisan who lives in Ely, the nearest town, 20 miles from my cabin. It's the perfect vehicle for my tastes and purposes—silent, graceful—and it can carry ten times what I could pack on my back.

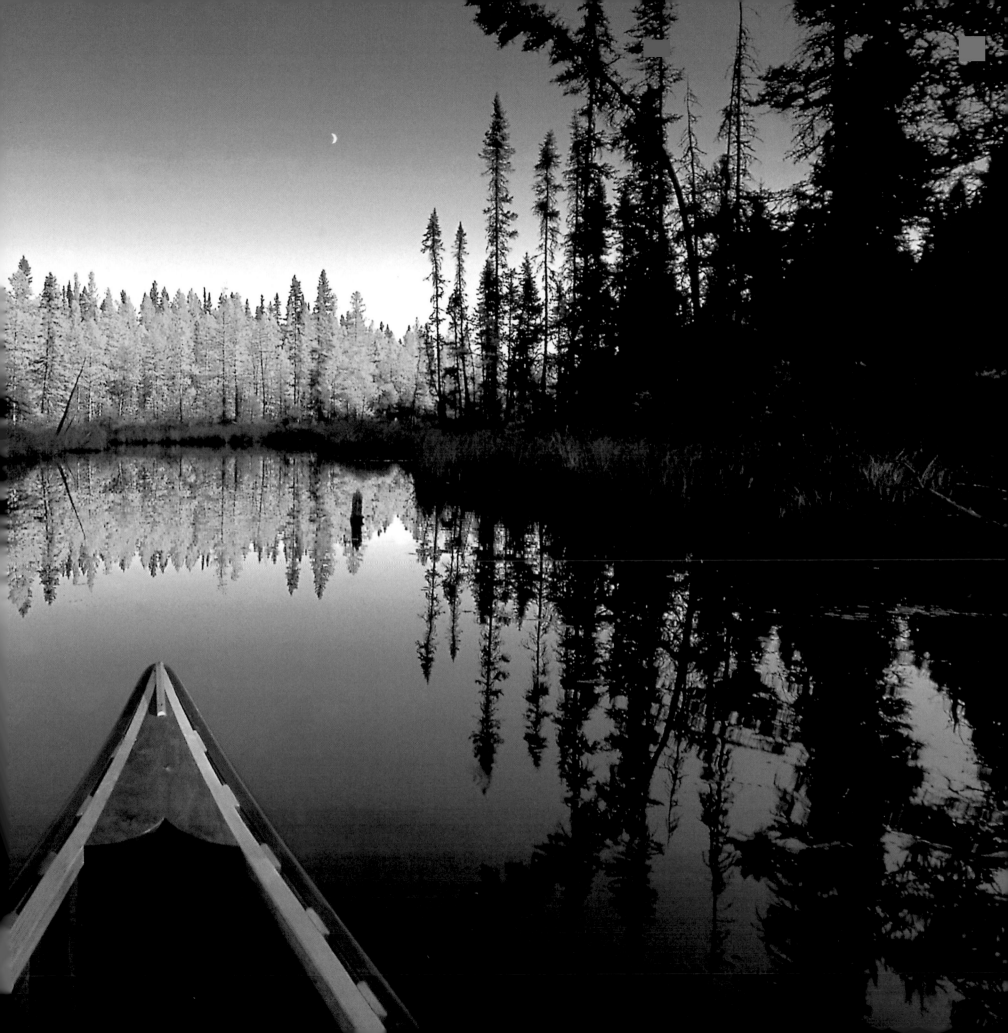

"The Lord did well when he put the loon and its music in the land," Aldo Leopold wrote of the ancient bird in his North Woods masterpiece, *A Sand County Almanac.* Loons have flown and fished unchanged in form or function for 20 million years. I found this pair, a parent with its immature offspring, one morning at dawn. A fishing line ensnared the younger one's neck; worse yet, a hook was buried in its flesh. Its disability allowed me to catch it, and I managed to remove the strangling line and the barbed hook. As the birds swam away, the youngster flapped its freed wings in what I took to be a thank you.

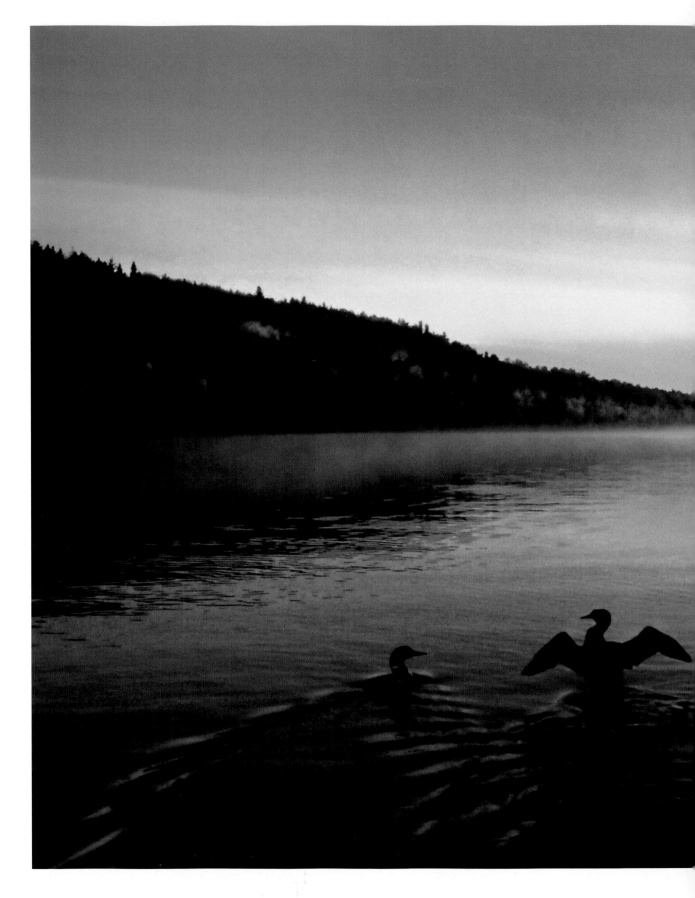

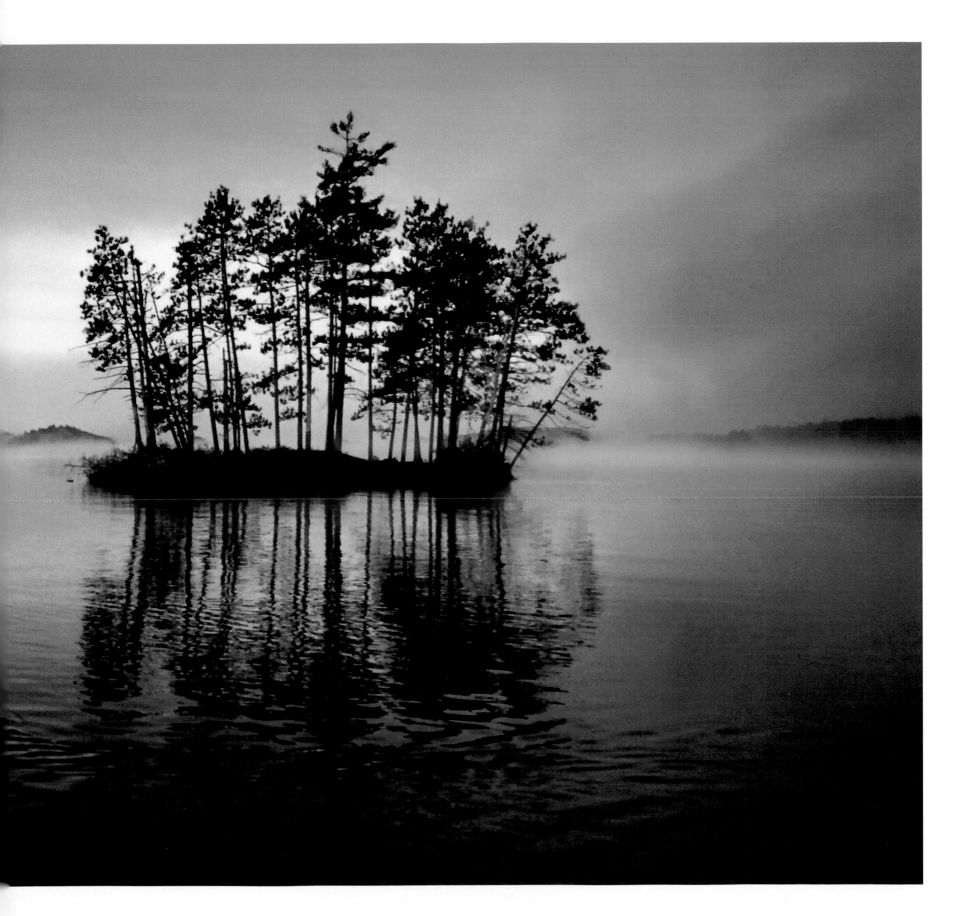

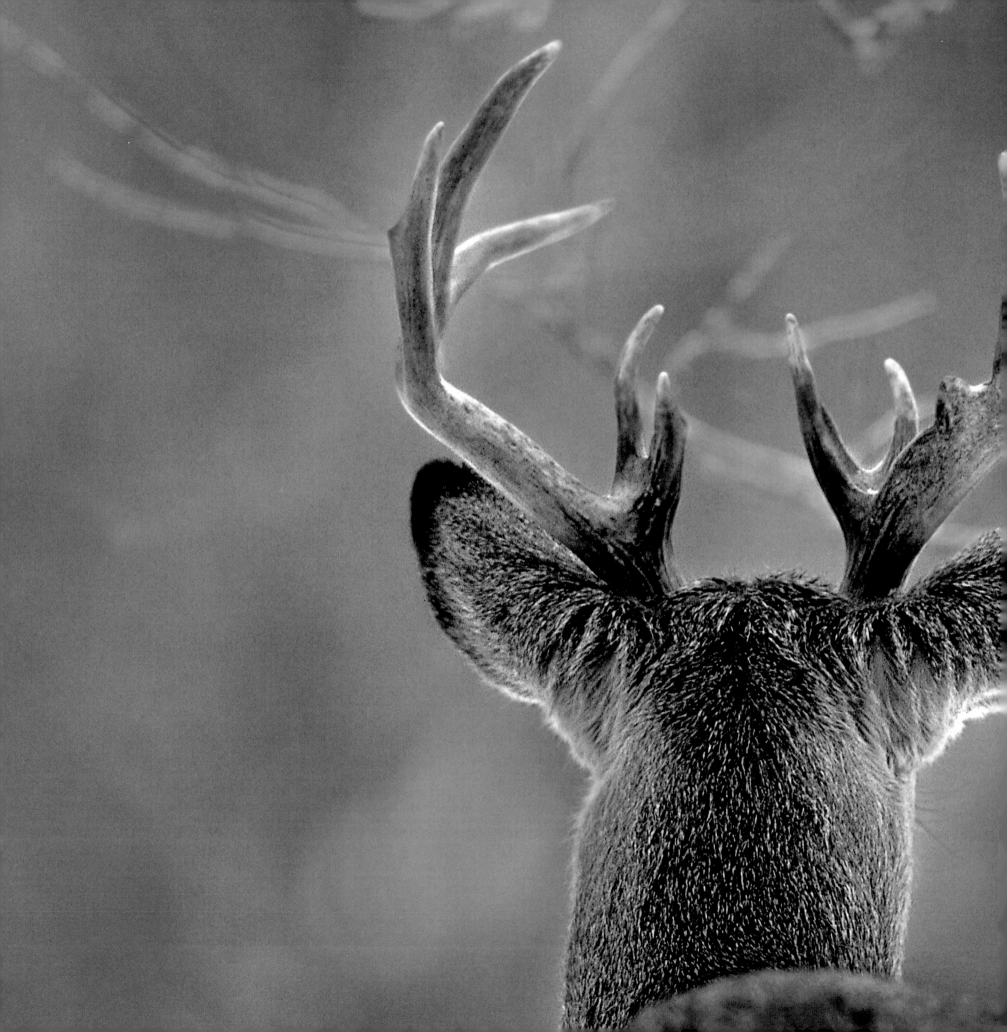

Watching for wolves is a lifelong vocation for white-tailed deer in these parts. Over 2,000 eastern timber wolves live in Minnesota, more than any other state except Alaska. But instincts weren't enough to save a buck from a poacher's illegal gun in the middle of a winter night. I heard the shot, and found the deer at dawn. Its eye (above) remarkably still looked alive.

FOLLOWING PAGES: The Little Dipper peers through a dancing curtain of northern lights on a night alive with energy. Some nights when the lights wave over the forest, I lie in my canoe and dream about this northern land.

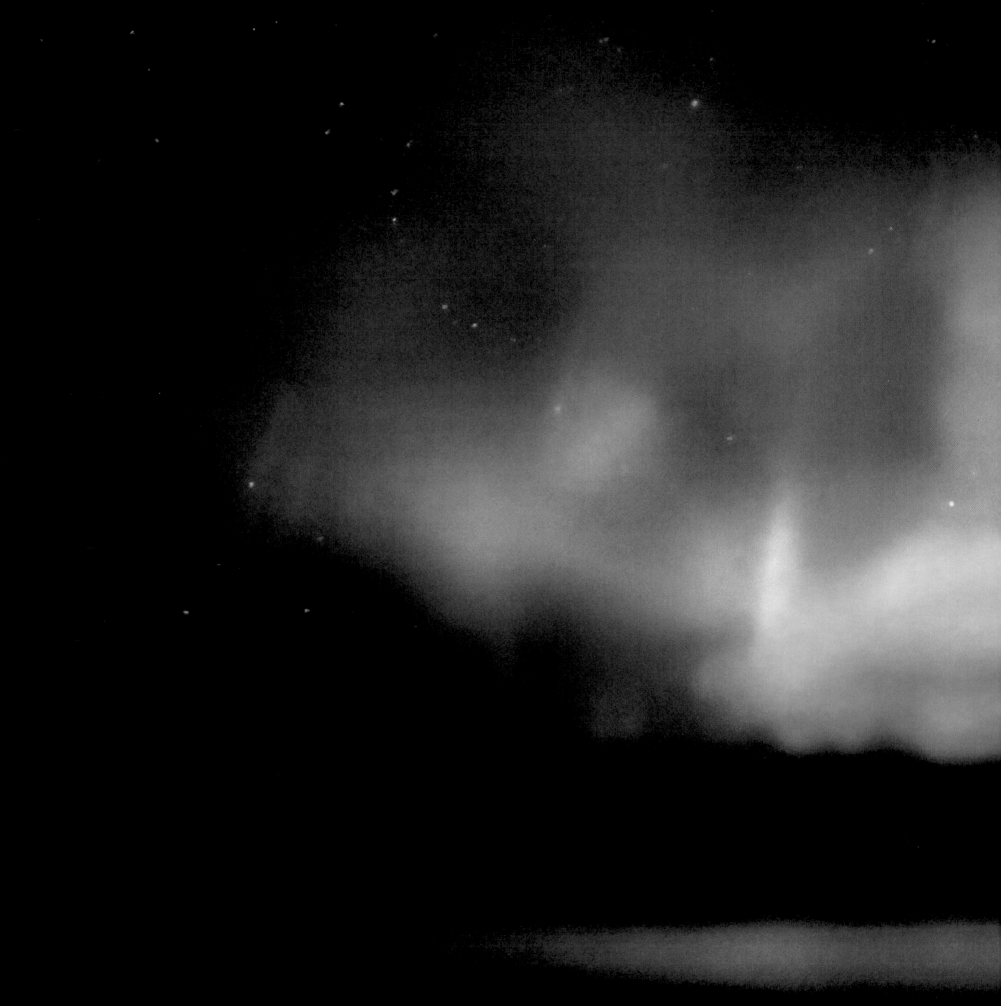

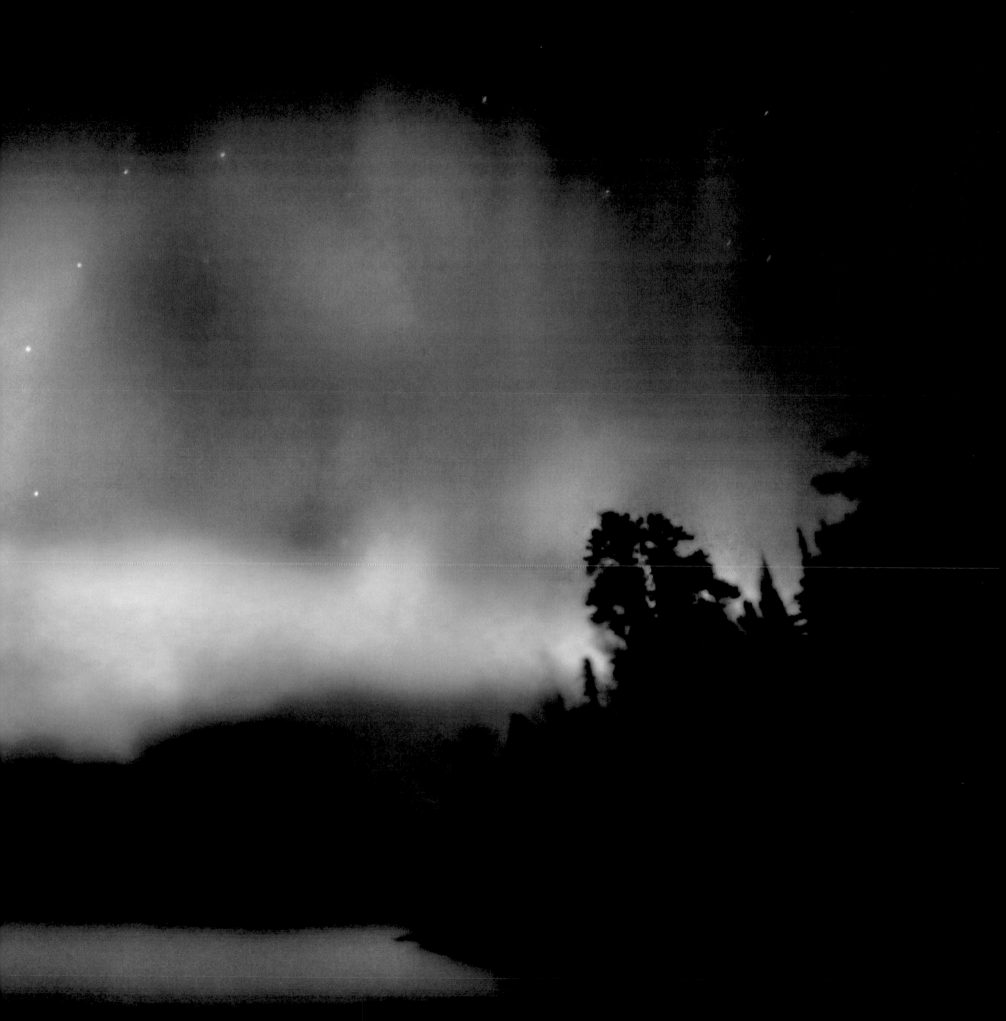

Scott Russell Sanders

Big Trees, Still Water, Tall Grass

*A tree stands there, accumulating deadwood, mute and rigid
as an obelisk, but secretly it seethes....*

—Annie Dillard

Maps tell me that my neighborhood of low hills and shallow creeks belongs to Indiana, a state bounded on the south and southwest by the Ohio and Wabash Rivers, on the northwest by Lake Michigan, and everywhere else by straight lines. The lake and rivers mark real edges, where you can wet your feet or row a boat, but the straight lines mark only human notions, inscribed with rulers on paper. The soil knows nothing of those boundaries. Birds glide over them. Deer browse across them. Winds blow and waters flow through them. Thunderstorms rumbling by make no distinction between Illinois and Indiana, between Indiana and Ohio. Monarch butterflies laying eggs on milkweed plants pay no allegiance to the state. Raccoons and coyotes prowl through our woods and fields wherever hunger leads them, indifferent to survey lines or deeds. Sandhill cranes trace their long journeys high overhead, guided by the glint of water and the fire of stars. These wild creatures are oblivious to the names and borders we have imposed on the land. They belong to a grander country, one defined by sunlight, moisture, soils, and the tilt of Earth.

For years I have aspired to become a citizen of that primal country, the one that preceded all maps. I find myself wondering how this region looked 200 years ago, before it was called Indiana, before it was parceled out by straight lines. How did the rivers run? How did the air smell? What color was the sky? What would an early traveler have seen in the forests, the wetlands, the prairies?

Trying to answer those questions, I spent the fall searching out remnants of land that have survived in something like their presettlement condition. And they truly are remnants, for less than one percent of the territory that became Indiana remains in our day relatively pristine, unaltered by saws and bulldozers and plows. I'll speak here of three such places—Donaldson Woods, Loblolly Marsh, and Hoosier Prairie. For shorthand I use their names, in case you wish to go look at them for yourself. But these refuges shrug off all titles, for they belong to an order that is far older than language. They remind us of our original home. They give us a standard by which to appraise how good or wise, how beautiful or durable is the landscape we have made from the primal country.

IN 1865, JUST AS THE CIVIL WAR WAS ENDING, George Donaldson came from Scotland to a spot in southern Indiana near Mitchell, where he bought a stand of old trees, built a house he called Shawnee Cottage, and soon earned a reputation for eccentricity. What the

neighbors considered most eccentric was that Donaldson permitted no hunting in his woods, no felling of trees, no collecting of mushrooms or ginseng roots. He didn't clear any ground for farming, didn't quarry stone for building. He made no use of the land at all, except to walk around and admire it.

What Donaldson set out to preserve was a scrap of the primeval forest, which in 1800 had covered some 20 million acres of the Indiana Territory, but which by 1865 had already become rare. In two-thirds of a century, nearly all the forest had been cut, the prairies plowed, the swamps drained. One scientist estimates that between 1800 and 1870, settlers must have cleared away one-and-a-half billion trees, an average of 7,000 acres a day. Most of the trees were never used, but merely killed where they stood by the peeling of a ring of bark around the trunks, after which the standing hulks were allowed to dry, then felled, rolled into heaps, and burned. For decades, the smoldering piles must have made the countryside look like a battleground. Earlier civilizations, from China and Mesopotamia to Greece and the British Isles, had stripped their own land of trees, exposing the soil to erosion and extinguishing much of the wildlife, but none had ever done so at this dizzying speed.

Resisting the advice of neighbors and the appeal of lumber merchants, Donaldson held onto his big trees. After his death near the turn of the century, a combination of good stewardship and good luck kept the woods intact until they were incorporated into Spring Mill State Park in 1927. The park map now identifies the 67 acres of Donaldson Woods as "virgin timber," a quaint label that joins a sexual term for an unviolated female with an industrial term for board-feet. Measured in board-feet, many an oak, maple, walnut, or hickory in these woods is worth as much as a fancy new car. Measured by their historical significance, by their contribution to air and soil and wildlife, by their dignity and beauty, by their sheer scale of being, these trees are priceless.

I have gone to visit them often, in all seasons, never without thinking gratefully of that eccentric Scotsman who refused to turn his land into money. As part of my search for glimpses of primordial Indiana, I visit Donaldson Woods on a bright, warm, nearly windless day in late October. Viewed from a distance along the park road, these might be any midwestern woods, fringed by sumac lifting its scarlet seed heads like torches, but up close they reveal their age, with fat trunks set far apart, scant undergrowth, and a canopy rising 150 or 200 feet. Stepping from the parking lot onto the trail at the edge of the sanctuary, I cross a threshold not merely from pavement to dirt but

from the realm of mechanical hustle into the realm of organic, planetary rhythms. It takes a few minutes for eyes to adjust, for heart to slow down, for mind to arrive in this company of giants.

Not far inside the woods, I approach a huge tulip tree, lean into it with open arms and press my cheek against the trunk, seeking to absorb some of its mighty stillness. The bark is so deeply furrowed that my fingers slide easily into the crevices. Even if a friend were to reach toward me from the far side, we could not join hands around the girth of this tree, for it is perhaps four feet in diameter at the height of my chest, more than twelve feet in circumference. After a spell I turn around, rest my back against the trunk, and gaze upward. Frosts have changed the leaves from supple green to brittle copper, iron, and gold. In summer, the shade here is so dense that only woodland flowers, ferns, and the most tolerant of saplings can thrive. Today, however, beneath a tattered canopy, the sun shines through with a beneficence of light. The most abundant saplings are beeches and maples, which will eventually supplant the oaks and tulip trees and hickories. The other common trees in the understory will never grow large—sassafras, with its mitten-shaped leaves; colonies of pawpaws, with leaves the size of mules' ears; and hornbeam, with narrow trunks reaching up like sinewy arms.

I walk on down the trail, passing among the giant columns, laying my hands in greeting on one great flank after another, seeking a blessing. Even the smoothest of trees, the beeches, have been roughened by age. Their gray elephant-hide bark has often been carved with the names and initials of lovers. Tony & Jill. Betsy & Bill. I wonder how many of those couples are still together, years after they left their marks. At least the beeches have remained faithful.

The fall has been dry, so the leaf duff crackles under my boots with every step. Several times I hear a ruckus in the leaves just over the next ridge, without spying what made the noise. Finally I surprise a deer perhaps 50 feet ahead of me on the path—a yearling that gazes at me curiously for half a minute, twitching its delicate muzzle, until it catches a whiff of man and with a flash of white tail plunges away. Otherwise, I hear only the hammering of woodpeckers, fussing of blue jays, crows guffawing, squirrels scolding, and the distant drumming of traffic.

Even in drought, the ground feels spongy, for this land has been covered with forest since the retreat of the last glaciers, 10,000 years ago, and during that time the soil has been gathering its dead. Many of these trees have grown here since before Indiana became a state, since before the American colonies became a nation. I come across fallen trees whose prone trunks rise to the height

of my chest, their roots thrust skyward still clutching rocks. They remind me of stories from early travelers who heard trees falling even on windless days. It must have been frightening to close your eyes at night in the ancient forest, never knowing when a massive tree, tipped over by the weight of so many years, might come crashing down on the spot where you lay.

There is nothing to frighten me here today in Donaldson Woods, no falling trees, no bears nor wolves, no poisonous snakes, no enemies of my tribe. I know how the fear would feel, because I've traveled in wild places where I understood, from moment to moment, that I could die. Such places hone your awareness more sharply than any small refuge ever could. Aside from caves and cliffs, where you can still break your neck, and aside from rivers, where you can drown, the only dangers left in Indiana are all in the human zone, in cities and schoolyards, on highways and factory floors.

Safe though it may be, I still relish this sanctuary of tall trees. I rejoice that there are no stumps here from lumbering, no straggling fences, no moldering foundations. This woods is like a country that has never known war, a land where all the citizens can hope to die a natural death. The trees stand for centuries, until succumbing to wind, shade, drought, ice storms, insects, disease, fire. Even after such assaults, the big ones often hold on for a long while, as you can see by the number of fat trunks bearing healed-over scars from lightning strikes. Of course we have left our own marks on these trees—from acid rain, alien pests, warming atmosphere, thinning ozone layer—but so far the obvious damage has not been of our doing. On leaving Donaldson Woods, I realize this is one of the attractions for me of primal country—that here one may taste the flavor of innocence.

SINCE THERE IS WATER ENOUGH EVERYWHERE IN INDIANA to grow trees, the only places that would have been clear of forest in 1800 were those where there was too much water, such as lakes and rivers and bogs. Even swamps grew trees, the species that don't mind getting their roots wet—red and silver maple, black and green ash, American elm, bur oak and swamp white oak, swamp cottonwood, willow, sycamore. On a misty morning in early November, sycamores lifting their creamy branches above the pathways of creeks are the clearest landmarks I can make out as I drive to the eastern border of Indiana, near the town of Geneva, to see what's left of a great swamp.

In 1889 a new bride whose first name also happened to be Geneva moved to that town with her husband, who ran the local drugstore. As business prospered, Geneva Stratton-Porter designed and oversaw the construction of a two-story log house, on a lot not far from the swamp. Against her husband's and neighbors' advice, she began to explore the 13,000 acres of wetland forest, braving the snakes and mosquitoes and desperados that flourished there. If her husband was worried about her safety, she told him, he was welcome to tag along. He often did, carrying her specimen boxes. Fascinated by the secret life of the swamp, Gene Stratton-Porter taught herself the new science of photography in order to record moths, butterflies, and birds; she painted the marshy landscape on canvas; and she wrote a series of books, including *Music of the Wild* and *A Girl of the Limberlost,* which would eventually carry the name of this place to millions of readers around the world.

Limberlost Swamp was a gift of the glaciers, which leveled out this borderland between Indiana and Ohio, covered it with rich soils, and left it soaking wet. Such flat country is a confusing place for water. Some of it flows northeast toward Lake Erie, and thence by way of the St. Lawrence into the Atlantic; some flows southwest toward the Ohio River, and thence by way of the Mississippi to the Gulf of Mexico; much of the water simply stays here, not inclined to go anywhere. At least, much of it would stay here, had the contemporaries of Stratton-Porter not dug so many drainage ditches and laid so many tiles, leading the water into one of many rivers that pass through this region—the Wabash, Mississenewa, Salamonie, St. Mary's, and Flatrock, among others.

The draining of the Limberlost had only just begun when Stratton-Porter arrived in Geneva, yet by 1913, when she left there for another town in northern Indiana, the swamp was all but dry. She grieved over that loss, even years later when she moved to Hollywood to oversee the translation of her novels into films. The destruction of the swamp made many people rich—from cutting timber, pumping oil out of the land, and farming the deep black soil—and you can still see evidence of that wealth in the size of the houses hereabouts. Stratton-Porter herself grew rich from film contracts and the sale of her books, the best of them rising from that rank, fertile, mysterious wetland.

On the damp November morning of my visit I expect to see nothing of the grand, primeval swamp, but instead look forward to seeing a small vestige of it called Loblolly Marsh, a 428-acre preserve where the ditches have been dammed, the tiles plugged, and the waters have begun to gather once more. Today they're gathering all the more quickly, because the mist has turned to

drizzle. Loblolly comes from a Miami word meaning "stinking river," a reference to the sulphurous smell of marsh gas. The only smells I notice on climbing out of my car are the perfume of decaying grass and the meaty aroma of mud. My boots are soon black from the succulent mud as I make my way into the depths of the marsh along a trail pocked by the prints of horseshoes and deer hooves.

On such a morning, with the grasses on either side of the path bent down by rain, bare trees looming on the horizon like burned matches, and the calls of geese filtering down from the gray sky, it's easy to imagine that the glaciers have only just withdrawn. There is a damp chill in the air. The earth yields beneath my feet. Even bent over by rain, the tawny foxtail grass reaches higher than my waist, the rusty big bluestem reaches above my shoulders. As I walk, my elbows brush the curled-up heads of Queen Anne's lace, the spiky crowns of thistles, the drooping fronds of goldenrod. Here and there, burst milkweed pods spill their downy seeds. The wet kettle holes are choked with sedges, rushes, blowsy cattails. In a few months these holes will ring with the mating calls of spring peepers and western chorus frogs, but right now they yield only a few forlorn chirps from crickets. The sound of drizzle stroking the lush vegetation is soft and caressing, like a brush in thick hair.

As I come within sight of a shallow pond at the heart of the preserve, I startle a great blue heron that has been feeding there. With a squawk of alarm and a frantic beating of wings, the stately bird rises into the mist and flaps away, its neck drawn back into a tense curve, its long legs trailing. I am dismayed by this undignified haste. I want to assure the heron that I mean no harm. Yet my kind has been harming its kind for hundreds of years, not by hunting so much as by destroying wetlands. Here in the Limberlost, just over a century ago, a great blue heron could have fed anywhere among thousands of acres of prime habitat; now it must wade in ditches laced with agri-chemicals, in scattered kettle holes, or in rare ponds, like this one I stand beside in Loblolly Marsh.

Rain dimples the surface of the pond between tussocks of willows and sedges. Beyond a palisade of cattails on the far shore, beyond a rolling expanse of grass, the horizon is rimmed by a line of trees, their branches reaching like frayed nerves into the leaden sky. My own nerves are soothed by the rain, by the prospect of water lingering here, by the resilience of this land.

In the mud I find the four-toed prints of a muskrat, the neat line of prints from a fox, and the splayed tracks of a raccoon, which resemble the tiny handprints of a crawling child. I see no beaver tracks, but I know that refuge managers have recently had to dismantle beaver dams in the drainage

ditches, to keep the nearby fields from flooding. I imagine that Gene Stratton-Porter would be cheering for the beavers. I imagine she would be delighted to learn that her beloved swamp is being restored, that herons and muskrats are feeding here, that wildness is returning to Loblolly Marsh.

WILDNESS ALONE WOULD NOT HAVE SUSTAINED the third sample of primordial Indiana that I visit, a prairie in Lake County, in the northwestern corner of the state near the steel mills of Gary and the skyscrapers of Chicago. At some 500 acres, never plowed nor paved, Hoosier Prairie is the largest remnant of the grasslands that once covered a few million acres of Indiana. Prairies on the Great Plains were kept free of trees by a drier climate, but here in the humid East they were kept open by fire. Lightning accounted for some of the fires, but others were deliberately set by the native people—mainly the Potawatomi, Kaskaskia, and Miami—who knew that clearings improve hunting.

The only hunter I meet on my visit to Hoosier Prairie is a red-tailed hawk, which spirals high overhead with barely a tilt of its wings. This day in late November is unseasonably mild, and the sky is clear. I pick up a handful of soil and stir it in my palm, a grainy mixture of sand and loam the color of bittersweet chocolate. Where I'm standing was underwater until about 9,000 years ago, when a vast inland sea formed of glacial meltwater gradually shrank back toward the present shoreline of Lake Michigan. The sand most likely descends from bedrock in Canada by way of grinding glaciers and pounding waves; the loam is a legacy from countless generations of prairie plants.

The plants I see on my walk today have lost their sap and most of their color. Aside from the golden leaves of willows and cottonwoods and the carmine leaves of blackberry, the prairie is now a medley of buff and bronze. From the stems and seed heads I can see downy sunflower, blazing star, leadplant, rattlesnake master, wild quinine, wild indigo. In the low spots that stay damp year-round, I find cattails and cordgrass and sedges. Observers with more knowledge than I possess have counted some 350 species of plants in this vibrant spot. As at Loblolly Marsh, the tallest grass is big bluestem, which even this late in the season still rises higher than my head.

The only big trees at Hoosier Prairie are oaks, mostly black oaks with a scattering of white. The big ones grow in clusters that are widely spaced over the prairie with grassland in between,

creating a distinctive type of landscape known as oak savannah. It's clear from the abundance of saplings that the savannah would soon give way to dense woods if it were not periodically burned. These days the fires are set by crews from the Department of Natural Resources, usually in late fall or early spring. A charred swath perhaps ten feet wide between the prairie and an adjoining field shows that preparations have begun for a larger burn. The big oaks can survive periodic fire thanks to deep tap roots and thick bark. The other prairie plants are likewise adapted to fire, drought, hot summers, cold winters, and grazing, because they store their vitality underground, in roots, rhizomes, bulbs, tubers, and corms. Roots may extend more than a dozen feet down, and they may stretch out horizontally ten or twenty feet from the parent plant.

By midday the heat has made me peel down to a T-shirt, and I am having trouble believing it's nearly December. A brisk wind from the southwest rattles dry leaves on the cottonwoods, like a fluttering of bangles. The hawk spins round and round beneath the implausible sun. Higher up, the silver needle of a jetliner pierces the blue. Nothing else moves in the sky except blown leaves, crows, and a scarf of starlings. In spring I would see yellowthroats, goldfinches, tree swallows, swamp sparrows, woodcocks doing their sky dance. For now, in spite of the heat, the land is locked down, the migrants have flown south, the crickets have fallen silent, the juices have been sucked back into the Earth. Today the hawk will have to make do with white-footed mice and meadow voles.

Earlier frosts have curled the fronds of bracken and the bushy sweet fern. These are northern species, hanging on since the retreat of the glaciers in this damp, fire-prone land. I crush a handful of sweet fern and tuck it under the shoulder strap of my pack so that I can smell it as I walk. I need this reminder of Earth's own potent smell, because the longer I stay here in Hoosier Prairie, the more I taste the murk of steel mills and refineries on the breeze. During my visit I never cease to hear the grinding of heavy machinery, bulldozers and trucks and trains, as relentless as any glaciers.

In the gravel parking lot I start up my own machine to drive home, adding my fumes to the air, adding my bit to the global warming that may well account for the crazy heat of this late November day. Every lot I pass on the road bordering the refuge is either listed for sale, torn up for construction, or already occupied by pavement and stores. So much dust blows across the road from new building sites that many cars approaching me shine their lights. I turn on mine as well. It's 3 p.m. The only clouds in the sky are ones we've made.

OFF AND ON THIS FALL DURING MY SEARCH for remnants of primordial Indiana, a muscle in my chest would twitch. The sensation was not painful, not especially worrisome, merely a light tremor as if a bird were shivering under the skin. When the twitching recurs this morning, the last day of the 20th century, I wonder if the troubled muscle might be my heart. Cold weather has come at last. I look out on a fresh snowfall—barely an inch deep, but enough to renew the complexion of things. I welcome the change, even though the white coating can't hide a history of loss.

In 1800 the grasslands that we glimpse in tiny scraps would have stretched westward to the Great Plains; the glacial wetlands that we've almost entirely drained would have stretched north to the Great Lakes and beyond; the hardwood forest that we've reduced to pockets of big trees would have stretched eastward to the Atlantic and south into the Appalachian Mountains. Bison, bears, lions, wolves, passenger pigeons, and countless other animals dwelled here in astounding numbers. This original abundance, thousands of years in the making, we have all but used up in two centuries.

I admit to feeling dismay over much of what we've done to this country—the clear-cuts, strip mines, eroded fields, fouled rivers, billboards, smokestacks, used-car lots, scourged rights-of-way for power lines, pastures grazed down to bare dirt, microwave towers looming on the horizon, tattered plastic blown against fences. I know I am party to this havoc. I live in a heated house; I burn coal to write these words. I could recite apologies for this human landscape, naming the energies and appetites that have brought it to pass, but it already has more than enough defenders. What so many people call progress will get along fine without any praise from me.

I speak instead for the original country, on which our survival and the survival of all other species depends. Our bodies, our families, our communities cannot be healthy in the long term except in a healthy land, and we can't measure what health means without looking at places like Hoosier Prairie, Loblolly Marsh, and Donaldson Woods. I seek out patches of wilderness because they represent an order, a beauty, an integrity from which everything human and nonhuman has descended. These fragments of primordial Indiana are refuges not only for the plants and animals that occupied this land long before we came, but also for us. I've kept a token from each place I visited—a curl of sycamore bark, the furry spike of a cattail, a handful of sweet fern. Touching one by one these talismans of the primal country, I think of those roots lacing through the black soil of the prairie, beneath the swamp, beneath the woods. I remind myself of all that buried strength. ■

R a y m o n d G e h m a n

Yellowstone:
The Cycle of Seasons

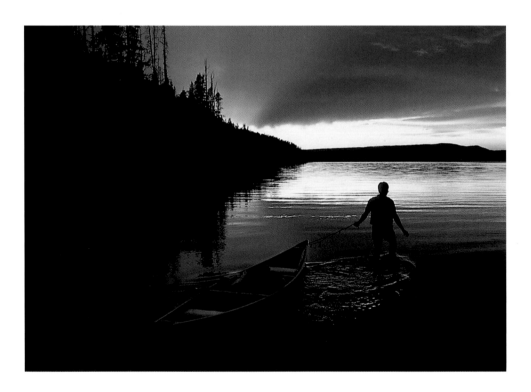

Wilderness is a part of the geography of hope.

—W a l l a c e S t e g n e r

"N"o sense of adventure!" Carl snorted from the canoe's stern, when I voiced a level of concern that was rising with the breeze. We were paddling Yellowstone's Lewis Lake into a bitter head wind. White-capped waves whipped around us. I was soaked, cold, and arm-weary. This was supposed to be a pleasant, mid-August canoe-camping trip. It was beginning to feel like a disaster.

I'd met Carl Schreier a month before, on my second day in Yellowstone National Park covering my first National Geographic book. We were both on top of Mount Washburn, photographing wildflowers. He was a park naturalist who had lived most of his life in the area. I had spent most of my years wandering the eastern woods, and I was admittedly nervous about climbing 13,000-foot mountains, hiking and camping where grizzlies ruled—and canoeing ice-cold lakes in storms.

But Yellowstone can change you, as I learned with Carl as my unofficial guide. The Greater Yellowstone Ecosystem is a 14-million-acre national jewel that also embraces Teton National Park and huge adjoining tracts of national forest lands and wilderness areas. The wilderness itself became my guide as I lived with it for an unforgettable year, from the summer of 1987 into 1988. I grew and learned to rely on my gut instincts and wits. Climbing through the clouds to the peak of Grand Teton brought on sheer terror. But I found reserves of strength I didn't even know were there. I made it to the top and gained more than just the summit.

The winter's isolation, loneliness, and weather—temperatures dropping to minus 50 degrees Fahrenheit, blizzards that can bury a tree—were an even greater challenge than rocky heights. But I survived them, too, and in winter's depths I made some of my best images.

A decade later I returned with my son Andrew and watched him fall in love with photographing wildlife. With equipment he borrowed from me, he went after elk, bison, foxes, coyotes, squirrels, and grizzly bears. His excitement put a spark back in my own eye, allowing me to see the park as if for the first time. I was transported ten years into the past.

Back to that summer day in 1987, even Carl Schreier looked frazzled by the time we arrived at Lewis Lake's shore. Rain fell as we dragged the canoe up a shallow stream to our destination on Shoshone Lake. Then, just as we approached, the setting sun dropped below storm clouds to flood the water, sky, and forest with brilliant hues. We ran the last hundred yards. I dried my camera and took my first photograph that truly showed the splendor and spirit of the Yellowstone country. ∎

Lewis Lake, Yellowstone National Park, Wyoming (opposite)

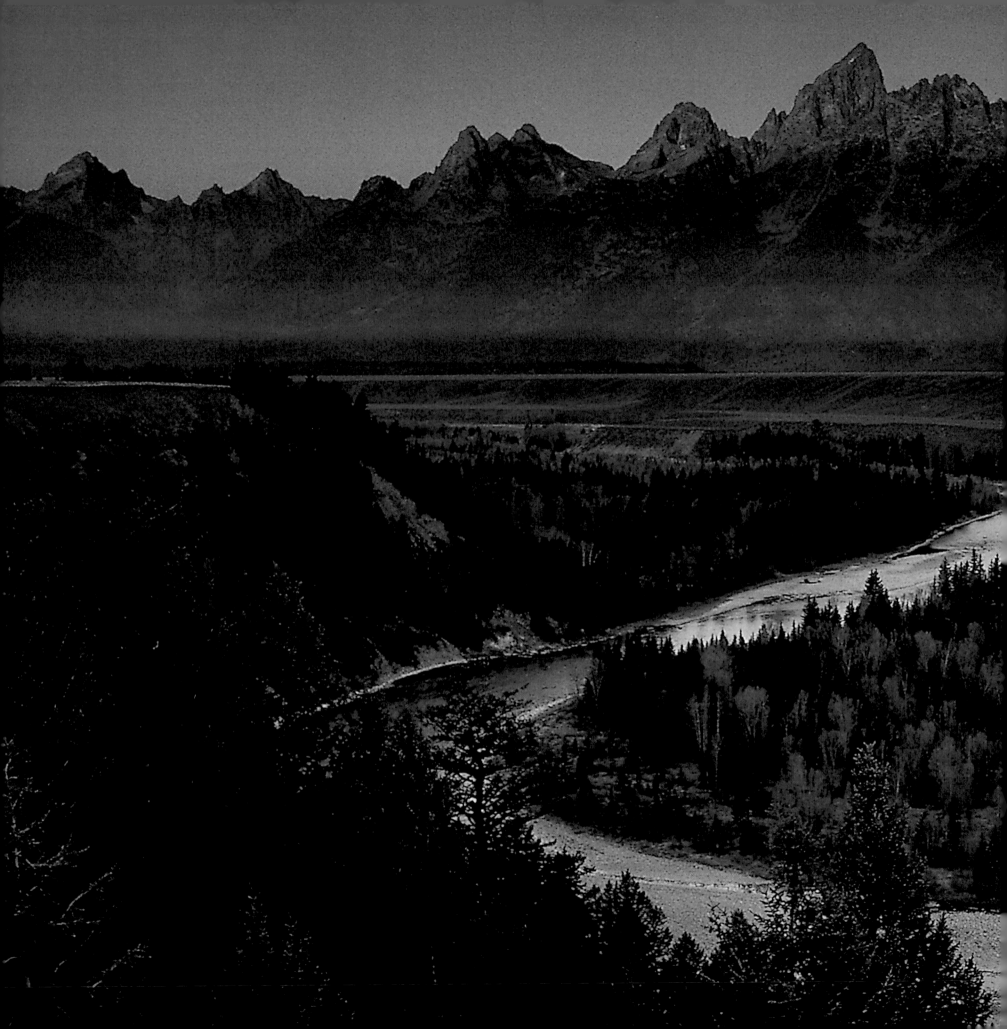

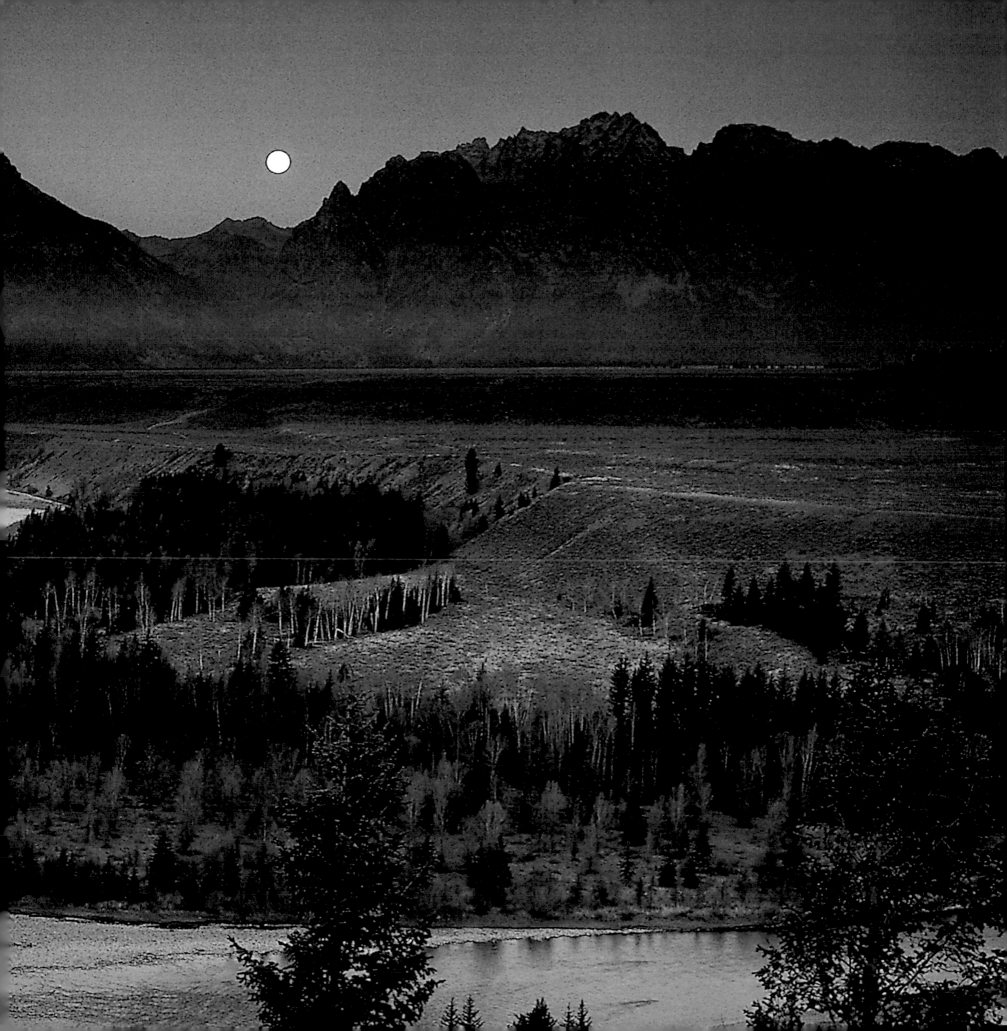

Earth's inner fires rise close to its surface beneath Yellowstone, creating a wonderland of volcanically heated waters and rock formations built of minerals. An aerial view (left) and one from poolside (right) show tinted algae in Grand Prismatic Spring, where water wells up at 188 degrees Fahrenheit, then spills over geyersite, rock that has accreted as the water cools.

PRECEDING PAGES: Dawn's first rays fire the Tetons as a full moon goes to bed behind the Rocky Mountains. The Snake River coils through leafless aspen groves frosted with October's warning of winter to come. Ansel Adams, pioneering photographer of the American West's heroic landscapes, enshrined this view in black and white.

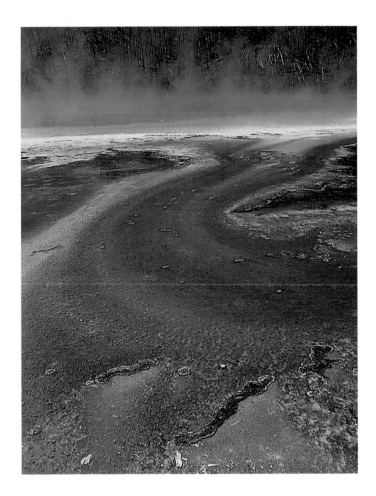

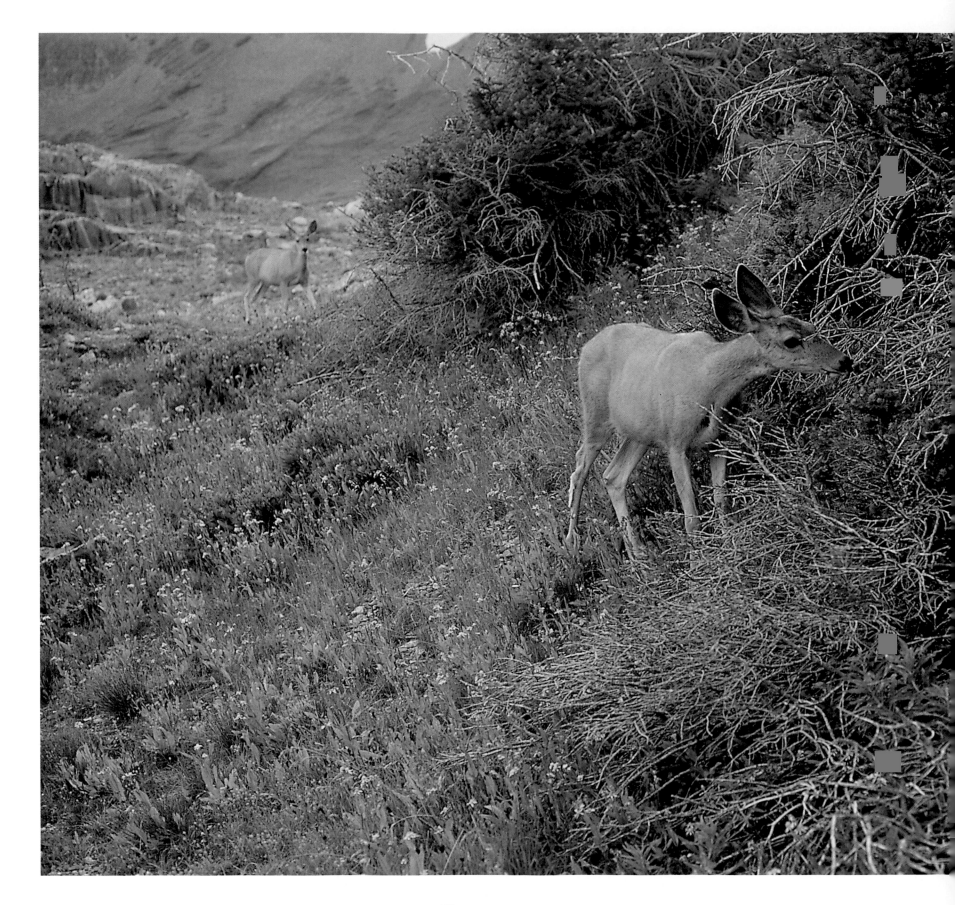

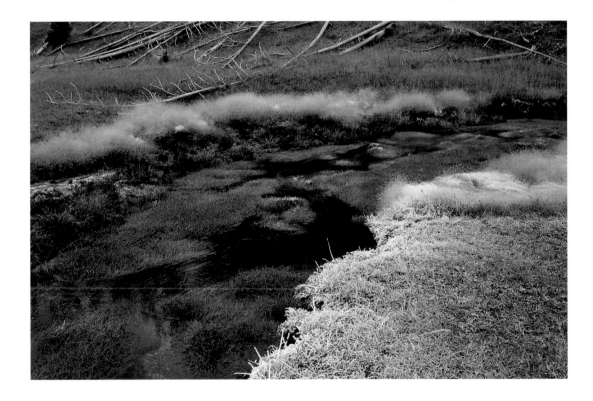

Summer sun coaxes groundsel into bloom in Hurricane Canyon, 9,500 feet up in the Teton Range, as mule deer (left) venture into the high country to forage among stunted subalpine conifers. In Yellowstone, thermal springs keep Obsidian Creek (above) open and warm year-round.

FOLLOWING PAGES: In the dead of winter, a lone bison approaches Terrace Springs, its unfrozen waters steaming in February's gripping cold. Emblematic of Yellowstone's Wild West, the park's herd is the only population of the native American icon in the lower 48 states to have survived intact since prehistoric times.

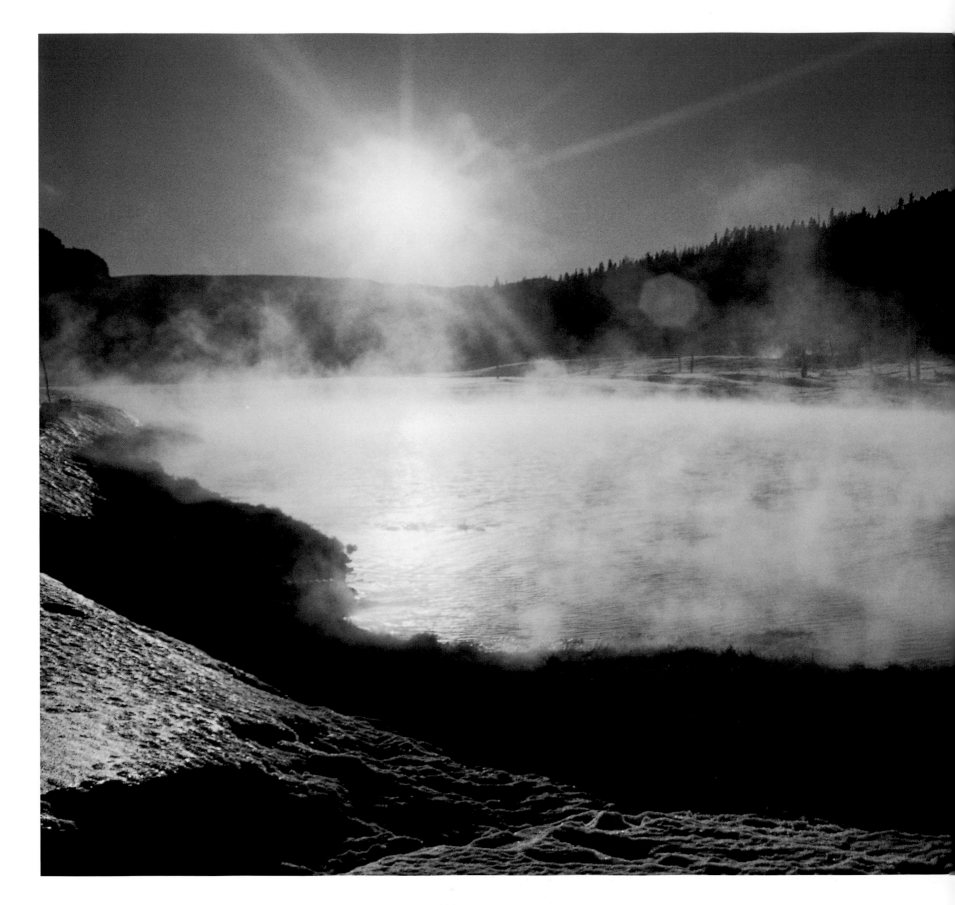

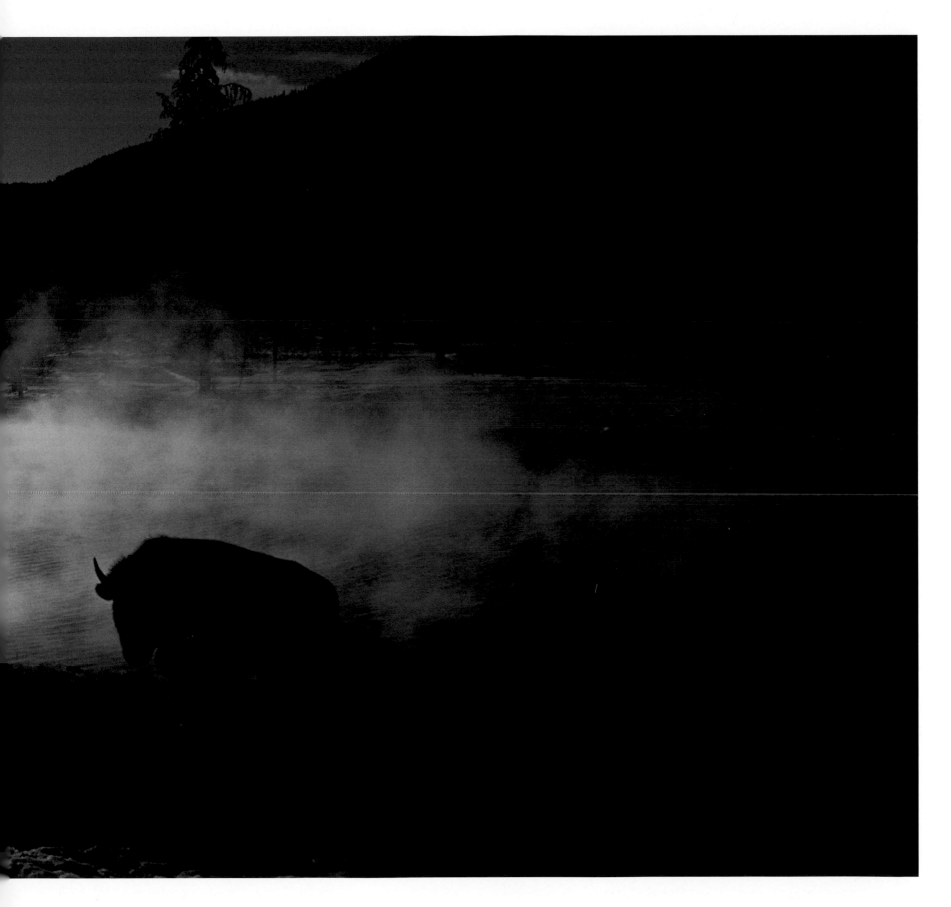

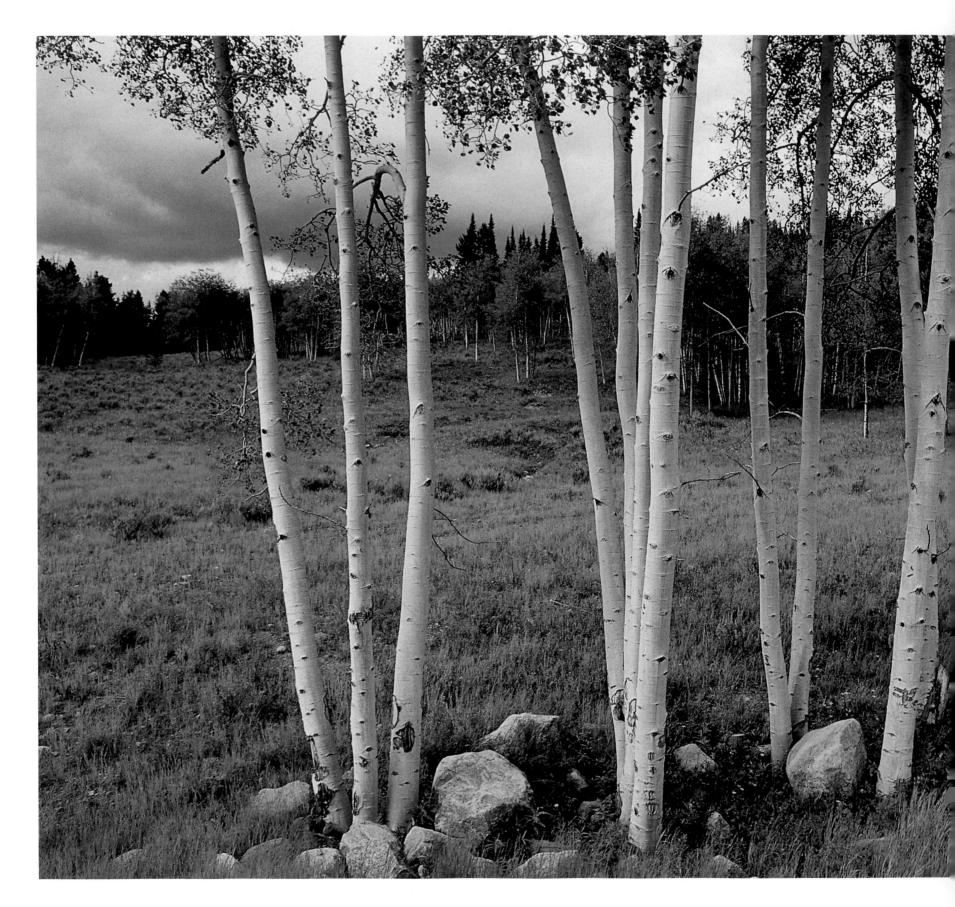

Signs legible to the informed eye point out the dynamism of the Greater Yellowstone Ecosystem, an interaction of life and landforms forever in flux. Aspens (left) tremble with new leaves at the approach of a spring storm in a valley covered by deep glacial ice until a geologic eye-blink ago. At their feet stand eloquent testimonials connecting the past to present-day landscapes: granite boulders called glacial erratics, which were carried on a flowing carpet of ice from higher valleys and dropped here when the glacier melted in retreat. The region's connections reach over distance as well as time: Sedges and aquatic buttercups (above) grow in Lake Isa on the Continental Divide, where waters flow to both Atlantic and Pacific Oceans.

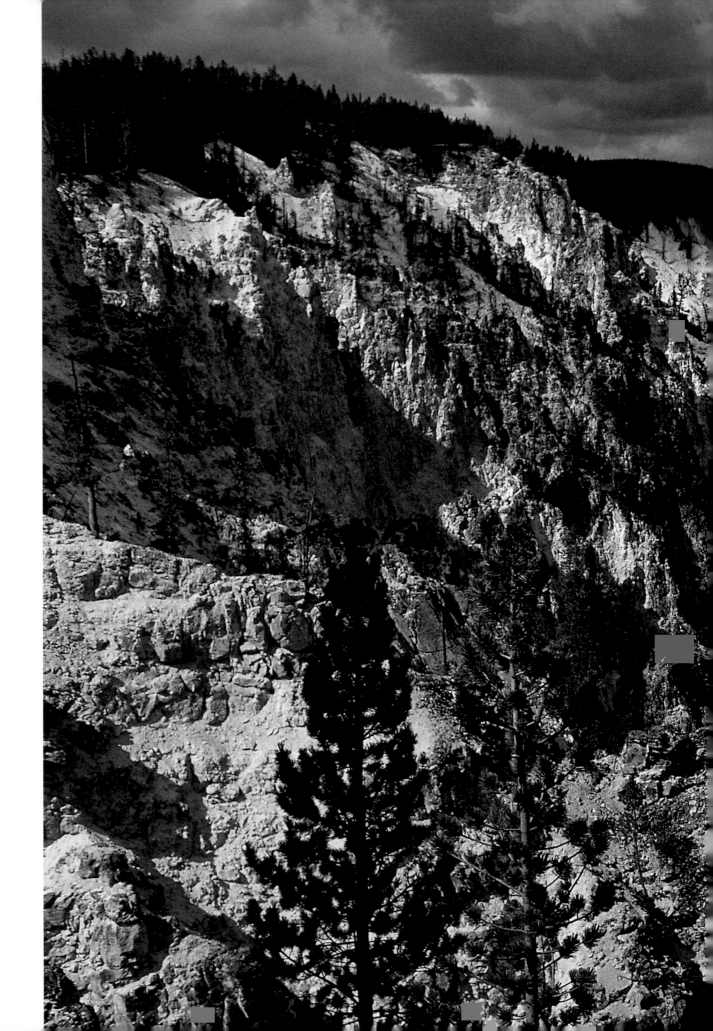

Painterly eyes have been drawn to the vantage spot named Artist Point since the park first came to photographers' and artists' attention in the 1800s. Framed in the gun-sight notch of the 1,200-foot-deep Grand Canyon of the Yellowstone, the river's Lower Falls drop 308 feet—twice the height of Niagara. Upper and Lower Falls mark borders between hard rock and strata weakened by steam that has percolated up from the underlying Yellowstone Caldera—the geologic kitchen of the region's above-ground sorcery. Downstream, the Yellowstone is undammed for its entire 692-mile length—the longest free-flowing river in America.

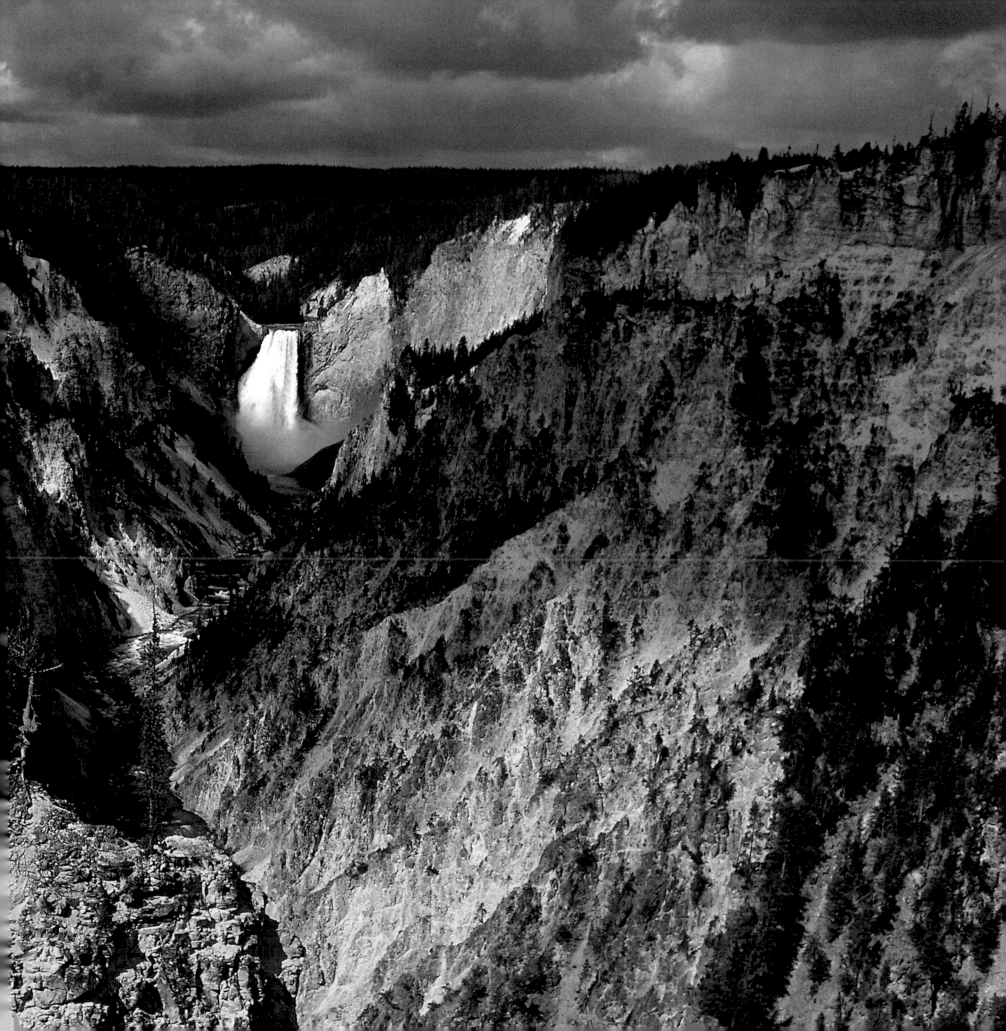

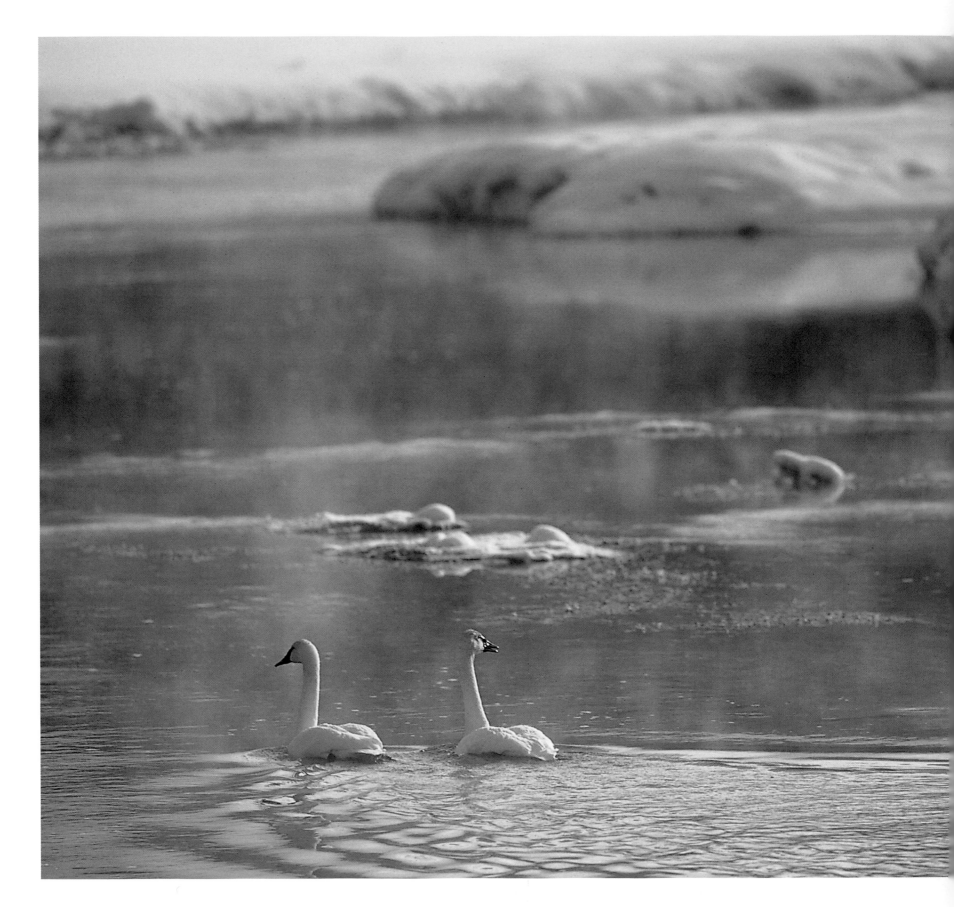

An icy fist rules with a crystalline glove in the heart of winter in Yellowstone. But small rebellions abound. Trumpeter swans (left) seek out open water on the swift-flowing Madison River. In the West Thumb Geyser Basin, heated ground keeps patches bare (right), even when hoarfrost glazes trees and mushrooms of snow grow above buried tree stumps.

FOLLOWING PAGES: Natural fireworks flash above Yellowstone as Great Fountain Geyser steams in readiness for its next eruption. Surrounding it are delicately terraced geyserite platforms of Sinter Cone, a geologic beauty mark first described in 1860 to a world newly captivated by Yellowstone's wonders, no less fascinating today.

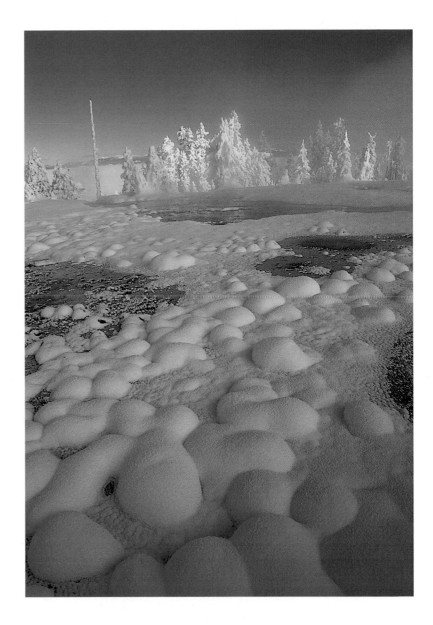

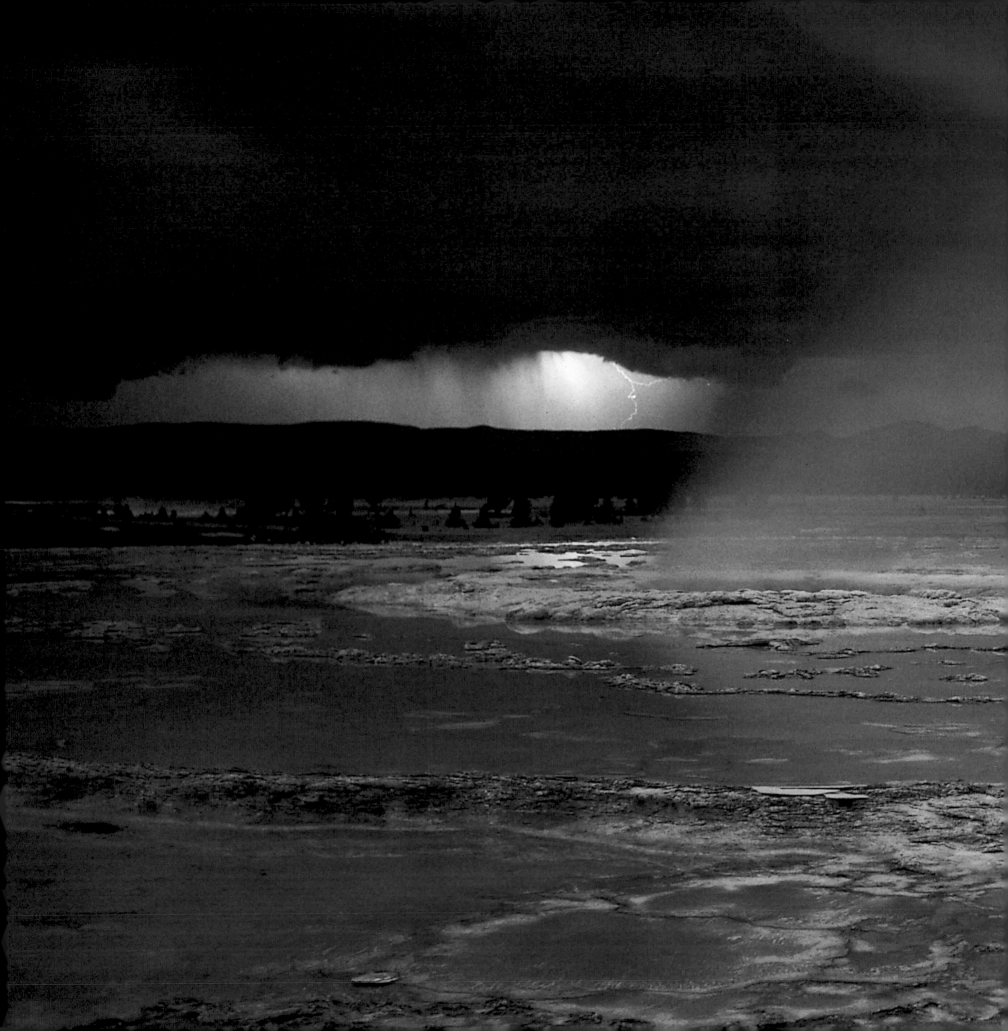

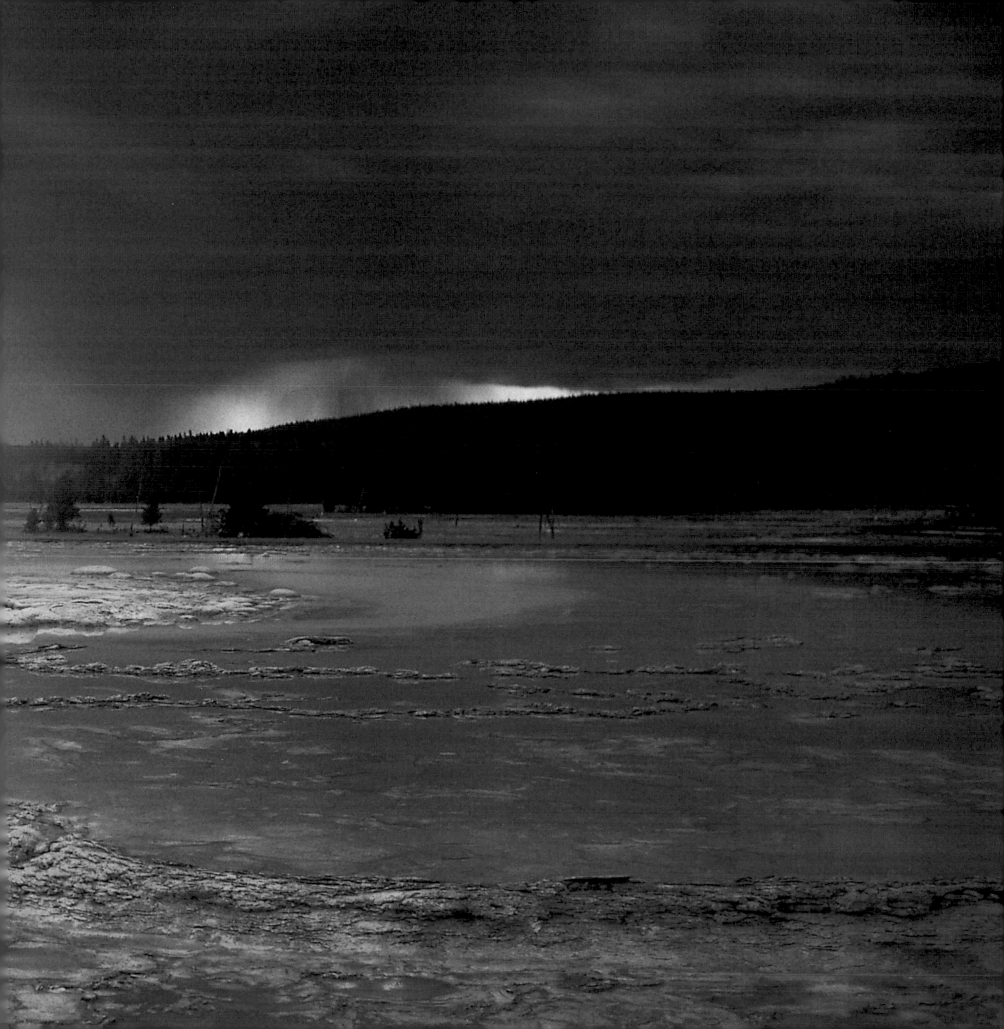

Linda Hogan

Indian Territory

*The Chickasaws were seen touching their old friends, the trees,
caressing their leaves, speaking with them, weeping.*

—Grant Foreman

Once, cartographers made maps of territories they didn't know, sometimes had only heard about. They were not real places, not actual geographies with latitudes and longitudes, not true accounts or descriptions of worlds with their animal life and their plants. In early European maps there were no real measurements of Earth. Islands that didn't exist were named. The maps were often charts only of the imagination, as if the human mind itself needed an internal cartography. The mapmakers created worlds for their own beliefs and desires. As late as 1720, California remained on some maps as an island. It took two hundred years after it was discovered to be proven to be part of the mainland, as if for some reason the European imagination had to believe in a fictional island and call it true.

While finding this fault, or confusion, in cartography, perhaps I, too, am guilty of it, but in a smaller way. The place most significant to me, Oklahoma, once called Indian Territory, is not only a place on maps. It is also a geography of memory, the map from a girl's mind, this girl a Chickasaw, which makes a place seem larger than it appears. I do not know any measure or lines of demarcation except that, at first consideration, this place seems round and nearly contained, as if there is no larger world around it, nothing beyond. It is more than a geology or a description. Maybe it is best described as a map of the heart, a center from which, for the rest of my life, all things in my life would turn, like a polestar. After the settlers, drillers, and tree stealers, I can't tell what the place might have been. I only know that I stand here, a woman over half a century old, in this place with the hot sun on my back, and I look at the old black walnut tree that stands with magnificence outside the once home of my grandparents.

It is a tree, still standing with sheltering branches, that witnessed our lives and doings, the men who came and went at night, my grandmother who cleaned fish beneath it, the chickens, even the sorrows of how we came to be in this place. I can still smell the soft grasses and the black walnut tree, its bark poisonous to horses. I go to Oklahoma, near Ardmore, and visit it, even now, years later.

H. B. Cushman, in his book, *History of the Choctaw, Chickasaw and Natchez Indians,* wrote about how the Chickasaws loved the land, especially their once homeland in Mississippi before the Trail of Tears. He wrote about those who, after removal in the 1830s, returned a few years after they had been forced west. They looked about with sorrow. Their souls could not brook the change, he

Trail of Tears, Tennessee; Phil Schermeister (opposite)

wrote. "They gazed awhile, as strangers in a strange land, then turned in silence and sorrow from the loved vision they never would enjoy or look upon again, but which they never would forget, and once more directed their steps toward the setting sun."

Here, in southern Oklahoma, red is the defining word. In places, and at dry times, the red earth is like powder, soft to the touch. When the wind blows, the sky turns red with it; the middle of the day appears to be rosy dawn or dusk. The sky is colored as if a reflection of land. In this country, the mountains are hidden. Underground, they are some of the oldest mountains on the continent, and they are covered by centuries of earth drifting and moving and blowing with geological change and time. It is, in a way, a deceiving place, and deception is also how we Chickasaws reached here, betrayed by a government that broke its own treaties and promises, using words that made legal the theft of land. The underground, both of history and of geology, is significant.

In one of my many returns, I have followed, in my body and in my spirit, the distances to the places once called Indian Territory. Most Americans call it Oklahoma, but for us native people, it will always be Indian Territory; and now, I stand in the heat of the place where my grandparents lived during my lifetime, and I see a world around me that is infused with history, memory, and meaning.

LAND AND PLACE ARE SIGNIFICANT for those of us who are indigenous peoples. Maori writer Keri Hulme said that in the Maori language the name for placenta is the same word as the name for land. In much this way, the place where my paternal family ended up after the forced removal of Indians from Mississippi and Tennessee over the Trail of Tears is called Oklahoma. Oklahoma is two words combined into one. The meaning holds together: Red people. Red land. There was intent in this name, more than would appear to others. The United States cavalry chased Indian tribes back and forth across this land, across Kansas and the plains, insisting all tribes enter this land unwanted by others. A trail, in fact, was worn into the land itself. From the northern plains, from the Midwest, the Southeast, all to this place where they wished to settle all Indians, among them my tribe as well as the Kiowa, the Cheyenne, and the Arapaho. It has been

said that the United States planned to build a wall around this territory so the native people could not escape.

Red is the color I think of when I think not only of people but also of place. The color of an Earth rich with iron. I remember one evening, not many years ago, standing with a friend near Talihina in the southeast corner of Oklahoma by the sacred bluffs called Nanah Wyah, a name carried with us and the Choctaw over the Trail of Tears. It is what the sacred Chickasaw Bluffs of Mississippi were called, as if a name, a word, was something, one thing, they could bring along the trail that couldn't be stolen or killed, a word that recalled a much loved place. My friend and I stood on the rust-colored road. The trees were scarlet with autumn. The leaves began to fall and blow, stirring with a light wind. The orange sun settled down the red sky to a world underneath. We were there collecting water at the same fresh spring where our ancestors had collected their water. It was one of those moments never forgotten in a lifetime. The color deepened and soon there was darkness, and we stood still in silence, both of us unwilling to break the spell of beauty, the sense of history, memory, land, the taste of spring water. All this moves so strongly in the heart, there are almost no words for it. Soon the owls called above us, and we went inside my friend's house to beds with quilts made of old dresses and shirts of grandmothers, aunts, and uncles.

Now, in the home where I live in Colorado, are two red rocks I picked up as a younger woman in Oklahoma, gathered from this place. These stones, from this place with one world beneath it, another laid down over it, are 400 million years old. I keep them near me. There are circles within circles in these round stones. An elder tells me these are the kind of stones some Chickasaws brought with them from Mississippi, and when I look at them I wonder if they were brought along that tragic journey by my own blood kin and left there. Perhaps someone from the past foresaw that the stones might one day be picked up by a person, yet unborn, who would love them, who would remember.

There are also plant fossils with hollow centers we girls used as necklaces, my sisters, cousins, and I, as we sat talking, thinking of earlier Indians, not knowing our own history, let alone that we were part of it. As girls, we didn't know our original homeland was Mississippi, or that our geography was not truly the area around my grandparent's house by Caddo Creek, but a journey. Some of these fossils are now threaded together like beads above my bed, so I will nightly remember this

place, a life and world inside that large movement called history.

For us, for me, this was *the* place. And no matter the poverty, as we traveled by horse and wagon in a contemporary world of cars, or used the outhouse, this was the point of our beginnings. In back of the house was an old icebox that contained bottled Coca-Cola, grape and orange sodas, and the ice my father went to buy at the icehouse in the nearby town of Ardmore. We'd chip it off with an ice pick, or break the block of ice by dropping it on the floor or ground. And at night sometimes there was the making of ice cream. We'd run through the darkness with ice in our hands, chasing one another.

I see the chickens, the board wagon, the house with bedsprings leaning against the back of it, an oil drum, an old barn with perfectly neat ropes along the wall. So much order always in the barn. I remember the stories of my great uncle, a man who wouldn't sit near a window in case he would be shot and wouldn't enter a barn without a second door through which he could escape. I don't remember his crimes, if any, or why other men were after him, but I recall my father saying that once this uncle was hidden in a woodpile listening to two armed men talk about him while they sat on logs; and as a boy, my father used to try to sneak up on this uncle often, with a boy's mischief, but never succeeded, even when the old man was asleep. Stories like these have been a part of this place. The words themselves are maps.

We children bathed outside in the beautiful light of dusk. We bathed in the galvanized tub out in front of the house. We used Lifebuoy or Lava soap, strong and medicinal enough to kill the chiggers that had embedded themselves in our skin. I still smell the soap and hear the night full of insect sounds. The bath water was hard to come by, and so we all shared it, because in this dry earth, cracked-clay place my family had no water. To get it, my grandfather hitched up the horses and wagon from the barn. We then rode to the public well in the town of Gene Autry, outside Ardmore, where our Aunt Patsy was the postmistress, and went to the community pump to fill milk cans with water. The town was fickle in its names. Once it was named Lou for one of my great aunts. Then, for a while, it was called Berwyn. The Berwyn High School, which all my aunts and uncles attended, is now the Gene Autry Museum. In it is at least one thing of my grandfather's, a saddle.

As a girl, we traveled there, following a map in my mind, to Gene Autry, with my

grandfather and the horses. To a child, none of the things that might be called hardships mattered; at night, sleeping with my cousins by lantern light, I'd watch the fireflies I had caught and placed in a canning jar, holes punched in the lid. By day I'd set them free. Our parents were close by, so was our grandmother with her hair that reached the floor. I felt happy. I loved it because I was loved there. It shaped my life all the way through, as an Indian, as a woman. It wasn't about identity—that would come later—it was about a heart based in a land, a history, and a people.

To reach my grandparent's home outside Gene Autry, there was the dirt road, which always seemed so long and far, with clouds of dust rising behind the cars along the winding road, gullies, dry land, and some hardwood trees on the way. But the road truly is not so large as I remembered, unless you consider it as the last part of the trail of our removal.

I return now and then and I look at the land where my grandparents lived in my lifetime. It is still the point of orientation of myself. I can feel the land that became my kind of world over the years, even when living in other places. There is a strange sense that I know it more deeply than I will ever know anything else in my life. Even more, there is a feeling that it knows me. It has been a presence, significant in the life of a girl who came and went, traveling other places, across oceans and continents. And who, even 50 years later, would still be returning. It is yet the map in my mind, of my mind.

The tree I stand beneath is still here. Nearby is the fishing pond that was stocked by silver-sided fish that arrived through tornadoes and rains. It's been said that a storm would take them up into the sky, where their eggs would develop and hatch and their weight would make them fall to Earth. There were also, sometimes, rains of frogs.

Here is much creature life. There are the water moccasins my aunt, now 90 years old, swam with. Here and there is a squealing armadillo, its segmented shell like armor. There are the bees, swarms of them my uncles and father would round up and place in one of the nearby trees so they'd have honey in the future. There are the tarantulas and the praying mantis, like the one that looked at me from the wagon one day many years ago as if it knew me better than any human ever would,

and because of that gaze, I screamed.

There is a stillness, a smell, the nights surrounded all around by sound and stirrings not human, the deep booming sounds of bullfrogs, the creaking and singing of insects on the clearest of nights. Outside at night is, was, the depth of sky, and stars upon stars. And occasionally the sound, like one night at my aunt's house, when the chickens that sometimes roosted in trees fell from the tree, waking up an entire barnyard. Horses, cattle, and all cried out, none of the voices human, and all of them more than awake in the night and aware of each movement, fall, or the presence of a coyote.

Around us by day were the scissortails, the blue-and-gold snakes called racers because of their speed. We even saw one fly by sheer muscular strength, rising up to catch a passing insect. In this place, it was as if everything, from tarantulas to the wild pig, all said, "Behold, look at this mighty world." And, as if to hold it all together, to show the connections, today a yellow corn spider has woven, from her own body, a huge web that stretches between two large trees, a wide net cast out to catch any living thing that passes through. Like us, it survives on the between. Disturbed, it puts its life back together, across, quickly, awaiting a certain angle of light to attract the insects. At houses, too, at windows, the spiders called the orb weavers work; they know a human will make a light and the night insects will fly toward it. In the morning the silken shining lines crisscross the windows, sun and dew resting on the delicate little traps.

Not too far away, just outside of Ardmore, is Lake Murray. It is a man-made lake my father and uncles helped build during the Depression years with the public-works projects. My young father was employed in several different ways. He learned to graft trees, to be a stone mason, and one of his projects was the creation of the lake where we yet hold our reunions. It is a warm lake, and large in width. It is a good lake for swimming, but I always stay close to the edges because of the giant fish I've heard live inside it. Catfish, I think they are, and some perhaps more than three hundred pounds. These fish, so I've been told, have been known to take down a calf. It is here, too, that I learned about horsefly territory, that I could outrun one of them on the trail and reach a certain point where it would stop chasing me and another would take over the chase.

All these are the telling features of this place as I look at it now, the low rise of the land, the

stillness of trees, the weight of heat and humidity. It is the center of the world, the navel and beginning. It holds stories. They are perhaps the only givens, along with memories and love deep and steady, rooted and embedded in this world.

IN *A NATURALIST IN INDIAN TERRITORY: The Journals of S.W. Woodhouse, 1849-50*, Woodhouse wrote of one of the places where my people had camped by water, that "it was a fine spring and the water strongly impregnated." He had seen herds of buffalo and then wrote about Pennington Creek, near Sulphur, Oklahoma, where 10,000 Chickasaws were compelled to camp during the Trail of Tears. Up above it, nearly 15 miles away, was a Kickapoo encampment. I never knew the real geography or history of Indian Territory. I've heard there were forests, but it became a land plundered and used up before my lifetime. Most remember it from the shock of Dust Bowl days, which resulted largely from a land deforested. The loss of forests created erosion. Then there was drought. But you can know what was there by the names. Wild Horse Creek, for example, a place named for what was taken away, not too very far from where the Army killed screaming horses so the Indians would be with neither the might to escape, nor the speed to hunt for food. Killing the horses forced tribal peoples into lives bound by lines of demarcation.

Here, in Indian Territory, my grandparent's place holds the unfolding of history, the loss of water, even though the grasses now seem to have a softness to them. Yet the history persists, even in the land and in its stories. I remember once, too, reading the story of walking bears. Many of them, walking together, across the land in Oklahoma. Three hundred, it was said, though I find that difficult to believe, especially with bears seeming to be somewhat solitary creatures. But even if it were only the product of just one man's imagination, as with some of the European maps, it is still an amazing vision.

Now, when I think of it, the moving bears, the horses running, the people escaping, I know that for us Chickasaws, place is a verb and not a noun like the places of so many other people. It is not, in truth, a place of boundaries, but one of movement and shifting ground. It is a journey in which the earlier Chickasaws, before reaching Mississippi, leaving out of an unknown west long ago, once followed a leaning pole that was planted in the ground each night. In the

morning, wherever it pointed, the people followed, out of trust. From an unrecalled west we are still trying to locate, the people moved toward an unknown east, the place of sunrise. This journey was divined not as water with a cottonwood branch, but as Earth with its holy instructions. The Chickasaws migrated at the direction of a tree. Why is it, I wonder, that a people followed an intelligence not wholly human? Faith, surely. Not the nautical charts of sailors, not their own significant knowledge of astronomy, either. It was trust in the power of a tree and the Earth it was set in. It was a map different than that on paper, a compass not attuned to true north, but just as real.

And then, still a verb, there was the westward movement of the Americans during the 19th century; their desires kept the tribes in motion as they were evicted or forced to escape to Indian Territory, with nothing about it fixed and permanent except in a human mind and the written, partly true map called history. Through time and passages, across a land, a curve of Earth, the swamp of a history of betrayal and sadness that would weaken any heart just to hear it, we traveled. Starting out in the 1830s as healthy and beautiful people, the descriptions of the Chickasaw men riding handsomely about on their horses, the women sitting well dressed and erect on Chickasaw ponies they themselves bred. We were known as joyful and content people after a long history of being the unconquered. Our journey began in this manner, and the Chickasaws had a love not only for the land, but also for the trees. We were seen touching them as we left Mississippi. The description I will never forget; how my people touched them tenderly and spoke to them. They were our relatives, and we knew we would not see them again. These are a few of the accounts of what our lives were like, what happened. We were called the They Left Not a Very Long Time Ago tribe. The land, I believe, was as bereft of us as we of it.

Along the way we became very unwilling to cooperate. I like this about us. The men went out hunting, because they were hungry, and the Army tried to stop them. Over the curved surface of our shifting world we walked, soldiers pushing us along. All alongside the constantly diminishing caravan of mourning people were thieves; it was a long trail of loss, lives, land, horses, and connection, with poverty and misery at the end of it. In later descriptions of Indian Territory, the Chickasaw had become a people broken, ending up lost and in poverty and weeping, unable to make it even to the place selected as Chickasaw land in what is now Oklahoma.

To this day, it seems our place is a process, an always arriving. Even the land is not constant. Rainy one season, dry the next. There is, without our knowing, a rebuilding of it, grain by grain, a drop of rain, a flake of snow, a footstep of hoof print; and everything, all of these, changes it. It is a movement imperceptible to most human eyes; there might be only a subtle bend in land, a motion of clouds, a change of wind. And, too, it is a sorrow forgotten by some, but a path of remembering for those who experienced it. This place, with history embedded in it, still is the orientation of a self.

IT SEEMS PEACEFUL NOW, as I stand by the black walnut, but leading here was dispossession, swimming horses, drowning people, gunshots. I still return. Here, years later, I feel the earth my people walked on. I feel it and know I am not an individual but a tribe. In this land, I am only a small human being standing at the ruins, the mysteriously burned house my grandparents once inhabited. I always felt this place was my true home. It reminds me of what one of our elders, Overton Cheadle, said about going to Mississippi and knowing the moment he was on the land where his ancestors lived; he felt it. Then, looking on a map, he saw it was true. I feel it; the land resonates here, as well.

There is a way of being with the land that remembers a place is more than geography, landmarks, and features. It's a bridge. Things pass over it. Through it. There are stories that dwell in it and these, too, are maps not just of place but also of meaning. And there is the experience of the senses. A scent, like the black walnut tree, can recall a place in the human memory. I think of hearing the owls, as I did at Nanah Wyah, the name of a place carried within a people, set down in a new place, as if to remember we began somewhere far away and long ago and brought this place, these names, the memories, with us. ■

Phil Schermeister

The Range of Light

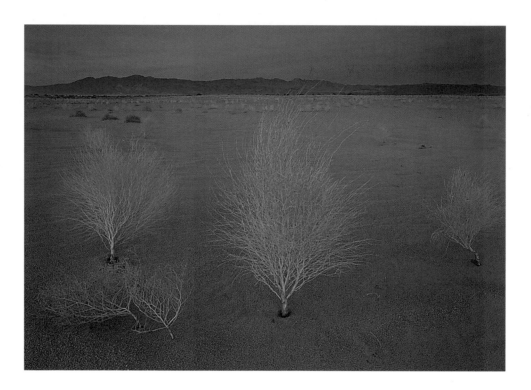

...the most divinely beautiful of all the mountain-chains
I have ever seen.

—John Muir

At first I found myself wondering if they were real, the groomed, immaculate forests set amid typecast peaks and valleys in eastern California's Sierra Nevada Range. The forests seemed too neat and orderly. Fallen ponderosa pines didn't rot. Day-Glo green lichen draped perfect tree branches, bugs were nonexistent, and self-composed deer wandered past tumbling waterfalls. Was this an ultimate California facade, a Hollywood vista erected for tourists and weekend visitors who come to escape the city?

The city might be Los Angeles, San Francisco, Sacramento. The Sierra Nevada run for 400 miles along the spine of the state, within a few hours' drive of the most populated centers. To residents of the Sierra, the city means people from the "other" California, people who live within shouting distance of the coast. People like I was, the first time I drove up from my San Francisco home.

As a newspaper photographer I had been trained to look for decisive moments between people. My trips to these mountains were my first attempts at shooting nature. At first glance, nothing much was happening. The forests and rocks stood completely still. The Sierra seemed devoid of any action whatsoever.

Frustrated, I turned away from photographing the mountains and started hiking, backpacking, and cross-country skiing in them whenever I could. It was by accidents of going out early, staying out late, and experiencing the worst possible weather that I began to see the decisive moments in nature that often appear in small and elusive ways: a full moon that slips unnoticed from behind a rock wall or the instant a sun-warmed dragonfly shakes off its dewy coat.

The key to photographing these subtle moments is light—not how much of it, but where it falls and where it doesn't. My pursuit of light's moments led me over the range's divide, where I discovered the Eastern Face—dry, nearly treeless, so different from the mountains' well-watered western side. Up and down the range, I made personal acquaintance with spectacular places I'd known only by name: Sequoia National Park, Lake Tahoe, the soaring waterfalls and plunging rock domes of Yosemite National Park.

Today, I live in Sonora, a small town in the western foothills of the Sierra. I travel into the mountains on their schedule, when things are happening. I always find images to be made, but I find contentment there as well.

Very often, I leave my camera at home. ■

Tumbleweeds at Olancha Dunes, California (opposite)

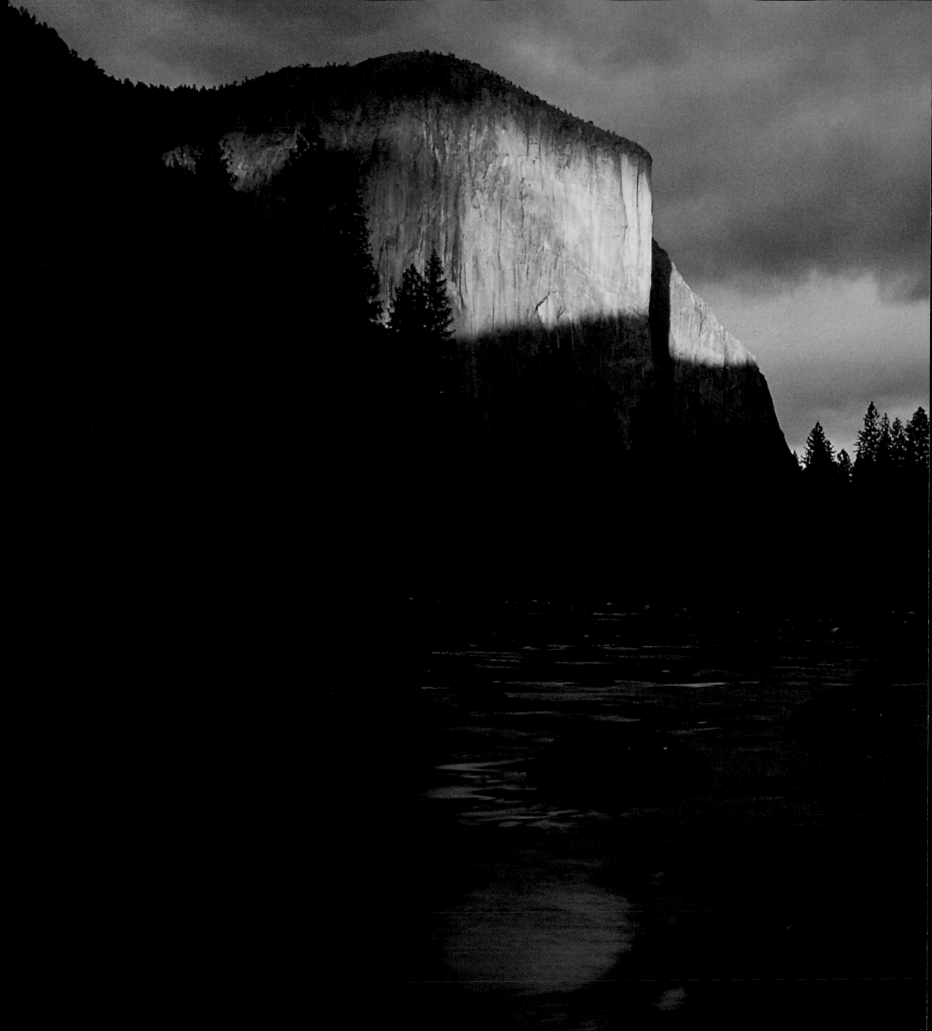

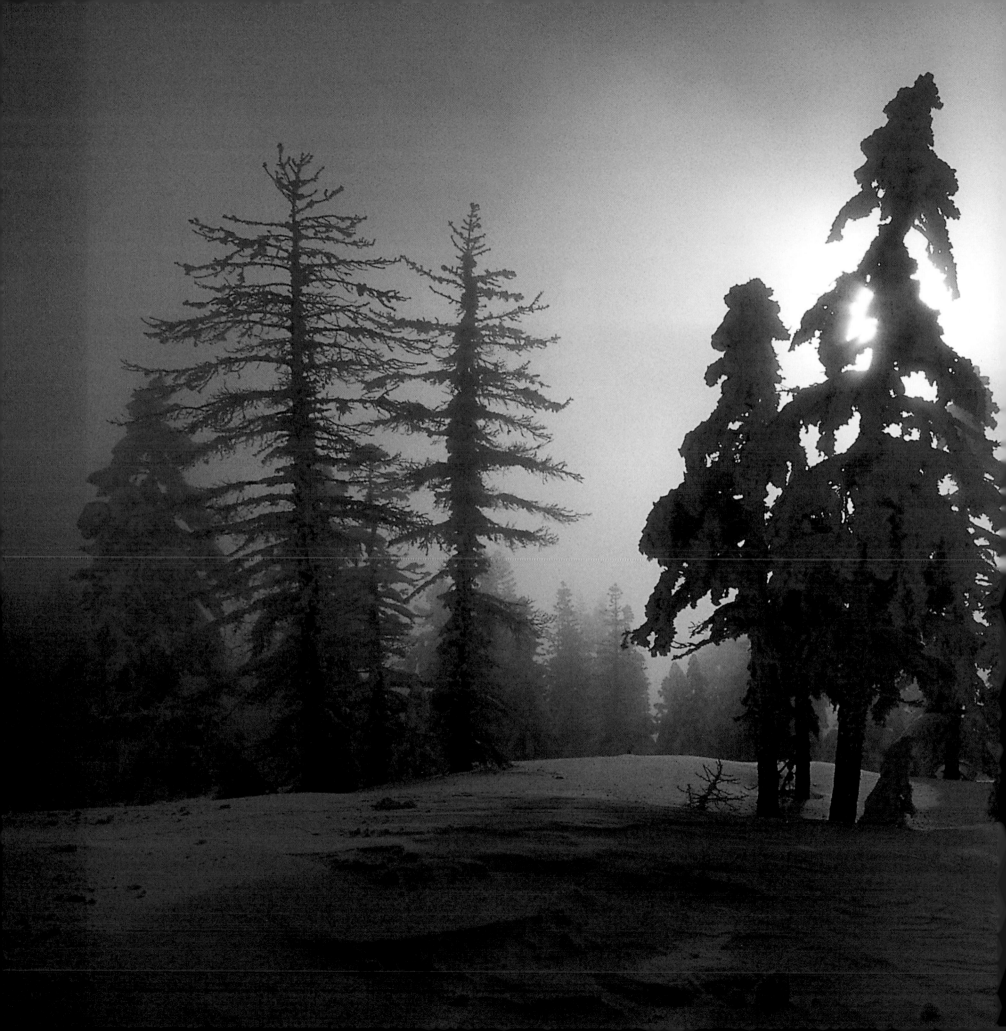

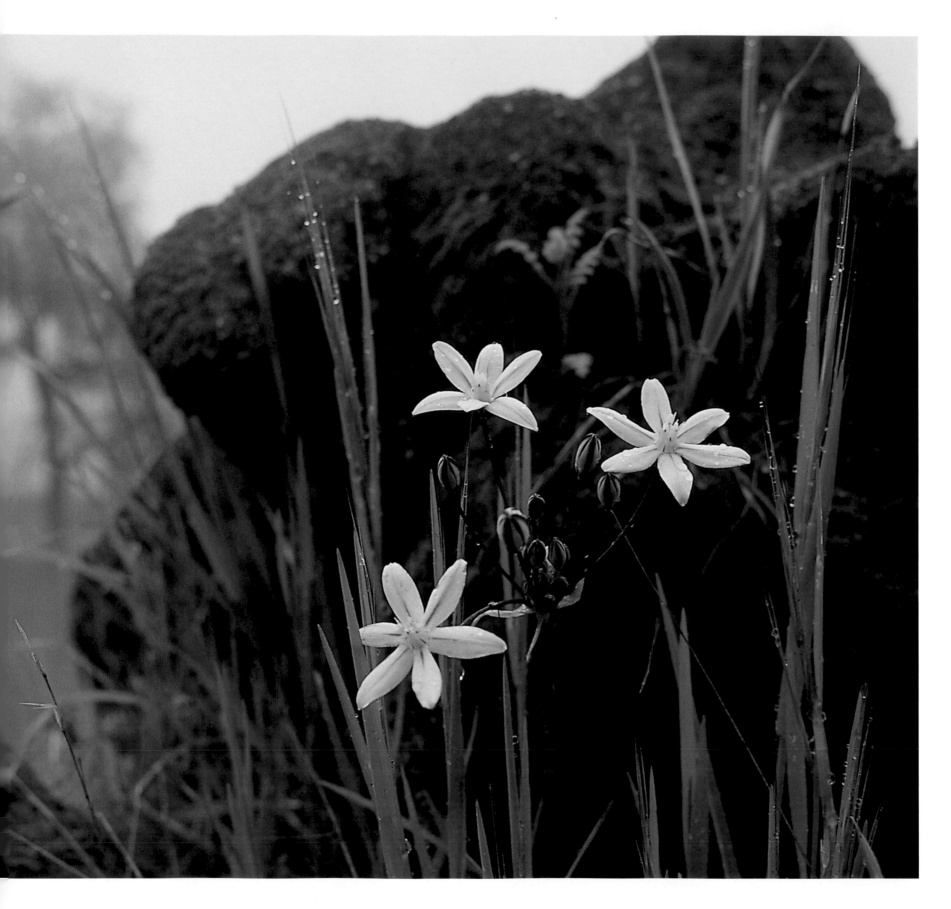

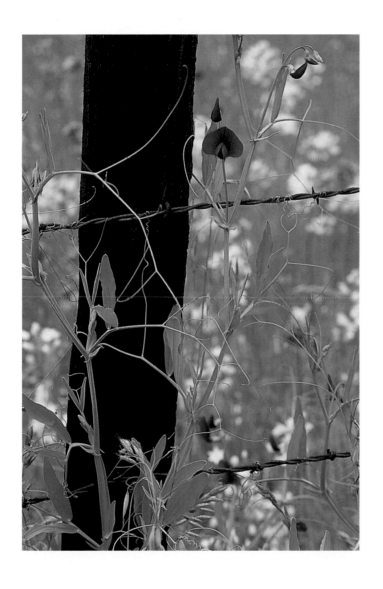

As with any relationship, the more I get to know the Sierra, the more I learn to appreciate the little things, which are often lost in the majesty of the grand natural setting. Awash in spring colors, tangles of tickclovers (left) and stands of alpine lilies (right) lend a quiet but elegant beauty to the landscape.

PRECEDING PAGES: Last light warms the monolithic face of El Capitan in the gallery of titans known as Yosemite Valley. The wall of granite drops 3,500 sheer feet to the Merced River. Along with glacial ice, the river has cut a knife-edged valley, which has inspired artists and climbers since the 19th century.

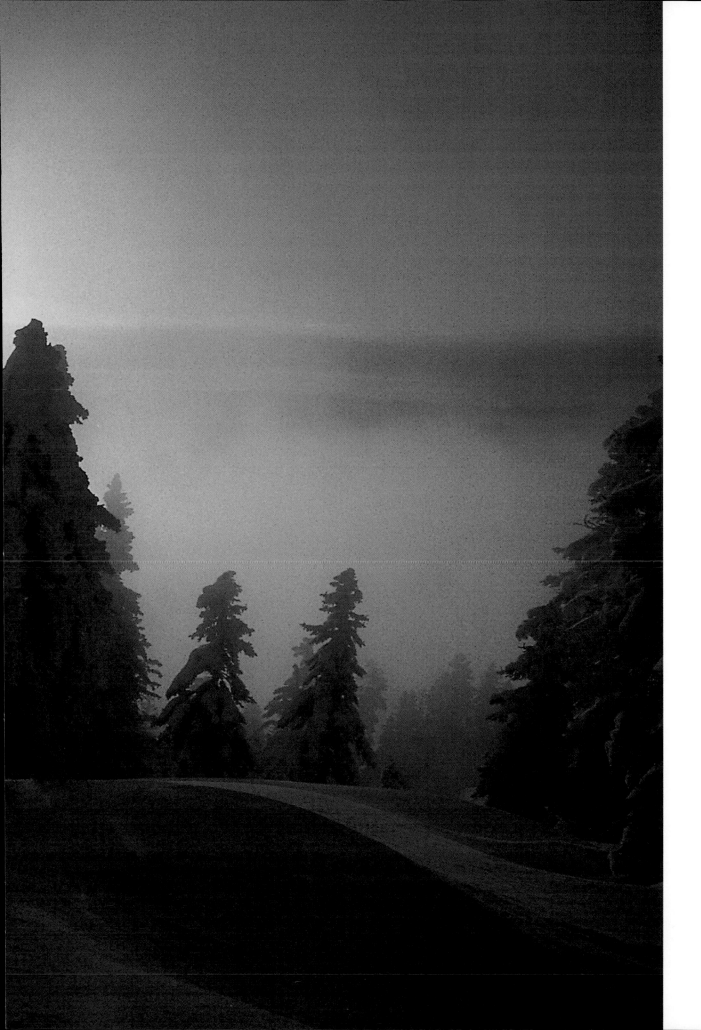

The crystalline stillness of a subzero February morning is unstirred by a breeze on Diamond Peak near the Nevada side of Lake Tahoe. Soon the 8,540-foot-high mountain will become busy with skiers ushered up by chair-lifts to revel in long downhill runs through fresh powder. Early morning is the time I savor most here, despite hands instantly cold when I take off my gloves to work the camera. Night's lacy shawl of ice lies undisturbed on the trees' shoulders. The only sound is a raven's distant caw. The Sierra never seems more alive than at such moments, when life's energy slumbers beneath a blanket of snow.

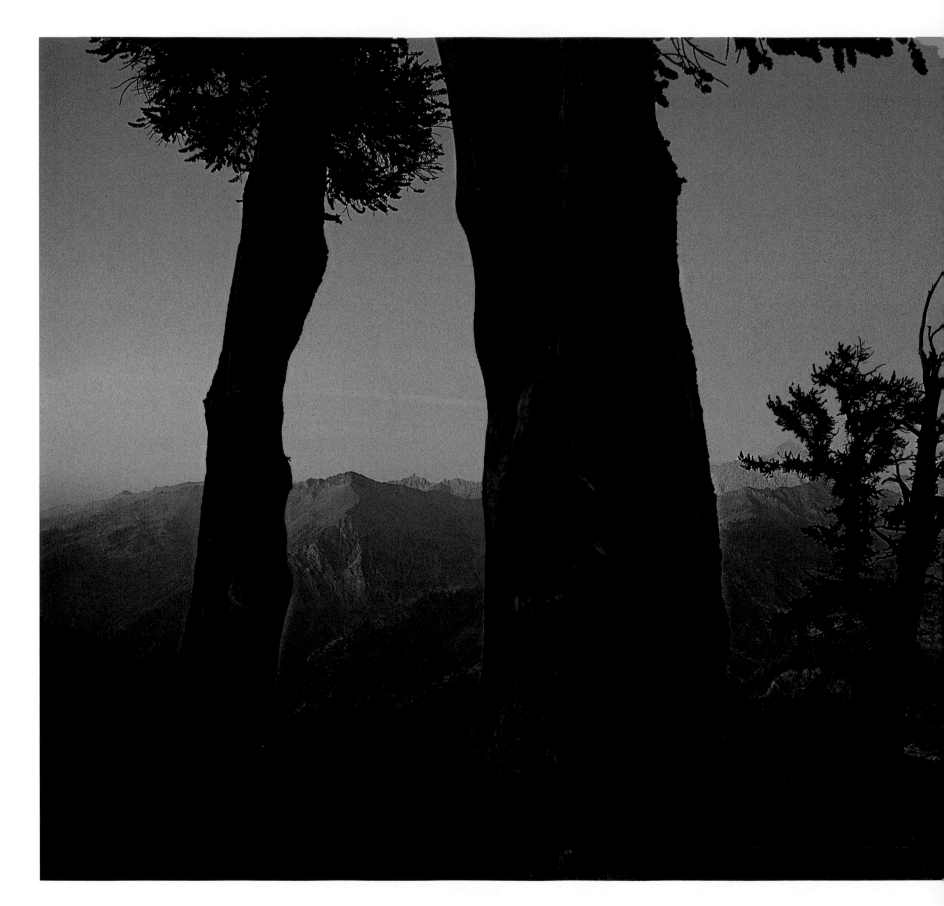

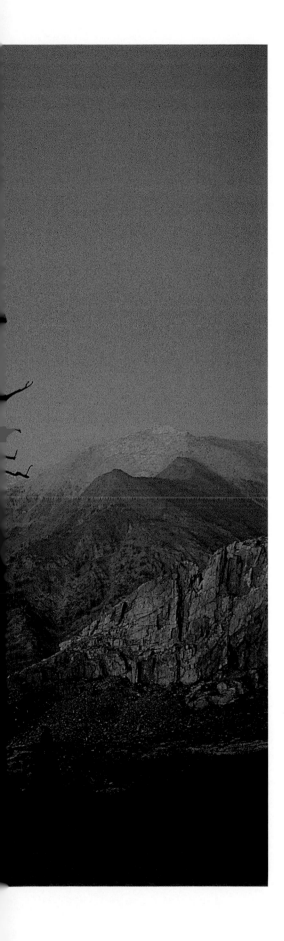

It takes a lot of fortitude to live 10,000 feet up in the high country of Sequoia National Park. Foxtail pines (left) manage to thrive in sheltered crannies. In a rain shadow cast by the eastern front of the Sierra, Mono Lake has undergone the indignity of shrinking to slake human thirsts. Towers of calcium carbonate known as tufa (right) once stood underwater and are revealed as the level of the lake drops.

FOLLOWING PAGES: On the shores of Mono Lake, foxtail barley waves in an invigorating breeze. The moisture that makes the area's short, lush growing season possible mostly comes from the mountains, running off in streams and seeping underground to dry lands far distant.

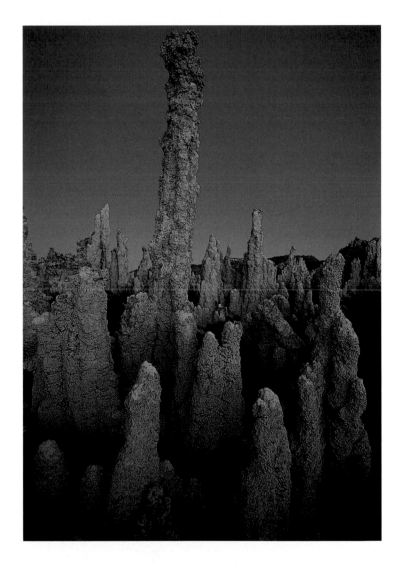

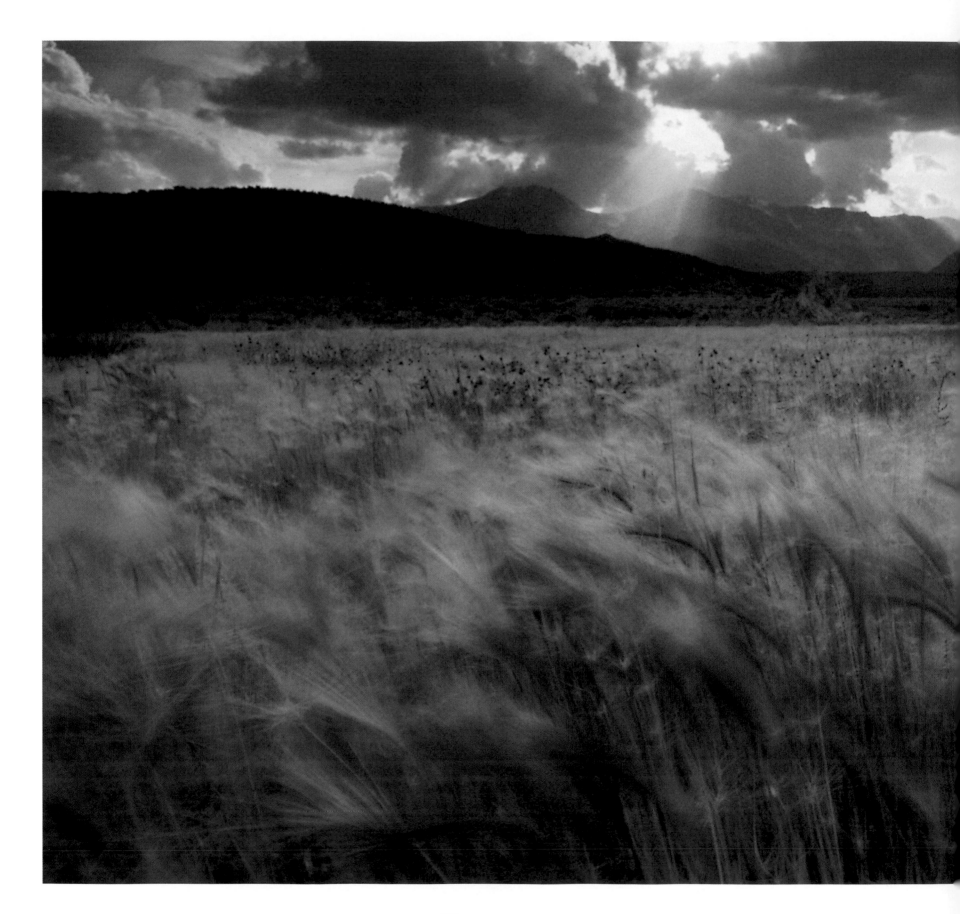

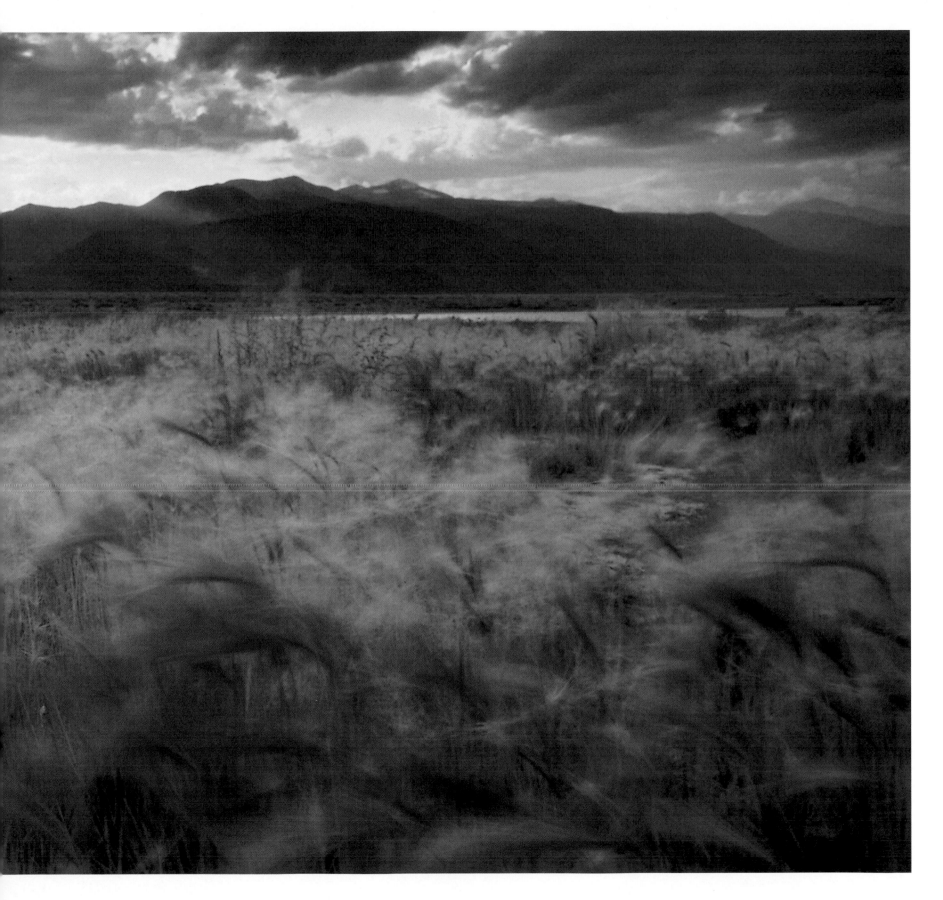

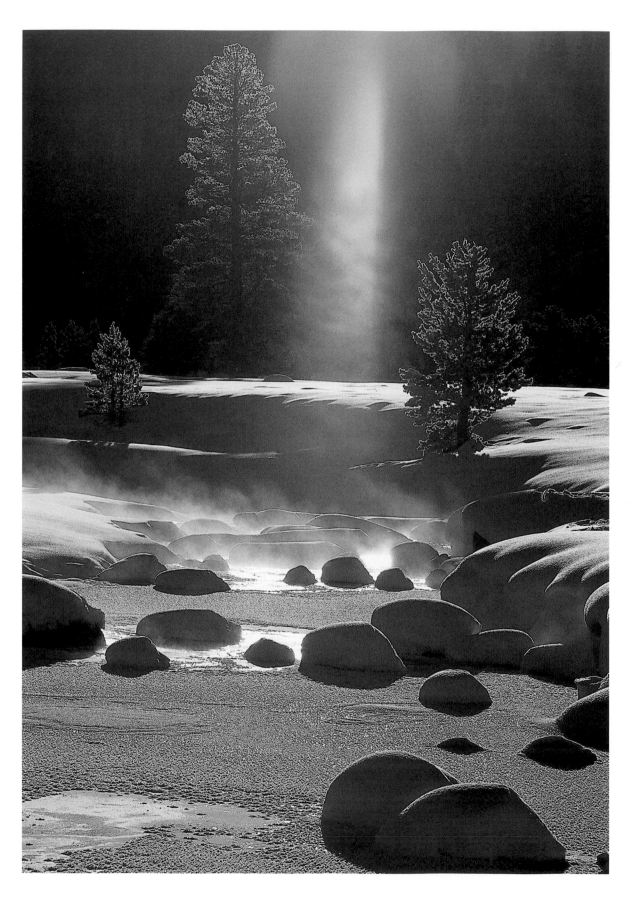

Early morning sun illuminates steam rising off the West Fork of Carson River near Lake Tahoe (left). Some stretches of the river stay open even in midwinter, warmed possibly by thermal springs bubbling up from the geological hotbed of the Sierra's tectonically active underpinnings. Lake Tahoe's Emerald Bay (right) offers a warmer-toned setting for sailors' and sightseers' contemplation.

FOLLOWING PAGES: Bridalveil Fall, one of Yosemite's signature features, drops 620 feet in a wide plume of water that inspired its name. A high hanging valley inset on Yosemite's astonishing rockface gives issue to the waterfall, which seems to drop from the clouds.

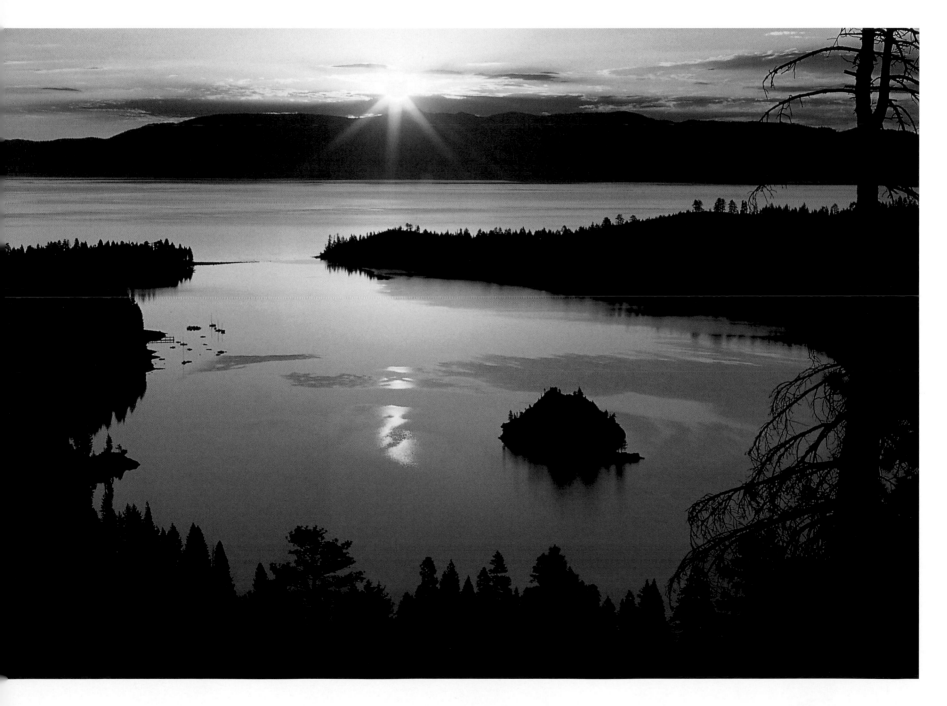

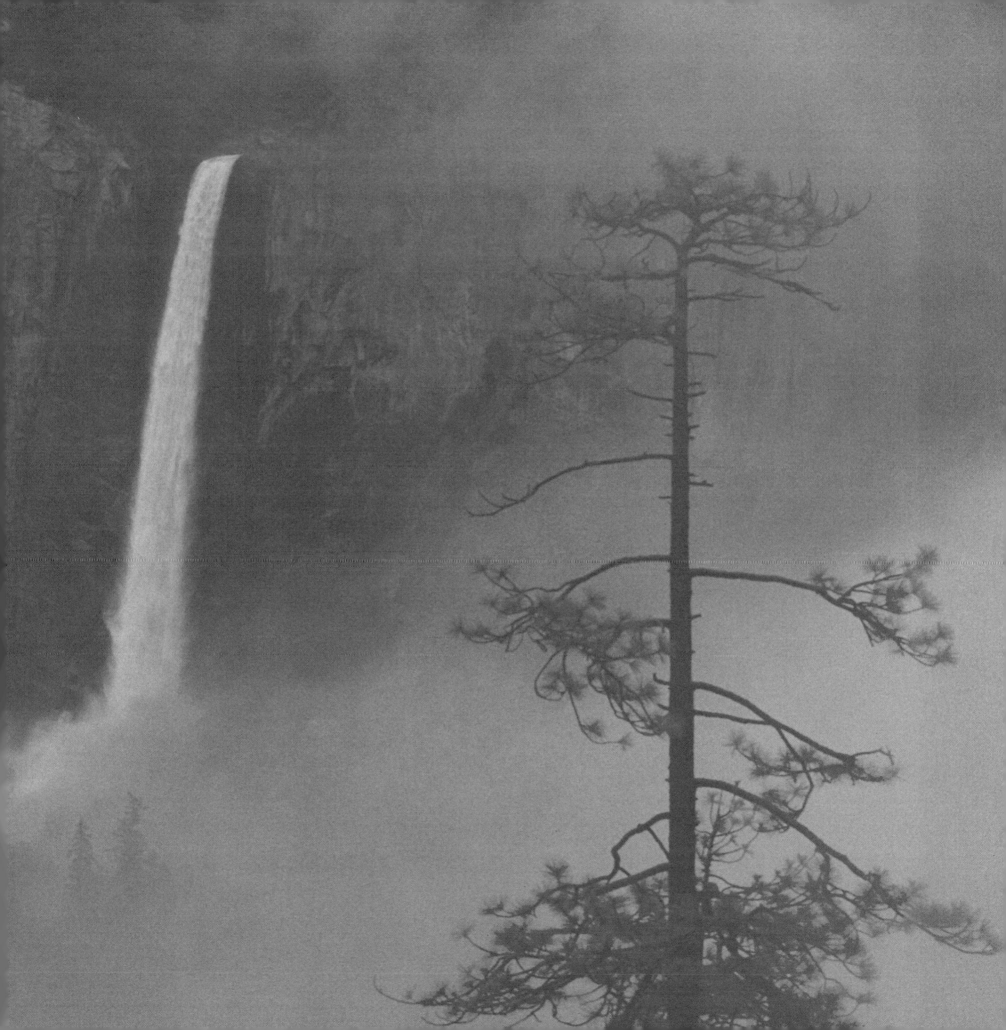

John A. Murray

Heart Lake

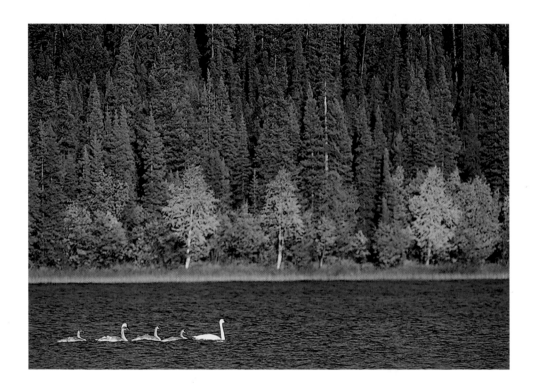

The great tragedy of life is not that men die,
but that they cease to love.

—*Somerset Maugham*

We begin in the hour before sunrise, a few stars still to the west. The lodgepole forest is dark but the sky to the east is bright. The morning air is cool, as it always is in Yellowstone, even in the month of June.

Soon we do not hear the passing cars on the road.

It is morning and the uplands are full of expectancy and invitation. Woodland birds twitter. Treetops stir. Aspen leaves rustle. Small rodents move in the grass. Insects murmur. Woodpeckers thump. Pine squirrels chatter. A raven caws.

Spider threads, thinner than a baby's gossamer hair, crisscross the trail. Everywhere there is the wet forest scent of fresh wildflowers opening to the day and fallen leaves turning to earth in quiet places. Sometimes in the air there is the faint suggestion of a large animal, of fur and musk and movements that are seldom heard or seen. Other times there is the incenselike fragrance of sagebrush, the tangy sweet essence of the Yellowstone backcountry.

At some point in the first mile we cross an invisible boundary and are no longer part of the world from which we came, but are silently absorbed into the older and richer community of Yellowstone.

It is quiet on the trail, and soon the ringing in our ears from the drive is gone.

After half an hour we stop so that my son can tie his boot laces. He says that his hands are cold, and so I reach into my pack and give him the pair of gloves I always carry. This is his first overnight trip into the wilderness.

He is ten years old.

My son, Naoki. How to describe him? His mother was Japanese and so his features are a mixture of those Asian and European. Sometimes I see him as he was when he was a baby. Other times I see him as the man he will become. This summer he has been crossing the bridge from boyhood to youth. The passage can be described as a gradual loss of innocence. On this trip to Heart Lake I am trying to teach him something more of my world, of our world, of that broad outer landscape that so brightens the horizons of life. I see myself as a kind of sherpa guide on his larger journey, pointing out landmarks, noting history, indicating routes, warning of hazards, suggesting side trips, examining possible objectives.

The rest will be up to him, whose name in Japanese means "like a tree, straight and upright,

never does the wrong thing."

As we walk I point out things, the cloven tracks of elk and deer and moose, the deep cut impressions of horseshoes, the tiny cuneiform scribblings of field mice, the three-toed imprints of birds, and, once, the familiar four-toed marks of a coyote. It being summer, the wildflowers are everywhere—wild roses dropping soft pink petals as smooth and glossy as teaspoons; the yellow balsamroot with arrowhead-shaped leaves; coral red fireweed; lake-blue day lilies; honey-orange paintbrush; and shooting stars with delicate blossoms of blue and black and yellow.

The sun rises slowly by degrees, and where the light strikes the trail the scattered flecks of mica in the dust sparkle. In the woods sunbeams fall here and there, brightening the flower patches and angular rocks and fallen trees. In places the trail is no wider than my son's shoulders, and the grasses nearly cover it. In other spots it becomes broad enough to accommodate two horses. We take our time along the path, stopping often to rest and talk. We do not hurry. We have all day to reach Heart Lake. I am trying to teach my son that the trip is as important as the destination, and that every step across a landscape is full of wonders.

The trail is gentle and climbs hills and follows streams and crosses meadows. The altitude is comfortable for Naoki's first long hike with a pack—around 8,000 feet. This is the southeast corner of Yellowstone, the least visited area in the park. The Thorofare Country, as it is known, is the wild heart of the central Rockies. Fittingly, our destination, at the head of the Snake River, is a place called Heart Lake.

We stop for a break midway, about five miles, and have a snack. There are no clouds. The sky is as blue and luminous as the enameled blue of a wolf pup's eyes. The day has become warm, and the gloves go back into the pack. We eat crackers and Colby cheese and drink water. We sit in the shade of a solitary standing tree. Our hearts feel good, beating rhythmically from the walk. An iridescent green hummingbird buzzes nearby, attracted by the red of Naoki's bandana, and then, like Prospero's Ariel, disappears into what remains of what was once an extensive forest.

All around us the lodgepole pines are burned. Most of the dead trees are still standing. Bereft of branches, the upright needlelike trees resemble porcupine quills. The trees range in color from bone white to charcoal black, from ghostly blue to pewter gray. Some still have their spire tops.

Others are broken over a third or halfway up. A few are collapsed together in groups. One lone pilgrim has fallen into what remains of a charitable neighbor. A gust of wind will soon bring them both down. In places the indefatigable lodgepole seedlings have begun to recolonize the slopes. Most of these cheerful pioneers stand about eight or nine feet—roughly one foot for each year since the fire. In the understory, wild raspberries and fireweed, dwarf willow and bluebells have taken over. The hillsides are green with new plant growth. Over the last decade what had been a sterile patch of overgrown timber has become a fertile open-country elk paradise.

Naoki wants to know what happened to the forest. I explain that for a hundred years fires were religiously fought in the park. Dead plants and dropped branches and storm-felled trees piled up, often chest-high, on the forest floor. Then, in the summer of 1988, there was a drought. Conditions became ripe for a conflagration. Lightning strikes ignited a fire on Two Ocean Plateau. Within days the blaze had moved north into Yellowstone, searching as if by intuitive sense for areas of accumulated dead wood. By the time the snows fell in October, more than a third of the park had burned. Despite the efforts of more than 10,000 firefighters and the expenditure of more than 100 million dollars, the forces of nature prevailed. The fire swept like strong medicine through moribund stands, clearing out dying and decayed trees, opening canopies, and bringing in sunlight to nourish the green plants that sustain the animal kingdom.

The real lesson, I emphasize to Naoki, is that in nature destruction is powerfully wed to creation. The Yellowstone fires show that what appears to be destructive and negative can actually be creative and beneficial.

"Like when President Lincoln waged war to stop slavery?"

I pause, surprised. Like his great-grandfather and his grandfather, Naoki loves American history.

"And now the world is a better place?"

I smile.

What I most enjoy about Naoki—and this is often the case for children of nine or ten—are his Heraclitean statements of truth, his simple, unadorned statements that come out of nowhere and cut right to the heart of the matter.

We mount up and move out. Gradually the pungent odor of sulphur fills the air. "It smells like

fireworks going off," Naoki observes, hopefully. Like all little boys and girls, he has a fondness for fireworks. Shortly we are standing on the northern edge of Heart Lake geyser basin, a treeless burning region about the size of a small college campus. The sprawling wasteland is filled with boiling mud pots, beautiful geothermal springs, barren baked earth, and trickling streams of steaming hot water. To the west is Factory Hill, especially hard-hit by the big fire. To the south is Heart Lake, gleaming in the sun, almost too bright to look at.

Naoki is speechless. He has never seen a geothermal basin. I had not told him about the place, so as to give him an unexpected surprise. With the irregular jets and puffs of mist, billowing white columns and dissipating vapor-clouds, the area resembles the month-old bivouac of a large army, with the smoke of a hundred campfires and bonfires rising into the air.

"Dad, what is this!" he exclaims, jumping up and down.

Again we take off the packs and have a closer look. Down the hill is a bubbling mud pot. I caution him not to get too close. A few feet from the edge he stops. The mud is churning and burning and turning over and over, as if in a pot over a gas range turned on full. The sounds—random belches and rumbles, burps and gurgles—are comical.

"Where does the heat come from?"

"Subterranean toy factory," I joke.

"Seriously, Dad."

I describe the geological miracle that is Yellowstone—how heat is generated by the friction of rocks shifting beneath the earth, and how that heat then leaks to the surface to become geysers and hot springs, sulfur pools and fumaroles.

He is excited as I have rarely seen him, and, with the boldness of Capt. William Clark, insists we continue deeper into the basin.

Shortly the trail drops down a steep hill. At the base of the hill is a stream, Witch Creek, so hot that it is steaming. Gingerly, he touches a finger to the water. There follows a smile I'm sure I'll recall in the final moments of life, reflecting on the high points of the passage.

A little further on we reach a series of geothermal pools. The colors are so intense I set up the tripod and take a few photographs. Most of the pools are a deep azure blue in the center, with a jade-green rim. A few are colored by algae beds—ochre yellow, brown sienna, pastel pink.

Photography involves waiting for the wind to blow the steam clouds away, which occurs about once a minute. Through that lens, or window, you then try to capture the brilliant color, the seething water, the ephemeral mists rising like the spirits of the departed.

A few minutes later we are back on trail, continuing south to Heart Lake, now less than half a mile away.

We pass the ranger cabin, no one home, and then veer down a grassy footpath to the right—to the lake and to our campsite in the trees. I set up the tent—the old North Face that has sheltered me faithfully, without one leak, from the caribou grounds of northern Alaska to the cactus country of southern Arizona—in the clearing. Naoki immediately disappears into the depths of the tent, refusing to come out, playing an electronic game on his sleeping bag and insisting that he needs a proper nap. "I'm a city boy, Dad," he protests. I surrender to the absurdity of the situation and read a worn paperback copy of Turgenev's *Sketches from a Hunter's Album,* a book I first read 30 years ago, when I was 15.

Eventually he tires of the bat cave and emerges blinking into the sunlight.

We walk down to the lake—that perpetual fish smell coming across blue and white-capped water—and gather driftwood for the kindling pile.

Afterward I take him to a special place. In the woods behind camp there is a knoll with an immense spruce that burned in the great fire. The tree still stands, most of the branches intact, in a place where it probably lived for three or four hundred years. At the base of a tree I had, the previous fall, carved a heart with the following inscription: Patricia Hall Murray, 1928 - 1998. I explain to Naoki that I had distributed some of his grandmother's ashes here, and a lock of her hair.

"Why did you bring her here?"

"Because when I was a little boy she always read to me from a book about a grizzly bear in Yellowstone."

"Who wrote the book?

"A nature writer named Ernest Thompson Seton."

"Do you think she gets lonely up here?"

"Nah. Not with all these wonderful animals and friendly people visiting."

"What do you think death is like, Dad?"

"I think it's like a snowflake falling on the water. I think we go back into the stream."

"Does Grandmother being dead make you sad?"

"Oh I don't know, she had a pretty good life. Nobody lives forever, you know. Not even these trees, not even these woods. Not even these mountains. That's what places like Yellowstone teach you—to accept the changes of life. If you stop and think about it, Yellowstone is like a great university. That raven over there, he's a dean. That tree behind him, he is a distinguished professor. He can teach you a lot of things if you only listen. And that lake down the hill is like a giant lecture hall. There is so much to learn in this country. I've been coming here for 27 years, and I'm just beginning to learn the lessons."

"Hey, what's that?"

Naoki has spotted something moving off in the woods. It is a fisherman from one of the other campsites, with a creel and a rod, headed down to the lake. Naoki insists we follow and so we walk down to the lake and watch him for a while, casting against the wind and across the waves in the middle of the day, having no luck whatsoever.

An hour later Naoki proclaims it is dinnertime and so, with a little assistance, he builds a cooking fire. Dinner is a gallon aluminum pot full of lake water and boiled carrots and potatoes, onions and celery, green beans and peas, with a little freeze-dried tenderloin mixed in, and served with French bread. We call it Heart Lake Stew.

After dinner is story time.

I tell him about my great-great-grandfather, Charles Evers, who first came to Yellowstone in the summer of 1883, and how he took the train to Miles City, Montana, and then caught a stage coach to Gardiner, and how it was difficult for him to get around because he carried a Confederate mini-ball in his leg from Chickamauga. And I tell him of my father, who came with his parents to Yellowstone in the summer of 1929, and how Dad still remembers the black bear sticking his head in the car window and how bad the breath of the bear was. I tell him of how I first came to Yellowstone in the summer of 1972, at the age of 18, with my girlfriend Paula and my father and little brother. And how I returned two summers later to work as a horse wrangler at a ranch, and how Doc and I packed some dudes into the headwaters of the Lamar River and

could only watch, laughing, as a herd of buffalo stampeded through camp, flattening all but the cook tent.

"You guys laughed?"

"Sure, sometimes things are so bad all you can do is laugh."

The conversation turns to bears. The rangers had us watch a mandatory orientation video on bears before setting out on the hike. Naoki is concerned about bears, but I tell him not to worry, that Daddy studied grizzlies for six years in Alaska and knows what to do and what not to do. I do not tell him about the Swiss woman who was killed by a grizzly at Heart Lake about 15 years ago, while sleeping in her tent; or about my Alaska friend Michio Hoshino, who was killed by a brown bear while sleeping in his tent in Kamchatka three summers ago.

I show him how to put the food up at a considerable distance from camp and to have absolutely nothing resembling food in the tent.

The stars thicken, the fire dwindles, the night darkens, my son yawns.

"What will we do tomorrow, Dad?"

I point to the mountain behind us, a 10,308-foot massif named Mount Sheridan for an old Civil War general who was not unfamiliar with these parts.

"Climb that thing behind us, if you're ready."

"I was born ready."

"That's my man."

Sometime in the middle of the night a great wind comes up and blows the fly partially off the tent. When I go outside to secure the covering I see the stars being rapidly blotted out by a black cloud coming in from the west. There are flashes of lightning in the hollows of the cloud, the bolts illuminating amphitheaters and antechambers of darkness. The thunder rumbles across the land. Ten minutes later the rain hits us—torrents and sheets and unbelievable waterfall-like deluges.

Naoki is a Buddhist, like his mother, and begins to recite a Buddhist chant. I tell him not to worry, I make a few jokes, and even when the lightning hits nearby we finds ourselves laughing.

I listen to the rain for a long time after he goes to sleep, and the storm is rolling out across Yellowstone Lake toward Montana and the wind is making gentle sounds in the trees.

Thy love to me is wonderful.

Breakfast the next morning consists of granola with coconut chips and dried pineapple bits, served up in bowls of evaporated milk, with some powdered orange juice to wash it down. Naoki is accustomed to a heavier meal at home—omelet, bacon, hash browns—and I explain to him that you don't want too full a stomach if you are going to climb a mountain.

He nods politely, unconvinced of the logic.

The trail begins just south of the campsite, veering north into the old burn on the south-facing side of Mount Sheridan.

Dewdrops sparkle in the grass, the woods ring with birdsong. The day is filled with happiness and hope.

Not a quarter of a mile up the trail we spot a cow moose and calf moving from right to left through the timber. I find a good log and we sit there, watching. Naoki takes out his disposable paper camera and composes a shot. I want to teach him to know the value of long intimate moments with the landscape, to be patient, and to become acquainted with deep time, because that is where all the best ideas come from.

Gradually the cow moose drifts off. The calf, browsing intently on some dwarf willows, suddenly realizes it is alone and nervously looks for its mother, bawling every step of the way. From the woods the cow huffs a response. The young one trots off to join its parent, and we continue up the trail.

Higher and higher we climb, following switchbacks, moving in and out of old burns and green timber, getting closer to the sky.

Everywhere there are the trails and paths of elk and moose and deer. At one point, in a grassy clearing, we come upon the contoured beds of five elk—three cows and two calves.

Always we are moving toward the light, toward the summit.

We round a bend in the trail, overlooking an avalanche slide, and Naoki shouts, "Dad, look!"

Naoki points into the slide and I see nothing.

"What?"

"There—by that rock shaped like a triangle. Something is moving. What is it?"

I squint and find a rock that resembles a pyramid, cast around, and then see it, a black bear.

We sit down and observe through our one pair of binoculars.

"What is he doing?"

"It is a she, son. You can tell by the shape of the head. She appears to be digging for ants."

Naoki is incredulous that something as large as a bear would eat insects, and so I have to explain the facts of life to him—that Yellowstone, a high and fairly dry plateau, is a hard place for a bear to make a living, and is not nearly as rich a habitat as Alaska, with the salmon, or Canada, with the huckleberries.

We watch the bear for nearly an hour as she scrambles up and down the snowslide, looking for something to eat. I explain that a person can learn what is edible in the wilderness—leaves, roots, berries—simply by watching bears. What they can eat, we can eat. Finally, her lovely ebony fur rippling in the sunlight, the bear ambles downslope, toward the timber, looking probably for a cool spot to nap away the hot hours.

After several false summits, we finally reach the real top of the mountain and sit down to survey our kingdom. The view is panoramic, and expands to the horizons. Far to the east are the Absaroka Mountains, jagged purple peaks that carry snow on them through summer's longest day. Nearer is the vast cobalt expanse of Yellowstone Lake. Nearer still is Heart Lake, which is, we can now see, shaped very much like a heart. To the south is Two Ocean Plateau, thoroughly burned over, the place where the fire started. Colter Peak, named for the first (1807) American visitor to these parts, is visible beyond the meadows of the Yellowstone River. Far to the south and west are the jagged Tetons, the mountains from which we just came. Due west are Lewis Lake and Shoshone Lake, sparkling like two twin sisters.

"Hopefully one day you can bring your son here," I say.

Naoki nods, gazing off pensively. His expression reminds me of the youth in Winslow Homer's painting "Nooning," a canvas I first saw when I was his age at the Metropolitan Museum of Art in New York. I am glad that I can give him this, the timeless treasure that is Yellowstone, at such a young age.

On the hike down we sing songs—beginning with contemporary songs and working our way back through the decades to show tunes such as "Oklahoma." We end on traditional folk songs like "Shenandoah." I tell him that we used to sing songs on long marches in the Marines, songs like "She Wore a Yellow Ribbon" and "When the Saints Come Marching In." A good song can carry you along for many a weary mile.

Back in camp we raid the food box and set out for Witch Creek, to rest our feet in its warm waters. As we sit there, munching on crackers and cheese, Naoki explains his theory that animals can talk to each other, and that certain children can talk to them as well.

It occurs to me on the walk back to camp that he just might be right.

iii
*A society is a group of reasonable beings in
common agreement as to the objects of their love.*

St. Augustine

In the morning I open the tent flaps and discover the cold has paid a visit. During the hours before dawn the world has been covered with frost. The green mosses near the tent are stiff and coated with tiny crystals of ice. Every blade of grass, every weathered stone, every wilted flower, every dead and living tree is covered with white. My breath makes a cloud in the tent. Our boots, left outside under the fly, are stiff. The air feels like November in the city.

An hour later we are on the trail, heading briskly back to the road, the sun already warm on our faces, the songbirds calling out, leaving it all behind for another day.

Although it is by human standards mute, Yellowstone has often spoken to me in the way of all landscapes that have not been adumbrated by the works of man. It has reminded me of how short life is, and how long death is. It has demonstrated to me what is noble and enduring in wild nature and what is valuable and unperishable in the human spirit. It has illustrated the necessity of establishing lofty but achievable goals. It has taught me humility and good humor. It has shown me

that I must be strong, and that to remain strong I must stay rooted to the Earth. When I have known solitude, I have found companionship in its hills and valleys. Grief and loss have been healed among its fire-charred trees. When I have fallen short of virtue, I have found purity again in its springs. Implicit in every aspect of Yellowstone, and my attachment to it, has been everything that is evoked by the word freedom. Above all, the park has underscored to me the importance of love—not just love of family and friends, but also love of culture and country, ideals and ideas, truth and beauty, forgiveness and compassion.

The importance of love comes to you most when you are alone.

In the end, Yellowstone, like so many of our finest parks, is too large to be folded in a map, captured in a photograph, or compressed into an essay. It is a trumpeter swan paddling quietly in the backwaters of Yellowstone Lake and a pack of wolves trotting out from the aspens in Hayden Valley. It is the roar of the wind in a bristlecone pine on Mount Washburn and the thunder of the Lower Falls in the gorge of the canyon. It is the travertine terraces along the Firehole River and the quiet splendor of Morning Glory Pool. It is a wide-eyed little girl from Tokyo seeing Old Faithful for the first time, and an elderly couple from Indiana seeing it for the last time. It is a place to carry deep inside and hold close whenever you feel yourself in turmoil, and instantly be at peace.

In the Middle Ages the faithful, at least once in life, made the pilgrimage to Canterbury, where they beheld the most beautiful cathedral in the land. In our time, we have Yellowstone.

Somewhere in the final mile of the trail, as we pause for a water break, I tell my son that everything he knows will one day pass away like the leaves of the trees around us or the clouds in the sky, and that one day even I will be gone, but that Yellowstone will always remain, like the oldest and truest friend in the world. ■

Pat O'Hara

Olympic Wilderness

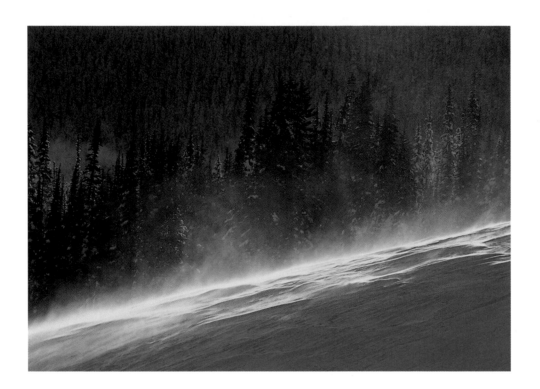

In wilderness is the salvation of the world.

—Henry David Thoreau

When I was growing up just east of Seattle, the mountains of the Olympic Peninsula floated like a snow-capped promise on the western horizon. Each summer the promise was fulfilled when my extended family gathered for a reunion at one of its beaches. In 1981 I was a young photographer just breaking into the professional sphere, and less than enamored with southern California where I'd gone to seek my fortune. So I jumped at the prospect of moving back to the Pacific Northwest when my wife, Tina, was offered a job in Port Angeles on the peninsula's northern coastline. I spread maps on the floor of our home in Del Mar and said, "Let's go!"

When we arrived in midsummer, it was hot. So hot that we escaped from our low-budget, non-air-conditioned motel room into the mountains on our first weekend. We hiked up to the high divide and had one of our first wilderness adventures as a married couple. At first light we opened the tent flap to gaze out across the Hoh River Valley to the august heights of Mount Olympus, just under 8,000 feet high, shining in the dawn like a welcome message.

I keep a picture I took then, with my camera and in my mind, of Tina sitting on the mountains' divide surrounded by wildflowers. We've lived on the Olympic Peninsula ever since.

I don't know any place in the continental U.S. that has its combination of coastline, old-growth temperate forest, alpine meadows, and mountains hung with glaciers. Almost a million acres of wilderness survive, with Olympic National Park at their core. A national marine sanctuary protects much of the surrounding waters and islands, and wilderness areas within the Olympic National Forest expand the untamed country. There's even a local county marine sanctuary, with an underwater nature trail for snorkelers and divers.

To fully appreciate this coast, you ought to brave a winter visit. Pacific Ocean breakers the height of two-story houses unleash a frightening power that hurdles gigantic driftwood logs as casually as you'd cast kindling into your fireplace. Yet a short walk away from the coastal tempest, mosses hang from ancient tree trunks, and limbs are decorated like Christmas trees with lime green tinsel.

When the wind is low, I find great peace on a stretch of coastline unassumingly named Third Beach. Gulls dance in the surf, the ocean rolls, and a light breeze drones through the old growth forest that extends down to the tide line. When the tide recedes, I ponder the dazzling creatures that live in the pools the ocean leaves behind and feel blessed to be here. ■

Olympic Mountains, Washington (opposite)

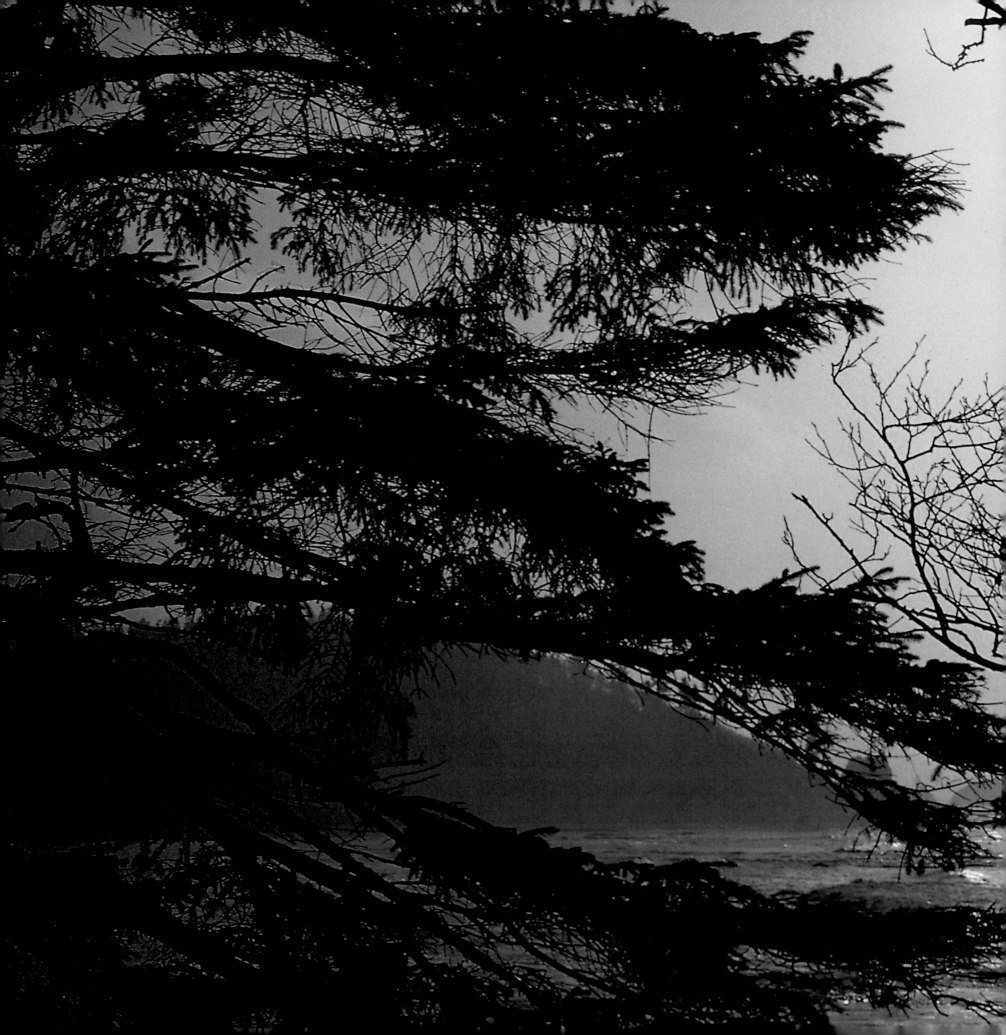

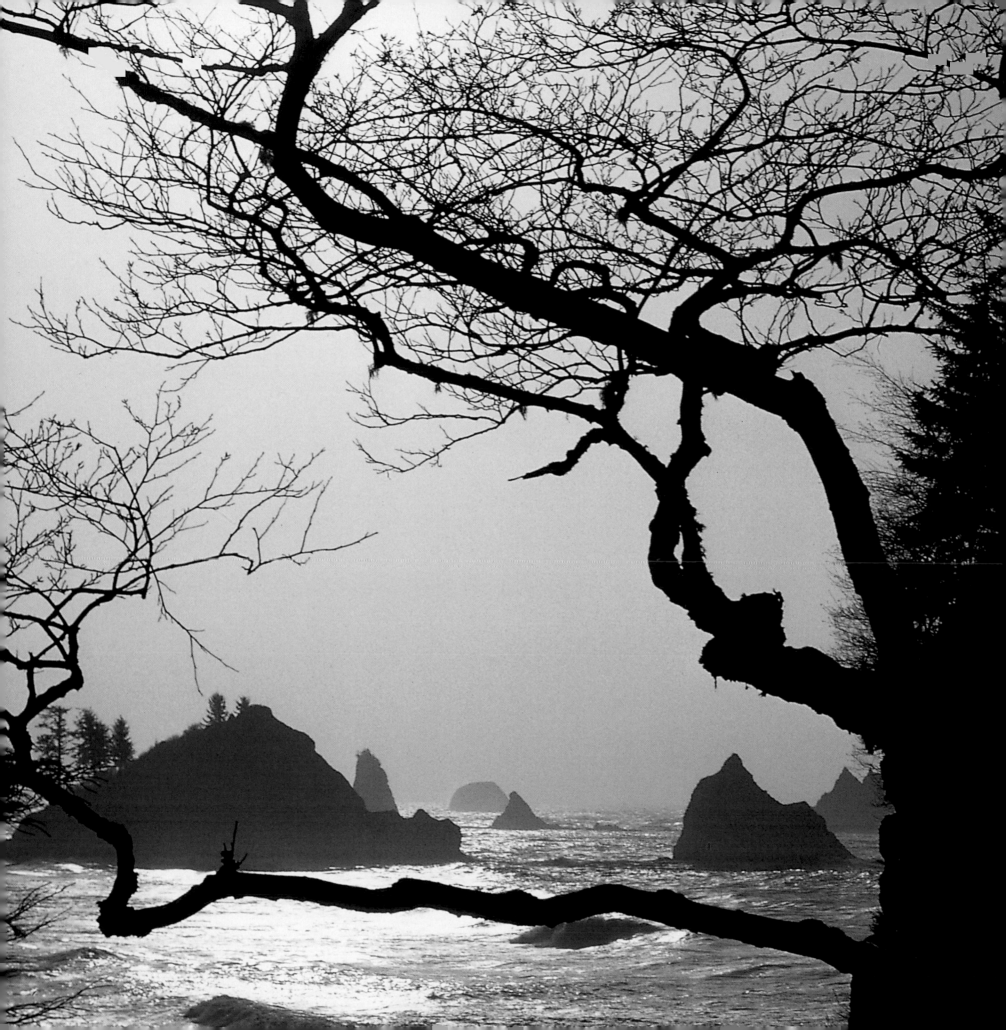

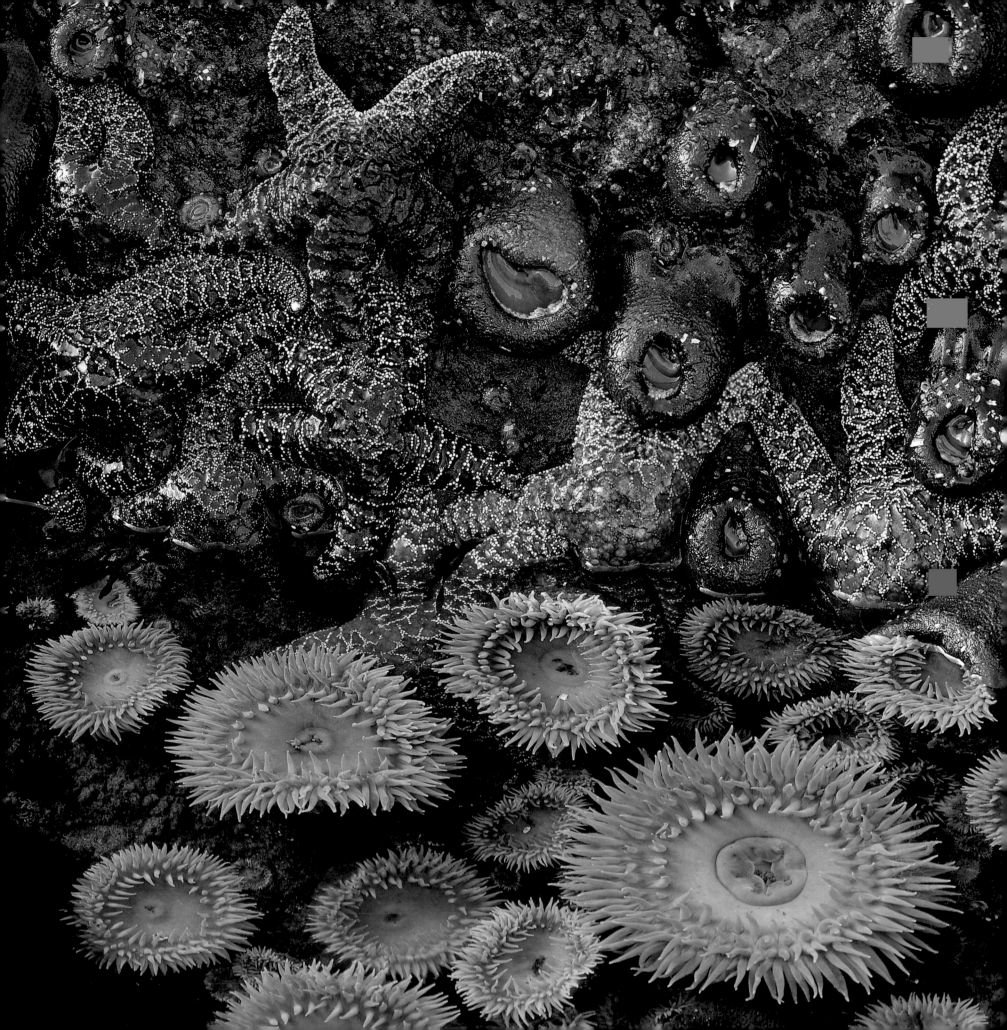

Flowers of the sea open as anemones (opposite) filter plankton in a tidal pool at Tongue Point Marine Sanctuary. Other anemones exposed on the rocks remain closed until the waves return, kept company by sea stars. Sea urchins (right) graze on rocks encrusted with sea algae. Their strong teeth can carve hiding places in coral, or even rock. Their spines help them move.

PRECEDING PAGES: In local parlance, they are called "sea stacks," jagged outcrops of stone that have resisted the attack of the Pacific's waves. Anyone can see them, off South Beach Wilderness near Taylor Point, via a trail that rises over headlands and dips down onto beaches that are covered up at high tide. Make sure to plan your walk with the tides in mind or you can end up stranded on a sea stack or a headland.

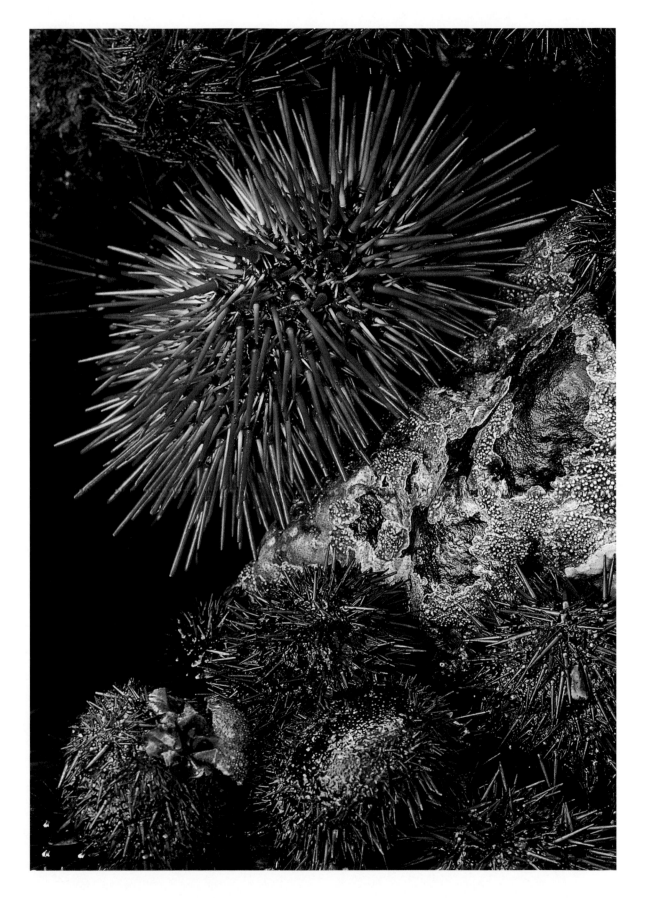

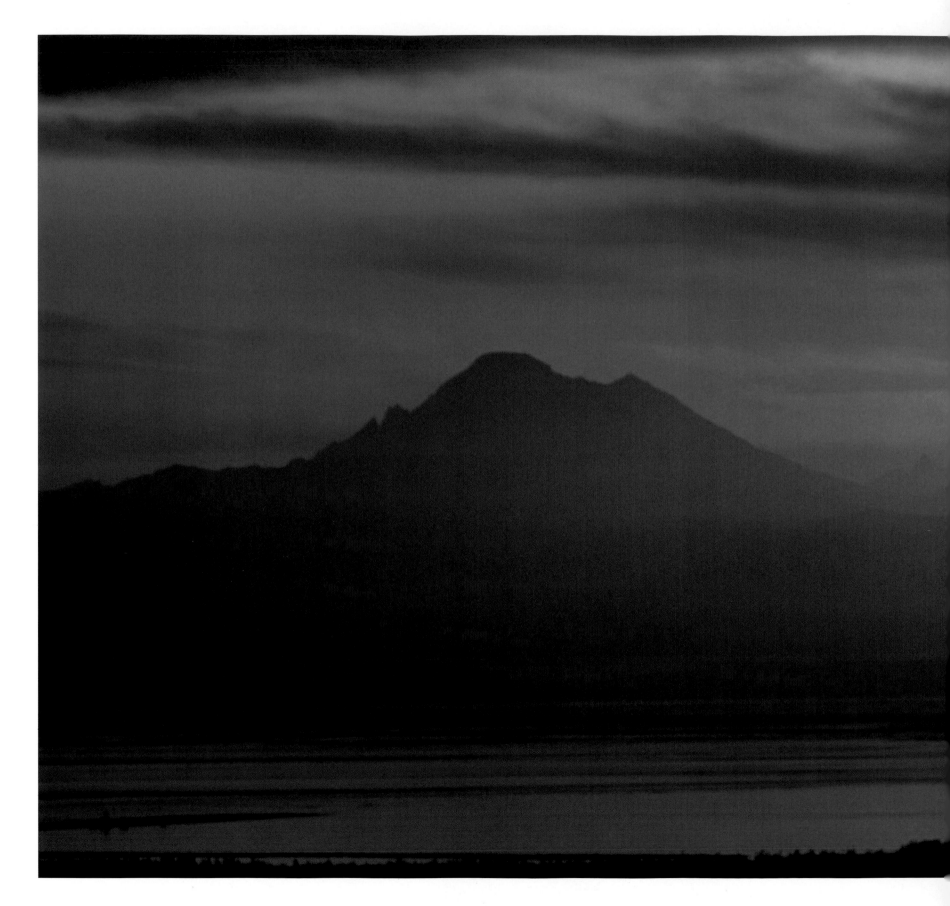

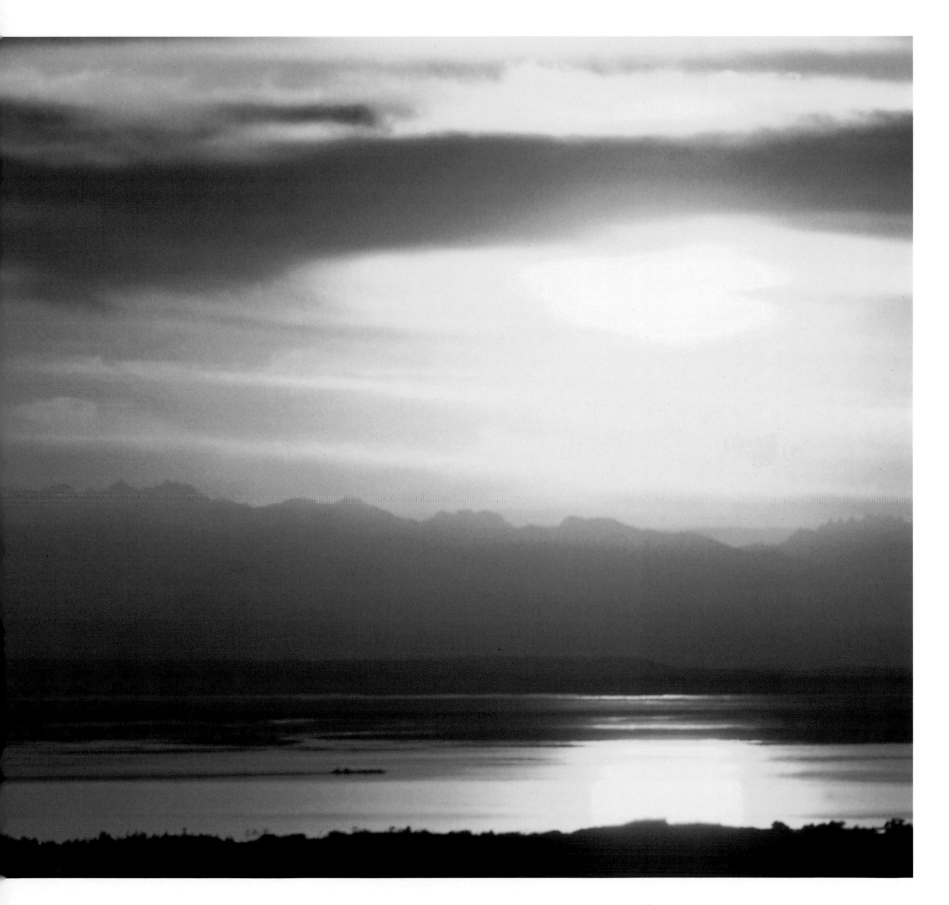

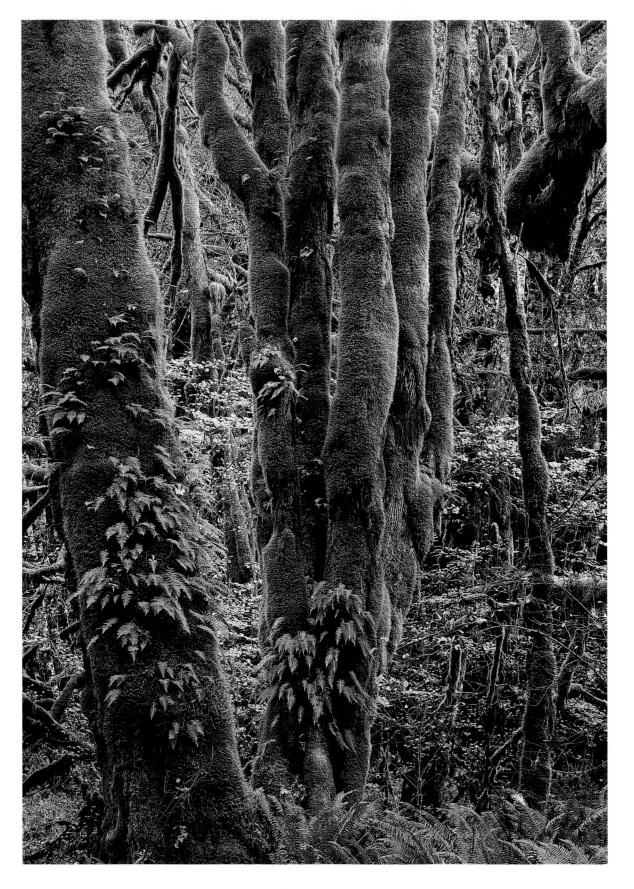

Raindrops seldom reach the rain forest's floor, but rather percolate downward through the canopy to drench a temperate-climate jungle that is protected on much of the peninsula. Moss and licorice ferns clamber up trunks of bigleaf maples (left), while sun reaches down through old-growth forest to a young hemlock (opposite), one species that can grow in shade.

PRECEDING PAGES: A passing oil tanker sketches a wake across the Strait of Juan de Fuca, a major shipping road for Seattle and other ports. The strait is also a rich and vital marine ecosystem, where orcas play alongside container ships. Beyond lies Mount Baker, which holds the world's snowfall record of 90 feet in a year.

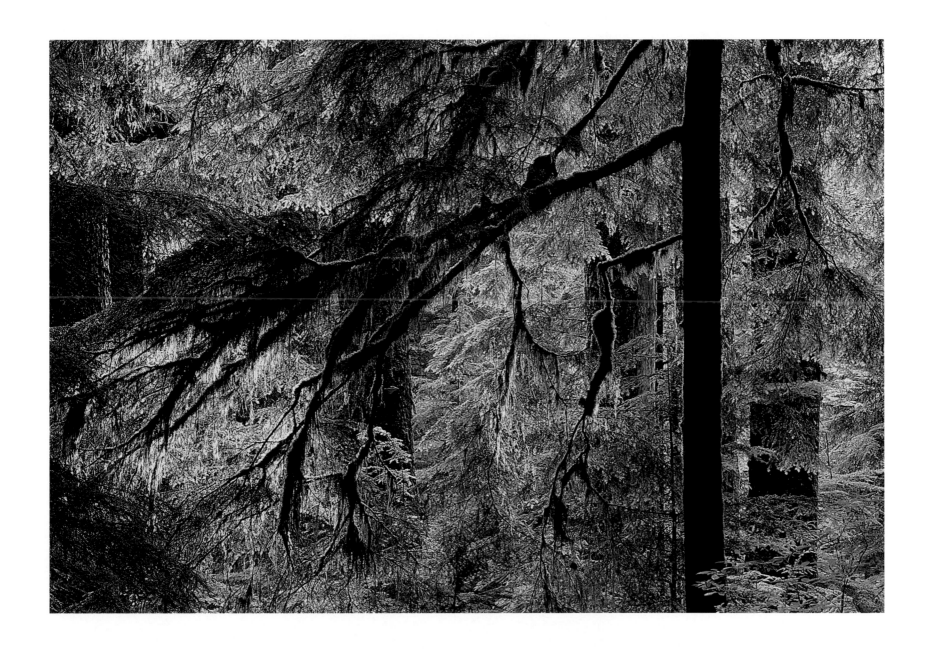

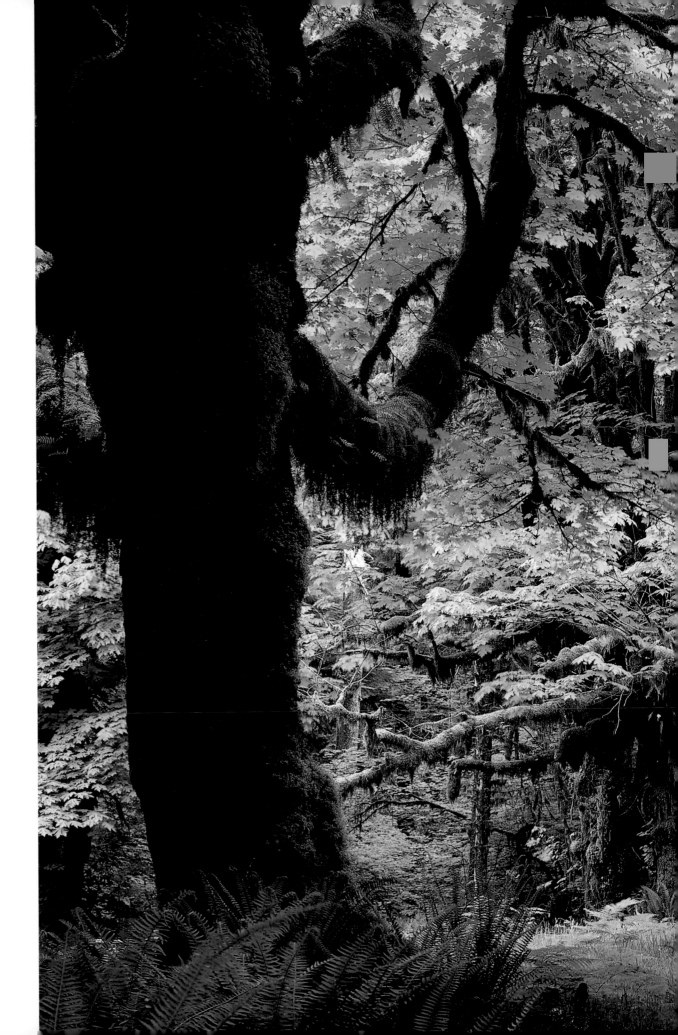

Lichen drapes from bigleaf maples like a velvet cloak, insulating trees from the 150 inches of rain that can fall each year. Left undisturbed, the area creates air so rich that the forest floor of ferns and mosses can feed on the air's nutrients. Naturalist and illustrator Roger Tory Peterson felt the area was so lush "that it may contain the greatest weight of living matter, per acre, in the world."

FOLLOWING PAGES: A seamless carpet of uninterrupted forests cloaks parkland above Lake Crescent. Slopes beyond it show the results of clear-cutting, the predominant logging technique in unprotected forests. Sadly, much of the peninsula has been denuded, attesting to the foresight of President Theodore Roosevelt and other champions of the wilderness.

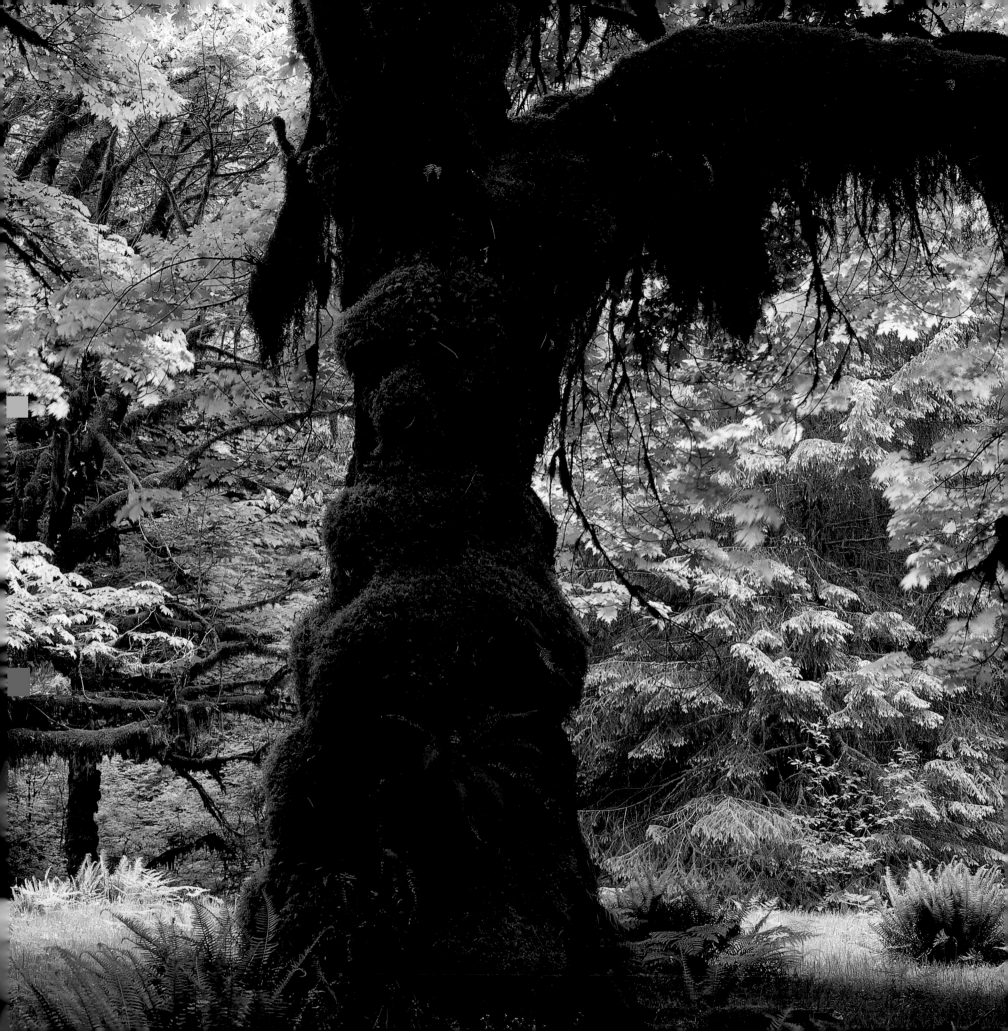

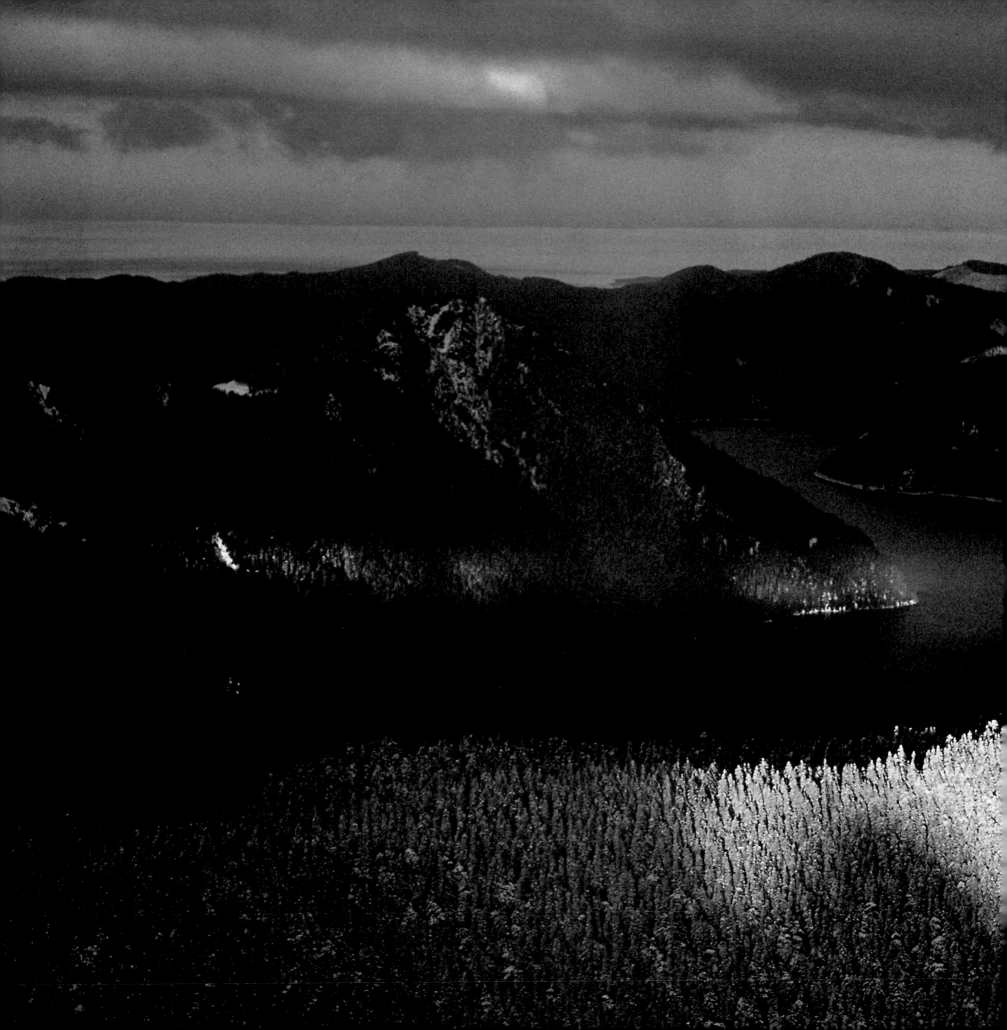

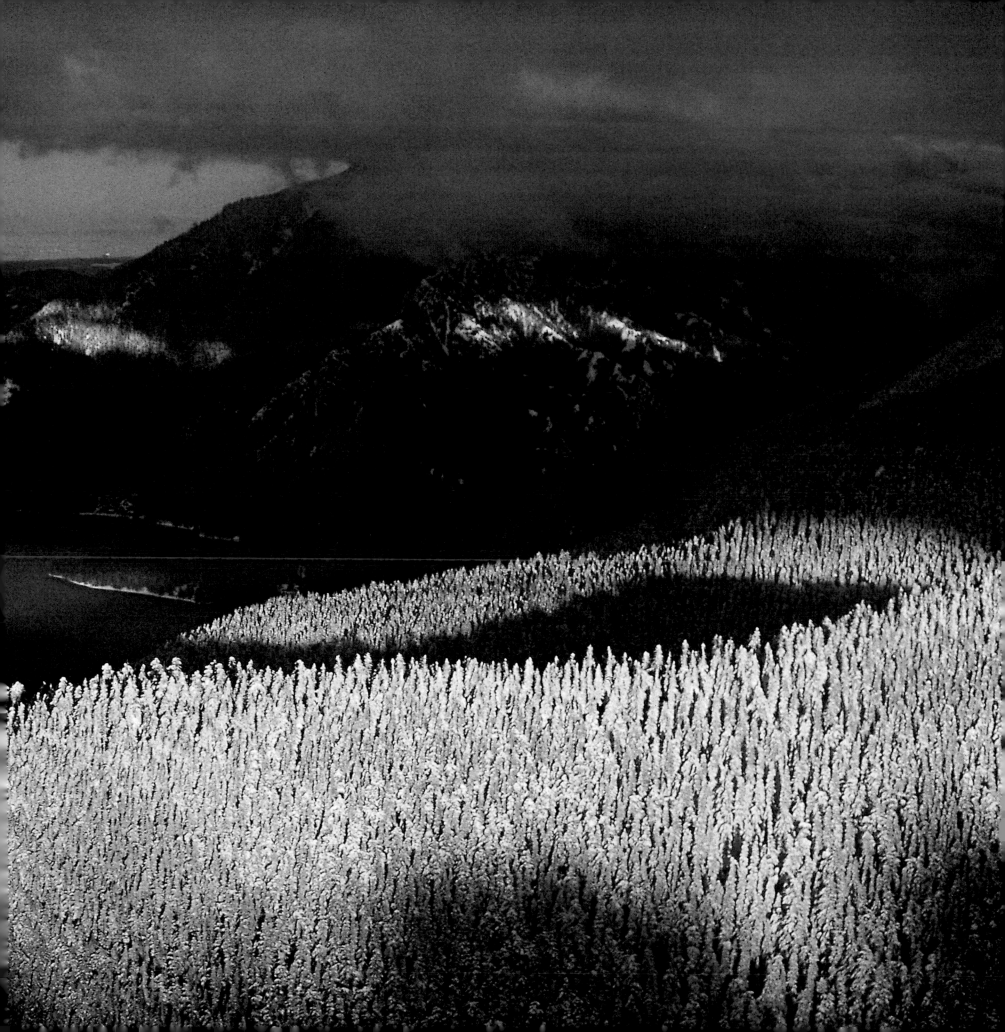

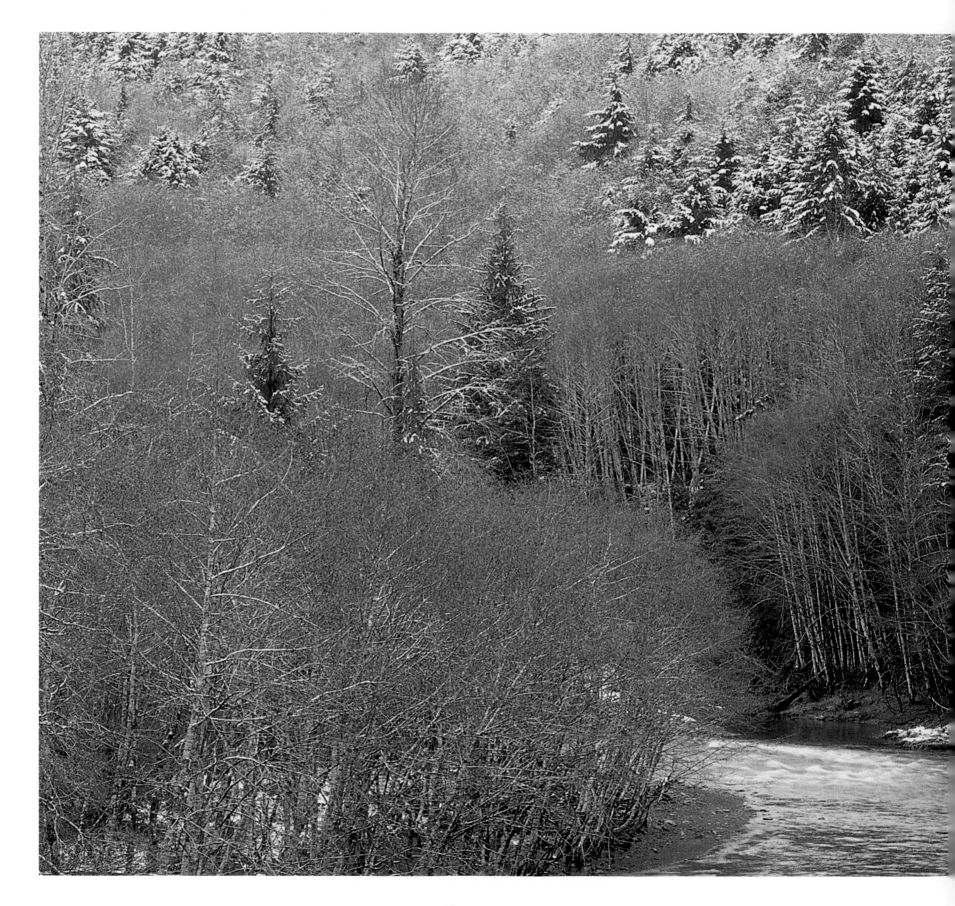

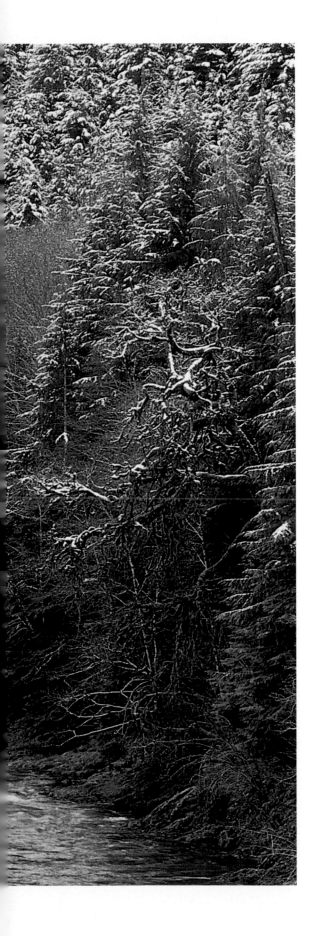

In deepest winter, red alder catkins on the Sol Duc River (left) provide essential winter browse for Roosevelt elk, named for the President who created the Olympic Elk Refuge in 1908. Indigenous to the Pacific Northwest, the elk rely on thick old growth forest (right) for shelter from winter's cruelties. Many creatures depend on old growth, which has been cut everywhere on the peninsula that is not protected. Spotted owls need old growth's cavities to breed; marbled murelets fly from here to the ocean to feed; salmon spawn in its clear streams; and black bears and cougars walk the woods.

FOLLOWING PAGES: Snow shadowed by sunlight coats Obstruction Point Trail in the Olympic Mountains of Washington. More than a hundred miles away, Mount Baker's peak gleams like a far-off beacon in the Cascade Range.

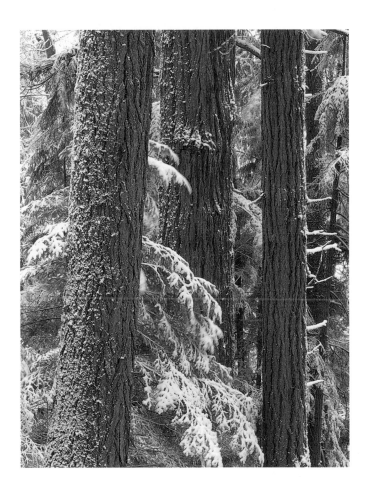

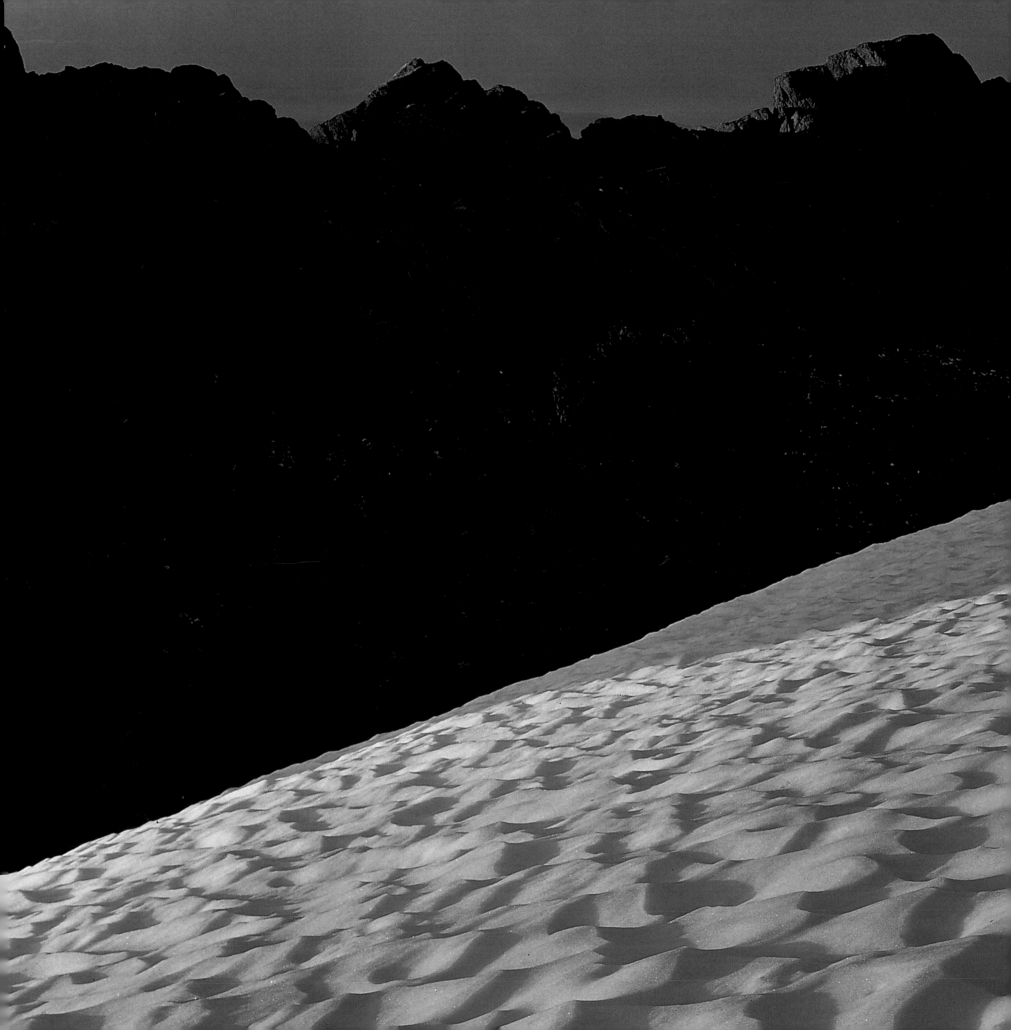

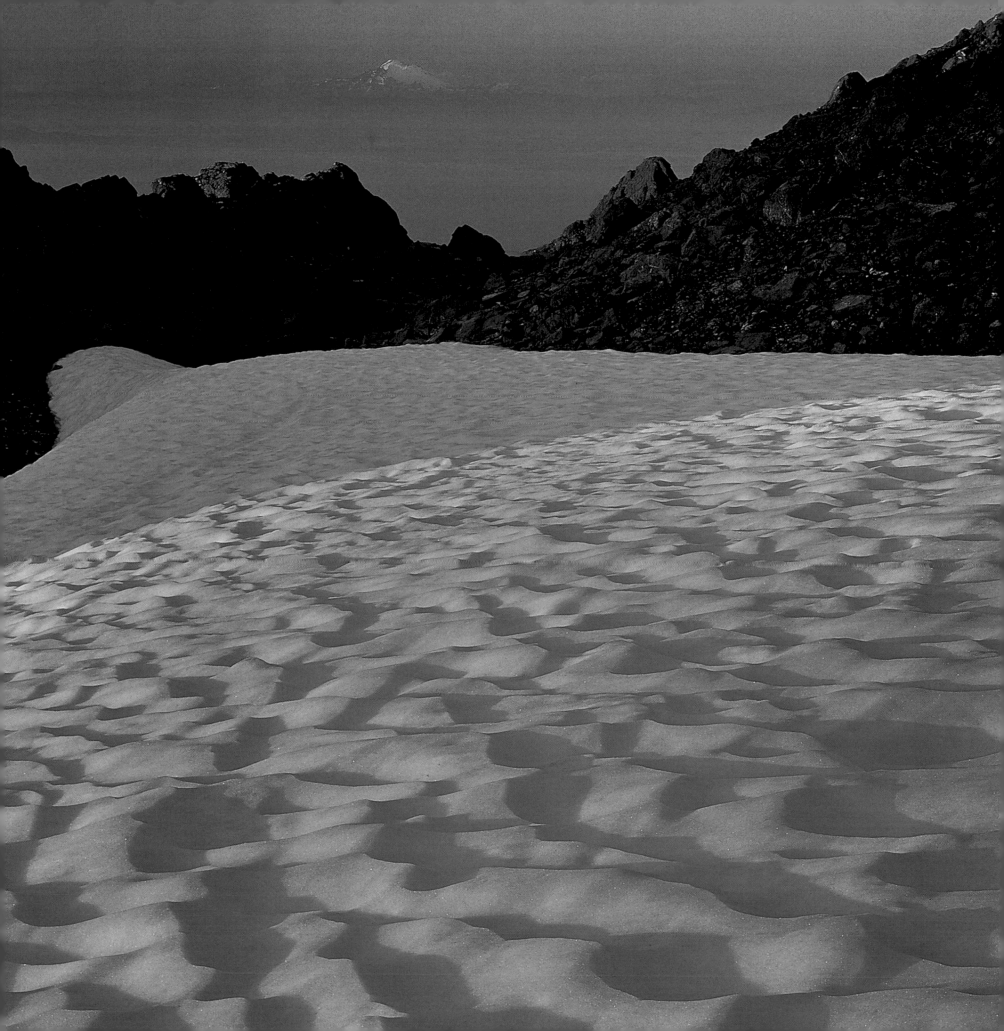

Terry Tempest Williams

The Birthing Rock

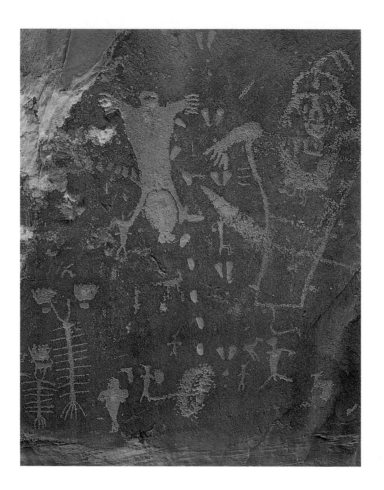

*Life comes; life goes; we make life.... But we who live in the body
see with the body's imagination things in outline.*

—*Virginia Woolf*

I forget the first time I saw this boulder, maybe 30 years ago as an adolescent traveling through Utah's redrock desert with my family. Or maybe it was 25 years ago, as a young bride making a pilgrimage to this part of the world with my new husband, not only in love with each other but also with this arid landscape that ignites the imagination.

Today, I return once again to the Birthing Rock.

I return because it is a stone slate of reflection, a place where stories are told and remembered. Call it my private oracle where I hear the truth of my own heart.

He called it his oracle, and said it pointed out

the time for every action of his life.

—Jonathan Swift, Gulliver's Travels

Yes, the actions of life are recorded, here, now, through the hands of the Anasazi, the "ancient ones" who inhabited the Colorado Plateau from A.D. 500 to 1200. Their spirits have never left. One feels their intelligence held in the rocks, etched into the rocks. This rock stands in Kane Creek Canyon, the size of a small dwelling, exposed and vulnerable, only a few miles from the town of Moab, Utah.

There she is, as she has been for hundreds of years, the One Who Gives Birth, a woman standing with her arms outstretched, her legs wide open, with a globelike form emerging. Four sets of tiny feet march up the boulder alongside her. There are other figures nearby: a large ceremonial being wearing what appears to be an elaborate headdress and necklace. It feels male but it could be female. Who knows what these Anasazi petroglyphs might mean? What is translated through stone is the power of presence, even centuries old.

Deer. Mountain sheep. Centipedes. A horned figure with a shield. More footprints. And around the corner of the boulder, two triangular figures, broad shoulders with the point down, made stable by feet. From their heads, a spine runs down the center. They are joined together through a shared shoulder line that resembles the arms of a cross. A slight tension is felt between them as each pulls the other, creating the strength of scales balanced. Next

The Birthing Rock, Utah; Tom Till (opposite)

191

to them is another figure, unattached. A long snake with nine bends in its river body is close to making contact. All this on the slate of blue sandstone that has been varnished through time; when carved it bleeds red.

Piñon. Juniper. Saltbush. Rabbitbrush. The plant world bears witness to the human one as they surround the Birthing Rock. They are rooted in pink sands when dry, russet when wet. It is a theater in the round choreographed on Navajo sandstone, reminding us of dunes that once swirled and swayed with the wind in another geologic time.

There is much to absorb and be absorbed by in this sky-biting country. At times, it is disorienting, the Earth split open, rocks standing on their heads, entire valleys appearing as gaping wounds. This is the power and pull of erosion, the detachment and movement of particles of the land by wind, water, and ice. A windstorm in the desert is as vicious as any force on Earth, creating sand smoke so thick when swirling it is easy to believe in vanishing worlds. The wind and fury subsides. A calm is returned but not without a complete rearrangement of form. Sand travels. Rocks shift. The sculpting of sandstone reveals the character of windgate cliffs, sheered redrock walls polished to a sheen over time.

My husband is climbing the talus slope above me. I hear a rock fall and call to him. His voice returns as an echo.

In repetition, there is comfort and reassurance.

I RETURN MY ATTENTION TO THE BIRTHING ROCK, this panel of petroglyphs that binds us to a deep history of habitation in place, this portal of possibilities, a woman giving birth, a symbol of continuity, past generations now viewed by future ones.

As a woman of 44 years, I will not bear children. My husband and I will not be parents. We have chosen to define family in another way.

I look across this sweep of slickrock stretching in all directions, the rise and fall of such arid terrain. A jackrabbit bolts down the wash. Piñon jays flock and bank behind a cluster of junipers. The tracks of coyote are everywhere.

Would you believe me when I tell you this is family, kinship with the desert, the breadth of my

relations coursing through a wider community, the shock of recognition with each scarlet gilia, the smell of rain.

And this is enough for me, more than enough. I trace my genealogy back to the land. Human and wild, I can see myself whole, not isolated but integrated in time and place. Our genetic make-up is not so different from the collared lizard, the canyon wren now calling, or the great horned owl who watches me from the cottonwood near the creek. Mountain lion is as mysterious a creature as any soul I know. Is not the tissue of family always a movement between harmony and distance?

Perhaps this is what dwells in the heart of our nation—choice—to choose creation of a different sort, the freedom to choose what we want our lives to be, the freedom to choose what heart line to follow.

MY HUSBAND AND I LIVE IN THIS REDROCK DESERT, this "land of little rain" that Mary Austin described at the beginning of the 20th century. It is still a dry pocket on the planet one hundred years later. Not much has changed regarding the aridity and austerity of the region.

What has changed is the number of needs and desires that we ask the Earth to support. There are places where the desert feels trampled, native vegetation scraped clean by the blades of bull-dozers, aquifers of water receding before the tide of luxury resorts and homes.

And the weight of our species will only continue to tip the scales of balance.

The wide open vistas that sustain our souls, the depth of silence that pushes us toward sanity returns us to a kind of equilibrium. We stand steady on the Earth. The external space I see is the internal space I feel.

But I know this is the exception, even an illusion in the American West, as I stand in Kane Creek where my eyes can follow the flight of a raven until the horizon curves down. These remnants of the wild, biologically intact, are precious few. We are losing ground. No matter how much we choose to preserve the pristine through our passion, photography, or politics, we cannot forget the simple truth: There are too many of us.

Let me tease another word from the heart of a nation: sacrifice. To not bear children may be

its own form of sacrifice. How do I explain my love of children, yet our decision not to give birth to a child? Perhaps it is about sharing. I recall watching my niece, Diane, nine years old, on her stomach, eye to eye with a lizard, neither moved as they contemplated the other. In the sweetness of that moment, I felt the curvature of my heart become the curvature of the Earth, the circle of family complete. Diane bears the name of my mother and wears my DNA as closely as my daughter would.

Must the act of birth be seen only as a replacement for ourselves? Can we not also conceive of birth as an act of the imagination, giving body to a new way of seeing? Do children need to be our own to be loved as our own?

PERHAPS IT IS TIME TO GIVE BIRTH TO A NEW IDEA, MANY NEW IDEAS.

Perhaps it is time to give birth to new institutions, to overhaul our religious, political, legal, and educational systems.

Perhaps it is time to adopt a much needed code of ethics, one that will exchange the sacred rights of humans for the rights of all beings on the planet.

We can begin to live differently.

We have choices before us, conscious choices, choices of conscience and consequence, not in the name of political correctness, but ecological responsibility and opportunity.

We can give birth to creation.

To labor in the name of social change. To bear down and push against the constraints of our own self-imposed structure. To sacrifice in the name of an ecological imperative. To be broken open to a new way of being.

IT BEGINS TO RAIN SOFTLY in the desert, the sand is yielding, the road is shining, and I know downriver a flash flood is likely, creating another landscape through erosion, newly shaped, formed, and sculpted.

I wonder when this catastrophic force will reach me?

Erosion. Perhaps this is what we need, an erosion of all we have held secure. A rupture of all we believed sacred, sacrosanct. A psychic scouring of our entrenched ideals such as individual property rights in the name of economic gain at the expense of ecological health.

I wonder when it will reach me?

Erosion. The wall of water hits. Waves turn me upside down and sideways as I am carried downriver. The road I stand upon becomes a river, my legs knocked out from under me. I am tumbling in the current, dizzy in the current, dark underwater. I am holding my breath, holding my breath. I cannot see but believe I will surface, believe I will surface, holding my breath. The muscle of the river is pushing me down, deeper and deeper, darker and darker. I cannot breathe, I am dying under the pressure, the pressure creates change, a change of heart. The river changes its heart and pushes me upward with the force of a geyser, I surface, I breathe. I am back in the current, I am moving with the current, floating in the current, face up, on my back. There are others around me, our silt-covered bodies navigating downriver, feet pointing downriver. We are part of the river, in boats of our own skin, finally, now our skin shining, our nerve returning, our will is burning. We are on fire, even in water, after tumbling and mumbling inside a society where wealth determines if we are heard, what options we have, what power we hold.

Can I get my bearings inside this river?

Erosion. I look up. Canyon walls crack and break from the mother rock, slide into the river, now red with the desert. I am red with the desert. I continue to float, my body rolls over and over in the current, and I pray the log jam I see ahead will not reduce me to another piece of driftwood caught in the dam of accumulation.

Who has the strength to see this wave of destruction as a wave of renewal?

I find myself swimming toward an eddy in the river, slower water, warmer water. We are whirling, twirling in a community of currents. I reach for a willow secure on the shore, it stops me from spinning. My eyes steady. The land is steady. In the pause of this moment, I pull myself out. Collapse. Rise.

Now on shore like a freshly born human, upright, I brush my body dry, my skin glistening, and turn to see miraculously once again that I am standing in front of the Birthing Rock, my

Rock of Instruction, that I have sought through my life, defied in my life, even against the will of my own biology.

No, I have never created a child, but I have created a life. I see now, we can give birth to ourselves, not an indulgence but another form of survival.

We can navigate ourselves out of the current.

We can pull ourselves out of the river.

We can witness the power of erosion as a re-creation of the world we live in and stand upright in the truth of our own decisions.

We can begin to live differently.

We can give birth to deep change, creating a commitment of compassion toward all living things. Our human-centered point of view can evolve into an Earth-centered one.

Is this too much to dream? Who imposes restraint on our imagination?

I LOOK AT THE ROCK AGAIN, walk around to its other side, the side that is hidden from the road I experienced as a river. The panel has been shot away, nicked by bullets, scraped and chipped to oblivion.

We have it in us to both create and destroy beauty.

Freedom and choice are at the heart of this nation. We can choose to participate in an ecological democracy born out of our love for the comprehensive community of rocks, river, plants, animals, and human beings.

Or we can disregard the depth of our relations beyond our own species and continue along a path of destruction where selfishness is encouraged and generosity is forgotten.

The heart of a nation.

Where is it? What is it? The heart of this nation is beating, beating, beating; the heart of this nation is wild, still wild; wildlands, wildlife, wild hearts in every one of us, wild with the courage to explore new terrain. To change our allegiance is new terrain.

I pledge allegiance.

Six small figures have survived the shooting rampage. I bend down and look more closely at

the deliberate nature of these petroglyphs.

Someone cared enough to create life on a rock face, to animate an inanimate object. Someone believed they had the power to communicate a larger vision to those who would read these marks on stone, a vision that would endure though time.

Call it faith.

Call it hope.

Call it the art of sustainability.

I see a spiral and what appears to be a figure dancing, her arms raised, her back arched, her head held high.

We can dance, even in this erosional landscape, we can dance.

I have come full circle around the boulder.

There she is, the One Who Gives Birth. Something can pass through stone. I place one hand on her belly and the other on mine. Desert Mothers, all of us, pregnant with possibilities, in the service of life, domestic and wild, it is our freedom to choose how we wish to live, labor, and sacrifice in the name of love. ■

George H. H. Huey

Islands of Hope

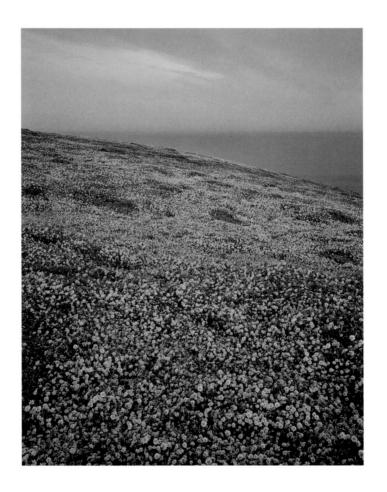

In the end, we conserve only what we love. We will love only what we understand. We will understand only what we are taught.

— Baba Dioum

In 1835 a schooner arrived at San Nicolas, one of the Channel Islands off the southern California coast, to carry the last Chumash Indians still living on their ancestral islands to the mainland. None would ever return, but it turned out that one woman stayed behind. Eighteen years later she was discovered living in a hut made of whale ribs and sea lion skins. Friendly ravens and feral dogs were her only companions. She had survived on the island's abundance of birds, fish, shellfish, and seals. Her rescuers took her to Santa Barbara, where she delighted in new clothes and fresh fruit and vegetables. Six weeks later, Juana Maria, the Lone Woman of San Nicolas, died. I can only imagine why.

Many years later, on a night of thunderous wind I found myself alone on a trio of sharp-ridged, nearly treeless islets collectively called Anacapa, one of the five islands protected within offshore Channel Islands National Park. The ranger had bid me a cheerful goodbye that morning before taking the only boat to the mainland. Now, weather howling in from the Pacific Ocean shook the windows and doors of the old Coast Guard bunkhouse. Ghosts and shipwrecks crossed my mind.

In the night, my ear caught a sound above the wind, like a door opening and closing, or maybe someone knocking. Fourteen miles across the storm-tossed Santa Barbara Channel lay the coastline of a megalopolis, Los Angeles, but I might as well have been a thousand miles away. I've camped alone in the High Rockies, when babbling streams seemed to speak to me in human voices. I imagine the noise I heard was a similar trick of sound and mind in the dark of the night. I saw nothing in the flashlight's beam when I investigated.

As a child, the islands seemed to be apparitions when I first glimpsed them from the Santa Barbara beach near my grandparents' home on visits from New York City. I remember the distant vision of Santa Cruz island on the horizon, so clear it seemed I could touch it, yet so far beyond my reach.

The Channel Islands reach out into the Pacific like stepping stones toward youth's inchoate hopes of a limitless world. One camper wrote in Anacapa's log book, "This island is the first in a series of platforms leading to the edge of space." Standing on its cliffs, with America behind me, looking out over Earth's largest ocean, the vastness filled me with hope. It was still a world of open space, with unknown possibilities. ∎

Goldfields on Santa Barbara (opposite)

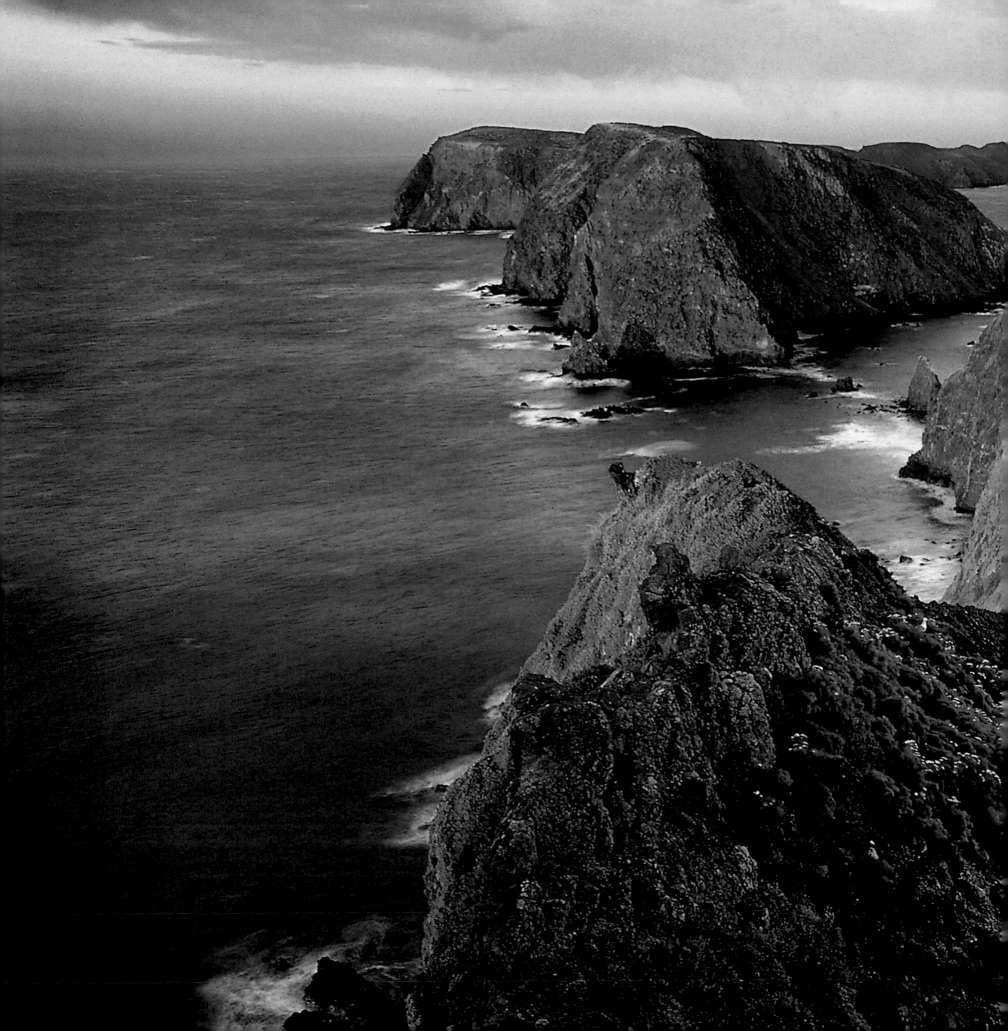

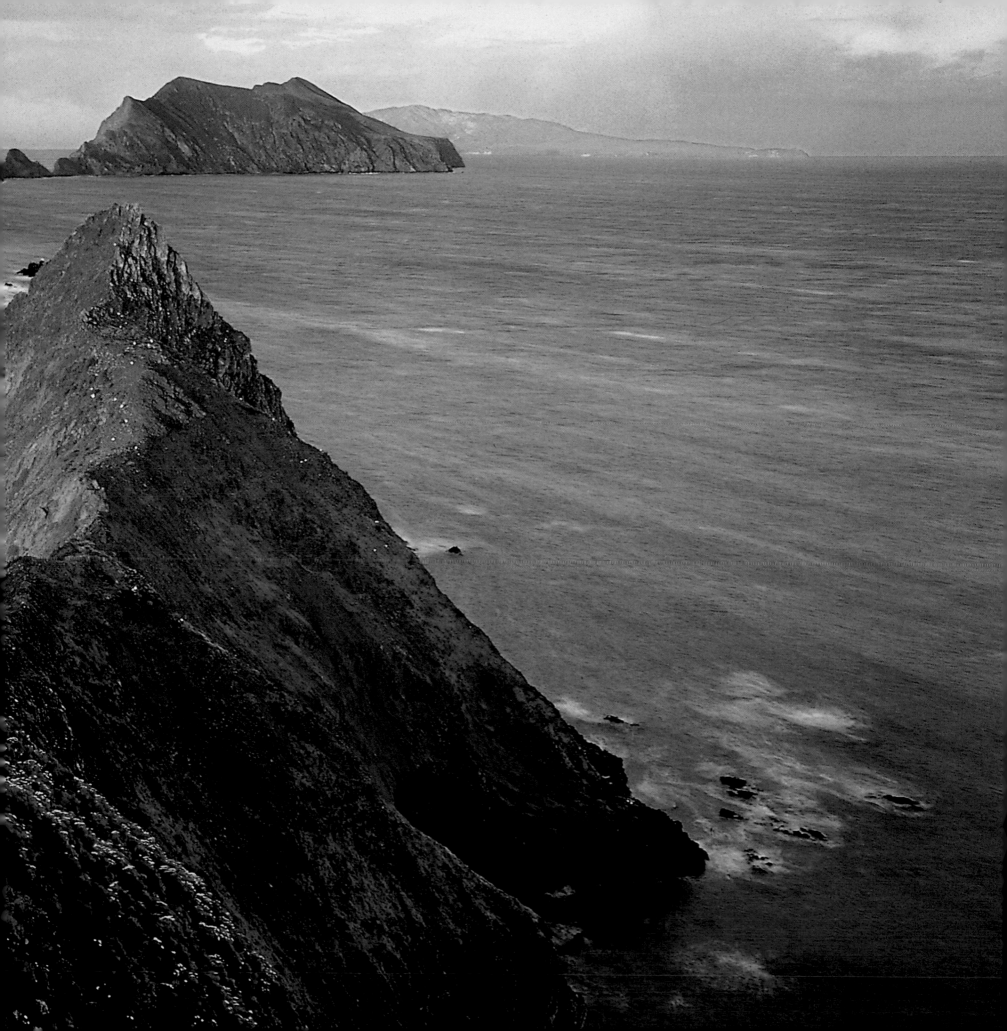

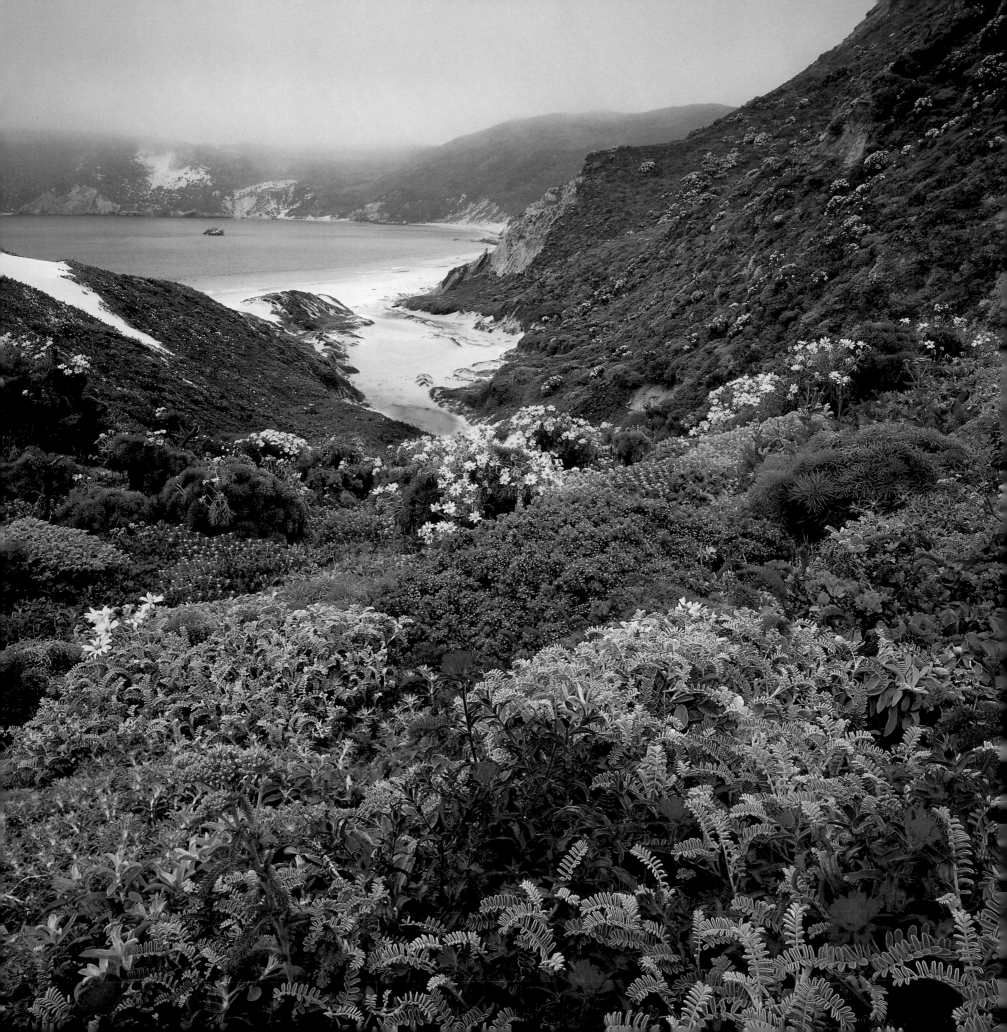

Winter rains transform the slopes of San Miguel from a drab California brown into a brief flowering garden of red paintbrush and yellow giant coreopsis (opposite). Succulents such as dudleya (above right) store moisture in juicy leaves through the dry months. In the splash zone, where waves bathe the rocks, a bat star (below right) finds its niche where air and ocean meet.

PRECEDING PAGES: Set in a sea of plenty, Anacapa's three islets total just over a square mile. Around them grow luxuriant kelp beds in cold waters that sustain a plethora of ocean life. On east Anacapa, nothing grows higher than my waist, and it seems that the bunkhouse must be anchored in rock to keep it from blowing away.

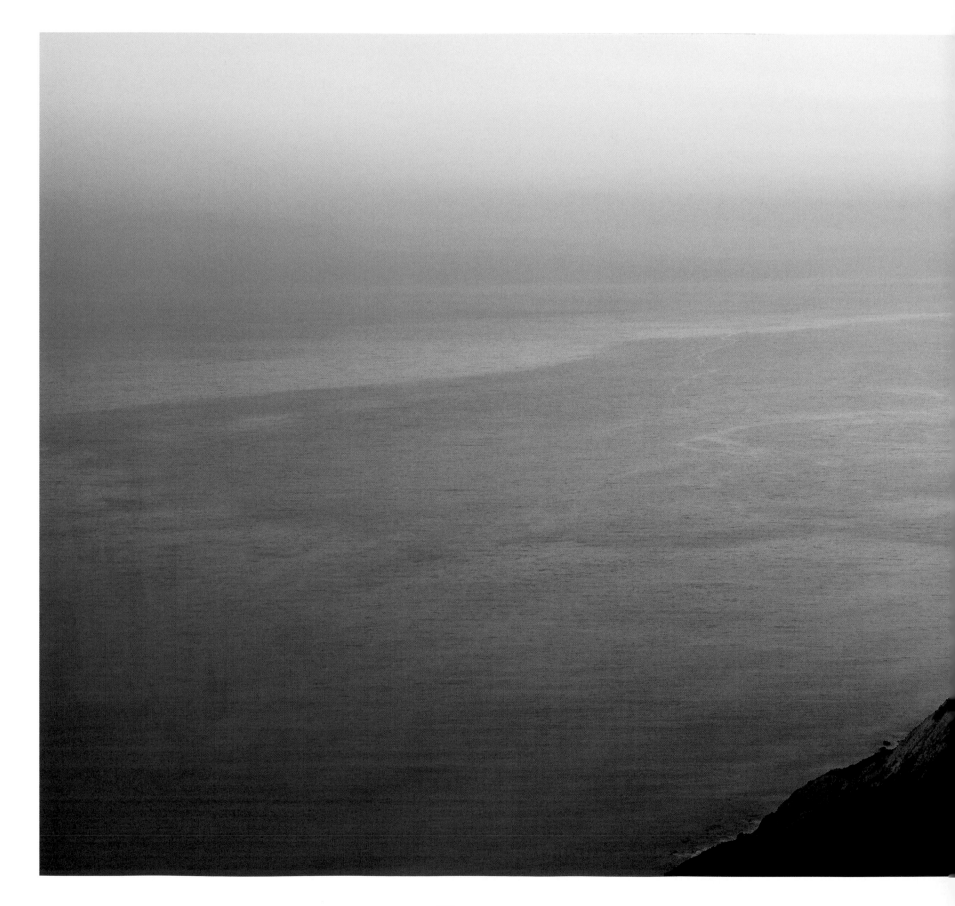

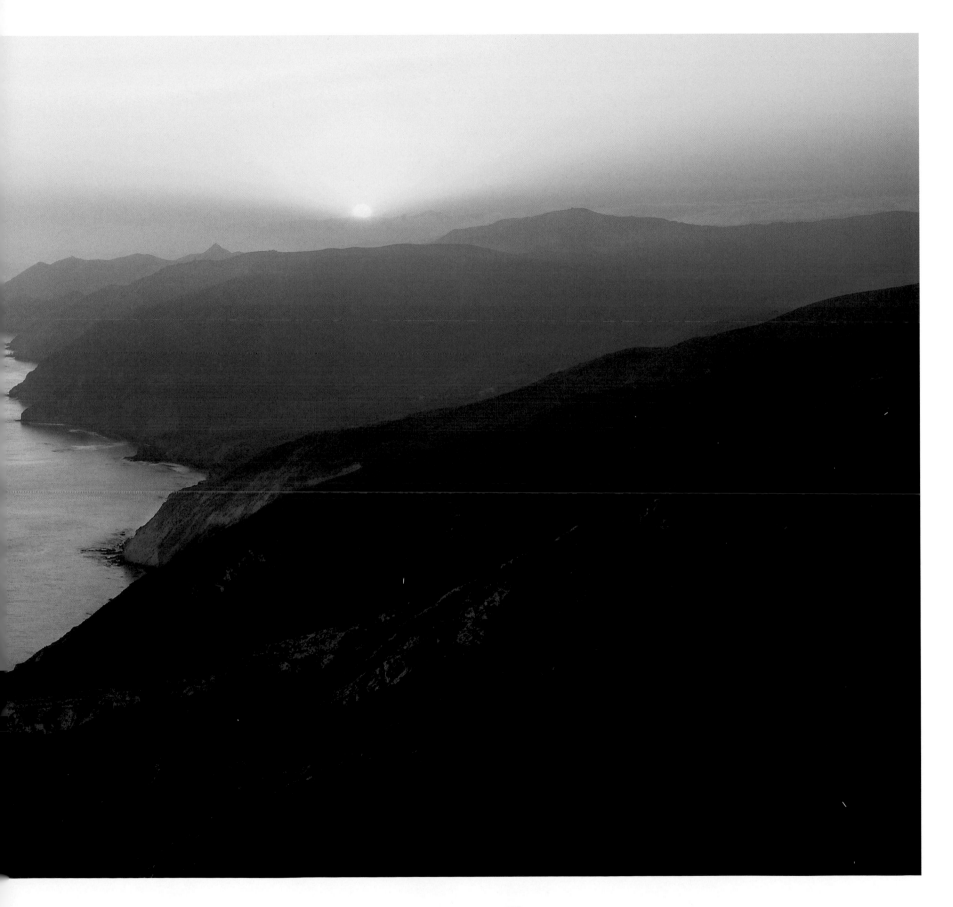

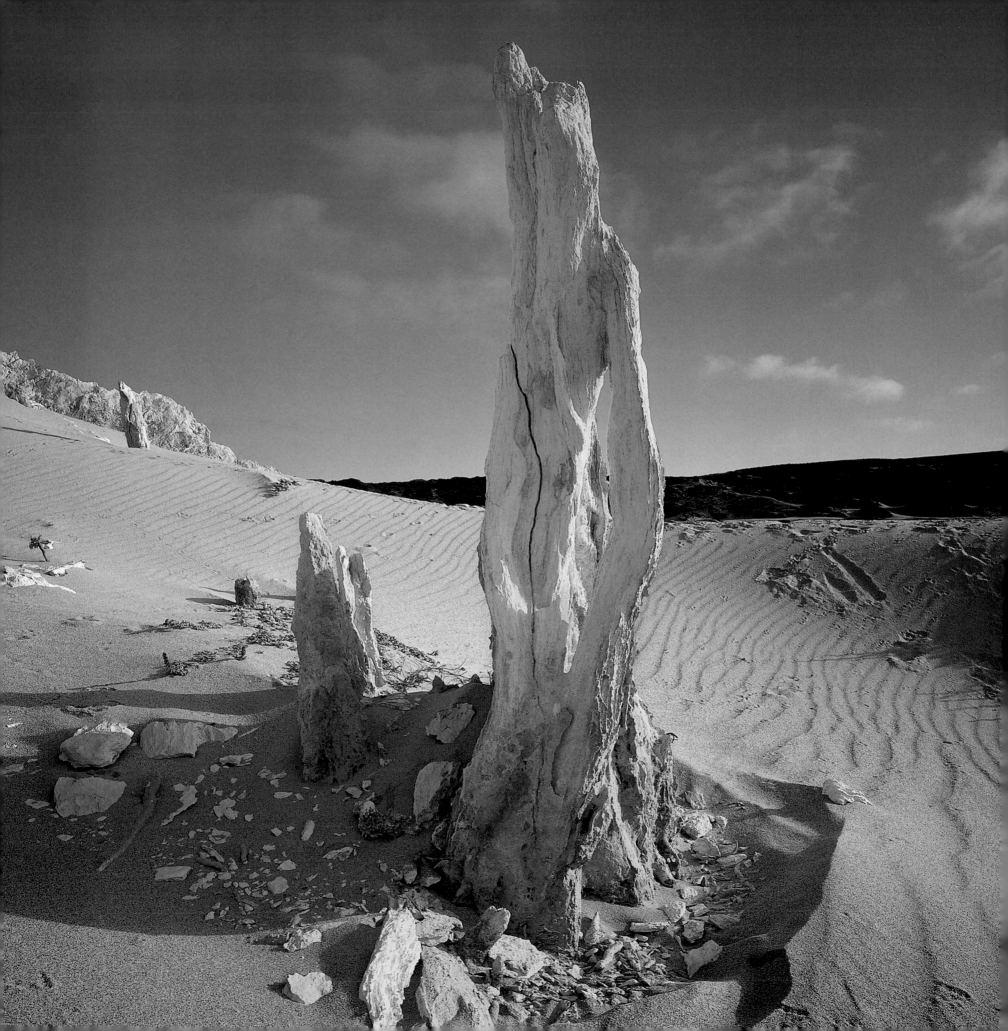

Forests of stone stand exposed on San Miguel, where shifting sands reveal mineralized caliche castings of long-dead tree trunks and roots (opposite). Lying 55 miles off the coast, the westernmost Channel Island is most exposed to wind and storms, and also to nourishing moisture from Pacific fogs. That may be what lured a land snail (below) onto a morning glory blossom, one misty morning when I was out for a walk.

PRECEDING PAGES: Looking west from a high point on Santa Cruz, nothing but ocean lies beyond the setting sun. Largest of the islands, Santa Cruz has touches of the mainland's diversity, with streams, waterfalls, oak groves, and a 2,400-foot peak.

On Santa Barbara island, a sea lion (below) heads for the surf. Many sea mammals beach on the Channel Islands' shores and feed off the rich waters that envelop the islands. On San Miguel, a juvenile northern elephant seal (opposite) huddles between its elders at Point Bennett. This promontory is favored as a haul-out spot for six species of pinnipeds, which include fur seals, sea lions, and elephant seals, in a congregation that numbers as high as 30,000.

FOLLOWING PAGES: No trails reach Webster Point on Santa Barbara island. There's something about this island, not much larger than Anacapa, that speaks to me: Small and well-defined, it is built to human scale, giving me the feeling that over time I can truly get to know and appreciate it.

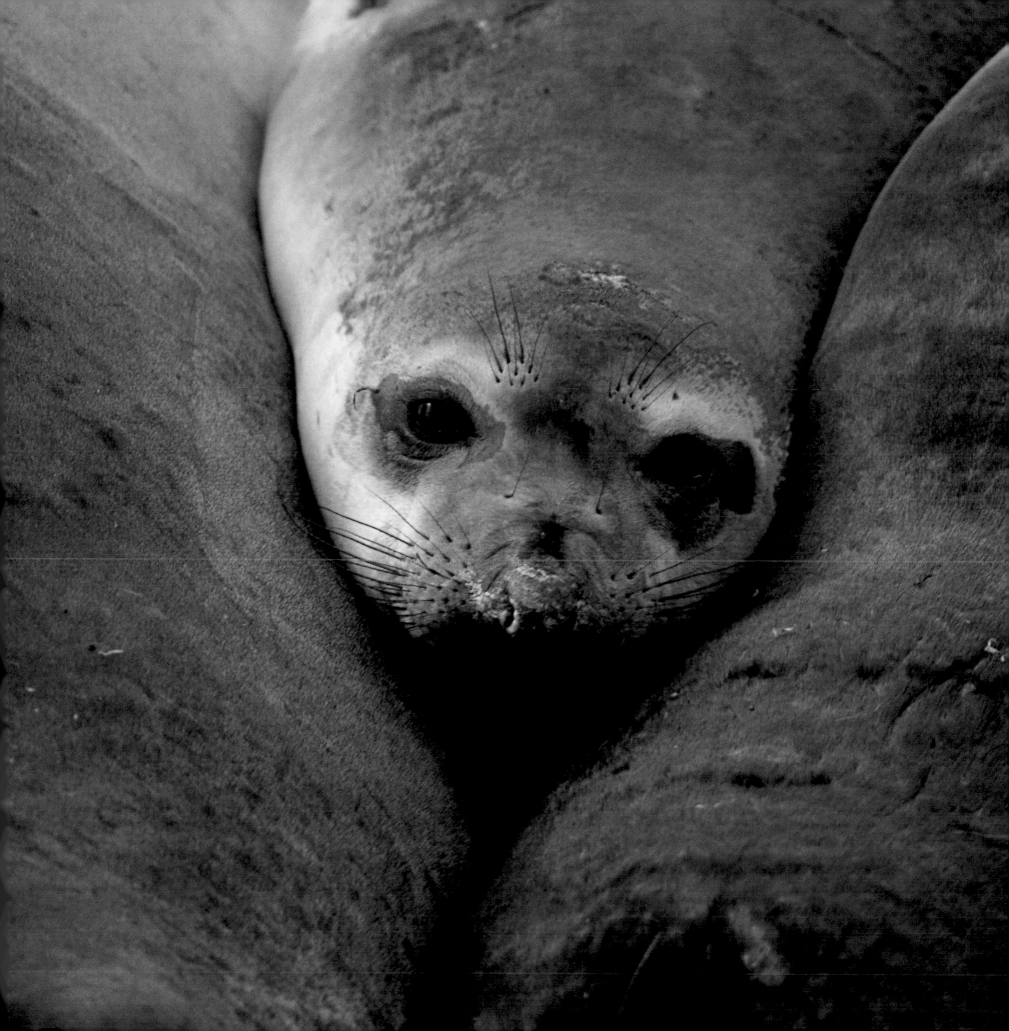

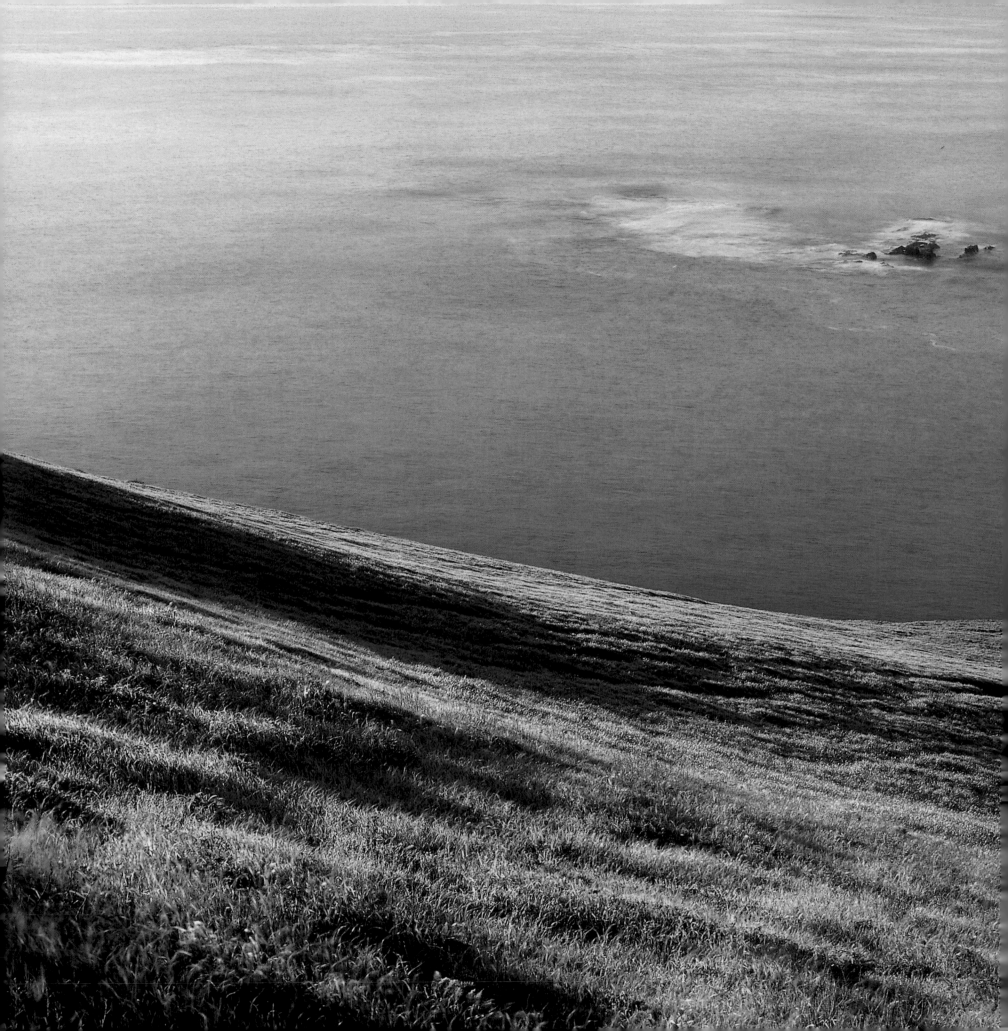

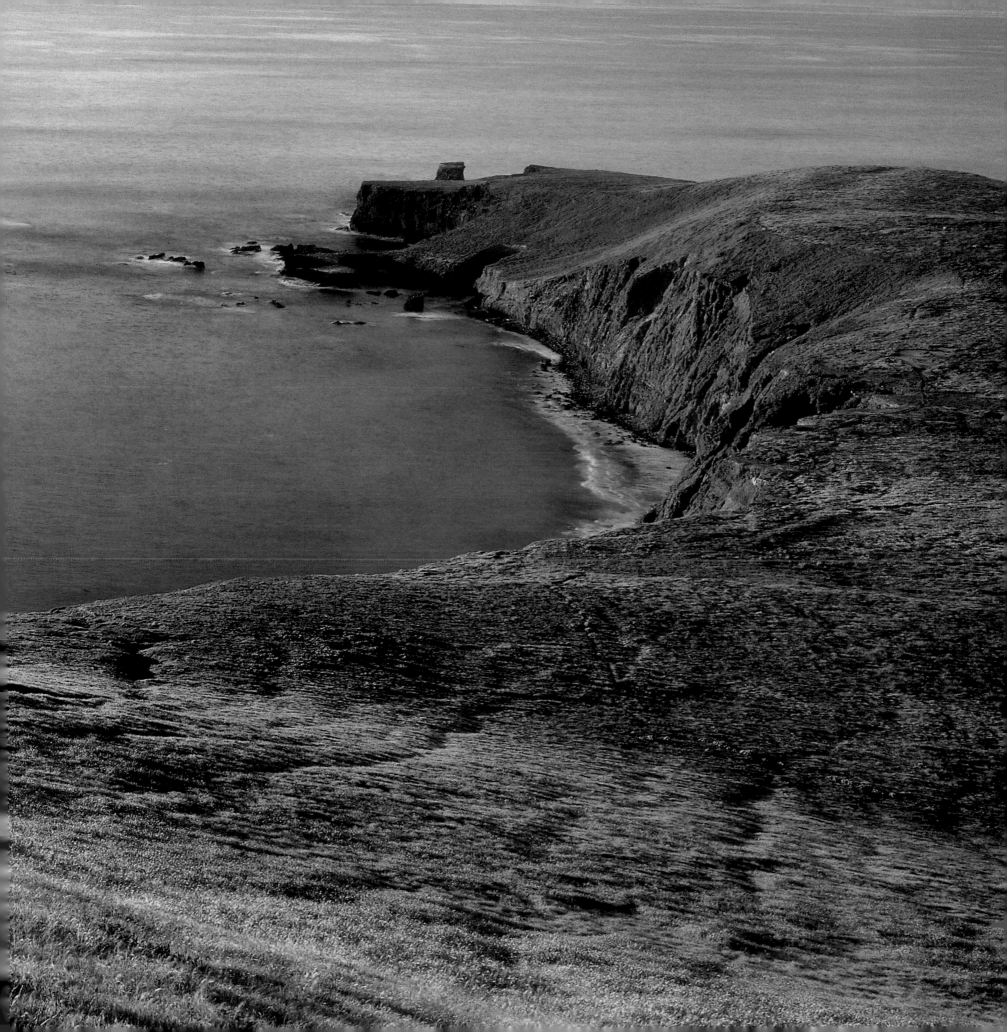

Richard Nelson

Island of
the Rain Bear

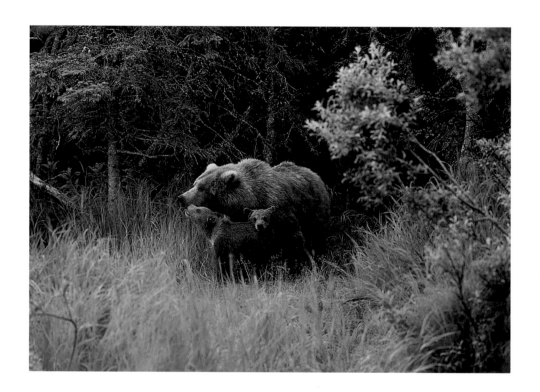

Everybody needs beauty as well as bread,
places to play in and pray in where Nature may heal
and cheer and give strength to body and soul alike.

—John Muir

A hushed, damp, cool August evening, embroidered with the sighing calls of mew gulls, the chiming of varied thrushes, the murmur of distant waterfalls. Our skiff glides easily into a narrowing estuary where the stream from Lake Eva swirls into Peril Strait. With my friend Don Muller, I've come 70 miles from Sitka, navigating the complex tidal channels of Baranof Island, in the Tongass National Forest of southeast Alaska.

A lone merganser duck paddles on the silky water, cutting a wake through reflected mountain walls. Her crested, cinnamon head turns this way and that, as if she's looking first at us, then at something else. Following her gaze, I pick out a hulky shape beside the far bank, shadowed by the boughs of an enormous spruce. It looks like a half-submerged boulder uncovered by the falling tide; yet there's something strange...a softness at the edges, a tangible ephemerality. As we idle closer, the rock seems to breathe and gently rise, triggering a crescent of tiny ripples.

For a moment, I'm distracted by a marmalade-colored jellyfish drifting beneath us, big as a basketball, trailing hundreds of threadlike tentacles. And then—looking back at the rock—I see the truth of it: sloping shoulders, neck as wide as a young tree trunk, and a broad, densely furred, tawny brown head.

"Bear!" I whisper. Don nods intently. I can only imagine his pleasure: A dedicated advocate for wildlife and forests, his face is absolutely beaming.

The animal peers our way, showing the humped shoulder and dished face of a grizzly, or brown bear, as it's called locally. I expect the bear—apparently a young male—to retreat, but instead he casually swims out into the lagoon, ducking his head underwater at intervals, searching for spawned-out salmon. Finding none, he heaves up onto the opposite shore. And there he stands, at the hard seam joining water and land: an upright bear perfectly balanced on the splayed paws of an inverted bear shimmering on the liquid mirror.

After a contemplative pause, the bruin shakes himself dry and rambles along the bank, stopping occasionally to sniff the air, still oblivious to our intrusion. He also ignores a yodeled voice tumbling from the high mountainside. I glance up to see a raven, black as the eye of night, soaring beneath latticework clouds.

Although I first came to southeast Alaska 30 years ago, the immense wildness and tranquility

Grizzly bears in Alaska; Johnny Johnson (opposite)

of this place still sets my heart thundering. It makes a child of me—an avid, eager, excited, impatient child, seized by a perpetual rage for discovery. Even in midsummer, when the daylight spans 20 hours, I mutter about the time lost to darkness and wish for a way to evade sleep. If only I had come to southeast Alaska much earlier in life...but more than anything, I'm grateful for the blessed serendipity of being here at all.

I had dreamed of this place—imagined myself living in the company of ravens and brown bears—long before I left the family nest in Wisconsin. As a college student majoring in anthropology, I became fascinated by Indian cultures of the north Pacific coast, and especially by their lavish temperate rain forest environment. In my class notebooks, I'd sketch an imaginary cove with a cabin among tall conifers, a simple garden, a skiff drawn up on the beach, a storehouse for venison and dried salmon and wild berries.

But instead of coming to southeast Alaska, I traveled much farther north and lived for some years with Inupiat Eskimos, Kutchin Indians, and Koyukon Indians, learning about their ways of hunting, fishing, and gathering. Eventually, I made a trip to Juneau, where I saw, for the first time, the snow-covered mountains, the deeply incised fjords, the great towering forest. Despite all the books and pictures and fantasies, I had no sense of encountering the expected or familiar—just the bewildering, incandescent elation of coming to a place where I *belonged.*

Years later I owned a homestead cabin just like the one in my sketches, overlooking an inlet on Chichagof Island near the village of Tenakee Springs. Together with my partner, Nita, I fished and hunted for food, cut firewood, helped to raise a growing boy, explored the valleys and waterways, and savored a life wholly imbedded in wild nature. Then one summer, chain saws and logging trucks entered the surrounding Tongass National Forest and over the following years clearcuts spread across the slopes facing our inlet. Our dream was slipping away, so Nita and I moved to the town of Sitka, on nearby Baranof Island, where the forest, waters, and wildlife seemed less in jeopardy.

The front window of our little house faces an open-mouthed bay, with a palisade of mountains on the east and south, rocky breakwater islands toward the west, and the open Pacific sprawling beyond. The line between town and wild is indistinct here: Cormorants, gulls, loons, and bald eagles frequent the bay; harbor seals, river otters, sea lions, and humpback whales are common off

our shore; millions of herring swarm along the beach each spring, followed by the summer runs of salmon; black-tailed deer visit our haphazardly gardened backyard; and brown bears haunt the forest just beyond.

But however much we relish the company of wild creatures, it's the human community, above all, that keeps us here. Our town stretches along 14 miles of crenelated shoreline, pinched between steep mountains and the sea. Most neighborhoods clump on either side of the single main road that terminates abruptly at both ends. To go any farther, you need a boat or plane. This brings a particular quiet and measure to the pace of daily life. Remoteness also tightens the bonds between people, reminds everyone of how much they need each other, and enhances the tendency for small towns to nurture big hearts.

Most of us came here from somewhere else, and to compensate for the severing of home ties, we've developed intricate webs of friendship, much like an extended family. An older social tradition persists among us: We visit constantly, thriving in the companionship of like-minded souls; we share foods from the wild and the garden; we watch out for everyone's safety in times of travel and storm; we take care of each other's children; we fish and hunt and gather together; we are united in our common love for this place and our concern for its well-being.

I think of my relationship to these home grounds as a kind of marriage—a commitment of body and heart. Although I enjoy the flirtations of travel and relish the beauty to be found elsewhere, I'm always drawn powerfully home, always excited to see this familiar coast again. Although I was not born *in* this place, I believe I was born *for* it. When I return from a long trip, I'm reminded of the urgent thrall that brings salmon back to their natal streams, and of the predators and scavengers whose hunger for fish draws them to the same locale each year.

On this summer evening, our Lake Eva brown bear is apparently so focused on hunger that he cares little about our presence. I wonder why he doesn't move farther upstream where he could snatch salmon almost at will from the riffles. Danger, I suspect. The best fishing spots are often defended by heftier bears—mothers with cubs, or especially the prime males weighing as much as 800 pounds. A smaller bruin edging into their territories risks being chased off...or worse.

And we know there are plenty of bears around. Earlier today, Don and I joined some friends

hiking along a tributary streamlet that meanders through a stand of ancient forest. We'd all come to assist the Landmark Tree Project, a search for the biggest trees remaining in the Tongass National Forest, with a goal of working for their protection. And we did pretty well, threading our way between massive trunks, peering into the perpetual gloom beneath overspanning boughs, and feeling as if we had entered a forest sanctuary guarded by a congeries of brown bears.

We followed heavily worn trails inscribed with the signatures of their makers: bear tracks, everywhere—imprints of broad leathery soles squashed far down into the mud, each pocked along the front by five toes and the probe marks of formidable claws. Our own boot prints looked puny and ridiculous beside them. Almost certainly there were bears listening to our voices as we passed, perhaps even scrutinizing us from hidden places; but we never glimpsed a tawny flank or heard a scuffle in the underbrush.

Tongass brown bears are seldom aggressive toward people, but there's always the danger of startling a bruin at close range or intruding on a mother with her cubs. For this reason, while hiking, some of us put up a noisy banter, a few carried pepper spray, and everyone kept a nervous watch on the thickets. Never had I come across such an abundance of bear sign in one place. The thrill of it set my whole body jangling, like being rumbled awake by an earthquake or watching a tornado reel across the plains. But let me confess right now: I was incredibly grateful not to be alone.

Scattered everywhere along the stream were partially eaten salmon—most of them cankerous with rot. A rich aroma of decay lay heavy in the supersaturated air, clinging to our skin and flooding down into our throats. I'd occasionally see a salmon that looked so fresh it might have been plucked from the water minutes before. These carcasses were like messages from an unseen overlord, lest visitors forget about the one who holds sway here.

Many of the fish were partly skinned—or rather peeled the way a child takes off socks—with chunks of rosy flesh torn away, bellies gaping open, innards trailing out. Sometimes only the back of the head was nipped off, as if the brain were a delicacy, and the rest abandoned to scavenging ravens, gulls, eagles, mink, and otters. There was blood and offal strewn over the rocks, strewn on the cushiony moss, strewn beneath the parasol leaves of devil's club bushes, strewn

in the murky basins of bear tracks.

The tributary was mostly narrow enough to jump across and so shallow it wouldn't cover a salmon's back, but there were plenty of fish circling aimlessly in deeper pools, skittering across riffles, bursting away as we came near, throwing sheets of spray with their tails. They had no place to hide or escape, so a hungry bear could simply choose a fish and swipe it out onto the bank. But the bears wouldn't catch them all, especially since they spent much of their time hunting along the main river just a hundred yards off, where incalculable thousands of salmon were heading upstream.

When salmon reach their gravelly spawning beds, the slender-bodied females swash out shallow nest depressions; then they quaver in a mating dance beside the humpbacked, hook-jawed males, which engulf the crimson eggs in chalky clouds of milt. Late into the fall, waves of salmon pour up into the river—pinks, chums, sockeyes, and finally silvers. Some fish spawn in the lower reaches, some carry on into Lake Eva, and others lay their eggs far up in the feeder streams.

I knelt beside a crystal pool containing five or six pink salmon. After a few minutes they settled down, nosed into the current, and languidly sculled their ragged tails. It was hard to imagine the journey they had undertaken since hatching in this same river system two years ago. They emerged as yolk-bellied alevins in late winter, grew into minnowy smolts, flushed down to saltwater with the spring runoff, and then spent a couple months in the estuary feeding on plankton. By late summer they made their way to the open sea, following an immense, circling gyre into the far reaches of the north Pacific, slashing through clouds of prey, fattening themselves from the riches of the distant ocean. Now, at the end of their second summer, they had returned to their home waters for the final miracle of their life cycle: mass procreation coinciding with synchronized, collective death.

JUST AS THE NORTHERN SEA NURTURES prodigious numbers of fish, it also gives life to the sky, spawning an oceanic mass of clouds and igniting powerful storms that charge up against the coast. This collusion of sea and sky dominates southeast Alaska's weather: Overcast is

the norm, rain is likely on most days, and sunshine in the forecast is rare enough to make a steadfast workaholic phone in sick. Most parts of the Tongass National Forest average about a hundred inches of precipitation yearly, about three times that of notoriously drenched Seattle. Even the profusion of streams channeling rainfall down off the mountains—these coalescing waters so vital to the lives of salmon—are a gift from the ocean.

During the fall and winter months, convergence of Arctic and oceanic air fuels a steady progression of storms, which often rumble through every few days, sometimes reaching hurricane strength. There are few things I'd rather do than run outside into the full, throaty rage of a north Pacific gale, to watch it flail the forest like a wheat field, tear off branches and pitch down trees, shake houses until they creak and groan, thrash the seas to a frenzy, and besiege the shore with explosions of white water.

To truly love southeast Alaska, you must learn to love clouds and storms and rain. You must accept that the human body, being mostly water on the inside, can thrive while constantly wet on the outside. But the truth is, most newcomers settle here for a while and then leave, like pilgrims questing for the desert, their palms opened to the sun. The few who stay can thank the rain for our mercifully small population, our luxuriously rich forest, our miraculously pristine environment.

For all the fierceness of its storms, southeast Alaska's winter temperatures are surprisingly mild, often above freezing and seldom below zero. But snow may come with a vengeance, piling up waist high in the meadows, sending avalanches down the slopes, turning the trees into billowing white colonnades. Winter can be tough on wildlife, especially the black-tailed deer, which survive in the old-growth forest where a dense canopy of boughs intercepts the snow and limits accumulation on the ground underneath. Only in these sheltered places can deer find the low-growing plants they rely on for food, and during severe winters death from starvation hits hardest where the forest has been cut down.

WINTER SEEMS LIKE AN ILLUSION on this August evening, as we drift lazily on calm water, watching the young brown bear wallow in a field of lush beachside grass. Even the high

mountain tundra, where brown bears hibernate in cave-like dens deeply buried by snow, is clothed in brilliant green. But summer is already on the ebb—the hunters and foragers and scavengers gathered along Lake Eva's stream are feasting not just for the pleasure of overindulgence but also to allay the coming trials of winter.

A slow current carries us parallel to the bear's bankside wanderings, bringing us within close range; but he remains almost alarmingly nonchalant about our presence, as if the skiff were nothing more than a floating log. At last, when we've come near enough to hear his scuffling footfalls, the bear finds a lifeless salmon in the grass. He nuzzles the carcass, flips it over, holds it down with one platter-size paw, and deliberately tears off hunks of meat. I'm struck by the powerful musculature in his shoulders, the brawny span of his chest, and the delicate precision with which he uses his long, burnished, scimitar claws. The rhythmic crunching of his jaws comes clearly to us on the still air.

Every time I see one of these island bears, I feel the privilege of encountering a creature unique to our tiny fragment of the world. According to biologists, brown and grizzly bears came into North America from Asia during glacial times, then spread widely across this continent. When the ice sheets withdrew, a small population of ancestral brown bears became isolated on three adjoining islands in southeast Alaska—Admiralty, Baranof, and Chichagof. These Tongass island brown bears have now been separated from their kin for many thousands of years and have changed relatively little from their ancient predecessors. Studies of mitochondrial DNA reveal that brown and grizzly bears everywhere else have become genetically quite different from the island bears (even though all are still grouped within one species: *Ursus arctos*).

There is another remarkable fact about these singular bears. Hundreds of thousands of years ago, the brown bear family tree separated into two branches: one leading to the modern brown and grizzly bears of North America and Asia, the other leading toward both our Tongass island brown bear and to its Arctic cousin—the polar bear. Because of this common ancestry, the Tongass bear is more closely related genetically to the polar bear than to other members of the brown and grizzly bear clan.

Tlingit Indians, who are native to southeast Alaska, call the brown bear *Xoots* (pronounced khoots), and as a gesture of respect for its physical and spiritual power they also address the animal

as "Grandfather." This honorific name seems all the more appropriate when we recognize the Xoots bear's status as a living ancestor.

It takes our young bear only a few minutes to finish eating his salmon and then lick every scrap from the grass. Relegated to the poorest fishing spots, he doesn't have the luxury of nibbling only the best parts of a fish and abandoning the rest. But like the other bears, he'll wander into the woods and bed down to digest his meal. Nutrients from droppings he leaves on the forest floor will dissolve into the soil, to be absorbed by the roots of spruce and hemlock trees, huckleberry and menziesia bushes, foamflower and goldthread plants, mosses and ferns. Many other mammals and birds that feed along the stream will contribute to this same process, as they've all done for millennia.

In this way, the forest has been nourished by salmon, and by the ocean from which they came.

As each season passes, thousands of salmon die in the stream, where their bodies decay and dissipate, endowing the water and the spawning gravels with rich organic material. These nutrients help to sustain billions of microscopic organisms, foundation of an aquatic food chain on which the growing salmon fry depend. And so, over a vast reach of time, each generation of fish has bequeathed their own bodies as sustenance for the following generation. In this way, the stream has been nourished by salmon, and by the ocean from which they came.

Insects, birds, small mammals, and large herbivores like the black-tailed deer depend on the forest plants fertilized by salmon. People also come here—as they have since ancient times—not only to explore and observe, but also to gather plants, catch fish, and hunt animals in the forest. In this way, humankind has been nourished directly and indirectly by salmon, and by the ocean from which they came.

The forest and sea flow inside my veins. I cherish them for the sustenance they provide, as much as I cherish them for their beauty. Venison, salmon, berries, and greens are among the staple foods in our home; foods we have harvested and processed ourselves. For me, it's important to know where they come from; to know they've grown in a clean, wild place free of pollutants and toxins; to take personal responsibility for the deaths of plants and animals by which my life is nourished; and to fully participate in the organic process that sustains all creatures on Earth, including humans.

When I lived with Koyukon Indian people, the elders passed along traditional ways of showing gratitude toward the living things that give us life. Success in hunting, fishing, and gathering depends not only on skill, they explained, but also on showing respect toward the game animals and toward all of nature, because everything around us is aware of our behavior, infused with spirit, and pervaded with a power far greater than our own. Koyukon people also believe it's essential to treat the environment according to principles of conservation and sustainable use handed down through the generations. These Koyukon teachings have been extremely valuable in my own life, alongside the similar wisdom being rediscovered today through Western science, philosophy, and religion.

Hunting, fishing, and gathering—which I first learned from Eskimo and Indian people—have become elemental to my sense of relationship with the place where I live. This is how I engage myself fully in the living community, recognizing that I am not merely an external observer here, as if the surrounding world were only significant as scenery. I am an omnivorous predator, an active member of the food chain, engaged in the most ancient of all human lifeways. These things undergird my spiritual relationship with the surrounding natural world, my physical connections with the sustaining environment, my sense of belonging within this mosaic of land and waters, and my love for the animals and plants from which my body is made.

Most people who live in Tongass communities eat wild food, which they harvest themselves or receive as gifts from their neighbors—a tradition rooted in the cultures of Tlingit and Haida Indians native to southeast Alaska, persisting strongly today among both native and non-native people. There are few other places in the United States where subsisting from the wild is such a vital part of the modern economy and culture; where navigating the remote waterways by boat is no less important than traveling the roads by car; and where townspeople discuss fishing or hunting or sea conditions more often than they talk about national events.

Subsistence livelihoods in southeast Alaska blend comfortably with another kind of wild harvest—commercial fishing. Trollers, seiners, gillnetters, and longliners crowd the harbors with brightly painted hulls and forests of labyrinthine rigging. The natural environment also attracts huge numbers of tourists who throng north in summer, hoping to experience the towns and their people, and to witness a spectacular landscape where much of the environment remains as it

was before Europeans set foot in North America, and where not a single native plant or animal species has yet disappeared.

The natural diversity and abundance of southeast Alaska is a gift of incomparable magnitude. In return for this gift, I feel a responsibility to give something back, by working to protect the peace and beauty, shelter and sustenance, uniqueness and diversity that so abound here. Because the Tongass National Forest is public land, I have the freedom to experience one of America's greatest wild places; the freedom to hike, camp, kayak, fish, hunt, gather, watch wildlife, photograph, and study here; the freedom to find peace and solitude in an open, accessible, unfettered land. And because the Tongass is a part of our national heritage, belonging equally to every American, my work as a conservation activist is volunteered in service to my country—a kind of patriotism for the American land.

On our way to Lake Eva, Don and I had passed many fishing boats working the waters, a few local folks in skiffs catching salmon for their freezers, and several tour ships crowded with visitors. We also saw a logging camp, and there were fresh clear-cuts splayed across the mountainsides for many miles along Peril Strait, some very close to the Lake Eva estuary. The future of wild animals like our young bear heavily depends on our efforts to protect all of the remaining forest, because Tongass island brown bears often fare poorly around logging operations and the associated roads, where they're susceptible to overhunting and poaching, and where they suffer nearly complete loss of habitat when the forest is cut down.

THESE WEIGHTY THOUGHTS VANISH FROM MY MIND as I watch the bear shamble along a muddy shore uncovered by the tide until he's come within 50 feet of us. At this point he stops, peers around for a moment, lifts his nose into the air as if he's searching for a scent, then eases down to the water and swims straight toward the skiff. Don's expression is one of complete amazement and mine is surely no different.

As the bear paddles closer, I realize that he may not be a behemoth, but he's still a formidable creature. The breadth of his back, girth of his head, and thickness of his neck are astonishing; and I know the true bulk of him, like an iceberg, is hidden underwater. He swims slowly, almost lazily,

looking back and forth, as if he has no destination in mind and might easily decide to clamber aboard the skiff. Instead, he passes less than 15 feet ahead of our bow.

It seems that the estuary has lapsed into a complete, almost oppressive silence, broken only by the powerful, deeply resonant huffing of the bear's breaths. I can see his nostrils flare and constrict, his jowls loosen and tighten. I can almost feel the sultry mist of his exhalations. When he swims by, he glances up and holds us in a momentary gaze, showing the creamy white crescents around the edges of his eyes. I have no doubt that this is a thinking animal and that he is thinking right now about us. Does he know us far better than we know him, as Koyukon elders would say?

For myself, I am only certain that I've never been so close to a brown bear, that I'm amazed and euphoric, and that an encounter like this scarcely seems possible at a time of such peril for wild nature.

When the bear approaches the opposite shore, I start the engine and gently ease the boat away toward Peril Strait. Don shakes his head and smiles, as we both look back, reluctant to let this end but feeling we should give the bear his time alone. The last we see of him, he's lounging content-edly in the grass, a dark silhouette beneath the sheltering wall of forest.

I switch the engine off and we drift on a cloud of glassy water, listening to the sighs and whis-pers of the trees. ■

A r t W o l f e

The Last Frontier

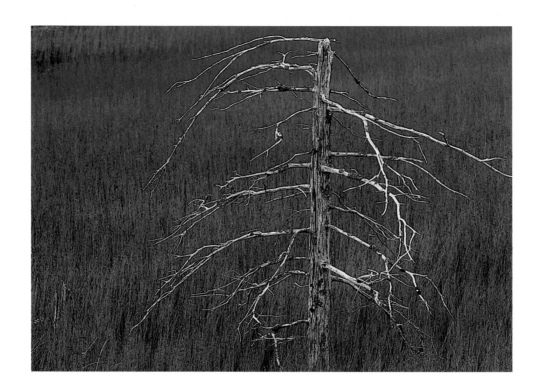

Those who contemplate the beauty of the earth
find reserves of strength that will endure as long as life lasts.

—Rachel Carson

There can't be many moments in the wild world more electrifying than sitting in a small, rubber boat on the mirror-smooth face of Frederick Sound, a fjord on the ice-strewn coast of southeast Alaska. The only noises around you are the calling of gulls and the rumbling of a glacier calving icebergs out of sight up the flooded valley. Suddenly a fizz of bubbles pops to the surface a few feet away.

I feel a surge of adrenaline shoot up my spine, because I know that beneath my boat, far down in the sun-shot, ice-water depths, a dozen humpback whales are streaking up toward me, mouths agape to envelop krill, tiny crustaceans they have herded into concentrated columns by blowing net-curtains of bubbles. In a few seconds they erupt out of the sea before me like volcanoes aborning.

As their doom nears, krill seethe within the bubbles' ringed perimeter, while herring leap desperately to escape the swelling pressure of the swimming maws rising from below. Then, in a shower of splashing confusion, leviathan heads bulge out of the water, knobby and barnacle-grown, streaming water and krill, to tower over my little craft. It's an outsized spectacle and is suitably matched to the giant scale of Alaska's 500 miles of panhandle that stretch along the north Pacific coast. For many years I've been lucky enough to return again and again to this place, the most compelling piece of landscape I know.

So much can be happening at once that I've often been confused as to where to point my camera: An eagle flies by while a pod of orcas swims past icebergs, whales feast on krill as a brown bear grazes—yes, grazes—on salt grass at the water's edge. This is a place where I can realistically imagine making a photograph of a breaching whale at the same time a bear feeds on the beach behind it. Ocean, mountains, glaciers, forests, and big animals of both land and sea all come together here in a wonderful way.

Even so, it can be a surprisingly benign environment. The lace of islands and inlets that runs the length of this coast breaks the fury of the open Pacific and creates scenes of unearthly serenity.

But it's undeniably a vertical coast, and above all dramatic. Nothing stands still in the face of its relentless dynamism. The land is in a constant state of transformation, its living creatures reacting and adapting to the ceaseless changes around them. This perpetual energy is something I hope never changes. ■

Evergreen in Tongass National Forest, Alaska

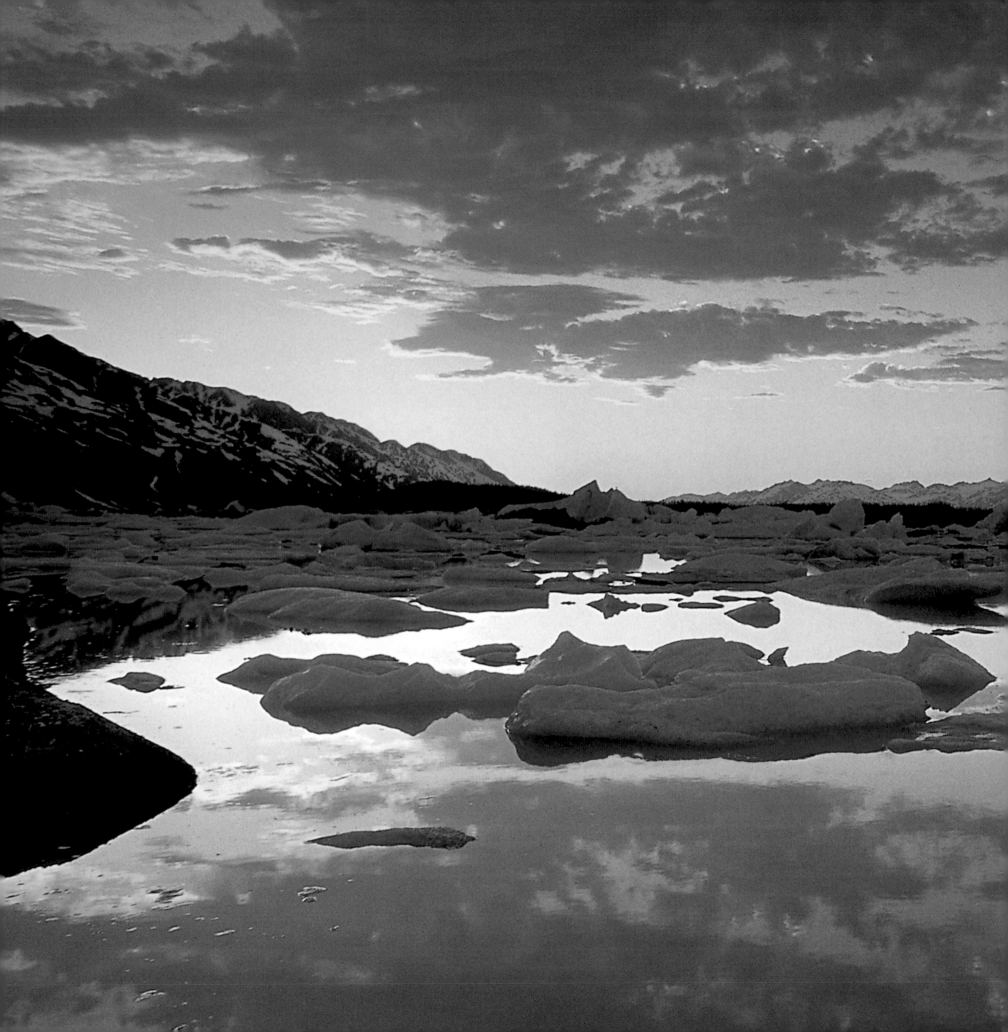

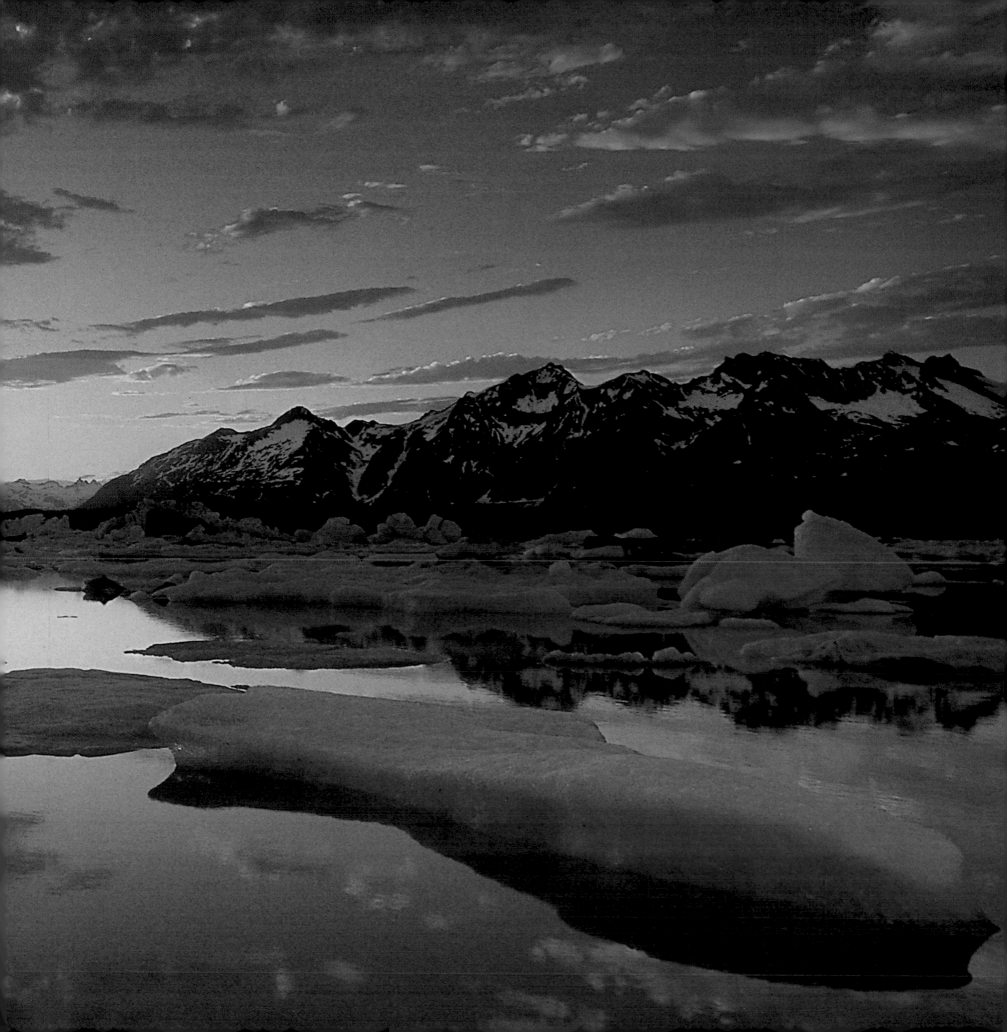

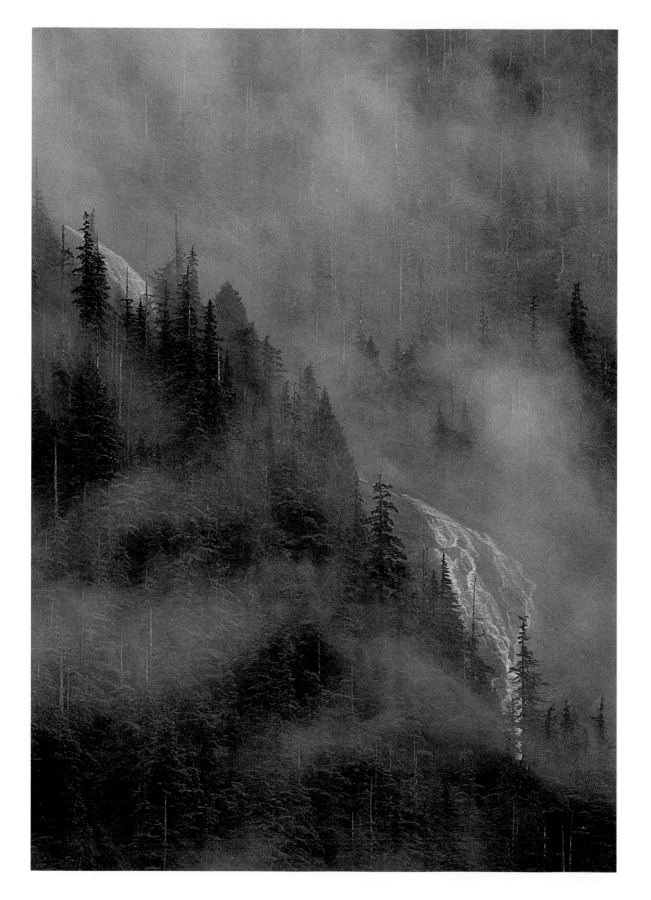

The line between what is organic and inorganic blurs in connections between landscapes and life-forms that knit the elements of this coast into a whole. A humpback whale (opposite) breaches to dislodge parasites—or maybe for the thrill of leaping—after feeding on krill in waters enriched by runoff that swells rivers and mountain-high waterfalls.

PRECEDING PAGES: In stillness at midnight, this remote world waits hushed in a twilight neither dusk nor dawn. Seldom have I been more happily discomfited than when an ice-jam delayed me for several days at a lake filled with Alsek Glacier's runoff on a raft trip down the Lower Tatshenshini, one of the wildest rivers in North America.

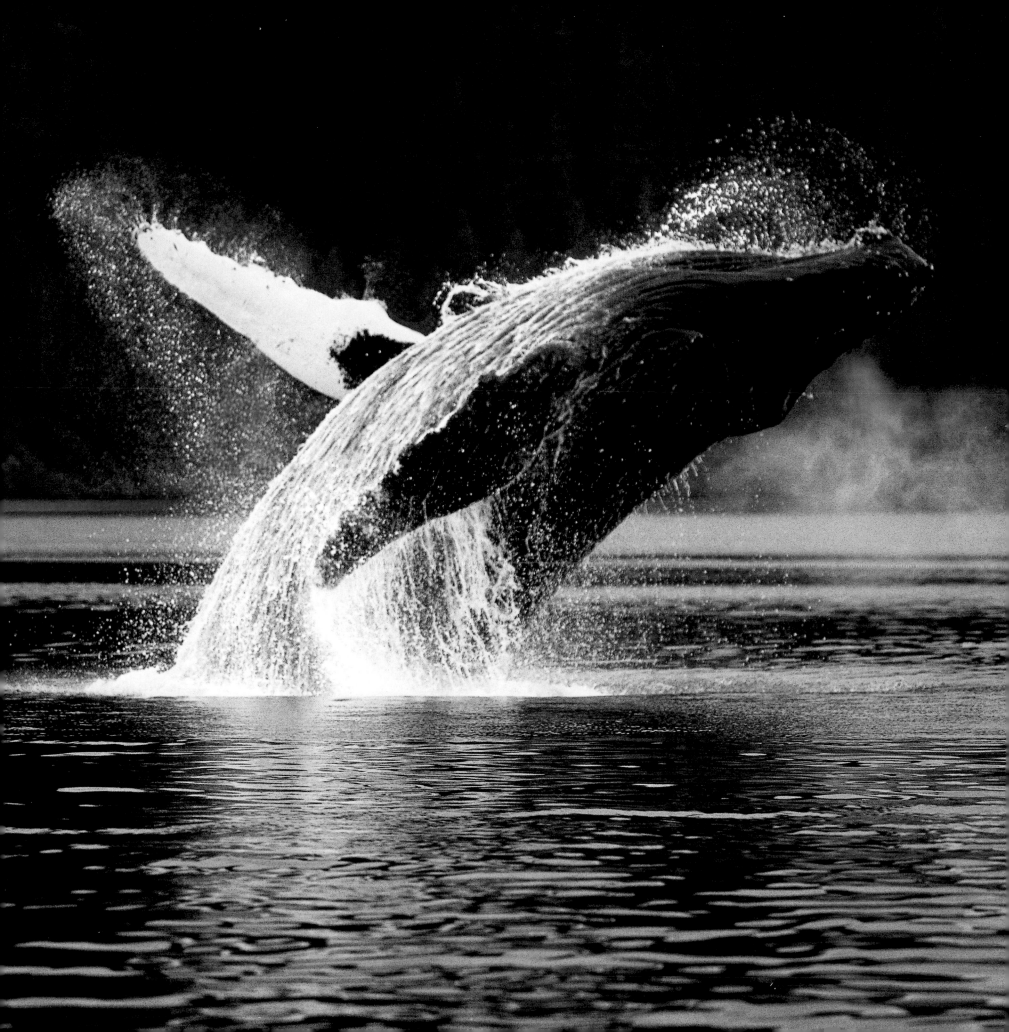

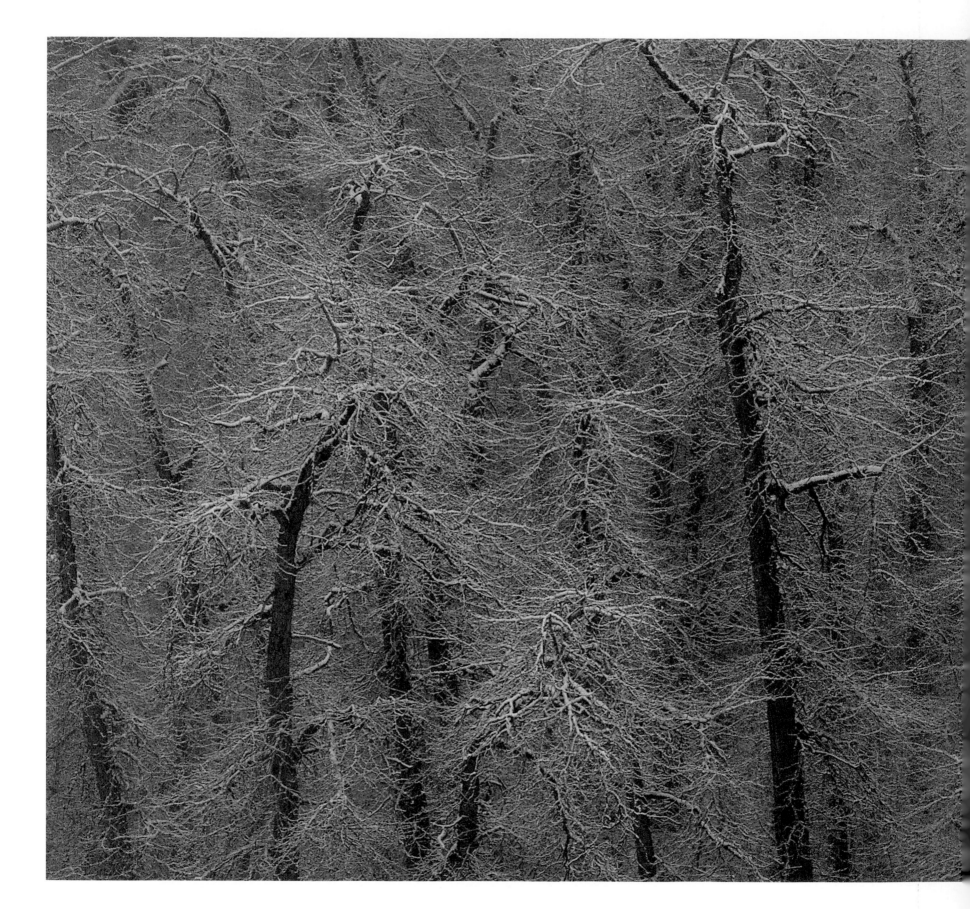

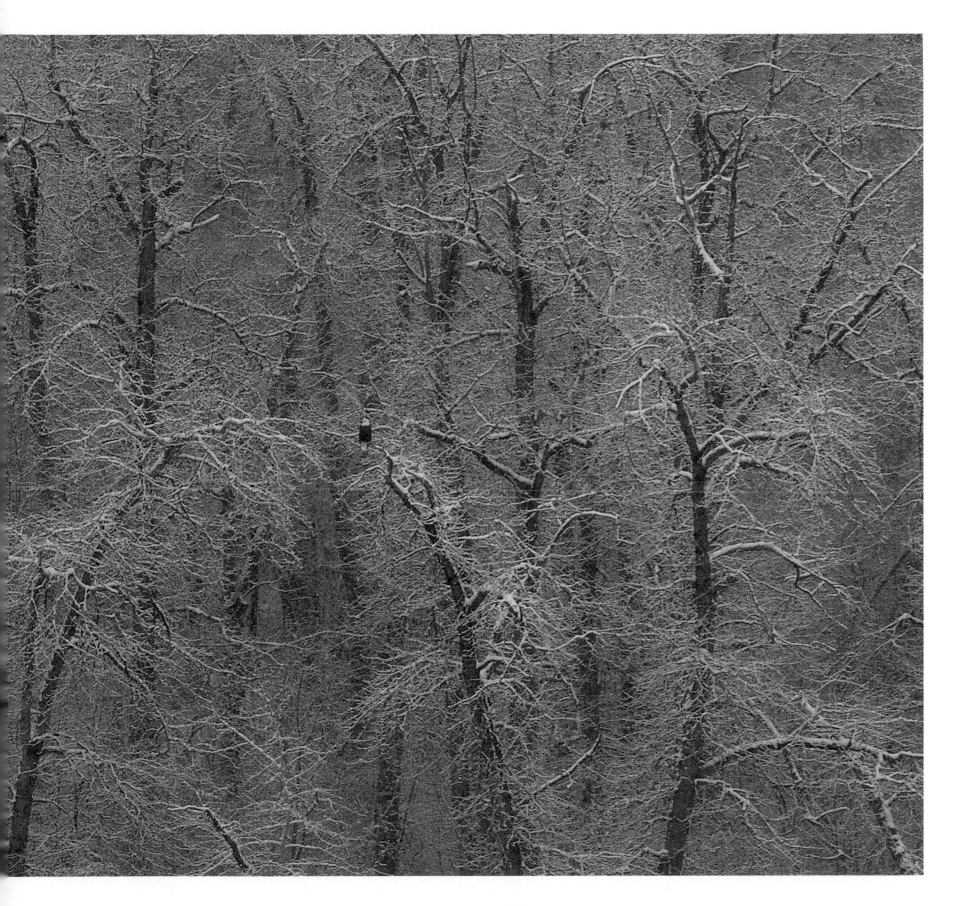

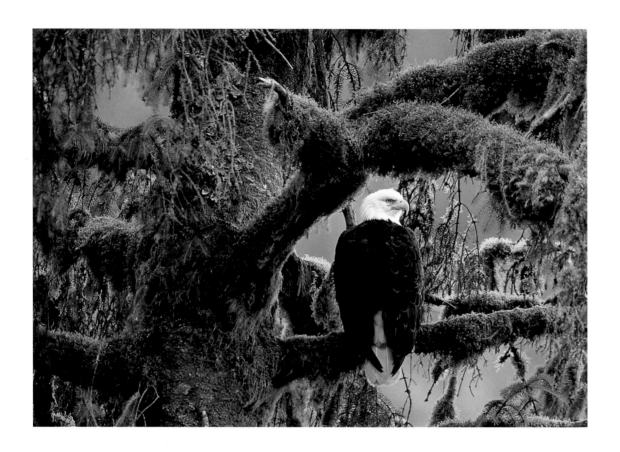

A mother black bear and cub (right) wait near a stream where salmon swim toward their rendezvous with death. A bald eagle (above) also waits to fatten up on this annual transfusion of energy, which runs up the rivers from the ocean, where salmon live most of their lives.

PRECEDING PAGES: A lone bald eagle perches in snowy cottonwoods near the Chilkat River. The world's greatest gathering of bald eagles takes place every autumn on the Chilkat when salmon thrash up its swift shallows to spawn and die.

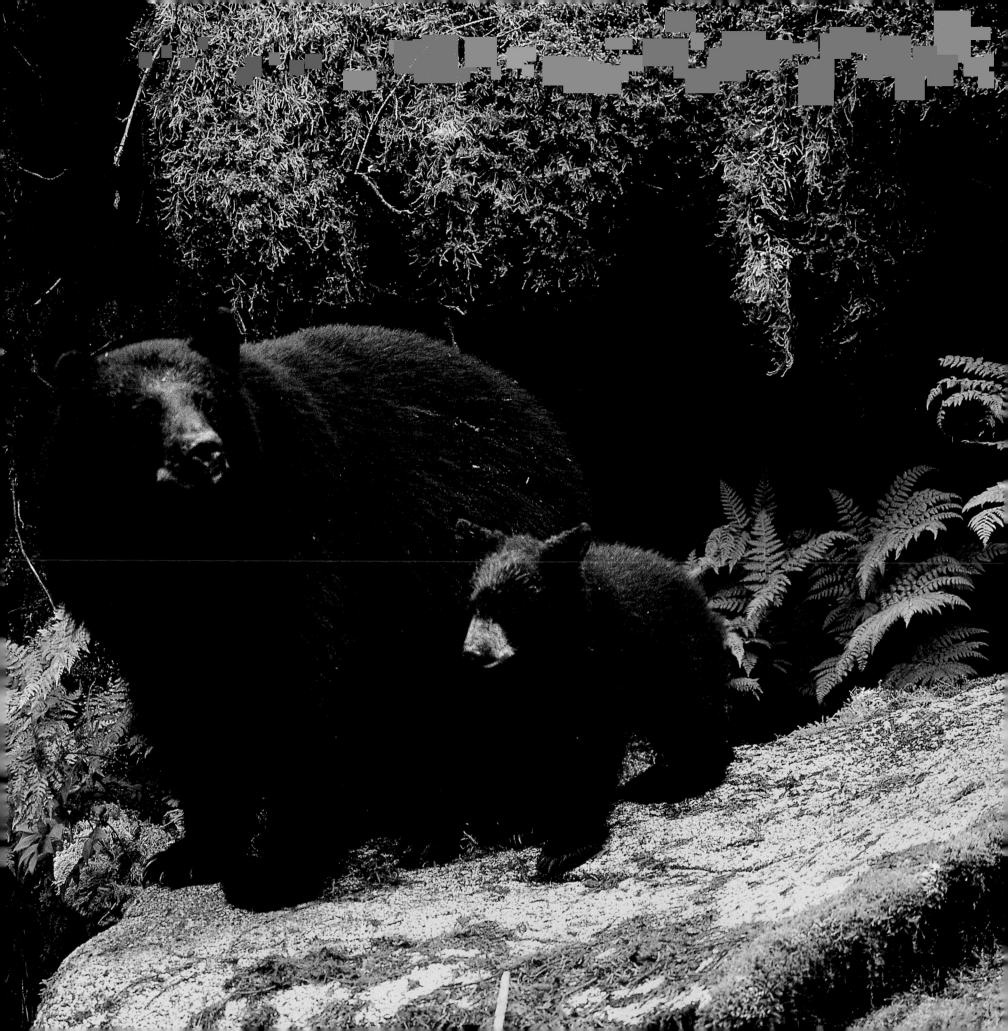

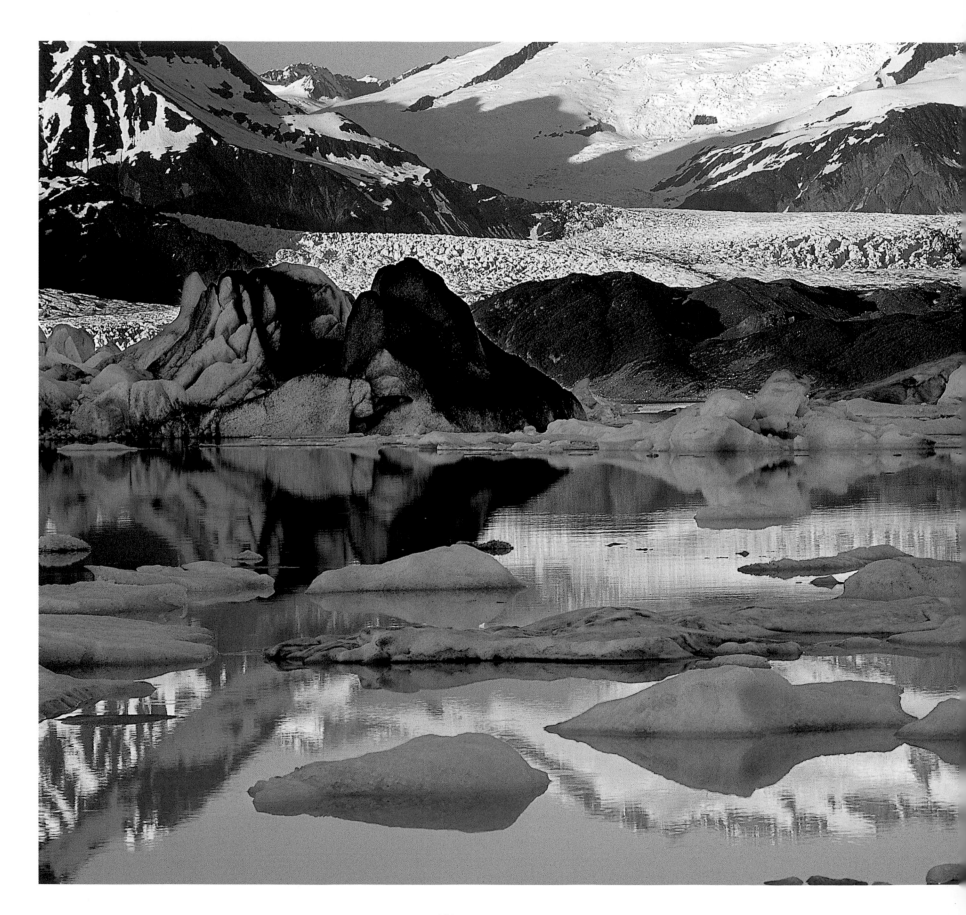

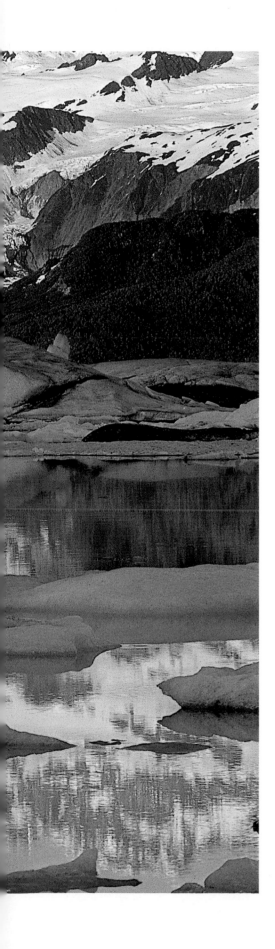

Mother of icebergs, the Alsek Glacier (left) spills out of the St. Elias Mountains into Alsek's lake just a few miles from Mount Logan—at 19,850 feet, the highest peak in Canada. Glaciers have been in retreat for several decades now, whether from man-made global warming or natural cycles. Last year's moose antler (right) shed on the lake's shore has been gnawed by ground squirrels and porcupines hungry for its minerals. Nothing goes to waste in the fierce recycling of life's elements.

FOLLOWING PAGES: Crowded onto a tiny islet in Frederick Sound, Sitka spruce grow on every square foot of rich topsoil created by the wealth of nutrients and water. Southeast Alaska can be gentle as a fog's caress or violent as a grizzly's swipe, but one thing I can count on is that it never fails to inspire.

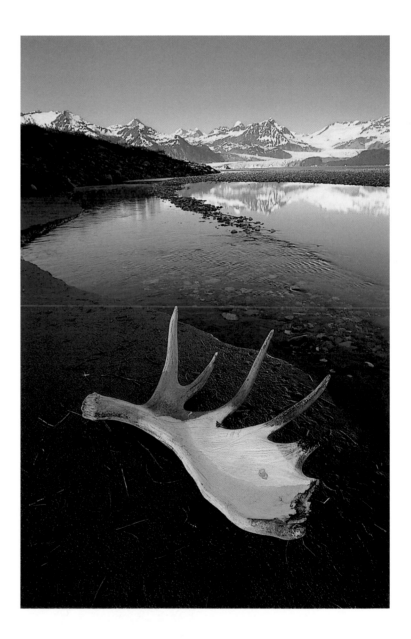

Notes on Contributors

JIM BRANDENBURG—One of the nation's premier natural history photographers, Jim Brandenburg has produced photographs for the National Geographic Society for more than 20 years. He has gained national and international acclaim, including twice being named Magazine Photographer of the Year by the National Press Photographers Association. He was also the recipient of the World Achievement Award from the United Nations. Brandenburg, who has published eight award-winning books and directed several documentaries, lives in Ely, Minnesota.

CHRISTOPHER BURKETT—Christopher Burkett worked as a printer for years, learning the fine art of color reproduction. While a brother in a Christian order he became interested in photography as a means of expressing grace, light, and beauty. His portfolio on Appalachia and his recently published book, *Intimations of Paradise,* reflect both his superb craftsmanship and his sense of spirit. Burkett says, "The purpose of my photography is to provide a brief, if somewhat veiled, glimpse into that clear and brilliant world of light and power."

LISA COUTURIER—Lisa Couturier has published numerous articles and essays about wildlife and urban nature, most recently in *American Nature Writing 2000* and *The Mountain Reader*. She is a contributing editor to *Potomac Review*, coeditor of an upcoming annual collection of women's writing, and teaches at the Writer's Center in Bethesda, Maryland. Couturier writes from her home in Brookmont, Maryland, where she lives with her husband and daughter along the Potomac River.

RAYMOND GEHMAN—Freelance photographer Raymond Gehman specializes in outdoor and natural history subjects, and prefers northern regions, where "life seems most fragile." He has contributed often to NATIONAL GEOGRAPHIC and *Traveler* magazines, as well as to the Society's books. His latest book, *Yellowstone to Yukon,* helped chronicle the initiative seeking to create a wildlife corridor from the northern Rockies to the Yukon Territory. Gehman lives in Pennsylvania's Cumberland Valley with his wife, Mary Lee, and sons, Andrew and Michael.

EDWARD HOAGLAND—An award-winning essayist and member of the American Acadamy of Arts and Letters, Edward Hoagland has explored the world of nature—both human and rural. Noted author John Updike has described him as "the best essayest of my generation." Hoagland, who has published four novels, eight essay collections, and travel books, lives in Vermont, splitting his time between Bennington and a cabin in the northern reaches of the state.

LINDA HOGAN—A member of the Chickasaw tribe, Linda Hogan draws on her Native American heritage in her fiction, nonfiction, and verse. A finalist for a Pulitzer Prize as well as the National Book Critics Award, she combines in her writings a female perspective, a deep theological insight, and a connection to the natural world that has been called uniquely Native American. Hogan currently lives in Colorado with her two daughters and teaches at the University of Colorado in Boulder.

GEORGE H. H. HUEY—George Huey photographs the American Southwest with a sensitivity and style that captures the unique beauty of the area. His photographs have appeared in many publications, including books for the Smithsonian Institution and the National Geographic Society. Huey was first intrigued by the Channel Islands as a boy when he saw them in the distant California horizon. Since then, he has visited the islands often, pursuing the mysteries of the vista that stirred his imagination as a child.

JOHN LANE—John Lane has written country songs and published two volumes of poems and a book of essays, *Weed Time: Essays from the Edge of a Country Yard*. He has also edited three anthologies of personal essays, most recently, *The Woods Stretched for Miles: New Nature Writing from the South*. He lives in Spartanburg, South Carolina, where he is cofounder of the Hub City Writers Project.

BARRY LOPEZ—Often using nature as a context in which to consider moral and philosophical issues, Barry Lopez weaves wonderful stories and passion for subject into his essays on the natural world. "In his fiction and nonfiction Lopez has become a bold, clear voice in American writing,"

in the view of one reviewer. His litany of awards includes the National Book Award and the John Burroughs Medal. Even though Lopez was only 11 years old when his family moved from California to New York, he had already formed strong bonds to the western United States. In 1970 he returned to the West and still lives there, on Oregon's McKenzie River.

BRIAN MILLER—Brian Miller has a masters-of-science degree in wildlife ecology from the University of New Hampshire and has been taking photographs for the last five years, focusing on nature and travel photography. His images have appeared in numerous magazines, calendars, and books, including NATIONAL GEOGRAPHIC and *Wildlife Conservation.* Miller hopes that his photographs inspire wonder for all wild places and creatures, as well as a passion that leads to stewardship of nature's gifts.

JOHN A. MURRAY—John Murray is the author of more than three dozen books, including such titles as *Wild Africa*, *A Republic of Rivers,* and *The Island and the Sea.* His forthcoming books include *From the Faraway Nearby*, *Mythmakers of the American West,* and *America's National Parks.* Murray lives with his son in Denver, Colorado, his home for most of the past 30 years.

RICHARD NELSON—Richard Nelson is a nature writer and cultural anthropologist who has spent many years studying relationships to the environment among Inupiat Eskimos and Athabaskan Indians in Alaska. His book, *The Island Within*—a personal journey into the natural world surrounding his home on the Alaska coast—won the John Burroughs Medal. His latest book, *Heart and Blood: Living with Deer in America*, received the Sigurd Olson Nature Writing Award. In 1999 he was named the Alaska State Writer. Nelson, an avid outdoorsman and a volunteer conservation activist, works for the protection of old-growth rain forest.

PAT O'HARA—Living in the foothills of Washington's Olympic Mountains with his wife, Christina, and daughter, Trisha, Pat O'Hara has photographed extensively in western North America and abroad, especially in the Soviet Union.

His work has been featured in many photography books, including a series of large-format publications on national parks. The photographer attributes his initial interest in nature photography to the exploration of the Yakima River corridor, while a student at Central Washington University.

SCOTT RUSSELL SANDERS—A distinguished professor of literature at Indiana University, Scott Russell Sanders explains that he learned to make sense of his life through tales told by his father, a gifted storyteller, and his mother, an avid reader. The writer conveys this emotion and meaning in stories both for children and adults. His awards include the John Burroughs Award for natural history.

PHIL SCHERMEISTER—Born in the Midwest, the freelance photographer began his career as a newspaper photographer. Over the past 13 years, assignments for the National Geographic Society have taken him to Mexico's Copper Canyon, Banff National Park in Canada, and numerous locations in the United States. Schermeister, his wife, Laureen, and daughter, Claire, live in the Sierra Nevada foothills town of Sonora, California.

TERRY TEMPEST WILLIAMS—Recognized by *Utne* as a visionary whose writing "follows wilderness trails into the realm of memory and family, exploring gender and community through the prism of landscape," Terry Tempest Williams draws on her Mormon background to interpret the landscapes of the western United States. Her books include *Refuge, An Unspoken Hunger,* and, most recently, *Leap.* A naturalist, she also strives to help conserve public lands. Williams lives in Utah with her husband, Brooke.

ART WOLFE—One of America's foremost landscape and nature photographers, Art Wolfe has published many books, including *The Living Wild* and *Light on the Land.* He has been honored by his peers as 1998 Outstanding Nature Photographer of the Year, and in 2000 he received the coveted Alfred Eisenstaedt Magazine Photography Award. Based in Seattle, Washington, Wolfe spends nine months out of the year roaming the world.

HEART *of a* NATION

Writers and Photographers Inspired by the American Landscape

Published by the National Geographic Society

John M. Fahey, Jr. *President and Chief Executive Officer*

Gilbert M. Grosvenor *Chairman of the Board*

Nina D. Hoffman *Senior Vice President*

Prepared by the Book Division

William R. Gray *Vice President and Director*

Charles Kogod *Assistant Director*

Barbara A. Payne *Editorial Director*

Staff for this Book

Charles Kogod *Editors*
Barbara A. Payne

Cinda Rose *Art Director*

Dale-Marie Herring *Assistant Editor*

Alexander Cohn *Researchers*
Amy Michelle Hoe

Douglas B. Lee *Contributing Writer*

R. Gary Colbert *Production Director*

Lewis R. Bassford *Production Project Manager*

Richard Wain *Production Manager*

Janet A. Dustin *Illustrations Assistant*

Peggy J. Candore *Assistant to the Director*

Manufacturing and Quality Management

George V. White *Director*

John T. Dunn *Associate Director*

Clifton M. Brown *Manager*

Phillip L. Schlosser *Financial Analyst*

The world's largest nonprofit scientific and educational organization, the National Geographic Society was founded in 1888 "for the increase and diffusion of geographic knowledge." Since then it has supported scientific exploration and spread information to its more than nine million members worldwide.

The National Geographic Society educates and inspires millions every day through magazines, books, television programs,videos, maps and atlases, research grants, the National Geography Bee, teacher workshops, and innovative classroom materials.

The Society is supported through membership dues and income from the sale of its educational products. Members receive National Geographic magazine—the Society's official journal—discounts on Society products, and other benefits.

For more information about the National Geographic Society and its educational programs and publications, please call 1-800-NGS-LINE (647-5463), or write to the following address:

National Geographic Society
1145 17th Street N.W.
Washington, D.C. 20036-4688 U.S.A.

Visit the Society's Web site at
www.nationalgeographic.com.

Heart of a nation : writers and photographers inspired by the American landscape.
 p. cm.
 ISBN 0-7922-7938-7 (deluxe) — ISBN 0-7922-7940-9
 1. United States—Description and travel. 2. United States—Pictorial works. 3. Landscape—United States.
4. Authors, American—Biography—Anecdotes.
5. Photographers—United States—Biography—Anecdotes.
6. Nature in literature. 7. Nature photography—United States—Anecdotes. I. National Geographic Society (U.S.)